DIFFERENCING THE CANON

In this major new book, renowned art historian Griselda Pollock makes a compelling intervention into a debate at the very centre of feminist art history: should the traditional canon of the 'Old Masters' be rejected, replaced or reformed? What 'difference' can feminist 'interventions in art's histories' make? Should we simply reject the all-male succession of 'great artists' in favour of an all-woman litany of artistic heroines? Or should we displace present gender demarcations and allow the ambiguities and complexities of desire to shape our readings of art?

Differencing the Canon moves between feminist re-readings of the canonical modern masters – Van Gogh, Toulouse-Lautrec and Manet – and the 'canonical' artists of feminist art history, Artemisia Gentileschi and Mary Cassatt. Pollock avoids both an unnuanced critique of masculine canons and an unquestioning celebration of women artists. She draws on psychoanalysis and deconstruction to examine the project of reading for 'inscriptions in the feminine', and asks what the signs of difference might be in art made by an artist who is 'a woman'.

Pollock argues that in order for difference to be understood as more than the patriarchal binary of Man/Woman we must acknowledge the differences between women which are shaped by the racist and colonial hierarchies of modernity. Pollock returns to Gayatri Spivak's injunction that we must always ask 'Who is the Other woman?', and explores questions of sexuality and cultural difference in modernist representations of black women such as Laure in Manet's *Olympia*, and in the work of contemporary artist Lubaina Himid.

Griselda Pollock is Professor of Social and Critical Histories of Art, and Director of the Centre for Cultural Studies, at the University of Leeds.

RE VISIONS: CRITICAL STUDIES IN THE
HISTORY AND THEORY OF ART
Series editors: Jon Bird and Lisa Tickner
Middlesex University

Art history has been transformed as an academic discipline over the last twenty years. The 'new' art history is no longer new, and that widely used and useful label has come to seem dangerously over-tidy.

Re Visions responds to the arrival of new ways of thinking in art history in a series of lucid and accessible studies by authors distinguished in their fields. Each book examines the usefulness of innovative concepts and methods, not in abstract terms but through the analysis of particular art objects, ways of writing about art, and cultural institutions and practices.

Other titles in the series:

CIVILIZING RITUALS:
INSIDE PUBLIC ART MUSEUMS
Carol Duncan

FEMINISM AND CONTEMPORARY ART:
THE REVOLUTIONARY POWER OF WOMEN'S LAUGHTER
Jo Anna Isaak

DIFFERENCING
THE CANON

Feminist Desire and the
Writing of Art's Histories

GRISELDA POLLOCK

London and New York

First published 1999 by Routledge
11 New Fetter Lane, London EC4P 4EE

Simultaneously published in the USA and Canada
by Routledge
29 West 35th Street, New York, NY 10001

© 1999 Griselda Pollock

Typeset in Sabon by
Keystroke, Jacaranda Lodge, Wolverhampton
Printed and bound in Great Britain by
Butler and Tanner Ltd, Frome and London

British Library Cataloguing in Publication Data
A catalogue record for this book is available from the British Library

Library of Congress Cataloguing in Publication Data
Pollock, Griselda.
Differencing the canon: feminist desire and the writing of art's
histories / Griselda Pollock.
Includes bibliographical references and index.
1. Feminism and art. 2. Women art historians—Psychology.
3. Psychoanalysis and feminism. I. Title.
N72.F45P63 1999
704′.042—dc21 98–28921

ISBN 0–415–06699–9 (hbk)
0–415–06700–6 (pbk)

For SARAH KOFMAN

May her memory be a blessing

CONTENTS

CONTENTS

CONTENTS

ILLUSTRATIONS

PREFACE

This book poses the question 'What is the canon?' from a feminist perspective, exploring the problems canonicity presents for feminist interventions in the field of art's histories at the level both of the exclusivity of the canon and of canonical interpretations and methodologies. Always embedded in feminism's encounter with the story of Western art that has become institutionalised in museal, scholarly and published art history, the question of a single standard of absolute, transhistorical artistic value embodied in the outstanding, exemplary, representative yet universalistic artist has presented major historiographical and theoretical problems. How could different narratives, models or identities intervene in what is generally accepted to be art's history without merely confirming the endless play of the One and its Other? Can the difference of the 'feminine' make a difference to what we learn from the cultural past? Can we escape the idealised Story of Great Men without longing for Heroised Women?

Since 1971, when Linda Nochlin first proposed that 'the woman question' transcended the local partisanship of setting the record straight by re-instating some 'old mistresses', feminists have been struggling to effect the paradigm shift in the conceptualisation of cultural histories and artistic practices that Nochlin saw as feminism's possibility and responsibility. I am a product of that moment of intellectual adventure and political reawakening in the 1960s whose result, for the first time in history, would be a sufficient number and density of women within academe and related professions not merely to effect an increase in token numbers but to create a theoretical and cultural revolution that has reshaped every discipline and practice it has touched. Since feminism and my academic interest in the history of art first collided, the questions of why women and art are set in contradiction by modern culture and how to challenge that discursive and ideological structure has shaped my work in as much as against art history. In this book, a return to the historiographical and theoretical terrain first charted in Rozsika Parker's and my *Old Mistresses: Women, Art & Ideology* (1978–81), I propose a dual strategy. Reading selected case studies predominantly from the historical moment of early European modernism through the theoretical prisms of contemporary feminist thought, I interrogate visual representations from that historical moment in the late nineteenth century for insights into the historical legacy of modernity that itself prompted and necessitated a feminist

xiii

revolt and re-vision: the feminist modernisation of sexual difference. Sexuality, subjectivity and representation form a critical set of inter-relating issues for feminist cultural analysis of visual representations that traverse the terrains of desire, fantasy and ambivalence for which a concurrent modernisation of psychology – psychoanalysis – provides the theoretical terms. It seems a feminist necessity to attempt to hold in tension and creative dialogue both a historical and social analysis of the semiotics of representation and an attention to the psycho-symbolic level of subjectivity and its enunciations in aesthetic practices.

The first part, *Firing the Canon*, engages in the so-called 'culture wars'. Proposing that the canon should be understood as both a discursive structure and a structure of masculine narcissism within the exercise of cultural hegemony, I examine the theoretical and political issues involved not in displacing the canon but in 'differencing' the canon, exposing its engagement with a politics of sexual difference while allowing that very problematic to make a difference to how we read art's histories. The second part, *Reading Against the Grain*, is about reading strategies, using case studies of two artists who are men – Van Gogh and Toulouse-Lautrec – to explore how a feminist reading of canonised artists can yield a different reading of their representations of women, and hence of masculinity as an ambivalent psychic position of cultural enunciation. Both artists enjoy a mythic status in both art history and popular culture, each for radically different reasons. Their lives and works sustain the mythology of the suffering hero of modern art. Framing their practices at the intersection of histories of sexuality and modernity around the figure of the Mother, I argue that the repressed questions not only of gender but of sexuality and sexual difference should be acknowledged as critical elements of both the content and the form of canonically acknowledged modern art and art history.

Starting at the heart of canonicity confronts the strategies of introducing difference into the canon so as to avoid two dangers. The first danger, the ghettoisation of feminist studies in art history because of an exclusive focus on art made by women, underplays feminism as a comprehensive perspective from which to reconsider the very constitution of the study of all of art's histories. The second danger is the corollary of the feminist adulation of its reclaimed 'old mistresses': namely, the unrelenting critique of masculine culture. My concern is to read some art by artist-men with a merciful irony, which is also self-irony, in order to establish the way consciously *feminist*, as well as unconscious *feminine*, desire can reconfigure canonical texts for other readings.

The third part, *Heroines*, takes on the problem of 'Setting Women in the Canon' by looking at feminist investments in the work and much abused biography of a seventeenth-century painter, Artemisia Gentileschi. Subjecting feminist writing to an equally critical self-analysis, I conclude that we must take responsibility for feminist fantasies and mythologies created around the woman artist by feminist discourse. Because the exact contents of Artemisia Gentileschi's oeuvre are still so unstable as a result of the predicament of the woman artist in the archive and in art history, we can ask ourselves: What are we looking for in the work we assume to be 'by a woman'? What would be the signs of difference – if we refuse the notions of authorship and

expressivity that sustain ordinary art histories? Can self-reflexive reading for differentiations rather than the projective attribution of an absolute difference derived from preconceived ideas of gender have a place in an art historical practice? Shifting from the project of reading 'as a woman', I propose reading for the 'inscriptions of the feminine' to create a 'view from elsewhere' (De Lauretis). Focusing on four paintings by Artemisia Gentileschi that feature a woman's body as the core of a complex narrativity around sexuality, trauma, bereavement and imaginary identification – *Susanna*, *Judith*, *Lucretia* and *Cleopatra* – I offer possible readings of her work 'against the grain of' both feminist celebration and canonical sensationalism.

In working on this section, I draw upon the work of Mieke Bal whose semiotic and narratological study of Baroque history painting provided a series of profound theoretical insights into how images are processed by their viewers and how we might formulate a politics of self-conscious and politically accountable cultural *reading of images*.[1] Bal fashions a new concept, *hysterics*, to describe a feminist poetics that conjoins semiotics and psychoanalysis. A *hysterical* reading attends to the rhetoric of the image rather than to the plot it seems to illustrate, preferring to focus on a revealing detail rather than the overall proposition, and it leads us to identify imaginatively with the victim rather than see the event through the eyes of the usually male protagonist. As a counter-strategy, *hysterics* exposes the implicit and misogynist violence within representation that canonical readings condone and naturalise.

But, if difference is not just to be a replication of phallocentric ideologies of *the* difference – based on a reified heterosexual opposition Man versus Woman – it must acknowledge the divisions within the collectivity of women that produce real, antagonistic conflicts shaped by modernity's imperialist and racist face. The section on Gentileschi and the possibilities of narrative figurative representation in the Western tradition lead to discussions of other axes of difference. A chapter on the work of the contemporary British artist Lubaina Himid examines the struggle for articulation of postcolonial black femininities repressed by white feminist discourse as much as by the canons of imperialism. How are feminist interventions in art histories with their almost all-white canon to respect that difference in ways which make the histories of black women artists part of the expanded cultural text of other modernities and other modernisms? Can we also desire alliance without negating the differences which are our specific historical, social and psychological legacies? What are the possible cultural implications of the representation of woman-to-woman bonds, social, political or sexual, in the struggle against the canonisation of but one form of difference and one hierarchical bonding: gender?

The final part poses the question: *Who is the Other?* in two chapters that return to the historical ground of modernist culture with which the book opened. Chapter 8 focuses on an exhibition in support of women's suffrage held in New York in 1915 where works by Mary Cassatt and Edgar Degas confronted each other across Knoedler's Gallery. In that historical moment an artist who is now a feminist heroine hung opposite the canonical modernist most notorious and debated for his misogynist views on and representations of women.[2] Using class rather than gender alone to tease

out the conditions of a historical reading of such contradictory projects, I seek a way to challenge my own partisanship as a feminist art historian working on Mary Cassatt. The final chapter focuses on a trio of women who figure at the beginning of modernism: Laure (no known surname), the model for the black woman in Edouard Manet's *Olympia* (1863–5); Jeanne Duval, the African-European companion of the poet Baudelaire apparently portrayed by Manet in 1862; and Berthe Morisot, the French European painter and recurrent model for Manet in the period 1868–72. In this weaving of three narratives I trace the real and imaginary African presence in the formation of white, masculine modernism. Laure, like some figures in Mary Cassatt's 1891 suite of colour prints I discuss in Chapter 8, worked as a maid. A liminal figure, the domestic servant has been noted in many feminist writings as a marker of social difference between women and as a mythic figure that breaks the hermetic enclosures of bourgeois familial and domestic ideology in which a classed and raced femininity was articulated and enforced.[3] This final section looks at the social relations between women in their differences as represented in works by both men and women while taking on once again what I have elsewhere called 'gender and the colour of art history'.

There is, I discover in retrospect, an unconscious agenda. The book is in part about loss, mourning and restoration. I lived this acutely during the process of writing a text that almost foundered on the difficulty of hanging on the edge of the 'depressive anxiety' that Melanie Klein argued is the the fate of all subjects, the condition of creative impulse, and the infantile space into which incomplete mourning can at any time precipitate us. Now, at a distance of three years from the moment of writing, I can see more clearly the way in which my own unprocessed grief as a motherless daughter presses upon and shapes my interests, my attention to facets of a painting, a debate, as well as my idealisations and mythologies. I ask indulgence of the reader for the ways in which a personal narrative informs and even might be said to intrude upon its apparently historical materials. At the same time, I draw encouragement from Shoshana Felman, when she writes of a covenant of reading in the exploration of women's missing autobiographies.[4] In opposition to simplified feminist notions of 'getting personal', Shoshana Felman suggests that our own stories are missing, yet are to be found as we read those of other women. While, following Hayden White, we must acknowledge that there is a convergence between 'history writing' and writing fiction, for all texts are structured by their own rhetorical figures, the conscious awareness of 'narrative' when we write 'history' has special resonances for feminists in their desire not only to do history differently but to tell tales in such a way as to make a difference in the totality of the spaces we call knowledge. I have used this book to find my own autobiography as much as I have lent some of my own story to the texts I discovered in the archive. The trick is to hold the two in a creative covenant. Across that moment of both distance and yearning plays what I call 'desire'.

NOTES

1 Mieke Bal, *Reading Rembrandt: Beyond the Word–Image Opposition* (Cambridge and New York: Cambridge University Press, 1991).
2 Richard Kendall and Griselda Pollock, eds, *Dealing with Degas: Representations of Women and the Politics of Vision* (London: Pandora, 1992; now London: Rivers Oram).
3 Jane Gallop, 'Keys to Dora', in *Feminism and Psychoanalysis: The Daughter's Seduction* (London: Macmillan, 1982).
4 Shoshana Felman, *What Does a Woman Want? Reading and Sexual Difference* (Baltimore and London: Johns Hopkins University Press, 1993).

ACKNOWLEDGEMENTS

In searching for a way to explore 'feminist desire in the writing of art's histories' I have held many real and several imaginary conversations. I want to acknowledge those that took place with the authors of books I found especially helpful and those with actual people: Mieke Bal, Shoshana Felman, Mary Garrard, Lubaina Himid, Judith Mastai, Nanette Salomon and Adrian Rifkin. Helga Hanks gave me support and understanding through the many years of this book's genesis and my own re-creation. I have dedicated the book to the memory of Sarah Kofman, whose work on the psychic underpinnings of writing on art I have used in this study as its organising theme and whose death in the middle of my belated discovery of her academic and auto-biographical writing brought into acute focus the issues of mourning, grief and loss in that complex conjunction of writing and the fabric of personal history that is Jewish experience in the twentieth century. This book has been long in the making and I would like to express my deepest thanks to my two series editors, Jon Bird and Lisa Tickner, who have read and re-read the manuscript, offering astute and always supportive guidance in the remoulding of an unwieldy text into its present form. They have provided the most valuable encouragement and intelligent guidance over the long genesis of a text which they gracefully accepted for their series despite its cavalier disregard of the original brief. It has been a productive process and I have learnt a great deal from them both. I thank Marquard Smith and Nancy Proctor, my research assistants at different times during the project. Their astonishing abilities to use all the new research engines and databanks was matched by their always interesting and supportive conversation about the project. I would also like to thank Rebecca Barden of Routledge for her consistent support of the project and wise management of the process of its editing and final form.

Griselda Pollock
Leeds 1998

Part I

FIRING THE CANON

As canons within academic disciplines go, the art historical canon is among the most virulent, the most virilent, and ultimately the most vulnerable.
Nanette Salomon, *'The Art Historical Canon: Sins of Omission'*, 1991

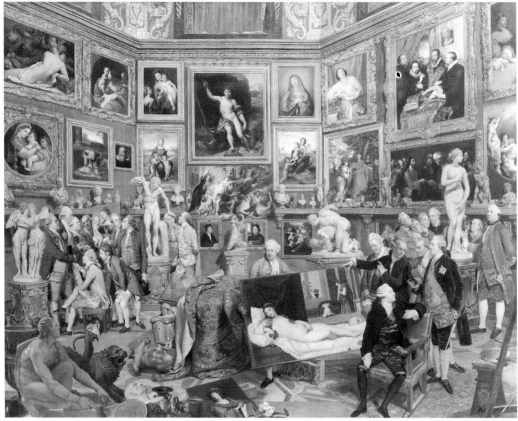

Fig. 1.1. Johan Zoffany (1733/4–1810), *The Tribuna of the Uffizi*, 1772–7/8, oil on canvas, 123.5 × 155 cm. London: Her Majesty Queen Elizabeth II

1
ABOUT CANONS AND CULTURE WARS

The term *canon* is derived from the Greek *kanon*, which means 'rule' or 'standard', evoking both social regulation and military organisation. Originally, the canon had religious overtones, being the officially accepted list of writings that forms the 'Scriptures'. The first canonisation exercise was the selection of the Hebrew Scriptures, made by an emergent priestly class around the seventh century BCE, of which the historian Ellis Rivkin has argued that the choice was 'not primarily the work of scribes, scholars or editors who sought out neglected traditions about wilderness experience, but of a class struggling to gain power'.[1] Canons may be understood, therefore, as the retrospectively legitimating backbone of a cultural and political identity, a consolidated narrative of origin, conferring authority on the texts selected to naturalise this function. Canonicity refers to both the assumed quality of an included text and to the status a text acquires because it belongs within an authoritative collection. Religions confer sanctity upon their canonised texts, often implying, if not divine authorship, at least divine authority.

With the rise of academies and universities, canons have become secular, referring to bodies of literature or the pantheon of art (Fig. 1.1). The canon signifies what academic institutions establish as the best, the most representative, and the most significant texts – or objects – in literature, art history or music. Repositories of transhistorical aesthetic value, the canons of various cultural practices establish what is unquestionably great, as well as what must be studied as a model by those aspiring to the practice. The canon comprehensively constitutes the patrimony of any person wanting to be considered 'educated'. As Dominick LaCapra comments, the canon reaffirms a 'displaced religious sense of the sacred text as the beacon of common culture for an educated elite'.[2]

Historically, there has never been just one, single canon. Art historically, there are competing canons. During the great era of art historical activity in the nineteenth century, many artists as well as schools and traditions were rediscovered and revalued. Rembrandt, for instance, was reclaimed in the nineteenth century as a great religious and spiritual artist instead of being dismissed, as he had been in the eighteenth, as a sloppy painter of low subjects, while Hals, long avoided as a minor Flemish genre painter of no great skill or distinction, became an inspiration to Manet and his generation of modernists in search of new techniques of painting 'life'.[3]

Always associated with canonicity as a structure, however, is the idea of naturally revealed, universal value and individual achievement that serves to justify the highly select and privileged membership of the canon that denies any selectivity. As the record of autonomous genius, the canon appears to arise spontaneously. In 'What is a Masterpiece?' the art historian Kenneth Clark acknowledged the fluctuations of taste according to social and historical vagaries that allowed Rembrandt to be disdained in the eighteenth century or artists that we no longer value to have been highly rated in the nineteenth. None the less, Clark insists that 'Although many meanings cluster around the word masterpiece, it is above all the work of an artist of genius who has been absorbed by the spirit of the time in a way that has made his individual experiences universal'.[4]

The canon is not just the product of the academy. It is also created by artists or writers. Canons are formed from the ancestral figures evoked in an artist/writer/ composer's work through a process that Harold Bloom, author of the major defence of canonicity, *The Western Canon* (1994), identified as 'the anxiety of influence', and I, in another mode of argument, the avant-garde gambit of 'reference, deference, and difference'.[5] The canon thus not only determines what we read, look at, listen to, see at the art gallery and study in school or university. It is formed retrospectively by what artists themselves select as their legitimating or enabling predecessors. If, however, artists – because they are women or non-European – are both left out of the records and ignored as part of the cultural heritage, the canon becomes an increasingly impoverished and impoverishing filter for the totality of cultural possibilities generation after generation. Today, the canons are settled into well-known patterns because of the role of institutions such as museums, publishing houses and university curricula. We know these canons – Renaissance, modernist, etc. through what gets hung in art galleries, played in concerts, published and taught as literature or art history in universities and schools, gets put on the curriculum as the standard and necessary topics for study at all levels in the educating – acculturating, assimilating – process.

In recent years the culture wars have broken out as new social movements target canons as pillars of the established elites and supports of hegemonic social groups, classes and 'races'.[6] Canonicity has been subjected to a withering critique for the selectivity it disavows, for its racial and sexual exclusivity and for the ideological values which are enshrined not just in the choice of favoured texts but in the methods of their interpretation – celebratory affirmations of a world where, according to Henry Louis Gates Jnr., 'men were men and men were white, when scholar-critics were white men and when women and people of colour were voiceless, faceless servants or laborers, pouring tea and filling brandy snifters in the boardrooms of old boys' clubs'.[7] Critique of the canon has been motivated by those who feel themselves voiceless and deprived of a recognised cultural history because the canon excludes the texts written, painted or composed and performed by their social, gender or cultural community. Without such recognition, these groups lack representations of themselves to contest the stereotyping, discriminating and oppressive ones which figure in that which has

been canonised. Henry Louis Gates Jnr. explains the political implications of enlarged canons that accommodate the voice of the Other:

> To reform core curriculums, to account for the comparable eloquence of the African, the Asian, and the Middle Eastern traditions, is to begin to prepare our students for their roles as citizens of world cultures through a truly human notion of the 'humanities' rather than – as Mr. Bennett [Secretary for Education under Ronald Reagan] and Mr. [Harold] Bloom would have it – as guardians of the last frontier outpost of white male western culture, the keepers of the master's pieces.[8]

The 'discourse of the Other' must of necessity 'difference the canon'. Yet it reveals a new difficulty. However strategically necessary the new privileging of the Other certainly is in a world so radically imbalanced in favour of the 'privileged male of the white race', there is still a binary opposition in place which cannot ever relieve the Other of being *other* to a dominant norm.

Different kinds of moves have been necessary even to imagine a way beyond that trap. Toni Morrison has argued that American literature, whose canon so forcefully excludes African American voices, should, none the less, be read as structurally conditioned by 'a dark, abiding, signing Africanist presence'.[9] By identifying this structurally negative relationship to African culture and Africans within the American canon of white literature, notions of excluded others are transformed into questions about the formation of Eurocentric intellectual domination and the resultant impoverishment of what is read and studied. This argument can be compared with that Rozsika Parker and I first advanced in 1981 in opposition to an initial feminist attempt to put women into the canon of art history. We used the apparent exclusion of women as artists to reveal how, structurally, the discourse of phallocentric art history relied upon the category of a negated femininity in order to secure the supremacy of masculinity within the sphere of creativity.[10]

In the early 1990s, the issue of the total gender asymmetry in the canon, implicit in all feminist interrogations of art history, became an articulated platform through a panel organised by Linda Nochlin, *Firing the Canon*, in New York in 1990 and through the critical writing of Nanette Salomon on the canon from Vasari to Janson, cited at the head of Part 1.[11] Feminist critics of the canons of Western culture could easily critique the all-male club represented by Ernst Gombrich's *Story of Art* and the original editions of H. W. Janson's *History of Art* that featured not one women artist.[12] Feminists have shown how canons actively create a patrilineal genealogy of father–son succession and replicate patriarchal mythologies of exclusively masculine creativity.[13] Susan Hardy Aiken, for instance, traces the parallels between the competitive modelling of academic practices, the Oedipal stories narrated by canons, the rivalries that serve as the unconscious motor of intellectual or cultural development, all of which produce the coincidence of the 'noble lineage of male textuality, the parallel

formation of canons and the colonizing projects of western Europe organised rhetorically around the opposition civilisation and barbarism'. She concludes:

> These links between priestly authority, the implications of 'official' textuality, and the exclusionary and hegemonic motives within canon formation have obvious significance for the question of women and canonicity . . . Woman . . . becomes a profanation, a heretical voice from the wilderness that threatens the *patrius sermo*, – the orthodox, public, canonical Word – with the full force of another tongue – a mother tongue – the *lingua materna* that for those still within the confines of the old order must remain unspeakable.[14]

Is feminism to intervene to create a maternal genealogy to compete with the paternal lineage and to invoke the voice of the Mother to counter the text of the Father enshrined by existing canons? Susan Hardy Aiken warns: 'one might, by attacking, reify the power one opposes.'[15] Against the closed library, from which, in her famous feminist parable on the exclusivity of the canon, *A Room of One's Own* (1928), Virginia Woolf so eloquently showed women to be shut out, we might propose more than another bookroom. Instead we need a *polylogue*: 'the interplay of many voices, a kind of creative "barbarism" that would disrupt the monological, colonizing, centric drives of "civilisation" . . . Such a vision lives, as Adrienne Rich has taught us, in a re-vision: an eccentric re-reading, re-discovering what the canon's priestly mantle would conceal: the entanglements of all literature with the power dynamics of culture.'[16]

THEORETICAL MODELS FOR THE CRITIQUE OF THE CANON: IDEOLOGY AND MYTH

The critique of canons has been made on the basis of an inside/outside opposition. The canon is selective in its inclusions and is revealed as political in its patterns of exclusion. We might, therefore, approach the problem of the canon as critical outsiders with one of two projects in mind.

The first is to expand the Western canon so that it will include what it hitherto refused – women, for instance, and minority cultures (Fig. 1.2). The other is to abolish canons altogether and argue that all cultural artefacts have significance. The latter appears inherently more political in its totalising critique of canonicity. Strategically, however, I suggest we need a more complex analysis if we are not to end up in a position where insiders – representatives of Western masculine European canons – gird themselves to defend truth and beauty and its traditions against what Harold Bloom dismisses as the School of Resentment,[17] while former outsiders remain outsiders, 'the voices of the Other', by developing 'other' subdisciplinary formations – African American or Black Studies, Latino Studies, Women's Studies, Lesbian and Gay Studies, Cultural Studies and so forth. There can be no doubt how necessary and creative

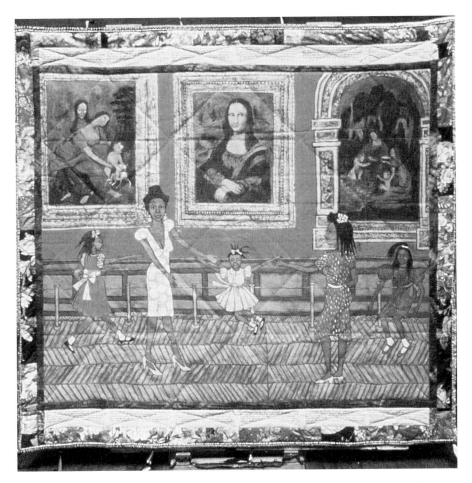

Fig. 1.2. Faith Ringgold (b. 1930), *Dancing in the Louvre*, from *The French Collection*, 1991, acrylic on canvas with painted fabric. 183.7 × 200 cm. Private Collection

such commitment of scholarship, resources and acknowledgement is to areas hitherto ignored and understudied. But this cannot avoid the danger, so evident in fundamentally, and often overtly, racist and sexist class societies, that these initiatives may unwittingly reproduce the very segregation – ghettoisation – which excluded groups aim to challenge by demanding intellectual and educational equal rights for their own excluded minority.

Following Teresa de Lauretis, the opposition between inside and outside can be displaced. De Lauretis locates the critical project of feminism as a 'view from elsewhere' which is, however, never outside that which it is critically 're-viewing'.

For that 'elsewhere' is not some mythic distant past or some utopian future history; it is the elsewhere of discourse here and now, the blind spots, or the space-off, of its representations. I think of it as the spaces in the margins of

hegemonic discourses, social spaces carved in the interstices of institutions and in the chinks and cracks of the power-knowledge-apparati.[18]

The movement is not from the spaces of existing representation to those beyond them, 'the space outside discourse', for there can be no such resource. Rather Teresa de Lauretis means 'a movement from the space represented by/in a representation, by/in a discourse, by/in a sex-gender system to the space not-represented yet implied (unseen) in them'.[19] This other scene, already there, which is as yet unrepresented, has, however, been rendered almost *unrepresentable* by the existing modes of hegemonic discourses. Working 'against the grain', reading 'between the lines', Teresa de Lauretis suggests that we have to take up the contradictions in which the represented and unrepresented concurrently exist.

Like Woman in phallocentric culture, feminism is already posited as the difference, that is, as something other to, and outside, art history, in contradiction to its inevitable logic. Thus feminist art history is an oxymoron. In this book I shall be exploring how to use this position of *apparent* alterity – the view from elsewhere/voice of the Other/Mother – to deconstruct the oppositions inside/outside, norm/difference which ultimately condense on to the binary pair man/woman for which the others become related metaphors. The question is how to *make a difference*, by analysing this structuring of difference, which already implicates me as a writer in ways that only writing itself will expose. My title uses the active verbal form, *Differencing the Canon*, rather than the noun 'Difference and/in the Canon' to stress the active re-reading and reworking of that which is visible and authorised in the spaces of representation in order to articulate that which, while repressed, is always present as its structuring other.

Furthermore, I suggest that we need to recognise another aspect of sexual differentiation, namely, *desire* in the formation of canons and the writing of counter-histories. The tenacity of the defenders of the present canon is explicable only in terms of a profound investment in the pleasures its stories and its heroes provide at more than social or even ideological levels. I shall argue for a psycho-symbolic dimension to the hold of the canon, its masculine ideals and not so much its intolerance of femininity as a masculinist boredom with and indifference to femininity's pleasures and resources as a possible and expanded way of relating to and representing the world.

Because of being structurally positioned as outsiders, feminists are susceptible to the desire to create heroines to replace or supplement those heroes our colleagues who are men find so affirming within the canonical structure. I am obliged to question both that desire and the very possibility of its realisation by looking again at the mythologies of the woman artist Western feminism has been fabricating. The introduction of this term, *mythology*, marks a shift of emphasis from the usual concerns of a social history of art, with its desire to reconfigure the conditions of artistic production in such as way as to get closer to the grain of historically sited social and cultural practices. In this book I am working from the side of reading and writing, reading the texts that different historical practices have left us and writing others that enter into a 'covenant

8

of reading' in a fully acknowledged search for the stories of women, my own included. The concept of myth seems for the moment as vivid and useful as the notion of ideology.[20] Bonding structuralist concepts of myth to Marxist theories of ideology, Roland Barthes identified the deep structures animating contemporary cultures that drew upon the character of myth itself to disown and to displace from view the ideologically fabricated meanings being produced. According to Barthes, myth is depoliticised speech, and its singular bourgeois form functions precisely to disown History, creating Nature – a mythic erasure of time and thus the possibility of political challenge and change.[21] In the writing of art's histories, the place of the artist, and of the woman artist, are overdetermined by mythic structures that naturalise a particular range of meanings for masculinity, femininity, sexual and cultural difference. Making a difference to the canon, itself a myth of creativity and gender privilege, cannot be achieved without a repoliticising scrutiny both of its deep structures – why are women Other to/within it? – and of its surface effects: the indifference to and exclusion of the work of artists who are women from the canon. Thus the question of desire – that enshrined in the canon as well as that which motivates a critique – runs parallel with analysis of the mythic structure which is encoded in the (sexual) difference the canon embodies.

Considering the canon as a mythic structure avoids the distracting arguments over who and what is or is not, should or should not be in which canon. Beyond the culture wars over its contents, which keeps us at the mythic level of a debate about quality, art, genius, significance and so forth, we need to pierce the naturalising carapace of myth to delineate the social and political investments in canonicity which make it so powerful an element in the hegemony of dominant social groups and interests and ask:

WHAT IS THE CANON – STRUCTURALLY?

More than a collection of valued objects/texts or a list of revered masters, I define the canon as a discursive formation which constitutes the objects/texts it selects as the products of artistic mastery and, thereby, contributes to the legitimation of white masculinity's exclusive identification with creativity and with Culture. To learn about Art, through the canonical discourse, is to know masculinity as power and meaning, and all three as identical with Truth and Beauty. So long as feminism also tries to be a discourse about art, truth and beauty, it can only confirm the structure of the canon, and by doing so corroborate masculine mastery and power, however many women's names it tries to add, or fuller historical accounts it manages to produce. There are famous women artists now: Mary Cassatt, Frida Kahlo, Georgia O'Keefe. But a careful analysis of their status will find that they are not canonical – providing a benchmark for greatness. They are rather notorious, sensational, commodifiable or token, and will be as virulently attacked as they are lovingly adored. The stumbling block at all times for their acknowledgement within the canon lies in the unassimilable

question of sexual difference as a challenge to the very possibility of one 'rule' or 'standard' that is the canon.

Canonicity exists in many forms, the better to produce, at the cultural and ideological level, the single standard of the greatest and the best for all times. 'Tradition' is the canon's 'natural' face, and in this form cultural regulation participates in what Raymond Williams names social and political hegemony. In distinction to gross forms of coercive social or political domination, the Marxist term *hegemony* explains the way a particular social and political order culturally saturates a society so profoundly that its regime is lived by its populations simply as 'common sense'. Hierarchy becomes a natural order, and what appears to survive from the past because of its inherent significance determines the values of the present. Williams calls 'Tradition . . . in practice the most evident expression of the dominant and hegemonic pressures and limits'. It is always, however, 'more than an inert historicized segment; indeed it is the most powerful practical means of incorporation'.[22]

Tradition is, therefore, not merely what the past leaves us. It must always be understood as *selective* tradition: 'an intentionally shaping version of a past and a pre-shaped present, which is then powerfully operative in the process of social and cultural definition and identification'.[23] Tradition cultivates its own inevitability by erasing the fact of its selectivity in regard to practices, meanings, gender, 'races' and classes. What is thus obscured is the active process of exclusion or neglect operated by the present-day makers of tradition. 'What has to be said about any tradition', argues Williams, 'is that it is . . . an aspect of *contemporary* social and cultural organisation, in the interest of the dominance of a specific class'.[24] Versions of the past ratify a present order, producing 'a predisposed continuity' which favours what Gayatri Spivak names as 'the privileged male of the white race'.[25]

Specific strategies characteristic, or even definitive, of the discipline of art history in the twentieth century can be read as not merely constituting a selective tradition privileging white masculine creativity to the exclusion of all women artists and men of minority cultures. The specific forms of art history's discursive formations tell more than a story of art. They also articulate historically changing configurations between classes, races, sexualities and genders secured by the production of sexual and other differentiations of power within our culture. Discrimination against women artists, for instance, can be understood institutionally. We can combat it through political activism, campaigning for more women artists at the Whitney Biennial and so forth, as we did in the early 1970s. But let us recall the response to the Whitney Biennial of 1993, where a broad and comprehensive representation of artists from all American communities evenly divided by gender, class and sexuality was met by an extreme, conservative negation of the event in the press. The exhibition was deemed to be unrepresentative of *the* American culture and *the* tradition these canonical critics sought to legitimate exclusively. The backlash reveals that the belief that we could correct the imbalances is mistaken. In order to shift the lines of demarcation we must attend both to the level of enunciation – what is said in discourses and done in practices in museums and galleries – and to the level of

effect, that is, how what is said articulates hierarchies, norms, asserting elite white masculine heterosexual domination and privilege as 'common sense' and insisting that anything else is an unaesthetic aberration: bad art, politics instead of art, partisanship instead of universal values, motivated expression instead of disinterested truth and beauty.

Since the potency of hegemony is not pure domination and absolute exclusion, it works by trying to draw us in so as to construct an effective *self-identification* with the hegemonic forms: a specific internalised 'socialization' which is 'expected to be positive but which, if that is not possible, will rest on a (resigned) recognition of the inevitable and the necessary'.[26] Cultural struggle at the moment is focused specifically on a contest around the canons of literature, music, art. These challenges to the existing selective versions of historical and contemporary creativity, which are passed off as the singular and valid for all times and places, and which we call Tradition, have arisen from those communities who most acutely experience the effects of exclusions. Desiring to be artists, or scholars or teachers, we are conflicted by the forced internalisation, in what the standard curricula of study decree, of our own communities' absence from, marginality in, or negation by the sphere of cultural production and meaning-making. Out of the range of the excluded jointly protesting the canon comes a counter-hegemony, with its counter-identifications – or at least the beginning of those alliances through which the domination of one social group can be contested by those others it denies and debases. At present the resistance is fragmented into special studies, each pursuing its own agenda in the name of a radical identity politics. Concepts of hegemony and counter-hegemony point in the direction of strategies whose aim is to foster alliance across the splintered fragments of the contemporary world. These must involve understanding of how difference currently works to organise segregation and division and even makes us desire the continuance of its frontiers.

At the same time, it would be counter-productive to seek to abolish difference for such an ideal of universalism without particularity retains an imperialist notion of imagined sameness and unity. Differences can co-exist, cross-fertilise and challenge, be acknowledged, confronted, celebrated and not remain destructive of the other in an expanded but shared cultural space. Instead of the present exclusivity of the cultural canon contested by fragmented special studies all premised on the binary oppositions of identity politics, insiders/outsiders, margins/centres, high/low and so forth, the cultural field may be re-imagined as a space for multiple occupancy where differencing creates a productive covenant opposing the phallic logic that offers us only the prospect of safety in sameness or danger in difference, of assimilation to or exclusion from the canonised norm.

Given that we can define art history as a hegemonic discourse, we are forced then to ask: can feminists be 'art historians' – that is, professionals within its extended remit of curation, history and criticism? Or does that not of itself imply self-identification with the hegemonic tradition embodied in institutionalised art history, with the canonical as a systematic pattern of inclusions and exclusions which are generated

from and sustain deep structures of social and economic power? All hegemonic systems depend for their survival on some degree of pliability towards the forces or groups which contest and resist incorporation. These oppositions must either be included or disqualified. It is not yet clear whether feminism can be incorporated or whether it will itself develop forms that radically resist and provoke the hegemonic.

The notion of hegemony implies the constant negotiation of such inevitable conflicts through the induction of the subjects, both potential art historians and the art-loving public, into an identification with its selective version of the past. Certain activities or positions may be incorporated better to protect the underlying interests by concession and innovation. A bit of newness and controversy may actually keep the discipline alive and so will be permitted, but always at the margins. What speaks out loud, however – the underlying formations of power, laying art history as an academic exercise bare to a more critical reading of its effects and purposes – will be derided, positioned as aberrant. One strategy has been to say that, for instance, social histories of art or feminist studies are no longer *art history*. They are politics, sociology, ideology, methodology, or 'women's studies' or, the worst, *Theory*.

like mine

Now, feminists face a new paradox. If we retreat to the more hospitable domains of interdisciplinary women's or cultural studies, if we do not engage continually with art history as discourse and institution, our work will not disturb the canon and its discourses on art and artists. Yet we may need to keep a distance from the professionalised disciplinary modes of art history in order to develop our ability to raise the repressed question of gender within it. We cannot simply decamp. That would leave artists to the effects of art history's canonising discourses, which, in real terms, may seriously damage chances of being able to work and live as an artist if you belong to a non-canonical social group.

As a selective tradition thus defined, the canon, therefore, poses further specific and complex problems for feminism which overtake the narrow focus of this Marxist analysis signalled here by the necessary recognition of hegemony as a social and political force in culture. Let me quote Freud on Marx:

> The strength of Marxism clearly lies, not in its view of history or the prophecies of the future that are based on it, but in its sagacious indication of the decisive influence which the economic circumstances of men have upon their intellectual, ethical and artistic attitudes. A number of connections and implications were thus uncovered which had previously been totally overlooked. But it cannot be assumed that economic motives are the only ones that determine human beings in society . . . It is altogether incomprehensible how psychological factors can be overlooked where what is in question are the reactions of human beings in society.[27]

PSYCHO-SYMBOLIC INVESTMENT IN THE CANON, OR, BEING CHILDISH ABOUT ARTISTS

In her interpretation of Freud's aesthetics, Sarah Kofman provided us with a way of analysing what is invested in the canon at a level beyond the economic or ideological interests of dominant social groups. Canons are defended with an almost theological zeal that indicates more than the historical coincidence between the ecclesiastical use of the word *canon* for the revered and authenticated texts of the Bible and its function in cultural traditionalism. The canon is fundamentally a mode for the worship of the artist, which is in turn a form of masculine narcissism.

As a mere layman, Freud appeared to play down his own contribution to the understanding of art. For Kofman these disclaimers were, in fact, ironic.

> But at the end of the text, as in 'The Uncanny,' the 'connoisseurs' are reduced to glib talkers caught up in subjective opinions, elevating their own fantasies about works of art to the status of knowledge, yet unable to solve the riddle of the text in question. Freud's plea to them for lenient criticism should thus be interpreted ironically. What Freud means is that the art 'connoisseur' critcizes without knowing what he is talking about, for he is talking about himself; only the psychoanalyst can disclose the 'historical truth,' if not the 'material' truth of what he says.[28]

For Freud, therefore, the 'public's real interest in art lay not in art itself, but in the image it has of the artist as a "great man"', even though this fact is often repressed.[29] To unravel the riddle of a text is consequently to do violence to the idealised image of the artist as genius – to commit some kind of 'murder' – hence the resistance, not merely to psychoanalytic work on art in general but to any kind of demystifying analysis such as that carried out by social, critical and feminist historians of art. In writings on art – his contemporaries were some of the so-called founding fathers of the discipline and canons of art history – as well as in general public interest in art, Freud identified a combination of theological and narcissistic tendencies. Freud established parallels between the history of humankind revealed in anthropology and the psychological history of the individual mapped by the discipline he was inventing. Thus ancient rituals and forms of religion such as totemism and deism appeared to correspond to stages of infantile psychological development operating in each individual.[30] Freud discerned the way in which what we might imagine to be a highly sophisticated social practice – art appreciation – can be informed by psychic structures that are characteristic of certain powerful moments of *archaic* experience in the history of the human subject which, in a sublimated form, are culturally perpetuated in social institutions and cultural practices such as religion and art.

The excessive valorisation of the artist in modern Western art history as a 'great man' corresponds with the infantile stage of idealisation of the father. This phase is,

however, speedily undermined by another set of feelings – of rivalry and disappointment – which can give rise to a competing fantasy and the installation of another imaginary figure: the hero, who always rebels against, overthrows or even murders the overpowering father. Sarah Kofman explains:

> People's attitude towards artists repeats this ambivalence. The cult of the artist is ambiguous in that it consists of the worship of the father and the hero alike; the cult of the hero is always a form of self-worship, since the hero is the first ego ideal. This attitude is religious but also narcissistic in character and repeats that of the child toward the father and of the parents towards the child, to whom they attribute all the 'gifts' and good fortune that they bestowed upon themselves during the narcissistic period in infancy.[31]

This theme of the artist as incorporating both worship of the idealised father and narcissistic identification with the hero leads to another observation which should resonate for the reader thinking about canonical art history and its typical forms of monograph, biography and *catalogue raisonné*. If the artist functions as a heroic object of narcissistic fantasy, inheriting the adoration accorded to the father, this might explain the strong interest in biography, psychobiography and the way, in art history for instance, that so much of the work on art works functions to produce a life for the artist, a heroic journey through struggles and ordeals, a battle with professional fathers for the final winning of a place in what is always his – the father's – canon. It also takes us beyond the issues of sexism and discrimination, for the artist is thus a symbolic figure, through which public fantasies are given representational form. To an extent these fantasies, infantile and narcissistic, are not gendered exclusively masculine. But they do function to sustain a patriarchal legend.

Writing about an artist in a biographical mode is itself a doubly determined operation. On the one hand, it represents a desire to get closer to the hero, while, on the other, the work and the hero must remain sacralised, *taboo*, in order both to avoid the unconsciously desired murder of the father that the hero disguises and to keep up the theological illusion of art which similarly compensates for these conflicting desires. Thus Freud wrote in his study on Leonardo:

> Biographers are fixated on their heroes in a quite special way. In many cases they have chosen their hero as the subject of their studies because – for reasons of their personal emotional life – they have felt a special affection for him from the very first. Then they devote their energies to the task of idealisation, aimed at enrolling the great man among the class of their infantile models – at reviving in him, perhaps, the child's idea of his father. To gratify this wish they obliterate the individual features of their subject's physiognomy; they smooth over the traces of his life's struggles with internal and external resistances, and they tolerate in him no vestige of human weakness or imperfection. They thus

present us with what is in fact a cold, strange, ideal figure, instead of a human being to whom we might feel ourselves distantly related.[32]

In her analysis of Freud's reading of biographers, for whom we could substitute art historians, Kofman noted the play of idealisation, identification and also the necessity to keep the artist as something apart, and special. Thus Freud carefully manoeuvres a space for the psychoanalyst to function as a mediator between the artist and the public. The biographer/connoisseur/art historian writes out of a constant ambivalence, a desire to bring the artist closer, and yet to maintain a distance, to manage admiration and rivalry in which the murderous desires unconsciously aimed at the father and displaced on to the admired hero are managed through the writer's mastery of the subject. The theological worship of the artist veils its underside, a narcissistic identification with an idealised hero. The application of psychoanalysis to art itself appears murderous because it tries to renounce these infantile investments in the figure of the artist/hero, to allow the artist to be examined and explained by psychic mechanisms to which we are all subject.

> On the one hand, the work of art is one of the offshoots of what is repressed in the artist, and as such is symbolic and symptomatic. It can be deciphered from traces, minute details which indicate that the repression is not entirely successful; this failure is the only thing which opens a space of legibility in the work.[33]

For Freud there is no mystery to art; but there is the challenge of deciphering its meanings which arises not because the artist is different, but as a result of the artist's 'normality' – being like the rest of us.

> The psychoanalyst acts as a mediator between the artist and the public, between father and son, because the son cannot bear to look his father in the face any more than he can confront his own unconscious . . . The contribution of psychoanalysis to biography is to have shown that the artist is no more a great man or a hero than we are. The 'application' of psychoanalysis completely reverses the stance of traditional biographies. 'Killing' the father means renouncing both the theological idealisation and the narcissistic identification which prompts the subject's desire to be his own father. Yet it also means respecting the superego, which alone makes possible the renunciation of the pleasure principle.[34]

Sarah Kofman positioned Freud, and indirectly psychoanalysis, as a 'new iconoclast', challenging the religious idealisation and narcissistic identification with the artist in order to pass beyond 'the childhood of art' into the realm of necessity where the idealising admiration for the artist is overcome by the 'adult' analysis of artistic works as texts to be deciphered. Demythifying analysis will, according to Freud, ultimately reveal not a mystical genius 'but a human being to whom we might feel ourselves

distantly related'. This insight is of particular importance to feminism as it battles with the canon. If we introduce into our readings in art history too much either about the personal life of the artist – traumas or specifically feminine experience for instance – or if we draw on our own life experiences to help understand what we are looking at, we might be dismissed for offering over-subjective readings that are insufficiently curbed by the necessary objectivity of rational historical distance. On the other hand, feminism can legitimately claim these Freudian insights to support the theorised attempt to balance historical scholarship with carefully presented insights developed from our lived histories about the significance of the psycho-symbolic in the making and reading of cultural texts.

Freud's proposed project, however, emerging at the same moment as art history itself came to disciplinary maturity, met, and still meets, with considerable resistance because:

> Psychoanalysis inflicted on man one of his three great narcissistic wounds by deconstructing the idea of the autonomous subject endowed with self-mastery and self-sufficiency, indeed a subject who was his own creator. Narcissism, however, is essentially a death force, so to denounce it is to work in favor of Eros.[35]

Sarah Kofman's reading of Freud thus sets up two registers. One enables us to have some insight into what is at stake in canonicity, as a formalisation of this religious-narcissistic structure of idealising the artist. The other is the highly gendered terms of such a structure. Fathers, heroes, Oedipal rivalries not only reflect the specifically masculine bias of Freud's attention. They suggest that, structurally, the myths of art and artist are shaped within sexual difference and play it out on the cultural stage. Linda Nochlin's founding question 'Why are there no "great *women* artists"' – with this addition 'in the canon?' – can be turned through this analysis to expose the canon's deeply *masculinist* structures of narcissism and idealism.[36]

The question then is: could we invert it, and insert a feminine version? Mothers, heroines, female Oedipal rivalry, female narcissism and so forth? Would we want to? Or would we try to side with Freud in the move into an adult rather than an infantile relation to art by wanting to disinvest from even a revised, feminised myth of the artist, and address ourselves to the analysis of the riddle of the texts unencumbered by such narcissistic idealisation? Surely we would rather be on the side of Eros than of Thanatos, of love and desire in our writing, than of death that, in the form of avoided 'murder' of the father/mother through idealisation of the hero/heroine, constantly presses on art history.

Using Sarah Kofman's analysis of Freud's aesthetics, we can then turn the analytical spotlight on feminist desire, and women's investment in art and artists who are women (Fig. 1.3). I pose the question: What makes us interested in artists who are women? It appears to be a simple question with an obvious answer. But it was only feminism – not the fact of being a woman – that permitted and generated such a desire, and created, in its politics, theories and cultural forms, a representational support which

16

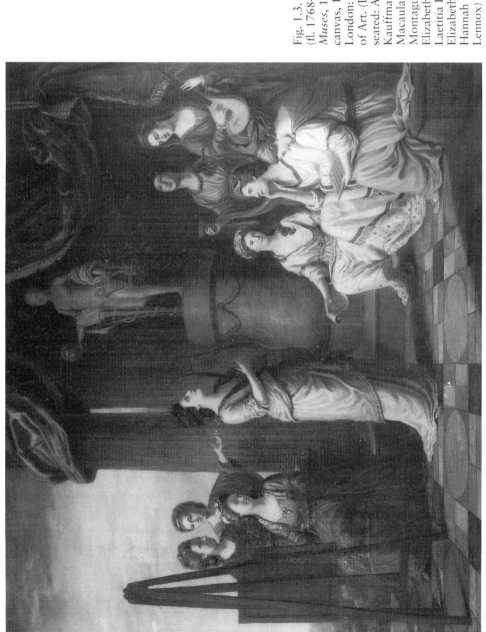

Fig. 1.3. Richard Samuel (fl. 1768–87), *Nine Living Muses*, 1779, oil on canvas, 130 × 152.5 cm. London: Royal Academy of Art. (Left to right, seated: Angelica Kauffmann, Catherine Macaulay, Elizabeth Montagu; standing: Elizabeth Carter, Anna Laetitia Barbauld, Elizabeth Linley-Sheridan, Hannah More, Charlotte Lennox)

could release into discourse aspects of feminine (which is, nevertheless deeply, ambivalent) desire for the mother and thus for knowledge about women.[37] In the light of the above, however, any desire, feminist or otherwise, now seems more complex. Why, as a feminist, am I interested in artists who, because of the rigorous sexism of art history, offer no reward as culturally idealised, canonised figures? Can the neglected women artists of the past function for me as a narcissistic ideal? Do I want to set them up as semi-divine heroines? What are we doing if we try to make them perform as such – if indeed, within the current regimes of sexual difference, we can? What if I desire something else from these stories of women? That is to say, is it possible to do the work I want to do on women artists within a disciplinary formation underpinned by an unacknowledged mythic and psychic structure that actively obstructs the historical discovery of difference, that renders uninteresting remembered stories of women? The answer is probably not. Would a writing of art's histories through *feminist* desire make a difference of another kind: anti-mythical, non-heroic, yet able to analyse works of art for the traces of subjectivities that are not like me because of a common womanhood, but can speak to me 'in the (historically variable) feminine'?

I have long suggested that 'art history', in so far as it embodies and perpetuates this dual narcissistic and religious attitude toward the artist as its disciplinary core, cannot survive the impact of feminism – a practice that, of necessity, must deconstruct this core if it is to be able to speak of the artistic practices of women. But here I want to propose that we apply theoretical insights acquired from Freud's work on 'the connoisseurs' to feminist practice. There is a space precisely here for feminist inter-vention. Even though Freudian psychoanalysis ultimately privileges the place of the Father, seeing all cultural stories as modelled on masculine Oedipal anxieties, and, as here, making the Father/Hero central to his analysis of art history, it theoretically offers a way to expose the desires and fantasies which have so far made it incon-ceivable to imagine women in the canon. Women, as representatives of the Mother, are not Heroes. The story of the feminine relation to the Mother takes a wholly different course. That is why I shall begin the book reading the work of canonical artists for traces of the maternal.

Women art historians are susceptible to identification, idealisation and narcissistic fantasy since many of the psychic processes Freud analysed are common to both masculine and feminine subjects in pre-Oedipal formation, and, more importantly, because, in the absence of any other legends, myths and images, women construct hybridised subjectivities with the bricolage of what phallocentric culture offers. Phallocentric culture, however, is premised on substitutions and repressions – particularly of the Mother. If one of the key projects of psychoanalysis is to read for the traces of incomplete repression, one way forward is, therefore, to read against the paternal grain *for the Maternal*. We can read for the Mother across the board, in the work of artists who are men and women, though there we will discover specificities and differences which are not the one difference that phallic logic decrees. This provides a territory in which we can both deconstruct the 'great man' myth and then productively read the works of men artists beyond its limited, repetitious refrains,

while being able to speak of the myths, figures and fantasies that might enable us to see what women artists have done, to read for the *inscriptions in the feminine*, to provide, in our critical writings, representational support for feminine desires in a space which can also comprehend conflicting masculine desires, liberated from their theological encasement in the idealised image of the canonical artist. Furthermore, the differences between men which are currently recognised only in the suppression of all but one group's ideal-ego can be articulated without the anxiety that attends even Freud's writing when he has to broach the homosexuality of Leonardo.[38] Difference will no longer be the line of demarcation between the canonical and non-canonical, but will be the very issue that we will complexly address in the expanded and more comprehensive analysis of culture freed from the idolisation of the white Father and the white Hero.

NOTES

1 Ellis Rivkin, *The Shaping of Jewish History: A Radical New Interpretation* (New York: Scribner, 1971), p. 30.
2 Dominick Lacapra, 'Canons, Texts and Contexts', in *Representing the Holocaust: History, Theory, Trauma* (Ithaca: Cornell University Press, 1994), p. 19.
3 Théophile Thoré, 'Van der Meer of Delft', *Gazette des Beaux Arts*, 71 (1866), pp. 297–330, 458–70, 542–75; 'Frans Hals', *Gazette des Beaux Arts*, 24 (1868), pp. 219–30, 431–48; R. W. Scheller, 'Rembrandt's Reputatie Houbraken tot Scheltema', *Nederlands Kunsthistorische Jaarboek*, 12 (1961), pp. 81–118; S. Heiland and H. Lüdecke, *Rembrandt und die Nachwelt* (Leipzig, 1960); T. Reff, 'Manet and Blanc's *Histoire des Peintres*', *Burlington Magazine*, 107 (1970), pp. 456–8.
4 Kenneth Clark, 'What is a Masterpiece?', *Portfolio* (Feb./Mar. 1980), p. 53.
5 Harold Bloom, *The Anxiety of Influence* (Oxford: Oxford University Press, 1973); Griselda Pollock, *Avant-garde Gambits: Gender and the Colour of Art History* (London: Thames & Hudson, 1992).
6 Henry Louis Gates Jnr., *Loose Canons: Notes on the Culture Wars* (New York and Oxford: Oxford University Press, 1992).
7 Henry Louis Gates Jnr., 'Whose Canon Is It Anyway?', *New York Times Book Review* (26 February 1989), section 7, 3, reprinted in a revised version in *Loose Canons*, as 'The Master's Pieces: On Canon Formation and the African-American Tradition', pp. 17–42.
8 *Ibid.*, p. 4.
9 Toni Morrison, *Playing in the Dark: Whiteness and the Literary Imagination* (Cambridge, Mass. and London: Harvard University Press, 1992), p. 5.
10 Rozsika Parker and Griselda Pollock, *Old Mistresses: Women, Art & Ideology* (London: Pandora Books, 1981, new edn 1996; now London: Rivers Oram Press).
11 Jan Gorak, *The Making of the Modern Canon: Genesis and Crisis of a Literary Idea* (London: Athlone Press, 1991); Robert Von Hallberg, ed., *Canons* (Chicago: Chicago University Press, 1984); Paul Lauter, *Canons and Contexts* (New York: Oxford University Press, 1991) and a special issue of *Salmagundi*, 72 (1986). Feminist challenges to the canon began in the 1970s. Linda Nochlin – who called the shots on questioning the art historical canon in her 'Why Have There Been No Great Women Artists?', in *Art & Sexual Politics*, eds Thomas B. Hess and Elizabeth C. Baker (New York and London: Collier Macmillan, 1973) – organised a session at the 1991 CAA in New York called *Firing the Canon* at which I first developed these arguments. Nanette Salomon, 'The Art Historical Canon: Sins of Omission', in *(En)gendering Knowledge: Feminism in Academe*, ed. Joan Hartmann and Ellen Messer-Davidow (Knoxville: University of Tennessee Press, 1991), pp. 222–36; Adrian Rifkin, 'Art's Histories', in *The New Art History*, ed. Al Rees and Frances Borzello

(London: Camden Press, 1986), pp. 157–63. See 'Rethinking the Canon', a collection of essays, *Art Bulletin*, 78, 2 (June 1996), pp. 198–217.

12 H. W. Janson was challenged about this omission and he stated that there had never been a woman artist who had changed the direction of art history and thus none deserved inclusion in his work. Salomon, p. 225.

13 Susan Hardy Aiken, 'Women and the Question of Canonicity', *College English*, 48, 3 (March 1986), pp. 288–99.

14 *Ibid.*, p. 297.

15 *Ibid.*, p. 298.

16 *Ibid.*, p. 298.

17 Harold Bloom, *The Western Canon: The Books and Schools of the Ages* (New York: Harcourt & Brace, 1994), p. 3.

18 Teresa de Lauretis, 'The Technology of Gender', in *Technologies of Gender: Essays on Theory, Film and Fiction* (London: Macmillan, 1987), p. 25.

19 *Ibid.*, p. 26.

20 Roland Barthes, 'Myth Today', in *Mythologies*, [1957], trans. Annette Lavers (London: Paladin Books, 1973).

21 'What the world supplies to myth is an historical reality, defined . . . by the way in which men have produced or used it; and what myth gives in return is a natural image of this reality.' *Ibid.*, p. 142.

22 Raymond Williams, *Marxism and Literature* (Oxford: Oxford University Press, 1977), p. 115.

23 *Ibid.*

24 *Ibid.*, p. 116.

25 Gayatri Chakravorty Spivak, 'Imperialism and Sexual Difference', *Oxford Literary Review*, 8, 1–2, (1986), p. 225.

26 Raymond Williams, p. 118.

27 Sigmund Freud, *New Introductory Lectures* [1933], *Penguin Freud Library*, 2 (Harmondsworth: Penguin Books, 1973), p. 215.

28 Sarah Kofman, *The Childhood of Art: An Interpretation of Freud's Aesthetics*, trans. Winifred Woodhull (New York: Columbia University Press, 1988), p. 11.

29 *Ibid.*, p. 15.

30 People always get anxious at this point, for it appears to suggest that certain peoples who still hold to these forms of religion are being called childish. The mistake is to assume that the infant stage is childish and, equally, that it is ever surpassed. Archaic experiences and their corresponding fantasies remain a rich resource in, and a powerful determinant on, adult behaviour. *Infantile* is a technical term and refers both to founding moments in individual psychological histories and to a continuing register of meaning and affect in the human subject.

31 Kofman, p. 18.

32 Sigmund Freud, 'Leonardo da Vinci and a Memory of His Childhood' [1910], in *Art & Literature*, *Penguin Freud Library*, 14 (Harmondsworth: Penguin Books, 1985), p. 223.

33 Kofman, p. 15.

34 *Ibid.*, p. 20.

35 *Ibid.*, p. 21.

36 In the first version of the famous essay, published in *Woman in a Sexist Society*, ed. Vivian Gornick and Barbara K. Moran (New York: Basic Books, 1971), pp. 480–511 this was the title. The later publication in *Art & Sexual Politics*, ed. Thomas B. Hess and Elizabeth C. Baker (New York and London: Collier Macmillan, 1973) bears the title: ' Why Have There Been No Great Women Artists?'

37 I am drawing on Kaja Silverman's arguments in her *The Acoustic Mirror* (Bloomington: University of Indiana Press, 1988), p. 125, about the way feminism draws on the 'libidinal resources of the negative Oedipus complex', this latter referring to a female child's Oedipal desire for the mother, as well as her identification with her in the formation of her own femininity. This desire, present in all women, is repressed by the culture. This comment

does not mean that feminism discovered woman-centred sexual desire, but that it unleashed into a cultural current that element of the feminine unconscious to which a phallocentric Symbolic denies representational support.

38 Sigmund Freud, 'Leonardo da Vinci and a Memory of His Childhood' op. cit.

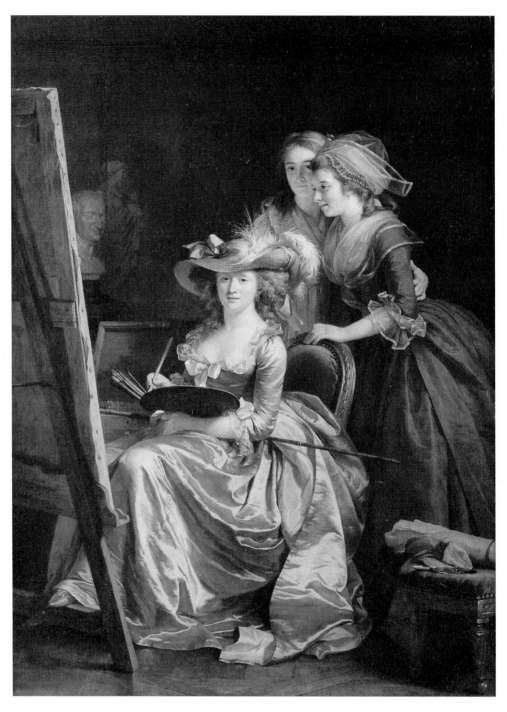

Fig. 2.1 Adelaide Labille Guiard (1749–1803), *Self Portrait with Two Pupils: Mlle Marie Capet (1761–1818) and Mlle Carreaux de Rosemond (d. 1788)*, 1785, oil on canvas, 210.8 × 151.1 cm. New York: Metropolitan Museum of Art

2

DIFFERENCING

Feminism's encounter with the canon

Feminism's encounter with the canon has been complex and many-levelled: political, ideological, mythological, methodological and psycho-symbolic. I want to lay out a number of different strategies which correspond to the related but also contradictory positions of feminism's encounter with the canon since the women's movement in the early 1970s first entered the culture wars. These different positions represent tactical moments, each as necessary as they are contradictory, while the accumulation of our practices and thinking is beginning to produce a critical and strategic dissonance from art history that allows us to imagine other ways of seeing and reading visual practices than those locked into the canonical formation.

THREE POSITIONS

Position one

Feminism encounters the canon as a structure of exclusion.

The immediate task after 1970 was the absolute need to rectify the gaps in historical knowledge created by the consistent omission of women of all cultures from the history of art (Fig. 2.1).[1] The only place where work by a woman might be glimpsed was in the basement or storeroom of a national gallery.[2] The recurring shock of discovery that there have been women artists at all, and so many and such interesting ones, which we as teachers, lecturers and writers regularly witness with each new class of students or new audience for our lectures on women artists, is proof of the reiterating need for this basic research. Evidence of women's uninterrupted involve-ment in the fine arts is still the fundamental step in exposing the canon's selectivity and gender bias. Yet, despite the expanding volume of research and publications on artists who are women, Tradition remains *the* tradition with the women in their own special, separated compartments, or added as politically correct supplements. In the Story of Art *women* artists are an oxymoron, an incomprehensible addition, available in our post-feminist days, for those women disposed to be interested to read about such marginalia. The real history of art remains fundamentally unaffected because its

mythological and psychic centre is fundamentally or exclusively to do not with art and its histories but with the Western masculine subject, its mythic supports and psychic needs. The Story of Art is an illustrated Story of Man. To that end, and paradoxically, it needs constantly to invoke a femininity as the negated other that alone allows the unexplained synonymity of man and artist.

Yet, as the phrase 'Old Mistress', first used in 1972 by Ann Gabhart and Elizabeth Broun, so tellingly suggested, the exclusion of women is more than mere oversight.[3] There is no equivalent term of value and respect for great *mistresses* of art comparable to the old *masters* who form the very substance of the canon. Structurally, it would be impossible to re-admit excluded women artists like Artemisia Gentileschi or Mary Cassatt to an expanded canon without either radical misunderstanding of their artistic legacy or radical change to the very concept of the canon as the discourse which sanctions the art we should study. The canon is politically 'in the masculine' as well as culturally 'of the masculine'. This statement does not in any way belittle the vitally important work that has been done in producing the research, documentation and analysis of women artists in anthologies, monographs and comprehensive surveys. The terms of the selective tradition render completely revising the neglect of women artists an impossible project because such revision does not grapple with the terms that created that neglect. So, after over twenty years of feminist work rectifying the gaps in the archive, we still face the question: How can we make the cultural work of women an effective presence in cultural discourse which changes both the order of discourse and the hierarchy of gender in one and the same deconstructive move?

Position two

Feminism encounters the canon as a structure of subordination and domination which marginalises and relativises all women according to their place in the contradictory structurations of power – race, gender, class and sexuality.

In response to not only exclusion but systematic devaluation of anything aesthetic associated with women, feminists have tried to valorise practices and procedures particularly practised by, or connected with, women that lack status in the canon, for instance art made with textiles and ceramics.[4] Patricia Mainardi wrote in 1973:

> Women have always made art. But for women the arts most highly valued by male society have been closed to them for just that reason. They have put their creativity instead into needlework arts which exist in a fantastic variety, and which are in fact a universal female art form transcending race, class and national borders. Needlework is the one art in which women controlled the education of their daughters and the production of art, and were also the critics and audience . . . it is our cultural heritage.[5]

Work on quilting, weaving and embroidery by women has exposed the troubled nature of the Western canon's attempt to valorise its fine art culture above all others by a hierarchy of means, media and materials. It has become more culturally advanced to make art with pigment and canvas, stone or bronze than with linen and thread, wool or clay and pigment. Feminists, however, have argued that textiles are both the site of profound cultural value beyond mere utilitarian usage and the site of the production of meanings that traverse culture as a whole: religious, political, moral, ideological. Thus the canonical division between intellectual and manual art forms, between truly creative and merely decorative practices, has been challenged on behalf of not only Western women but non-Western cultures in general. By showing the ways in which the art of embroidery, once the most valued cultural form of medieval ecclesiastical culture, was progressively deprofessionalised, domesticated and feminised, feminist art historians have exposed both the relativity of cultural valuations and the intimacy between value and gender.[6]

Such cultural practices that are typically downgraded because they are (mis)-identified with the domestic, the decorative, the utilitarian, the dexterous – that is with what patriarchal logic negatively characterises as quintessentially 'feminine' – appear as merely instances of difference, and paradoxically confirm (rather than afflict) the canonical – normative – status of other practices by men. This is a prime instance of being trapped in a binary where reverse valuation of what has hitherto been devalued does not ultimately breach the value system at all. None the less, feminist discourse on and from the position of marginalisation, interrupting art history by a political voice challenging hierarchies of value, does have subversive force. It gets entangled with the underlying structure I insist on drawing out: art is often a debate in disguised form about gender. So the basis of the revaluation of patchwork quilts and weaving is the shifted appreciation of the work and creativity of the domestic sphere, or of traditions of working-class female aesthetic choices and challenges. Inside the categorical division of the genders there is a realignment of what is aesthetically valued through determining more complex relations between art and the social experiences of its classed and gendered producers.

The difficulty remains, however, that, in speaking of and as women, feminism confirms the patriarchal notion that woman is the sex, the sign of gender, perpetually the particular and sexualised Other to the universal sign Man, who appears to transcend his sex to represent Humanity. This interest in art that stays close to the practices of everyday life also keeps this art tied to the realm of the Mother. The tropes of Other and Mother, always powerful resources for resistance, none the less trap us in a regressive compartment of a patriarchal narrative and mythicisation of Culture as the realm of the Father and the Hero. Thus to speak openly of the repressed question of gender is to confirm the dominant culture's worst suspicions that, if women are allowed to speak, all they can speak of is (their) sex.

Position three

Feminism encounters the canon as a discursive strategy in the production and reproduction of sexual difference and its complex configurations with gender and related modes of power.

Deconstructing discursive formations leads to the production of radically new knowledges which contaminate the seemingly 'ungendered' domains of art and art history by insisting that 'sex' is everywhere. The canon becomes visible as an enunciation of Western masculinity, itself saturated by its own traumatised sexual formation. The key difference from position two is this. In the same gesture as we confirm that sexual difference structures women's social positions, cultural practices and aesthetic representations, we also sexualise, hence de-universalise, the masculine, demanding that the canon be recognised as a gendered and an *en-gendering* discourse.[7] Not a matter of reverse sexism, this third strategy overcomes sexism and its straight inversion by naming the structures which implicate both men and women because they produce masculinity and femininity relatively, suppressing, in the same move, the complexity of sexualities that defy this model of sex and gender. The feminist interruption of the naturalised (hetero)sexual division identifies the structures of difference on which the canon is erected by examining its mechanisms for maintaining only *that* difference – woman as Other, sex, lack, metaphor, sign, etc.

This third position no longer operates within art history as an internal contestant or corrective to the discipline. Its purposes are not equity. It does not aim at only more women in the art history books or at better coverage for decorative as well as fine arts (position one). Nor, however, does it operate outside, or in the margins, a voice for women's absolute difference, valorising the feminine sphere (position two). It implies a shift from the narrowly bounded spaces of art history as a disciplinary formation into an emergent and oppositional signifying space we call the women's movement which is not a place apart but a movement across the fields of discourse and its institutional bases, across the texts of culture and its psychic foundations.

The play on the word 'movement' allows us to keep in mind the political collectivity in which feminist work must be founded and, at the same time, it enables us to refuse containment in a category called feminism. Feminism will not just be one more approach in the chaotic pluralisation to which a threatened art history desperately turns in the hope of maintaining its hegemony by tactical incorporation. The notion of movement is also associated with that of the eye as it reads a text: re-vision in Adrienne Rich's terms. Reading has become a charged signifer of a new kind of critical practice, re-reading the texts of our culture symptomatically as much for what is not said as for what is. Meaning is produced in the spaces between, and that is what we are moving across canons, disciplines and texts to hear, see and understand anew. It is precisely through these movements between disciplinary formations, between academe and street, between social and cultural, between intellectual and political, between semiotic

and psychic, that women were able to grasp the interrelations between the dominant formations around sexuality and power which inform but are mystified by the outward and visible signs of a discipline's or practice's particular habits and professional procedures.

Thus from the novel space and connections between women practising in many fields created by the formation of the women's movement, feminists intervene in art history to generate expanded forms for art's histories.[8] I study some of the same objects as the canonical art historian – Van Gogh, Toulouse-Lautrec, Degas, Manet – as well as those ignored by art history: Artemisia Gentileschi, Mary Cassatt, Lubaina Himid. I use some of the same procedures and analyse some of the same documents. But I work in and on another domain of study which produces a different object. Michel Foucault defined a discourse not by the given things it studies but through the objects discourse produces. Thus, art history is not merely to be understood as the study of the artistic artefacts and documents left deposited in the present by time. Art history is a discourse in so far as it creates its object: art and the artist. From the 'space off' of feminism, I do not confirm the mystical status of the art object nor the theological concept of the artist that are the central projects of art historical discourse. The terrain I explore is the socio-symbolic process of sexuality and the constitution of the subject in sexual difference, itself within the field of history, as it shapes and is shaped in a history of aesthetically crafted visual representations. The phrase 'the subject in difference' moves us beyond some fixed idea of masculinity or femininity towards the dynamic process of subjectivity as socially, historically constituted at the level of the psycho-symbolic which is the level at which cultures are inscribed upon each sexed, speaking person.

History is traditionally conceived in terms of rapidly changing, event-led developments. The *Annales* school of French historians, however, turned their attention to the impact, on social and cultural life, of factors that have a long duration, like climate, geographical location, food production, established culture and folklore. Many things which, because of their extended temporality, seem to be unhistorical can thus be differerently understood as, none the less, historical. Julia Kristeva has taken up this challenge in thinking about the issues of sexual difference and their inscription through psychic formations that have such long histories – like the phallocentric order in the West – that they come to appear as natural and unchangeable givens.[9] Freud's theories of subjectivity and sex are often deemed to be universalist and ahistorical for the same reasons. Clearly sexuality and subjectivity have histories on several planes and temporalities – changing under the force of immediate social, political and economic upheaval, while, at other levels, remaining more constant.[10] Feminism – a product of a modernist historical conjuncture dating actively from the mid-nineteenth century – has a *longue durée* in that we are still, at the end of the twentieth century, attending to its unfinished business: the modernisation of sexual difference that has gone through several phases from philosophical to political and now on to the corporeal, the sexual, the semiotic and the psychological. But that attempted modernisation could also be read as a new chapter in the history of ancient structures of sexual difference. Feminist

theory in its contemporary complexity rooted in its historical legacies is now able to imagine and fashion a challenge to the *longue durée* of the deep structures of patriarchal or phallocentric systems the world over that have reigned so long that they have come to appear as a 'fact of nature'. This is why one major partner in feminist interventions in historiography and art history is psychoanalysis. It has become the provisionally necessary theoretical resource within modernity that enables us to operate on the cusp of these intersecting if often extended temporalities of sex, subjectivity and difference.

According to psychoanalytical discourse, each subject, each sex, each identity passes through processes and structures of differentiation that are, however, figured in cultural representation from language to art, as separate positions, as fixed sexes, as distinct identities that need no production. Moving away from the representation of innate, anatomically or biologically determined difference to the ever unstable and unravelling processes of psychological and semiotic *differentiation*, with the always dynamic play of subjectivity, creates the space for a feminist differencing of canonicity, which is an element in the larger politics of differencing current orders of sexual difference.

If this engagement with histories of the subject and theories of its sexing enables us to destabilise the illusory image of the masculine subject, it also undoes any comparable myth of femininity, the idea that femininity is or has an essence, that it is the opposite of masculinity, that the feminine is in any way less conflicted or desiring. For the feminine subject, by definition, must be just as much a complex, ambivalent, contradictory and precarious subjectivity as the masculine. At times both share comparable processes in their archaic formation. Yet they are subject to marks of distinction where a culture already erected on the difference of sex anticipates as yet unformed subjects with fixed and fixing expectations. These cultural signs of a particular system of sexual difference feminist analysis takes as its cue for its contest with phallocentrism. Yet far from simply repudiating all signs of femininity and feminine difference as the effect of a phallocentric system, feminism also recognised in the variations, labelled feminine, of the trajectories that lead to the (unstable) sexing of subjectivity, the sources of pleasure in and for the feminine and the articulation of specifically oppositional feminine desires.

There are, of course, femininities in the plural rather than femininity *tout court*. The encounter between feminist readings and the canon must disorder the familiar regime of difference, but neither in the name of liberal sameness (we are all human beings) nor in terms of an absolute and fundamental difference (men versus women). (What men? and what women?) The project of a feminist critique is undertaken in the name of those who suffer most the effects of a regime of difference which demands its price of all the subjects it constitutes. Those living under the sign of Woman, marked 'feminine', have a special investment in the deconstruction of phallocentrism, and a particular purpose in the expanded understanding of all subjectivities and their social conditions to which feminist re-readings contribute. The term 'feminine' can thus be radically understood to signal both the negated other of the phallocentric model – an

absence – and the as yet uncharted potentiality of what is beyond the phallocentric imagination – an enlargement. The feminine is, therefore, both a 'difference from' the norm and the signifier of a potentially *differing* structure of subjectivity.

Feminist interventions must involve a materialist and social conception of what Gayle Rubin has called 'the political economy of sex'.[11] Equally, by addressing the social also by means of subjectivity as process, we need to attend to an interrelated but irreducible domain theorised by psychoanalysis – the psycho-symbolic domain.[12] The subject of this theory is split, conscious and unconscious, and is formed through its involvement with the use of symbols, namely language, that radically separates it from its own never fully known materiality. The subject is an accumulation of losses and separations which cast it adrift from the mother's body and space, creating, in that division, retrospective fantasies about wholeness, unity and undifferentiation. It is here that the terror of difference first marks the masculine subject with an anxiety towards the other, signified by the feminine. The division from the process of its becoming a subject which is marked by accession to the Symbolic domain of language, each culture shaping that in specific ways, generates another signifying space, which always accompanies the speaking subject. This Freud named the unconscious. The unconscious is the active determining location for all that is repressed from the long and arduous journey the individual undertakes to become a subject, within sex and language. What is not admitted to consciousness by the regulated order of the culture, its Symbolic order, is reshaped by its transformation into the other signifying regime that characterises the unconscious, known to us only through dreams, slips of the tongue and in incomplete repression surfacing within aesthetic practices. In turn, the repressed becomes a kind of structuring unconscious of the subject – who, as a result of both the cultural unconscious embodied in the language to which the subject accedes, and because of its individual unconscious produced by its singular familial and social history, lives in a paradoxical condition of perpetually not knowing what it is, yet filled with illusions and representations which fabricate an identity that remains ignorant of its real conditions of existence.

ABOUT DIFFERENCE AND *DIFFÉRANCE*

Difference, sociologically defined as gender difference, and more recently conceived as a psychic and linguistic position through psychoanalysis as sexual difference, has played a vital role in feminist theory. Difference signifies division between 'men' and 'women' resulting in a hierarchy in which those placed within the social category of the female gender or assigned the psycho-linguistic position as feminine are negatively valued relative to the masculine or 'men'. The French philosopher Jacques Derrida has invented a new term, *différance*, to draw out two meanings in the French verb *différer*: 'On the one hand, [*différer*] indicates difference as distinction, inequality, or discernibility; on the other, it expresses the interposition of delay, the interval of *spacing*, and *temporalizing* that puts off until "later" what is presently denied.'[13] This is closer

to the verb *to defer* in English, and the point is that language, whose meanings are produced by differences (rather than by positive terms), tries to set up distinctions necessary for there to be meaning, while structurally undermining any fixity of meaning, since all meaning relies on what is not said, that is, on all the other signifiers in the system as a whole, or in a set, that lie in waiting, negatively supporting the signifier that has been uttered or written.

Man and Woman – two terms that mutually affirm a difference by appearing to be the fixed poles of a natural opposition – are but two relative signifiers in a chain down which meaning is constantly deferred. Man can mean nothing without that other term whose co-presence in the very meaning of either term undermines the kind of fixed value or meaning that Man tries to assert and contain. *Différance* is not a concept that replaces difference. It defies it, exceeding and disturbing the 'classical economy of language and representation' that is the instrument of hierarchy and social power. Man is a moment in a chain of signs that always includes as its differentiating, meaning producing others: Woman, Animal, Society, or whatever difference is the axis of the given statement. The signifier Man seems to promise the presence, self-constituted and fixed, of some entity. In fact, there is no presence but an implied and negative relation to a range of signifiers, themselves no more firmly attached to an essence. The binary opposition which structures so much of modern, bourgeois culture is Man versus Woman: two separate and distinct items, categories, beings. Deconstruction suggests that what we have instead is a system whose effect is *binary division* while it is in fact a *signifying system* that arbitrarily creates distinctions which are always co-dependent, co-extensive and shifting.

The signifiers Man and Woman are not arbitrary at the level of language alone. They make a difference, inscribing socially and culturally determined value on to what is thereby differentiated. This is done not by merely linguistic markers of given difference but by signifiers that serve to differentiate *prima facie* in particular ways. Semiotics thus identifies the overtly ideological character of the appeal to nature, that is, to given, visible or deducible differences, deconstructing these assumptions to expose an always socially and politically motivated regime of differentiations.

The signifiers Man and Woman, moreover, mark spaces in a continuum of meanings that depend upon the whole system for the values that are attributed to these particular terms. Woman belongs in a set that includes nature, body, passivity, victim, lethal sex, timelessness and so forth, while Man relates to notions of mind, the social, the rational, the historical, activity, authority, agency, self-determination etc. These sequences are political and historical, and thus they can be and have dramatically changed. Contesting the uses of the signs and articulating them differently – a battle of representation – is both possible and, from the feminist perspective, necessary.[14]

Joining semiotics and psychoanalysis in her own neologism, *semanalysis*, Kristeva, like Derrida, although from a different premise, that of the psychoanalytically defined division of the subject, stresses the *process* of meaning in language over its structure.[15] Language is not a sign system; meaning is rather a *signifying process* constantly moving between and being moved by the tensions between the *semiotic* – Kristeva's

special term for the disposition towards language found in rhythm, sound and their traces of a relation to the body and its drives – and the *symbolic*, that which makes of these dispositions formal articulations, attempting to regulate and establish a unity, a momentary fixity for meaning and its social communication.[16] Language becomes a double space once the subject is positioned as part of it, bringing the material and psychic body (what Freud called the drives and their representatives) into play with the social constraints of its processes and potentialities (the family, modes of production etc.), bringing fantasy relations (the unconscious) into play with the function of social exchange and the establishment of authority. This model always implies the means of change – a transgression of the frontier of the symbolic by irruptions from the excess of the semiotic with its privileged relations to the archaic moments of the drives and the maternal space/voice/gaze. Kristeva positions art – literature, poetry, dance, music, painting – as a privileged and yet non-regressive means of renovating but also sometimes revolutionising the symbolic and the social, that is, radically changing the social order of meaning, because it makes possible new concatentations of signifiers and subjective relations to them.

> But since it is itself a metalanguage, semiotics can do no more that postulate this heterogeneity: as soon as it speaks about it, it homogenises the phenomenon, links it with a system, loses hold of it. Its specificity can be preserved only in the signifying practices which set off the heterogeneity at issue: thus poetic language making free with the language code; music, dancing, painting, rendering the psychic drives which have not been harnessed by the dominant symbolisation systems and thus renewing their own tradition.[17]

Concerned rather abstractly with linguistics and its subjects, Julia Kristeva identified femininity, as a linguistic position, with semiotic transgression and renewal while not equating it with women. Perceived as an intellectual lapse, her position has inspired much criticism, for the absence of a feminist avowal of the implications of her theory. Julia Kristeva has since, through her own more active engagement with psychoanalysis, substantiated her interest in femininity as the psychic domain of women as well as the *other* of the phallic symbolic system. But to move from the abstract linguistic frame linking femininity and revolutionary poetics to a more concrete engagement with women is to betray precisely what is important in her early formulations. That femininity – which we may well be forced to live under and even subsequently embrace – is not equatable with a term, woman, or with the social collectivity, women, which is always a fixing of only some of that possibility to a place in a system which is ultimately supportive of meanings for the term, man, that negate femininity and its potentialities.

On the radically other hand, Julia Kristeva dares to insist upon a body for the speaking subject, a body that is never a nature, and never has a fixed identity. It is a Freudian body, radically heterogeneous and fantastic, the site of mobile drives and signifying resources which the symbolic tries to harness to its repressive but socially

productive purposes. The body at this point is not thought of in terms of gender – and could never be. But, as her work progresses into psychoanalysis, Kristeva can see how the child's experience of its undifferentiated body is shaped in relation to fantasies of sexually marked bodies – the maternal and the paternal bodies. The shaping of the speaking subject involves a patterning of its body through identification with, and relation to, culturally differentiated rather than physically different bodies. Sexual difference comes to the child from outside through its *incorporation* of images and signifiers of that between which the culture (*a*) makes a distinction, but (*b*) sets in a mutual relation. Thus the parental figure of the infant's early life, dominated as it will be by a maternal, nurturing body, voice and presence while including an archaic father, is divided culturally, at the Oedipal stage, only when the incest taboo creates the necessity of the child's aligning itself with only one aspect of its parental generation – linguistically marked by the terms 'mother' and 'father', which stand for the sexual and gender role division that is thus instituted as masculine and feminine.

Because this process – which is hypothetically narrated as a passage from birth to the accession to language and Oedipalisation, sexing and sexualising – is always occurring in the presence of a fully formed symbolic system, and is always grasped only in retrospect, and always in the present as the repressed contents of the unconscious which is formed by accession to the Symbolic, we have to imagine, difficult as it is, that the body of the child is both undifferentiated and always already part of that process of *différance*. Thus without evoking a natural, given, innate femininity, we can and must imagine the female child experiencing its emergent body and its psychic shaping in preparation for its insertion into language and the symbolic of the culture in ways that can be spoken of using sexually differentiated terms. Not given, but always in the process of becoming, there are possible becoming-female bodies and there we can think of both effective as well as affective femininities.

Thus the pre-history of the child who will be called to see herself as woman is not the mirror image of that term because she was *born* woman. But that pre-history is always on the way to *becoming a subject* in the feminine, and there will be a specific excess for that proto-feminine subject because that *becoming* occurs under the always already active phallocentrism, itself structured by the femininity it attempts to negate as absence. Thus the equation between femininity and the transgressive excess that can contest the present order is at once a structural property, as Julia Kristeva's early work proposes, and a more experiential process which feminism actively takes up. But, if we adopt that possibility of speaking of femininity and its privileged relation to revolution without keeping the linguistic-structural aspect in mind, we will fall right into the phallocentric trap of binary oppositions, fixed difference, as if feminism or aesthetic practice is to be resourced only from what 'women' are. Femininity then will signify only as an unnecessary synonym for Woman/women, when the whole thrust of this difficult theoretical passage through semiotics, deconstruction and psychoanalysis tries to define the magnitude of the distance and difference between 'being women' and 'becoming in the feminine'. On that difference hangs our politics and the possibility for real change.

I did emphasize this

In the final parts of this book I will draw on yet another feminist psychoanalytic theory that attempts to realign the symbolic order by an acknowledgement of a non-essentialist structuring of the subject in relation to the invisible specificity of the feminine body and its effects in fantasy on the psychic formation of subjectivity, sexuality and art. This is the theory of the Matrix advanced by Bracha Lichtenberg Ettinger,[18] who argues that Julia Kristeva's theoretical revisions are still engaged with a phallic account of the coming of sexed subjectivity. Bracha Lichtenberg Ettinger defines the feminine as the basis for a stratum of subjectivity in which there is a minimal difference – distance and relatedness – from the inception, and not only after or in the anticipation of castration. From a phallocentric model in which the subject is formed by the always traumatising encounter with the principle of difference via a series of threatening separations which are veiled by anxiety, and in the masculine subject, disavowed via fetishism and the castration complex, Bracha Lichtenberg Ettinger delineates an archaic co-emergence of part-subjectivities 'in the feminine'. These are derived from the fantastic imprint of the invisible specificity of feminine sexuality on both feminine and masculine subjects-in-becoming. The concept of the Matrix, realigning subjectivity from under the solitary sway of the Phallus as sovereign signifier, is a revolutionary theorisation that marks a historic break within the canon of psychoanalytic discourse that has made femininity almost unthinkable. It shifts even more productively the relations of feminism and psychoanalytic theory on to the terrain of aesthetic practices where Bracha Lichtenberg Ettinger identifies a correlation between creativity and sexuality.[19]

THINKING ABOUT *WOMEN* . . . ARTISTS

If we use the term *women* of artists, we differentiate the history of art by proposing artists and 'women artists' (Fig. 2.2). We invite ourselves to assume a difference, which all too easily makes us presume that we know what it is. Furthermore, art becomes its deposit and expressive vehicle. Julia Kristeva's view of aesthetic practices as a transgressive and renovative force, sometimes captured by the system and reified as something akin to religion or transcendence, at other times revolutionary in its poetic transformations, is based on her definition of a signifying process. Aesthetic practices shift meaning, undo fixities and can make a difference. In the work by artists we name women, we should not read for signs of a known femininity – womanhood, women like us . . . – but for signs of femininity's structurally conditioned and dissonant struggle with phallocentrism, a struggle with the already existing, historically specific definitions and changing dispositions of the terms Man and Woman within sexual difference. We can read for *inscriptions of the feminine* – which do not come from a fixed origin, this female painter, that woman artist, but from those *working* within the predicament of femininity in phallocentric cultures in their diverse formations and varying systems of representation.

There can, therefore, be no way of, and no point in, 'adding women to the canon'.

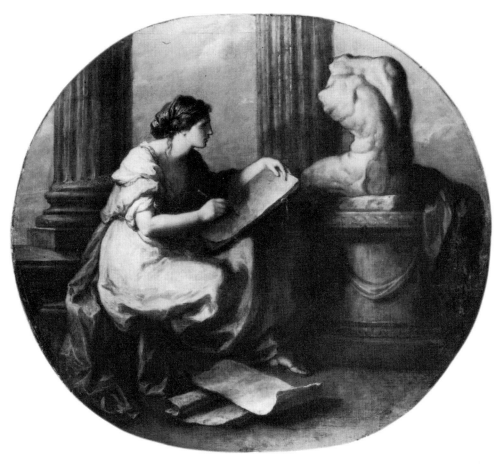

Fig. 2.2 Angelica Kauffmann (1741–1805), *Design*, 1779, grisaille, 130 × 147 cm. London: Royal Academy

There are, however, productive and transgressive ways to re-read the canon and the desires it represents; to do deconstructive readings of the disciplinary formation that establishes and polices the canon; to question the inscriptions of femininity in the work of artists living and working under the sign of Woman, who were formed in historically and culturally specific femininities. And finally there are ways to question our own texts for the desires they inscribe, for the investments which we feign through telling the stories of our own ideal egos: the women artists we come to love and need to love in order to find a cultural space and identification for ourselves, a way to articulate ourselves – to make a difference to current systems that manage sexual difference as a negation of our humanity, creativity and safety.

I am searching for ways to be able to write about artists who are men and artists who are women in order to go beyond the concept of binary gender difference. By journeying through the defiles of psychoanalysis, I find myself tracking both coincidence

and divergence between the two. The sign of an always sexually differentiated and differentiating convergence of masculine and feminine interest is the 'mother', a sign in psychic fantasy and an aspect of signifying space whose 'murder', or perhaps repression, has been consistently identified as a structural necessity for, and a founding myth of, patriarchal societies. One of the faces of modernist culture is the construction of artistic identity that is not only virile but autogenetic, claiming creativity for its masculine self through a radical displacement of the maternal feminine in imageries of prostitutional and lesbian bodies. As obsessionally recurrent as the image of vacant Madonna and kingly Son were to Renaissance culture, the figuratively non-maternal body of the sexualised woman, the prostitute, functions in the modernist canon from Manet to Picasso and De Kooning. Yet, as I shall argue in the next two chapters, the maternal haunts the culture that the modernist sons attempted to create. A feminist 'view from elsewhere' within the discursive-political field, scrutinising early modernism, reveals the 'ambivalence of the maternal body' in the stylistic rhetorics and formal 'innovations' for which that avant-garde fraction has been canonised. The mother is a space and a presence that structures subjectivities both masculine and feminine; but differerently.

The trajectory of the book follows, case study by case study, the questions of feminist differencing of the canon by the desire for some way to acknowledge and speak of the maternal in all its ambivalence and structural centrality to the dramas of the subject, the narratives of culture and the possibilities of reading within culture 'inscriptions of/in/from the feminine'. Without in any sense privileging maternalism or motherhood, feminist theorisations of the feminine and analysis of representations made within its psychic economies have to rework and think through the mother: voice, image, resource, absence and matrixial borderspace (Bracha Lichtenberg Ettinger). To identify and yet disrupt the matricidal murder characteristic of Western modernist culture, in the work of Van Gogh and Toulouse-Lautrec, to explore the fantasy and loss of the maternal in cultural formations and individual subjective trajectories in the paintings of the Italian seventeenth-century artist Artemisia Gentileschi, and to recognise it in the work of American modernist Mary Cassatt, work that already offered a counter-modernism in the very same spaces as its canonical *confrère*, Degas, to read for feminine co-emergence across the discourses of class and race in Manet: these form the project.

But while the figure of 'the mother' functions as one organising concern, that of 'the sister' is also explored through the study of differences between women and the possibilities of alliance (Fig. 2.3). Sisterhood was such a vital slogan of the women's movement of the 1970s and it was shipwrecked on the reefs of unacknowledged racism and class relations. But the project of feminism, while no longer complacently assuming a collectivity called women, must in the nature of its project work ceaselessly to create a political collectivity. The ambivalence and antagonism between women cannot be wished away in some euphoric idealisation. For once we explore the issues of the maternal and of feminine loss, we will have actively to generate new relations between women: elective affiliations. The concluding chapter of Part 3, on Lubaina

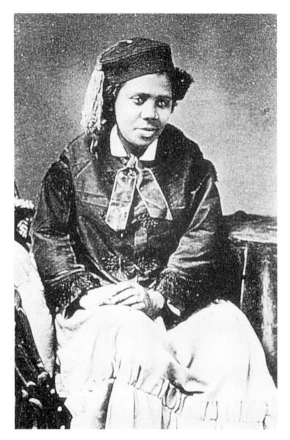

Fig. 2.3 *Edmonia Lewis* (1843? – after 1909), photograph. Washington, D.C.: National Archives of American Art

Himid's project *Revenge*, and the final chapter of the book, *A Tale of Three Women*, develop this other necessary work of differencing all canons, including those that, as a white feminist art historian, I may seem to be setting up.

As a whole, the book struggles with some of the complexities of contemporary feminist theory and its cultural politics. We cannot let our work be reduced to a mere 'approach' or a new 'perspective' waiting to be dismissed as outmoded. It is an engagement in the field of representation, power and knowledge that must touch all fields and all topics. I write in the role of an interested reader of culture and a motivated analyst of representation. A difference that I can introduce into the canon is the difference of that specific, invested, historically and socially overdetermined position from which I read, and then write, what I hope will in turn be read as a contribution to the continuous production of provocative polyvocal feminist interventions in art's histories. The driving force is desire for change, desire to find stories that will sustain those called or prepared to identify with women, that will enable us to discover what it is to be the historical 'subject of [a long-term] feminism'.

NOTES

1 This is the major discovery and argument of Rozsika Parker and Griselda Pollock, *Old Mistresses: Women, Art & Ideology* (London: Pandora Books, 1981; new edn 1996; now London: Rivers Oram Press).

2 The first article I ever wrote as a 'feminist' in 1972 was a study of the paintings by women artists in the open basement galleries of the National Gallery in London. I entered a correspondence with Michael Levy, the then Director, as to why all the paintings by women were kept below stairs. This included Rosa Bonheur's *The Horse Fair*, the first painting by a living artist to be admitted to the National Collection. Admittedly, it is not the original version, now in the Metropolitan Museum of Art in New York. Admittedly, Rosa Bonheur was assisted by another artist, her companion Natalie Micas, in painting this reduced version for Ernest Gambart, the dealer, who was to make an engraving of the work. These reasons were used against the public showing of the only painting of this major, decorated nineteenth-century artist. A large pastel portrait, *The Man in Grey*, by Rosalba Carriera was also downstairs; and a Berthe Morisot, part of the Lane Collection, was in Dublin at the time. Michael Levy felt I would be misrepresenting the gallery if I did not take all these factors into account.

3 This was the title of their exhibition at the Walters Art Gallery in Baltimore. For discussion see Parker and Pollock.

4 One of the classic texts of this moment is Judy Chicago, *The Dinner Party* (1979), re-exhibited in 1996. For a review of responses to this project and its meanings within feminism see Amelia Jones, *Sexual Politics: Judy Chicago's Dinner Party in Feminist Art History* (Los Angeles: University of California Press, 1996) and Judy Chicago, *The Dinner Party* (London: Penguin Books, 1996); Anthea Callen, *Angel in the Studio: Women and the Arts and Crafts Movement* (London: Astragel, 1979).

5 Patricia Mainardi, 'Quilts – The Great American Art', *The Feminist Art Journal*, 2, 1 (1973), reprinted in *Feminism and Art History: Questioning the Litany*, ed. Norma Broude and Mary D. Garrard (New York: Harper & Row, 1982), p. 331.

6 Rozsika Parker, *The Subversive Stitch: Embroidery and the Making of the Feminine* (London: Women's Press, 1984). See also 'Crafty Women', in Parker and Pollock.

7 Teresa de Lauretis, *Technologies of Gender: Essays on Theory, Film and Fiction* (London: Macmillan, 1987).

8 This concept was originally developed in the introduction to my book *Vision and Difference: Feminism, Femininity and the Histories of Art* (London: Routledge, 1988).

9 Julia Kristeva, 'Women's Time' [1979], in *The Kristeva Reader*, ed. Toril Moi (Oxford: Basil Blackwell, 1986), pp. 187–213.

10 Michel Foucault, *The History of Sexuality* (Harmondsworth: Penguin Books, 1979), would be a prime example of the development of the historicisation of sexuality and the location of psychoanalysis within a historical framework.

11 Gayle Rubin, 'The Traffic in Women: Notes on the "Political Economy" of Sex', in *Toward an Anthropology of Women*, ed. Rayna Reiter (New York: Monthly Review Press, 1975), pp. 157–210.

12 For a useful discussion of the social importance and theoretically distinct status of what Freud theorised, see Paul Hirst and Penny Woolley, *Social Relations and Human Attributes* (London: Tavistock Publications, 1982) esp. ch. 8: 'Psychoanalysis and Social Relations', pp. 140–63.

13 Jacques Derrida, 'Différance', in *Speech and Phenomena and Other Essays on Husserl's Theory of Signs*, trans. David B. Allison (Evanston: Northwestern University Press, 1973), p. 129.

14 This argument is cogently placed in historical context by Denise Riley, *Am I That Name? Feminism and the Category of 'Woman' in History* (London: Macmillan, 1988).

15 Julia Kristeva, 'The System and the Speaking Subject', *Times Literary Supplement*, 12 October 1973, pp. 1249–52, reprinted in *The Kristeva Reader*, pp. 24–33.

16 It is confusing that she uses this term, *symbolic*, in a way that differs from its use by Lacan, with a capital, Symbolic. For Kristeva *semiotic* and *symbolic* are characteristics of signifying systems, not the names, like Imaginary and Symbolic, of actual registers of meaning and psychic dispositions. The Symbolic is a realm or order which contains both symbolic and semiotic elements, although it cannot exhaust the semiotic. See Kelly Oliver, *Reading Kristeva* (Bloomington: Indiana University Press, 1993), pp. 9–12.

17 *Ibid.*, p. 30.

18 For an example of this theorist/artist's writing on art and the Matrix see Bracha Lichtenberg Ettinger, 'The With-In-Visible Screen', in *Inside the Visible: An Elliptical Traverse of Twentieth Century Art in, of and from the Feminine*, ed. Catherine de Zegher (Boston: MIT Press, 1996), pp. 89–116.

19 The literature on Bracha Lichtenberg Ettinger's theories is now quite extensive. Key works are 'Matrix and Metramorphosis', *Differences*, 4, 3 (1992), pp. 176–207; *The Matrixial Gaze* (University of Leeds: Feminist Arts and Histories Network Press, 1994); 'The Red Cow Effect', in *Beautiful Translations ACT 2* (London: Pluto Press, 1996); 'The With-in-Invisible Screen'.

Part II

READING AGAINST THE GRAIN: READING FOR . . .

The canon is held in place by the power of the stories it tells about artists. These mythologies are not all the same. Some call upon images of personal suffering that have an almost religious aura; others stress a secular, overtly sexual character. Both the sacrificial and the virile are elements of a construction of modernist masculinity. In this part, two artists, Vincent van Gogh and Henri de Toulouse-Lautrec, provide case studies in these different facets of masculinist mythologies of modern art. They are subject to an irreverent feminist reading, which seeks to defrock the discourses that sustain their cultural iconicity. The purpose is, however, not to leave them bare but rather to find ways to read the art historical moment Van Gogh and Toulouse-Lautrec variously signify for another subtext that feminist analysis might tease out from the mythologies of modernist and avant-gardist stories of art. The aim is to see the ways in which historic regimes of sexual difference, as theorised by both artists' younger contemporary Sigmund Freud, shaped a trajectory of modernism around what I have called 'the ambivalence of the maternal *body*'.

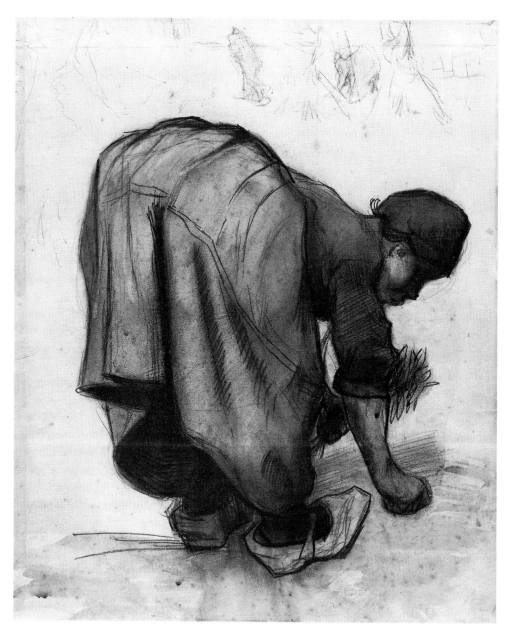

Fig. 3.1 Vincent van Gogh (1853–90), *Peasant Woman Stooping, Seen from Behind*, 1885, black chalk on paper, 52.5 × 43.5 cm. Otterlo, Rijksmuseum Kroeller Mueller

3

THE AMBIVALENCE OF THE MATERNAL BODY

Re/drawing Van Gogh

A FEMINIST READING OF VAN GOGH?

I would like to explore how to introduce difference into the problem of the canon, allowing several discourses to co-exist, thickening the slim volume that Western white phallocentric logic inscribes within culture. We must get beyond competing heroisations, using culture to fashion our ideal egos. We must grow up, renouncing the regressive pleasures of infantile investments in order to look at ourselves, through the inscriptions in culture of those non-mystic beings, artists, who are driven to give their desires form in ways that breach the (socially fabricated) personal to touch on common territories of fantasy and desire.[1]

The ways in which images of masculinity are stencilled by the discourse of art history on to the materials offered by cultural practices are not uniform. Different artists are mythicised in various ways. It has long been argued there is a heterosexist imperative in canonical art history.[2] Nanette Salomon argues that this works to keep references to homosexuality out of the canonical texts on great artists such as Michelangelo and Caravaggio.[3] Picasso is, however, celebrated grandly as potent man, and sexuality, signalled both by the phallic imagery in his work and by his constant female companions, is an accepted and necessary part of the characterisation of his work and his status as a representative figure of the artist in the modern era.[4] In cases such as Degas's, sexuality functions in the negative. The artist is represented as a celibate or as sexually dysfunctional in a life story that artistically produced a disconcertingly, if oblique, address to the sexual in art that a great deal of formalist attention to his innovative use of pastel or monotype and compositional bravura disavows. In the case of Van Gogh, a Christological identification as the suffering outsider sacrificed by a mercenary culture makes any reference to sexuality almost an obscenity in connection with his name or work.[5]

Masculine heterosexuality has become a constitutive trope in the modernist myth of masculine, phallic mastery that was circulated through the image of the male artist with the female nude in the studio (Fig. 3.2).[6] Troping modern art as a form of sexuality, these images also point to a specifically psychonalytical concept, wherein

41

Fig. 3.2 Postcard of book covers, including Irving Stone, *Lust for Life*, and Pierre La Mure, *Moulin Rouge*

sexuality is almost synonymous with the unconscious. It relates to fantasy and to the very structures of subjectivity and the construction of sexual difference. By introducing this psychically formed *sexuality* – rather than a sex life – into the canonical field of Van Gogh studies, I want to read his works posing the question of 'sexuality in the field of vision'. That is, I aim to question the configurations and anxieties attendant on the formation of subjectivity within the ordeals of sexual difference at the beginnings of modernism. We might then find a place where difference can be studied without excluding either the masculine or the feminine trajectories of desire, for it is the very complexity of their formation, repressions and defences that constituted the object of a contemporary development, psychoanalytical enquiry.

BENDING WOMEN

Let me start with a drawing I hate (Fig. 3.1).

The drawing is by Vincent van Gogh (1853–90). It was produced in the village of Nuenen in the province of Brabant in the southern Netherlands in the summer of 1885: *Peasant Woman Stooping, Seen from Behind*. There are some other figures doing harvesting tasks in the upper right, including another sketch of a peasant woman bending, with an exaggeration of her hips and buttocks.

The drawing belongs in a series of studies of peasant men and women from the village of Nuenen engaged in agricultural tasks produced in the summer months of 1885 after Van Gogh suffered a crushing blow when his artist friend Anton van Rappard had dismissed his major oil painting, *The Potato Eaters* (completed April 1885, Amsterdam, Rijksmuseum Vincent van Gogh), considering inappropriate Van Gogh's invocation of the name of the French painter of rural figures and scenes, Jean-François Millet (1814–75), as a reference point for the work as 'peasant painting'. To prove he had understood how Millet represented labouring bodies, Van Gogh set himself to draw local peasants engaged in typical rural and seasonal tasks made popular by Millet's engraved series *Les Travaux des Champs* (The Labours of the Fields) of 1853.[7]

Most of Van Gogh's studies after Millet are more fully developed drawings than *Peasant Woman Stooping*. They have more of a setting, and a recognisable task like digging up potatoes or sheathing grain. Many of them show elderly peasant women bending to their work. Bending has, however, class specific connotations. It is a strenuous posture. Ladies do not, and could not, bend. It is also a vulnerable posture. It is potentially a sexual position for a form of intercourse known as *more ferrarum*, in the fashion of animals.

The drawing (Fig. 3.1) is sometimes called *Peasant Woman Gleaning*. Such a specific titling attempts to make the drawing belong to a genre, to an art historical narrative by means of which Van Gogh can be inserted into tradition, into the canon, through his apparent deference to established painters of the genre of rural painting: Millet's *The Gleaners* (Fig. 3.3) and Jules Breton's *The Recall of the Gleaners* (Fig. 3.4). Millet's

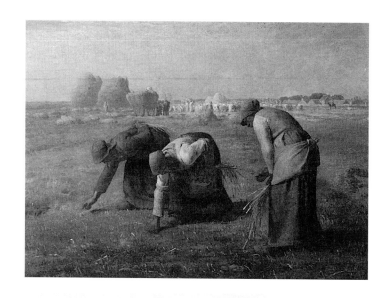

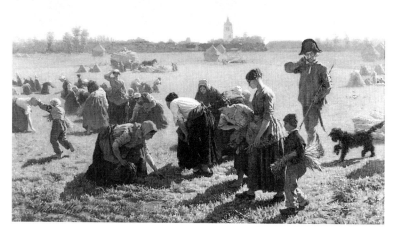

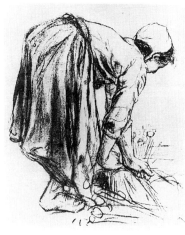

Fig. 3.3 Jean-François Millet (1814–75), *The Gleaners*, 1857, oil on canvas, 83.5 × 111 cm. Paris, Musée d'Orsay and London/New York, Photo: Bridgeman Art Library

Fig. 3.4 Jules Breton (1827–1906), *The Recall of the Gleaners*, 1854, oil on canvas, 93 × 138 cm. Dublin, National Gallery of Art

Fig. 3.5 Jules Breton, *The Oil Poppy Harvest*, black chalk, 32 × 49 cm. France, Private Collection

statuesque version of the posture seems to belie any sexual connotations, dignifying the act of labour, gleaning, by locating these poorest of the rural workers in the foreground of a monumental painting about social relations in modern capitalist agriculture.[8] The bodies are carefully construed by the representation of their costumes. Heavy, coarse cloth weighs them down. Grim faces and weather-roughened hands, the colour of earth and leather, insist upon a reading of the labouring bodies, shaped, marked, strengthened and exhausted by the sheer physical demands of daily work. These are images of working women, women made thus by emiserating labour.

The viewing position proposed by Millet's composition defines a way of reading the painting. The viewer is situated at an oblique angle to the women advancing across the foreground. The woman seen from a three-quarters back view does not bend, but is caught leaning forward at the beginning or end of that movement. The viewing position is also low; the viewer looks up through the women to the vast expanding plain beyond, where a great deal of activity, brilliantly illuminated, attracts and thus distracts the viewer's attention.

The practice and postures of gleaning – with its politicised overtones in a period of struggle over traditional agricultural rights and a capitalising agrarian economy –

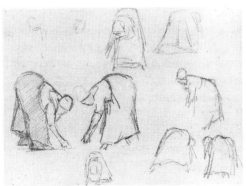

Fig. 3.6 Camille Pissarro (1831–1903), *Studies of Female Peasant Bending*, 1874–6, black chalk, 23.8 × 31.6 cm. Oxford: Ashmolean Museum

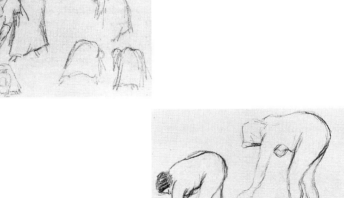

Fig. 3.7 Camille Pissarro, *Four Studies of Nude Women Bending*, early 1880s, black chalk, 17.5 × 21.9 cm. Oxford: Ashmolean Museum

attracted many artists in the mid-nineteenth century. Peasant women are represented bending or kneeling and seen from behind by Jules Breton, a highly successful Salon painter and younger contemporary of Millet (Fig. 3.5); and by Camille Pissarro, member of the Parisian independent group better known to art history as 'the Impressionists' (Fig. 3.6). Pissarro even went so far as to try out the pose in the studio in the nude, in order, perhaps, to understand what happens to the body as the spine is stretched and elongated and the body bends from the top of the thighs to flatten out the hips (Fig. 3.7). Pissarro tends to maintain a profile view; but when he moves around the body and encounters a rear view, his pencil anxiously veils what is potentially exposed.

Van Gogh's drawing (Fig. 3.1) could be called an offensive drawing of a peasant woman with her broad hips and massive buttocks presented to the viewer. Would a refusal of identification with the canonical veneration of Van Gogh's drawing allow me to read, not just as a woman, or as a feminist, but against the man, or rather against the order which creates that sexual division? Here I am falling into my own trap, a binary opposition, simply turning back the violence I feel was done to the woman by the man who made her model for this image by the violence of my own crude denunciation of the drawing and the man who made it. This way of negotiating my unease is too *ad hominem*, as well as too *ad feminam*, and to get a better grip on the structural problems and their resolution we should start with a proper art historical question: How was this drawing made?

INSIDE A STUDIO BEHIND THE VICARAGE IN NUENEN

In August 1885 a Dutch man with some money asked an elderly woman to his makeshift studio to model for him. He is bourgeois; she is from the rural working class. He is from the Protestant elite that owns the factories in the village; she is a Catholic from the impoverished majority of field and factory workers whom the Protestant bourgeoisie employ. Why did she agree?

Van Gogh's letters complain about difficulties he experienced in getting models in this village far from the centres of artistic production. Local workers agreed to the artist's bizarre request only because they needed money. Why were they in need of money? By the mid-1880s a traditional peasant subsistence economy was rapidly being invaded by the belated capitalisation of agriculture which introduced money as its necessary currency of exchange. The family Van Rooij from whom Van Gogh hired his models did not own land in the commune of Nuenen. They worked for other people for money, especially seasonally, at harvest time. Then they would not need the money of Van Gogh. He tried to follow the harvesters to the fields, and draw them at work. But his drawings got dirty and covered with flies and sand. The people did not stand still. So he hired models from those who were still unemployed, too old or too sick to be hired for the fields. Like those urban women whom poverty drove to prostitution,

this woman sold herself to the artist. She exchanged the sight of her body, posed as if working, for the money she needed because she was not working. This exchange between artist and model articulates their social relation within the socio-economic transformations of the capitalisation of the Dutch countryside in which class power was both an integral part and a newly intensified effect.

But the artist with the money to buy this body to look at and draw is also empowered through his gender. Gender power is enacted in the drawing. The artist, with the money to determine how her body will work, is a man. The man obliges the woman to bend over. He places himself almost behind her. She has to take up a pose neither his bourgeois mother nor sisters would ever adopt in front of a man and a stranger, if at all. Although she did it when working, she had never posed her body for such a viewing. The body of the bourgeois lady was disciplined from childhood by both whalebone and convention not to bend. The feminine body of the bourgeoisie functioned through the artifice or effect of costume: the masquerade of a de-corporealised femininity. It became a sculpted landscape without any unnecessary reminders of actual bits – legs, arms, buttocks etc. or one so artificially remodelled to emphasise its curious undulations that any correlation between its actual contours and those costumes offered to the viewer ensured a radical, fetishising dislocation between female bodily form and the eroticised costume of a thus fantastic femininity.[9] The working-class woman's body was, by contrast, defined precisely by being made insistently physical. It was marked by a costume that revealed the bodily construction beneath. Without corsets, working women's costume, composed of a roughly joining skirt and jacket, stressed a living body with arms (revealed by rolled-up sleeves), legs (exposed by shortened skirts), a waist and hips (emphasised by the two garments), breasts (emphasised by the lack of restraints) and buttocks (Fig. 3.8).[10] The eroticised topographies of the nineteenth-century female bodies were quite distinct from those produced today through targeted advertising and associated commodification of bodies both more fully seen and physically exposed. Bared and upraised arms, naked ankles and feet, large hands, uncorseted torsos, exposed necks, all these currently unremarkable features were the object of fascinated attention in art, literature and photography in the nineteenth century in contrast to the formally draped and contrived artifice of the bourgeois lady's form. So too were buttocks – but rarely were they imagined or imaged as in Van Gogh's drawing.

Nineteenth-century bodies were classed as well as gendered. For working women the two orders – of power and of social and sexual identity – were often in contradiction. A body that laboured became ineligible as a feminine body. Yet the working woman's body was clearly a sexually different body. Through the complex displacements of the bourgeois social and sexual imaginary, the working woman's body signified 'female' in a sense related to the physical and even animal, and thus created one level of the dichotomy between feminine and female that was so critical to bourgeois masculine psycho-sexual development. As Freud demonstrated in his papers on the psychology of love, bourgeois men fantasised in the gap between the incongruent bodies of the lady – the feminine (derived from the idealised and rarely

Fig. 3.8 Ernest-Ange Duez (1843–1896), *Splendeur*, 1874, oil on canvas, 119.1 × 102.5 cm. Paris, Musée des Arts Décoratifs. Photo: Laurent-Sully Jaulmes

glimpsed mother) – and the working-class woman – the female (the socially inferior but intimately known, smelt and touched nursemaid or servant). Bourgeois men projected into that cleavage the pain of their own masculine formation, punishing the female body that solicited ambivalence by imagining it as the locus of an unregulated, animal sexuality that was both liberating and disgusting, familiar and strange. This fantasised and socially other body was both a comforting link to some archaic moment, and, yet, also profoundly troubling in that reminiscence of infantile dependence and even shame, and of the necessary, Oedipal expulsion from a longed but prohibited intimacy and era of primary eroticisation.[11]

The body on the drawn page of the drawing by Van Gogh is, at closer inspection, quite disturbing in a misconstruction that takes some seeing. The distortions might be misrecognised as the traces of the artistic signature of 'Van Goghness'. His singular graphic style all over its surface distracts us from too close a scrutiny of the body he

has created. Perhaps we accept the oddities because they conform to one class's expectations of the body of its social other. Is it not common knowledge that old peasant women are fat, ugly and ungainly through overwork and undernourishment?

Massive, almost giantesque, the figure suffers moments of significant disproportion. With scarcely a head, the face is obliterated by shadow. An overlong arm emerges, jointless, from the blouse ballooning to a tumescent forearm, ending abruptly in a huge fist – almost larger than the figure's head. The scale suggests an archaic, maternal body, vast and impossible for a small child to master, a child both comforted and alarmed by turns. Both distortions and overemphases on hands, feet and buttocks suggest the process of fetishism, hence of both desire and disavowal. Enlargement incites the gaze to look but distracts attention from what is looked for, but also dreaded, in the absence, for which size alone is inadequate compensation.

All these oddities are compounded by the inconsistency of the viewpoints which travel around and over the body in this scopic journey. The torso is too narrow and too foreshortened for the massive area of the hips and buttocks which occupy almost half the drawn area. This suggests an upright viewpoint, the artist looking down upon and watching his model from behind. Yet, with face and arms, the viewing point is at right angles to the model. It then shifts. Legs and feet are defined from behind and from a low, almost a sitting position. Finally we note that the buttocks, which have been viewed and drawn both from above and below, have also been pulled round to lie across the plane of the drawing's flat surface, giving an almost frontal view. This registers an overwhelming desire to look there. There is a disproportionately large area of skirt hung over the rear and lower parts of the body. The skirt is raised just above our sight line but we see nothing. The drawing produces a fantasy of the signs of femaleness that falls back into a fearful, not just veiled but hooded displacement of sexuality. Contrast this body with the drawing by Jules Breton (Fig. 3.5) A single continuous line defines the arch of the back running from the neck to the top of the thighs. It ends with a sudden drop of the cloth that forms the skirt. The torso is elongated and the body seen in continuous profile. In the Van Gogh drawing, the swivelling round of the hips and buttocks is possible only because the draughtsman conceived and drew a body he knew but did not see. What is represented is a body that abruptly changes at the waist – in accord with a class-specific costume and not an anatomy taught, studied and internalised at art school or academy. The body conceived in this drawing dramatically differs from the bourgeois lady's perceived body from whose silhouette a waist is abolished by the long line of the rigid corset that runs continuously down to the hips: the head versus the figure is the critical division, not the waist marked by the jacket and skirt. Van Gogh's drawn body differs from Breton's because the latter exhibits signs of art school training which, basing anatomical proportion on classical sculpture, defines the torso as a single anatomical unit. The unusual topography of Van Gogh's drawing makes the woman bend in ways which are loaded with potential significance precisely because it deviates from those conventions it aspired to assimilate. They are the signs of what Freud called the incomplete repression. These are the traces we can then read.

SEXUALITY AND REPRESENTATION

What we are seeing is the production of a fantastic body.[12] Movements of a hand have registered the journey of a look over and around a space, not a person; an object (in the psychoanalytical sense, the object of a drive) and not a subject.[13] The marks laid down by the drawing hand register a desire to see, indicating by its emphases and anamorphoses a motivated fascination with selected zones of a body being recomposed from discrete but overdetermined fragments that constituted a body that was, in actuality, never there in the studio in August 1885.

On the opaque screen of representation an imaginary body is being reassembled, shaped by patterns of desire and anxiety which were culturally supported by officially legitimated cultural formations such as the genre of rural imagery that was extremely popular in both Salon painting and the print market during the second half of the nineteenth century. Indeed, in the play of canons, it is one of the failures of art history to have been unable to account for the cultural significance of rural genre in general, and the majority of its specific aesthetic economies.[14] Van Gogh's drawing records a play of meaning and impulses. Some of these are intentional, evidence of an ambitious artist wanting to succeed in the art world of his day through participating in this particular genre of art. Others are unconscious, traces of the historically particular socio-psychic 'author' we name, after reading the patterns in his whole oeuvre, 'Van Gogh'.[15] The currency of the drawing is the active relation between the structures of fantasy that united this particular 'Van Gogh' and the bourgeois masculinity of a specific historical moment to which varied cultural forms gave representational support and public, cultural articulation.

Read from this enlarged use of psychoanalysis to inform analysis of cultural practices in history, I would mount the following argument. In bourgeois culture the body operated as a privileged metaphor for social meanings by 'transcoding'.[16] The European bourgeois is the head, his wife the heart, the working classes of all peoples are the hands, and, in general, they are associated with the lower body – and thus with what is expunged from the bourgeois's cerebral definition of himself: dirt, sexuality, animality. Bourgeois culture has dramatised the anxieties resulting from this metaphoric social body through an obsession with both the city and its key tropic figure: the prostitute, who embodied a fascinating but abject darkness, lowness and sexual mystery that was both a sexual channel and a sewer. In contrast to the transcodings relating to urban filth, sewers, darkness, back passages and below stairs, the countryside became a highly invested imaginary site, signifying a healthy space for access to an unregulated sexual pleasure signalled by transcoding its female inhabitants with Nature. The pleasures offered by this genre of rural imagery, so often populated exclusively by mothers suckling children and nubile young women returning from the harvest, are of a regressive kind, allowing an imaginary space for reimagining access to the archaic and beneficent Mother of infancy. This, however, because of class and the high/low opposition, could easily be rerouted by later psychic twists, towards other infantile fantasies leading to an identification of the rural woman with animals,

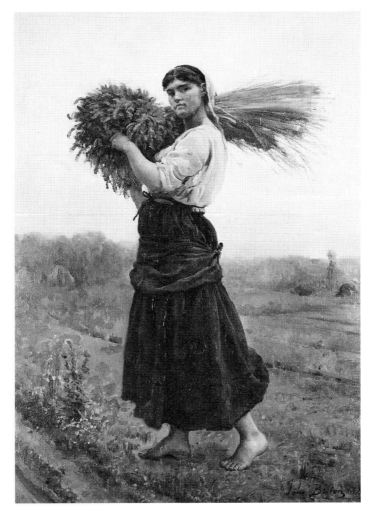

Fig. 3.9 Jules Breton, *The Gleaner*, 1875, oil on cavas, 73.5 × 54.9 cm. Aberdeen: City Art Gallery

collapsing into bestiality. Thus, in sun-filled images of large bodied women bending or otherwise working, imaginary anal pleasures could be highly coded without transgressing the socially policed boundaries beween cleanliness and dirt, bourgeois and prostitute, a frontier around which anxieties surface so insistently in the obsessive character of discourses on prostitution in nineteenth-century fiction, medicine, police files and of course modern art (Fig. 3.9).

Van Gogh drawing's (Fig. 3.1) extracts the rural working woman's body from the elaborated pictorial evocation of a beneficent, sun-filled, fertile rural setting and from the narrative context of social naturalism. Van Gogh was an autodidact and, without long years of art training, he had not internalised the rules which govern the making of art. Such rules, varying historically, serve to manage the psychic drives released and

sustained by artistic figuration. In the artistic formation we name nineteenth-century rural naturalism, the conventions Van Gogh should have learned provided the costume of aesthetic conversion to sublimate the equivocal pleasures bourgeois men enjoyed by consuming the sight of working women's socially other and sexually configured bodies disporting in imaginary Nature.

The body is not innately sexed. Mapped, as it were, for sexuality through fantasy, a sexual topography is produced by the localisation of psychic investments into eroticised zones which progressively sexualise various sites such as the mouth, anus, penis or clitoris, and, belatedly but traumatically, focus sexuality on the genitals, while leaving the traces of the more dispersed and unregulated eroticisation Freud called polymorphous and perverse. The buttocks, so prominent a feature of this drawing, were a multiply determined erotogenic zone, fixated by the social arrangements of childcare in the nineteenth-century family. Here the social division overlaid a sexual division producing for the male child an encounter with a femininity that was divided between the upper body, heart and head, associated with the clean but distant mother, and another more physical body, that of the working-class wet-nurse and nursemaid who caressed the child's body in the daily routines of cleaning, feeding and playing. It was her proletarian body which carried the memories of infantile intimacies, associated with the patterning of the bourgeois boy's sexual geography. The effects of these arrangements were noted by Freud in his paper on the 'Universal Tendency to Debasement in the Sphere of Love' (1912) in which he analysed cases where bourgeois men loved only where they could not desire and desired only where they did not love.[17] Indeed the sexual object had to be debased in order to solicit desire and effective sexual activity. In such a context of imaginary transcodings, anal eroticism is represented in terms of bestial sexuality – a fantasy of escape from the regulative, i.e. reproductive, bourgeois heterosexual ordering of its sexuality, necessarily gratified only through projection on to the bodies of the social as well as sexual or racial other. It could also be seen as a defence against the primary pleasures of passivity associated with the infant's handling by older women. Such memories would be hard to accommodate to post-Oedipal sexuality without the surfacing of a passive homosexual desire that the heterosexual-identified masculine subject must disavow at all costs.

In bourgeois fantasy working-class women could be equated with animals. In Emile Zola's novel *La Terre* [The Earth] (1888), read by Van Gogh with admiration, a young girl takes a cow to be serviced by the local bull and has manually to assist the creature with his copulation. Sexuality is all over the scene, enacted between the animals, aided by the girl, watched by a man. This displaced sex scene was sufficient to get the novel banned in England until 1954. Harvesting was a common narrative setting for such scenarios and the heated desires aroused by sights of women bending in the fields. Zola wrote: 'Whenever Buteau straightened up long enough to wipe his brow with the back of his hand and noticed her too far behind, with raised buttocks and her head close to the ground in the posture of a ready bitch, his tongue seemed to grow drier.'[18] Bending over to gather sheaths of wheat is represented to the reader as a sexual provocation through the device of the reader's surrogate, the arousable peasant man watching the

woman at work. The peasant woman is compared to a female dog on heat, her buttocks proffered. Reduced to this bodily part, she is thus reduced to sex. But sex is imagined from both an infantile and a masculine perspective. The woman is only that part or place he needs for gratification. The bestialisation of a working woman becomes a necessary sign within this construction by a bourgeois writer of another class's animality in contrast with, but also as a fantasised escape from, the conventions and guilts of bourgeois sexuality. And, as Foucault argued, 'sexuality' in its modern sense is a specifically bourgeois construct.[19]

WHAT ARE THEY REALLY TALKING ABOUT?

Few of the current art historical attempts to reclaim Salon naturalism against the modernist canon's disdain for artists such as Breton address the centrality of the young female peasant to the painting of rural genre. Only Linda Nochlin has gone straight to the heart of Jules Breton's success. He ejected men from the fields and populated his sun-filled scenes with sensuous women, and children.[20] Over these selective bodies a range of stylistic possibilities were played out, probing the dense freight of meaning the feminised countryside could carry within both a bourgeois political and a sexual economy. Millet's statuesque ruggedness contrasts with the smoothly finished surfaces of narrativised rural scenes by Breton during the 1860s (Figs. 3.4, 3.5). But in the 1870s and 1880s, tougher styles emerged in the works of Jules Bastien-Lepage, Léon Lhermitte, Josef Israels, Léon Frédéric and Cécile Douard. Critics were anxious about the overt abjection of such representations of an impoverished and unidealised peasantry. Jules Breton's work shifted over his long career, and multi-figured compositions in extensive landscapes gave way to monumental studies of a muscular female peasant body, in for instance *The Potato Harvest* (1868, Philadelphia, Pennsylvania Academy of Fine Arts) and *The Close of Day* (1865) (Fig. 3.10). These met with considerable critical and popular success. But in what terms was Breton praised while the other paintings were worried over? Critical responses to the idealising trend endorsed the revelation of the 'poetry' of rural labour, and wrote of harmony and beauty. A lot was, however, not being said in the pact between critic and his reader.

Take the republican critic Théophile Thoré writing on Breton's *The Close of Day* (Fig. 3.10). By overt negation, the text traverses a double register of an aesthetic said and a sexual unsaid:

> Breton's painting, chaste in idea, sober in style and execution, translates the serenity of a hardworking life, in which artificial passions are unknown. His personages have natural distinction without affectation. Can a beauty of form, and figure and of expression be found in the savages of the country-side? Apparently a young peasant, carrying a sheaf on her head, evokes the symbolic image of Ceres better than a bohemian from Paris, undressed in a studio.[21]

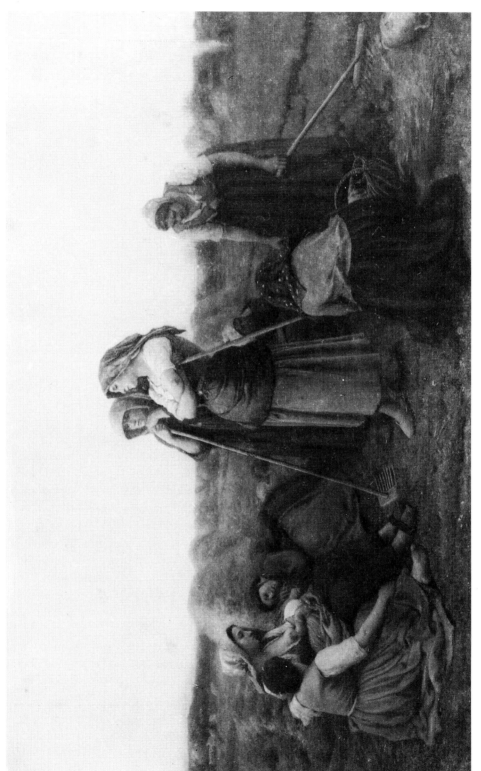

Fig. 3.10 Jules Breton, *The Close of the Day*, engraving after the painting exhibited at the Salon of 1865. Present location unknown

To evoke chastity is to imagine its opposite. Thoré's approbation of the sobriety of the style raises the ghost of that which style and execution must discipline. Work and sex function as antidotes. The artist's good work as a painter is matched to the peasant's dedication to labour. Both work to forestall their opposite: artifical passions. Against the figure of the hardworking woman of the fields emerges the shadow of another kind of working woman, in the city: artificial, passionate, incited by sexuality into the moneyed world of luxury and consumption. The rural woman is the natural antidote to her affected, urban and sexualised sister: the prostitute. But then there is a break in the critic's discourse. A distance has to be violently created by abruptly racialising the rural population as 'savages'. Stepping back to identify with the 'upper' city, with civilisation, the critic establishes another dichotomy. The almost symbolic figure of the rural woman, made timeless and allegorical through the invocation of Ceres for which she 'naturally' models, is the opposite of the hired, money-bought, urban studio model, artifically dressed down as a classical goddess of plenty. The rural woman works and gives as bountifully as nature – without the exchange of money, the symbolic representative of all commodities. Sexuality signified as 'artificial passions' joins money and the city of commodities in a negative chain of associations. Despite all the dangers and doubts about rural savages, the countryside is secured as the world of nature where chaste and sober artists may safely work to produce a place for an untainted pleasure signified as art. Art is of course artifice. But, served by nature and not venal sexuality, a decommodified rural domain can be soberly manufactured for aesthetic contemplation that is subliminally erotic within a heterosexual masculine and bourgeois economy.

CLASS, SEXUALITY AND ANIMALITY

Van Gogh's writings display a comparable inconsistency between class superiority over, and identification with, the countryside and its workers. He wrote: 'I often think how the peasants form a world apart, in many respects so much better than our own civilised and cultured world. Not in every respect for what do they know about art and other things.'[22] In such views he was not untypical, but the appeal of the rural world could involve a setting for much more violent and conflicted emotions. In 1885, Van Gogh read Emile Zola's novel about industrial conflict set in a mining community, *Germinal*. Van Gogh chose to copy out for his brother one of the key dramatic scenes in which Zola's purpose in the novel is revealed. To his pupil Edouard Rod, Zola wrote of this section that he planned to place 'above the eternal injustice of classes, the eternal pain of the passions'.[23] For Van Gogh the figure of the sexually frustrated mine-owner Hennebeau became the figure for identification.

> Bread! Bread! Bread! [shout the starving strikers]
> 'Fools,' repeated M. Hennebeau, 'am I happy?'
> A fit of anger rose within him against those people who did not

understand. He would gladly have made them a present of his huge revenues if he could have a tough skin like theirs and easy copulation without regrets. Oh, that he could let them sit down at his table and stuff them with his pheasant, while he went out to fornicate behind the hedges, tumbling the girls without caring a rap, about those who had tumbled them before him. He would have given everything, his education, his good fortune, his luxury, his power as a director, if only he could have been for a single day the least of the wretches who obeyed him, master of his flesh, enough of a brute to slap his wife's face and take his pleasure with the women of the neighbourhood. He also wanted to starve . . . Ah! live like a beast, having no possessions of one's own, flattening the corn with the ugliest, dirtiest coal trammer, and being able to find contentment in it . . . someday they would howl when they had left behind the easy satisfactions of their instincts by raising them to the unappeased suffering of the passions [*souffrance inassouvie des passions*].[24]

From such passages there can be no doubt as to whose sexuality is at stake in the fictive conflict of the classes. The constructions of pleasure, desire and the body, which the term *sexuality* attempts to specify in disinction from historically different managements of procreation, is deeply imbricated in the constitution and enactment of bourgeois class identity. As this extract reveals, only the bourgeois are imagined as sexual beings, as subjects of psychology and passions. The proletarian body figures as a radical other through which to displace sexual frustrations and to fantasise a state of untrammelled physical licence unconstrained by morality and even self-consciousness. Closer to animals, the workers lack the angst of psychological life and remain instinctual beings, satisfied by mere physical activity. The bourgeois suffers unappeased passions which necessitate and define sexuality – sexual practices which cannot provide the gratification of the desire – passion – that motivates the act. Thus bourgeois men are trapped within the law of desire, according to the novel's vision. The (lost) object of desire within a sexual economy determined by castration, or the Name of the Father, is imaginary unity with the body of the Mother, with its dream of reassimilation to a maternal space of undifferentiated plenitude – the Mother Country, the Country of the Mother, the Mother as the Country. But anger and rage against the impossibility of gratification render the desired maternal body the object of hatred and a desire to degrade, to reduce it to the bestial, punished, used, violated and abjected physicality signified in the novel by the working-class woman miner who labours in the dark interior of the death-dealing earth. In Zola's text, the bourgeois Hennebeau imagines revenge on his unfaithful wife who asserted her own sexuality outside the laws of property, by dreaming of having sex with a nameless, ugly, dirty body of a working-class woman, access to whom requires no love and no decorum, merely his rights and attributes as a man and a bourgeois. Zola's scene of *Hennebeau Furioso* is a fantasy of violence and a violent fantasy projected out from a masculine sense of Oedipal betrayal on to the bestialised body of a woman of the rural proletariat who

is 'blackened', dirtied and abused, the dark underside of Jules Breton's idyllic and sun-filled images of rural plenty.

With its recurrent tropes of ugliness and dirt (both metaphors for abjection and sexual licence), Zola's text channels into Van Gogh's project. Van Gogh's framing of his extract from the novel suggests a reading inattentive to Zola's political project. Van Gogh's reading compounded and identified with the bourgeois economy the novel imaginatively disorders through its semiotically radical proletarian bodies and their desperate political actions. Van Gogh's drawing (Fig. 3.1) needs to be read against Zola's literary delineations of working women's bodies so that the investment in these tropes within nineteenth-century bourgeois culture cannot be erased in the sterilised asexuality of canonical discourses on Art. 'Reading against' means recognising the differing political valencies of this vocabulary of the fictive body of the sexual and social other. Van Gogh's bending woman brings *le derrière de l'ouvrière* into view. But it is another, younger literary contemporary of Van Gogh's who ultimately permits a reading of it.

FREUD, VAN GOGH AND THE WOLF MAN: *MATER* AND NANNY

In his case study of the 'Wolf Man', 'From the History of an Infantile Neurosis' (1918), Sigmund Freud identified slippages between the higher and lower body, as well as between the human and animal in the formations of his patient's sexuality.[25] Freud's archaeological dig through the layers of memory constituting the 'Wolf Man''s unconscious threw light on the fact that as an adult, this man could enjoy sex only with a working-class woman, and only using a rear entry. Freud recreated a primal scene, in which, as a baby, the man had witnessed his parents' *a tergo* intercourse in response to which he had defecated. Freud postulated that on to this as yet uncomprehended memory of the disappearing paternal penis and its association with his own anus the sight of animals mating *a tergo* was later imposed. It was, furthermore, significant that the Wolf Man's initial neuroses were precipitated by the sudden expulsion of his working-class nurse from the family. It was as if her body incorporated some of these unformulated memories of the body, its motions and feelings. Her loss figured a kind of dramatic severance from a maternal body, displacing what it had contained on to his now manifested symptoms. This case study was at once a detailed analysis of an individual's particular history and a revelation of what structured bourgeois masculine fantasy at this time within that interface of actual social relations and their investment by unconscious meaning and fantasy during the uncertain journey through the psychic thickets of formation as a sexual subject.

Van Gogh's work as an artist amidst the peasant communities of Nuenen in his natal province of Brabant in 1884–5 brought comparable elements of his individual history as a boy brought up by both bourgeois mother and peasant nurse into play with an artistic tradition and a social history which are the conditions of their becoming art.

What his representations of peasant women reveal is not the articulation of bourgeois sexuality through the widespread tropes of pure lady/wife versus debased prostitute which came to structure so much of the culture of urban modernity that has been canonised as modernism.[26] Rather it brings to light another, equally compelling fantasy that oscillates between the mother and the peasant nurse, the *Kinderfrau*, a figure as much part of the household of Theodorus van Gogh as of that of Jacob Freud or the Wolf Man.[27]

In the drawing we have been considering, the peasant woman's figure must be read as a vortex of contradictory registers and effects. Maternal in scale, the figure is obsessively differentiated from the body type of the bourgeois mother by almost 'grotesque' overemphasis on difference. The drawn peasant woman is disfigured and dissected in every stroke of the chalk by which the image is produced, by its disjointing attentiveness to huge fists, broad, flat feet and the humiliating but infantile peering up the skirts at the buttocks which are then offered, as if seen from above, for humiliation or punishment.[28] Enacted by the draughtsman on the fictive space of the drawing, relived by the man in that social space with the woman whose time and body his brother's money bought him, the relations of class and gender power provided the *mise-en-scène* for fantasies of bestiality which signal the pain of loss, and its underside, aggression, this latter being a defence against the former. The drawing and its psychic dispositions were produced in the social and subject-forming conditions of these historically specific relations between bourgeois men and working-class women. Where the codes of class predominate in shape and point of view, one body is produced to be aggressively debased and rejected as aged, immodest and bestialised. Yet against that pressure, another body, monumental and maternal, swells to dominate and entrance a diminutive, curious and desiring child.

This drawing dramatises – or overlays in its different registers – a conflict that can be construed schematically thus. A pre-Oedipal fantasy of love and pleasure associated with the working women's nurturing and utterly female corporality contests the space of the drawing with a resisting, Oedipal, castration-fearing aggression violently afflicting the body of this socially other, and almost bestially abject, lower female body. In one case the size and physicality of the body's lap, buttocks and torso are the very signs of comfort. In another the exaggeration of these parts set against the lack of head or face, of gaze or possible voice, register the violation and rejection of the humanity of this fantasised non-being. The drawing seesaws across these registers of threat and pleasure, love and aggression, fear and desire. These are the traces of failed repression, traces which make legible the uneven negotiation of the sacrificial process by which masculinity was formed in its peculiar relations to lost maternal bodies created in the social division of bourgeois childcare at the time.[29]

What is the point of speaking of the incoherence and contradictions of European bourgeois masculinity, and of naming the cost at which it is produced – what Freud called castration within a typically nineteenth-century emphasis on the body, but which Julia Kristeva, true to a post-structuralist reading of psychoanalysis with its emphasis on language, calls sacrifice? I began this chapter with the intention of doing

'symbolic' violence to a drawing I claimed to hate in order to fracture the canon with which the violence of such representations of working-class women is protected as great art made by great men. I have travelled a theoretical and historical journey through a range of nineteenth-century visual, verbal and theoretical texts, which suspend the drawing as mere visual violation of a woman by a man, whatever class. The passage via Freud's analyses of the men of his class and generation has taken us back to the matrix of violence which defines the formation of subjectivity according to the classic psychoanalytical model. The revelation of that model is the formation of human subjectivity, as speaking and sexed, at a terrible price, the cost exacted by Western, and possibly all, regimes of sexual difference. The price is the separation from the maternal body, the fullness of her space, the presence of her voice, the both thrilling and fearful fantasy of her plenitude and power. It is, however, represented through the mechanisms of the Oedipal complex, as a defence against supposed maternal lack and the danger of her contaminating the boy subject with that lack. Yet to be a subject, speaking and sexual, this separation must be internalised by feminine subjects too, but according to an asymmetrical logic which never completely accepts the patriarchal untruth about who is lacking what.

It is not that women do not lack. But they *are* not lack, and men inevitably 'lack' too.[30] The child comes into some sense of self in the presence of an already possessed and empowered Other – language, culture, mediated and represented by an older generation already bound into the legally defined familial couple: Mother and Father. *Vis-à-vis* language, culture and the family, the child discovers the impossibility of the gratification of its desires and the impossibility of gratifying the desires of those who figure as its initial love-objects. Masculinity disavows its lack – as a child *vis-à-vis* the adult world, as a subject *vis-à-vis* language – by projecting all sense of lack and threat on to the body of the once all-powerful and desired Mother (as we have seen often a composite figure dividing along psychic fracture lines provided by class relations), that is on to a body that, from a literal point of view, lacks least.

Feminists often query the privilege given by psychoanalysis to the phallus, to which the penis stands in imaginary relationship. Why doesn't the child instead perceive the mother's body to be richly endowed with what the boy lacks – a womb and breasts? Indeed. But what appears to happen is that, by culture as well as in language, these desirable attributes, precisely because they are inaccessible to the masculine subject, are effaced by that which, the lacking masculine subject having singular access to it, must, as a defence, be elevated into being the single, only desirable attribute of the symbolically privileged body. Thus the phallus is a very unstable signifier of 'having' versus 'not having' because it veils the transpositions, substitutions, inversions and disavowals that are necessary for so insignificant a thing to gain the sovereignty the phallus comes to enjoy in a phallocentric Symbolic order. What lies behind this formation is not a real absence any more than a real presence, but the complex fantasies orchestrated by the signifiers language offers for managing the ordeal to which, according to phallic logic, all subjects must submit: separation and loss – of the maternal space, voice and gaze.

So the ironies continue. Julia Kristeva has argued that feminism must renounce fantasies of absolute difference or ambitions for equal sameness, which replay feminism within a relentlessly phallocentric logic of either/or, and must, therefore, also interiorise 'the founding separation of the socio-symbolic contract' so as to 'introduce its cutting edge into the interior of every identity, whether sexual, subjective or ideological'. Commenting on this in relation to feminist desire, Kaja Silverman concludes, 'This is the point at which to note that Kristeva knows how to read *motherhood as the emblem not of unity, but of its opposite – the 'radical ordeal of the splitting of the subject* (my emphasis)'.[31]

The maternal body can thus be released from its function as a fantasy of wholeness – like the countryside with its bountiful, fertile, archaic bodies – and, its inevitable underside, as abjected horror[32] – the site/sight of lack and its threat of death, to function as a complex sign of the ambivalent process of human subjectivity.

In Van Gogh's ambitious and doomed attempt to master the rhetorics of contemporary representations of rural life and labour, the countryside would have functioned, had his artistic ability been up to it, as a re-staging of a pre-Oedipal fantasy which brought him close to the scenes and bodies of his childhood memories and those archaic sensations that lay even beyond memory. Yet that same landscape was stamped by the Oedipal law which demanded sacrifice of desired proximity with the maternal body to the paternal law. The potential collapse of class difference was policed by the necessity to maintain gender distinctions. The patriarchal law of sexual difference has the effect of marking all bodies as lack *vis-à-vis* the Father. None the less, the law allows masculine subjects to project the violence of that 'castration' on to the feminine body, which in this drawing has become a fantastic figure of psychic disintegration, imaged as physical distortion. Ideally, in rural genre painting of the female peasant, the conflicted feminine body must be tamed and reshaped never to recall that which it once contained, or it must be aesthetically made into an obviously magical image of the fertile, natural, archaic goddess. In Van Gogh's drawing, such separations that the different genres of art kept apart, collapsed. It is only in seeing the co-existence and tension between the maternal, the feminine and the female bodies that the power of the image to keep people looking at it might be explained.

WHO'S SEEING WHOSE MOTHER? FEMINIST DESIRE AND THE CASE OF VAN GOGH

Differencing the canon is not about feminist rectification of, or moral judgement on, canonical art or men artists. The point is to admit to the radical splitting of the *feminist* subject as well. I can perceive these multiple presences at play in the image only in so far as I admit to sharing some of the psychic materials and processes. The mother, which I am arguing is a structural trace and fantasy in this image, can be glimpsed as much because the viewer, here a *she*, can see it, as because the producer, then a *he*, unconsciously deposited its traces in the drawing process.

What will my writing inscribe – my resistance to exclusion from the masculine pleasures of the canon, or the presence of a feminist desire cohabiting with others' both different and corresponding desires? They can both be present in a way that also gives us access to a 'Van Gogh' that does not have to be canonically great to be interesting, good and pleasant as a hero to be worthy of writing about. Where the writing of my desire meets historical representations shaped in his, we have differenced the canon and made its hierarchy and valuations an irrelevance, ceding place to a more polylogic tracing of the social semiotics and psychic investments that characterise subjectivity, sexuality and artistic production within a historically specific moment.

By starting with one drawing by Van Gogh, the very paradigm of the popular conception of the modern, suffering, male genius, I seek to gain a distance from the legend of the artist so central to canonical art history. The distancing rationality of the social history of art refuses indentification with a mythic but also overpsychologised and individualised 'Van Gogh'. Popular fascination with an aberrant but typological hagiography, biography or martyrology is displaced by using psychoanalytical concepts to quite different effects: reading an image rather than reading a life off the work and back into the work. In place of over-psychologised biography, this drawing, and others, becomes available for a more critical, semiotic and analytical reading of artistic practice as a site of subjectivity 'in process' and 'on trial', that is defined both in its singular articulations and wider cultural inscriptions in artistic and literary formations.

In my writing, the relation of singular experiences of one historical, psycho-social subject and the wider patterns of sexual formation (Freud crossed with Williams) traced in cultural discourses (Millet, Breton, Thoré and Zola) create a new intimacy with a nineteenth-century Dutch drawing of a rural woman worker by a bourgeois man. There is a balance to be found between the claims of the represented other and of the representing author. Canonical art history – Van Gogh's case epitomises this – makes its artists into heroes. Yet I do not aim to be so anti-humanistic that structuralist analysis excises all traces of the subject and subjectivity. In the field of art history and its critics, we have see-sawed between a mystical and mythical concept of the artist as the enlarging mirror of the ideal Western self and a deconstructive erasure of the subject by insisting on only textuality and structure. Feminism necessitates an ironical review of both improbabilities. How can we attend to the specificities of artistic practice as inscription, representation and 'meaning donation and affect' while also maintaining a clear sense of producers working in histories that are singular, yet culturally shaped, that are fantasmatic as well as considered and consciously strategising within ideological and political motivations?

By seeking to elaborate possible relations between social historical analysis, psychoanalysis and feminist theory, I seek to find a difference that will allow us to read images, pay attention to visual representation, and perhaps find other stories of ourselves in the inevitable intersubjectivity of our reading and writing, which will always be a staging of desire.

NOTES

1 This Freudian reference, based on Sarah Kofman's *The Childhood of Art: An Interpretation of Freud's Aesthetics*, trans. Winifred Woodhull (New York: Columbia University Press, 1988), was elaborated in Chapter 2.

2 See Richard Easton, 'Canonical Criminalisations: Homosexuality, Art History, Surrealism and Abjection', *Differences*, 4, 3 (1992), pp. 133–75.

3 Nanette Salomon, 'The Art Historical Canon: Sins of Omission', in *(En)gendering Knowledge: Feminists in Academe*, ed. Joan Hartmann and Ellen Messer-Davidow (Knoxville: University of Tennessee Press, 1991), p. 229.

4 This was evident in the popular press's reviews of the exhibition *Picasso and Portraiture* (Paris, Grand Palais, 1996) and is also present in the multi-volume biography by John Richardson, *A Life of Picasso* (London: Jonathan Cape, 1995–).

5 Carol Zemel has explored the dimension of love in relation to Van Gogh's drawings of Christina Hoornik, 'Sorrowing Women; Rescuing Men: Van Gogh's Images of Women and the Family', *Art History*, 10, 3 (1987), pp. 352–68.

6 This observation is one of the founding points of a feminist reading of modernism and was first argued by Carol Duncan in her path-setting article 'Virility and Male Domination in Early Twentieth Century Vanguard Art', *Art Forum*, December 1973, pp. 30–9; reprinted in *Feminism and Art History: Questioning the Litany*, ed. Norma Broude and Mary D. Garrard (New York: Harper & Row, 1982), pp. 292–313.

7 These had been engraved by Adrien Lavieille, and Van Gogh owned the cheap printed version which he was to use repeatedly in his own art education in the 1880s and again in 1889 when he made painted copies of the series. Another series, *The Four Hours of the Day* (1860) had provided the motif for *The Potato Eaters*, which represents something akin to the evening scene *La Veillée*. In LT 418 Van Gogh calls the series he is making 'veldarbeit' – field labours. LT numbers refer to letters by Vincent van Gogh to Theo van Gogh in *The Complete Letters of Vincent van Gogh*, 3 vols (London: Thames & Hudson, 1959).

8 J. C. Chamboredon, 'Peinture des rapports sociaux et l'invention de l' éternel paysan: les deux manières de Jean-François Millet', *Actes de la Recherche en Sciences Sociales*, ed. Pierre Bourdieu (Paris, November 1977), pp. 17–18.

9 Of course I mean her actual body as opposed to the fictitious and artificial body which was written over the lady's physical form by fetishistic and often painful, impeding clothing and fashions.

10 In a letter to his brother Van Gogh wrote that his territory is more women who wear skirts and jackets than those who wear dresses (LT 395), and later he wrote that the peasant girl in her dusty patched jacket and skirt is more beautiful than a lady, and he found that when she put on a 'lady's dress', she loses her peculiar charm' (LT 404). On peasant costume in Brabant, see *'Die jakken en rokken dragen': Brabantse klederachten en streeksieraden* (s'Hertogenbosch, Noord Brabants Museum 1986).

11 These ideas were originally published as 'The Ambivalence of the Maternal Body: Psychoanalytical Readings of the Legend of Van Gogh', *International Journal of Psychoanalysis*, 75, 4 (1994), pp. 802–13. My argument is much enhanced by the reading of Jim Swan, '*Mater* and Nannie: Freud's Two Mothers and the Discovery of the Oedipus Complex', *American Imago*, 31, 1 (1974), pp. 1–64. Swan advances a combined Freudian and Marxian analysis of class and sexual formation through a careful reading of Freud's biography and dreams to show how the theorised versions of the Oedipal complex and its attendant anxieties and aggressions screen the conflict between the bourgeois mother and the working-class Czech peasant woman who was nursemaid to the infant and toddler Freud.

12 I derive this concept from the work of Heather Dawkins, 'Frogs, Monkeys and Women: A History of Identifications across a Phantastic Body', in *Dealing with Degas: Representations of Women and the Politics of Vision*, ed. Richard Kendall and Griselda Pollock (London: Pandora, 1992), pp. 202–17 (now London: Rivers Oram).

13 This is not the usual feminist indictment of masculine art for making women an object. In Freudian theory, we desire only objects; the object is one of the elements which defines the drive. Thus in the psychic economy the drives have aims directed at objects which promise gratification. One of the primary objects is the carer, 'the mother'. Mark Cousins, 'Contributions to a Psychoanalytic Theory of Love', Lecture at University of Leeds, 26 January 1994.

14 Thus Jean-François Millet was allowed back into the canon after Robert Herbert's work from the 1960s onwards, while Jules Breton and Jules Dagnan-Bouveret remain outside as *Salonnier* realists, unassimilable to the teleological histories of modernism.

15 For my argument about this designation see 'Agency, and the Avant-garde: Studies in Authorship and History by Way of Van Gogh', in Fred Orton and Griselda Pollock, *Avant-gardes and Partisans Reviewed* (Manchester: Manchester University Press, 1996).

16 Allon White and Peter Stallybrass, *The Politics and Poetics of Transgression* (London: Methuen, 1986), pp. 125–46.

17 Sigmund Freud, 'On the Universal Tendency to Debasement in the Sphere of Love' [1912], *Standard Edition* 12 (London: Hogarth Press, 1953–74), pp. 177–90.

18 *Ibid.*, p. 195.

19 Michel Foucault, *The History of Sexuality, Volume I: An Introduction* [1976], trans. Robert Hurley (Harmondsworth: Penguin Books, 1979), p. 127.

20 Linda Nochlin, review of *The Realist Tradition*, ed. Gabriel Weisberg (New York: Brooklyn Museum of Art, 1980), *Burlington Magazine*, 123 (April 1981), pp. 263–9.

21 Théophile Thoré, 'Le Salon de 1865', in *Salons de Willem Bürger: 1861 à 1868* (Paris, 1870), p. 188, cited by Hollister Sturges, *Jules Breton and the French Rural Tradition* (New York: The Arts Publisher, 1982), p. 79.

22 LT 404.

23 A letter dated 27 March 1885 cited in *Germinal*, ed. Henri Mitterand, Bibliothèque de la Pléiade: *Les Rougon Macquart*, vol. 3 (Paris: Gallimard, 1964), p. 1440. For an analysis of this passage in the context of the whole work see Sandy Petrey, 'Discours social et littérature dans "Germinal"', *Littérature*, 22 (1976), pp. 59–74.

24 Written out in LT 410; *Germinal*, trans. Leonard Tancock (London: Penguin Books, 1954), pp. 397–8.

25 Sigmund Freud, 'From the History of an Infantile Neurosis' [1918], *Standard Edition* (1955), pp. 1–122.

26 See Chapter 5.

27 See Swan on Freud's working-class and Catholic Czech *kinderfrau*.

28 The language used here is potentially offensive to certain people, who have particular conditions in their bone formations leading to unusual proportions. I do not see this woman's size or scale as automatically 'disfigured'. I am suggesting that it was manufactured, in part, to read as difference from the ideal body formation of bourgeois white femininity. It is in this sense that maternity and its effects on the female body are, in significant ways, perceived by culture as 'unfeminine' – what Queen Victoria, significantly, called the 'animal parts' of being a woman.

29 Originally I specified heterosexual masculinity – but I purposively leave this question open.

30 A fuller explanation of these odd arguments about lack will be provided later in this chapter.

31 Kaja Silverman, *The Acoustic Mirror* (Bloomington: Indiana University Press, 1988), p. 126; referencing Julia Kristeva, 'Women's Time' [1979], in *The Kristeva Reader*, ed. Toril Moi (Oxford: Basil Blackwell, 1986), p. 210.

32 In Zola's *Germinal*, La Maheude, the mother figure, repeatedly described through her heavy, milk-filled feeding breasts, dies at the conclusion of the story, having been forced by the destruction of her family, back into the mines to labour 'in the bowels of the earth'.

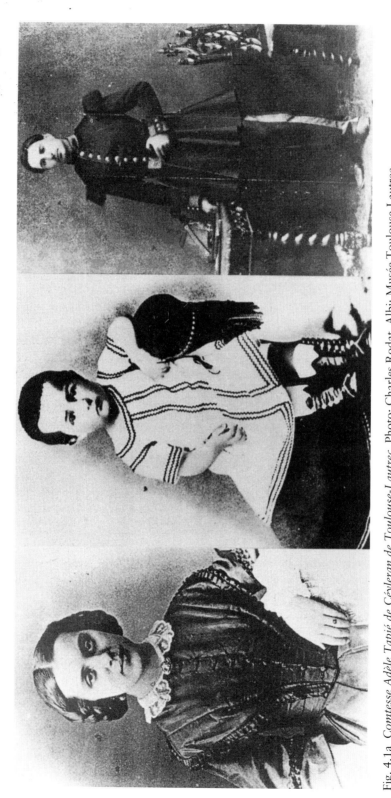

Fig. 4.1a *Comtesse Adèle Tapié de Céyleran de Toulouse-Lautrec*. Photo: Charles Rodat, Albi: Musée Toulouse-Lautrec
Fig. 4.1b *Henri de Toulouse-Lautrec, c.* 1867. Photo: Georges Beauté. Albi: Musée Toulouse-Lautrec
Fig. 4.1c *Comte Alphonse de Toulouse-Lautrec.* Photo: Charles Rodat. Albi: Musée Toulouse-Lautrec

4

FATHERS OF MODERN ART: MOTHERS OF INVENTION

Cocking a leg at Toulouse-Lautrec

What is the significance of *the cocked leg* in the work of Henri de Toulouse-Lautrec?

The starting point for this project is not the authored works, the cherished depositories of artistic authority which are the stuff, the object of art history's fetishising narratives of individual genius. It is a subtext composed of photographs of the artist and his circle. With the seeming documentary affirmation of presence, being and identity attributed to the photographic image, these photographs promise a historical authenticity to 'the artist and his times'. I want to introduce some feminist trouble into this archive, displacing the defining categories of art history, the oeuvre and the author, by the themes of fantasy and fetishism which are beginning to define a specificity for feminist analysis of the visual field.[1]

LATE-COMING AND PREMATURE DEPARTURE

Henri de Toulouse-Lautrec (1864–1901, Fig. 4.1b) was outlived by both his parents, La Comtesse Adèle de Toulouse-Lautrec (1841–1903), who was with him when he died (Fig. 4.1a), and the Comte Alphonse de Toulouse-Lautrec (1838–1912), who insisted on driving the hearse at his son's funeral (Fig. 4.1c). Much of the published correspondence of Henri is addressed to his mother and it reveals an easy, open relation between them, which often includes admiring and affectionate references to his father.[2] Henri drew and painted his mother many times. There are several imposing painted portraits, for instance one of his mother at a coffee table in 1883 (Albi, Musée Toulouse-Lautrec), and another, 1886–87, showing her in profile in a drawing room (Fig. 4.2). These are decorous images, seemingly well able to hold their own amongst the new painters of Paris, with the subtle orchestrations of many shades of white to create a luminous interior, not a little reminiscent of Mary Cassatt's more monumental portrait of *Woman at a Coffee Table* (1883–5, New York, Metropolitan Museum of Art). In the 1884 portrait (Brazil, Museo d'Arte São Paulo) the Countess in her brilliant white morning dress is set in a garden. In all three portraits la Comtesse

Fig. 4.2 Henri de Toulouse-Lautrec (1864–1901), *Portrait of Adèle de Toulouse-Lautrec*, 1886–7, oil on canvas, 59 × 54 cm. Albi: Musée Toulouse-Lautrec

Fig. 4.3 Henri de Toulouse-Lautrec, *Medical Inspection at Rue des Moulins*, 1894, oil on cardboard mounted on wood, 83.5 × 61.4 cm. Washington, D.C., Chester Dale Collection, National Gallery of Art

is suitably placed in what I have elsewhere called the spaces of femininity, the scene of an enclosed and withdrawn world.[3] In the portraits her eyes are downcast and her gaze averted. Her body is still, while her muted gaze folds back on to her contained body in repose. In the garden setting, she is pinned to the surface of the canvas, looking off into space. The figure has no volume and substance, but blends with and echoes her cultivated but organic, rural setting in a modern *hortus closus*.

In every way this aristocratic feminine body is still and iconic. Painted with affectionate respect, it is, none the less, both idealised and distant. La Comtesse Adèle is the very antithesis of the bodies (Fig. 4.3) through which Henri, her son, would establish his artistic paternity and make the once 'glorious' name of the house of Toulouse-Lautrec live on beyond the archaic redundancy of the French aristocracy into the annals of modern art: see also *Dance at the Moulin Rouge* (1889–90, Philadelphia Museum of Art). These images produce antithetical female bodies which signify a deregulated physicality. By their activity, the free movement of the limbs, or the lack of the sheathing costume of femininity, they escape from confining contours of decorous containment or corseted restraint. They reveal women without signifying femininity. Femininity was, in the nineteenth century, as we know, a classed and raced construct. It unevenly included women, while it was the hegemonic norm by which all women were both judged and (ab)used. The opposition between the still remote and idealised femininity of the upper class, white mother and the bacchanalian animal energy of the working-class dancer or the abject physicality of the working-class prostitute awaiting medical inspection is thus an inscription of both class and sexual difference – a site of their mutual construction through the projections of the aristocratic man's fantasies on to the perceived physical otherness of working women who then signify symbolically in opposition to the still, calm, white madonnas of his own incestuously desired object, the mother. It is that mother who must be seen as the structuring absence which creates the necessity for the incessant re-engagement with the bodies of her 'other' and the stylistic deformations from bourgeois realism which then become the formal hallmark of his modernist oeuvre.

DEBASEMENT AND DESIRE: REGISTERS OF SOCIAL AND SEXUAL DIFFERENCE

In 1912 Sigmund Freud wrote a paper about some male patients who suffered from a specific form of impotence.[4] They were 'men of strongly libidinous natures', whose organs were physiologically capable of sexual arousal and discharge, and who were psychically motivated to do so. Freud argued that it is in the complex character of the sexual object that this paradox of sexual activity and impotence was to be explained.

Freud set up two currents, the affectionate and the sensual, a compromise between which secures adult sexuality. The *affectionate* is the older of the two, arising in earliest infancy. Based on instincts of self-preservation, it is directed towards the family members who care for the child. In the dependent relation of child to primary nurturer,

the components of sexuality are also present and become attached, eroticising the relationship to the maternal caretakers who then become the child's first object choice(s). In the form of its rules and taboos, Culture aims to divert these passions from their immediate sexual aims, while holding them in promise for a later substitute object, to whom will also become attached the other, *sensual* current that develops during puberty as the adult expression of transformed infantile sexual drives.

This sensual current should be always directed towards socially condoned sexual objects – for a heterosexual man that would be women other than his mother, aunt, sister etc. The new objects, however, will be chosen on the model or image formed in infancy, attracting to themselves the eroticised *affection* they once inspired. The ideal pattern is determined by the cultural law prohibiting incest, which is identified by Lévi-Strauss as the founding rule of human sociality. In this formation of the adult heterosexual man, the *affectionate* and the *sensual* should reunite in a surrogate female figure, ensuring the conjunction of both the loyalty deriving from ancient affections and the desire generated by denial and pubertal reawakening, both the high social and emotional valuation of the beloved and pleasure in erotic activity with a sexual object.

In the case of those patients who experienced periodic impotence, Freud hypothesised that a profound disparity between the affectionate and the sensual occurred, arising from the failure to pass through the Oedipal complex with the socially desired outcome and disposition of sexual interest. The disjuncture could be attributed to two factors, firstly, too much frustration which in reality opposes new object choices;[5] secondly, the continued attraction exerted by the objects of infancy. In these cases the libido turns away from reality – i.e. the socially sanctioned norm of a suitable adult woman – and becomes prey to fantasy, imaginative promiscuity in a sense, remaining fixated on the objects of infantile affection, which, of course, are always sexually taboo. Thus these are turned into objects that can only be desired unconsciously – 'a young man's sensuality becomes tied to incestuous objects in the unconscious . . . becomes fixated to unconscious incestuous phantasies', the result being total impotence.[6]

The psychic impotence of which Freud writes is a less severe variation of this in that the sensual current manages to be sufficiently strong to find partial discharge in reality. Freud remarks, however, that the sensual current of such people is capricious, easily disturbed and not carried out with much pleasure. The reason is that the sensual current is blocked off from the affectionate current because of the latter's fixation on forbidden incestuous objects. Thus Freud concludes:

> The whole sphere of love in such people remains divided in two directions personified in art as sacred and profane (animal) love. Where they love they do not desire and where they desire they cannot love. They seek objects which they do not need to love, in order to keep their sensuality away from the objects they love; and, in accordance with the laws of 'complexive sensitiveness' and of the return of the repressed, the strange failure shown in

psychical impotence makes its appearance whenever an object which has been chosen with the aims of avoiding incest recalls the prohibited object, through some feature, often an inconspicuous one.[7]

Psychical impotence occurs when the chosen sex object mimics or fails to avoid recalling the prohibited incestuously loved object: the mother or her surrogates. The main strategy for avoidance of this disaster is the recourse to debasement of the sexual object, clearly separating it from the emotional overvaluation – love – associated with the integration of affection and sensuality, which is reserved for the incestuous object and its representatives. Freud thus concludes by saying that 'We can now understand the motives behind the boy's fantasies mentioned [above[8]] which degrade the mother to the level of the prostitute'.[9] This is a symptom of an attempt to bridge the gulf, but in other cases the gulf remains unbridgeable and the man debases a woman or chooses a woman from a socially debased group in order to maintain the split which is historically known as 'the double standard'.

Freud's 1912 text, I suggest, describes the psychological formation of a masculine heterosexuality which has a specific, historical, institutional and economic location in the hegemonic bourgeois family and bourgeois social relations of which Freud (born 1856) and his male patients, as well as artists of the first generations of late nineteenth-century modernism, were products.

While it may be argued that the incest taboo is the law of culture in general, there are historically specific ways in which it has been enforced or enacted. The peculiarity of the situation of the social and gender group from which Freud drew his male patients and his own understanding of their situation, was that the incest taboo had been made so difficult to enforce precisely through the ideological programme which Foucault has termed the 'sexuality' of the bourgeoisie.[10] The reshaping of the family as an intimate set of relations especially between woman, now idealised as loving mother, and children, made vulnerable to emotional investments through familial intimacies and guilt that were the ideological hallmark of the bourgeois family accelerated the conflicts which psychoanalysis, a technology of sexuality shaped in the mirror of this bourgeois family structure, emerged to manage. The bourgeois family, as both ideology and sexual technology, developed modes of intimacy and emotional dependency which fostered attendant anxiety and guilt.[11] The family was at once a hothouse of sexual incitation and the place of a rigorous policing and repression of the very eroticism it stimulated. The generations which the incest taboo must force apart sexually were, in fact, bound together through the new ideas of maternal bonding and personalised infant care – breast-feeding was advocated while intense emotional ties with the infant were demanded. The infant son was, in effect, encouraged to be Oedipus and love his mother above all women. But this ideological and emotional structure of the bourgeois family was practised within a social as well as a sexual division of labour.[12] The class formation of this sexual technology meant that the maternal caretaker was like as not to be split, divided between the angelic and idealised bourgeois mother, a woman almost unimaginable as a genetrix and sexual body, and

the working-class women employed as wet-nurses and nursemaids who in fact washed the infant body, fondled it, nourished it at their breasts, and shaped the components of its sexuality through the constant attendance to its physical processes and needs.

The bodily presence of the working-class nursemaid and these physically mediated semiotics of woman–child transactions were traced in the masculine bourgeois subject's psyche, attracting to it memories of plenitude and sensuous enjoyment. Yet it was overlaid by the social hierarchy which, in terms of social power and status, effectively 'castrated' the child's female caretakers. As class came to be experienced as difference and power, working-class women increasingly appeared powerless before the bourgeois mother, who then attracted an over-evaluated and defensive notion of the maternal bliss figured in the angelic yet untouchable femininity she signified in her aestheticised 'distinction'. Searching out the lost pleasures of the nursery in the sweating bodies of musical performers, with their easy speech and physical exuberance, as did Toulouse-Lautrec, the bourgeois man was driven only to experience conflict at a level which might well incite aggression towards these apparent objects of sexual fascination.

Equally this complex could take the form of a symbolic sadism, enacted in representation on the fictive screen where the unconscious can drive the drawing hand. Drawing and painting, symbolic or surrogate manipulation through the fabrication of a fictive body in the graphic or painted image, these activities provided an experience of mastery at the same time as they produced the space for unconscious restagings of fantasmatic scenarios of the play between hostility and desire – of the fascination with, and fear of, difference in which what is social and what is sexual difference become hard to disentangle, for both are the condition of the other.

LOOKING UP TO DAD

If Henri's relations with women were split between his position as son to his mother and his experience of masculinity through social and sexual proximity to and artistic manipulation of the bodies of working women, it was through this latter practice that he could identify with his father. 'Identification', in the classic Freudian sense, takes place within the 'paternal-homosexual facet' which, through the Oedipal suppression of desire for the father, becomes expressed through homosocial bonding.[13]

Comte Alphonse-Charles de Toulouse-Lautrec-Monfa (Fig. 4.1c) was in his own way quite legendary, making up, it is said, for the aristocrat's political insignificance – Bernard Denvir calls it impotence[14] – through making a spectacle of himself in the night spots of Paris. He was a great hunting man, and the worlds of horses, racing and hunting were part of the rituals of his class and its masculinities. His were also the urban haunts of a more explicitly sexual chase through which his son, not only as consumer but as painter, would eventually make a slight reputation as an artist.

Comte Alphonse was fascinated by image-making, but not as a serious painter. He did draw and even make sculpture. Like his contemporary, Virginia Verasis, the

Comtesse de Castiglione,[15] Alphonse de Toulouse-Lautrec liked dressing up for the camera, and had a wardrobe of costumes in which he arranged to be photographed – as Turk, Caucasian, Crusader and as a Highlander (Fig. 4.4). His son Henri shared this taste, and we have quite a few examples of his masquerade photography – as a samurai in 1892 and dressed as a choirboy for a fancy-dress ball organised by *Le Courier Français* in 1889. A photograph of one episode of cross-dressing sets off a fanciful chain of speculation. It represents Henri dressed both in the clothes and in the costume of Jane Avril (1892, Albi, Musée Toulouse-Lautrec).[16] Cross-dressing was also one of Comte Alphonse's little games; he once came downstairs for lunch in a plaid and a ballerina's tutu. But there is too striking a visual rhyme between the photo of Comte Alphonse as a falconing Highlander, in his kilt, with one black-stockinged-leg raised (Fig. 4.4), and the pose in which Henri immortalised Jane Avril in the poster *Jane Avril au Jardin de Paris* (1893), for which there is also a painted sketch (Fig. 4.5). Jane Avril was painted in the same posture in Anquetin's *Moulin Rouge* (1893, Paris, Josefowitz Collection) which may also have been taken from a photograph dating to 'before 1893?'.[17] Jane Avril's cocked leg has almost become *the* graphic sign for *Toulouse-Lautrecness*, the hallmark of Toulouse-Lautrec's image-making, the stylistic signature, we might call it.[18] At a formal level, the image for the poster (Fig. 4.5) achieves its impact, and its modernist difference, through the striking character of the design, rather than through its iconic elements, the latter being not uncommon in the ephemeral imagery of the period. The distinguishing semiotics of a *Toulouse-Lautrec* image involves radical formal simplification achieved by repression of half-tones in favour of bold colour contrasts. These are themselves set off by the use of decorative areas of unmediated black. Formal derivation from precedents already valorised in the artistic community to which he attached himself in Paris – Manet and Japanese prints – as well as other graphic designers, cannot account for the power of this startling condensation which print historians rightly identify as a major break from the contemporary fussiness of even leading poster-makers such as Jules Chéret, whose energetic compositions had already been of such importance to Georges Seurat in his attempt to produce an image of modernity reduced to venal and commercial entertainment (*Le Chahut*, 1889–90, Otterlo, Rijksmuseum Kroeller-Mueller).

The formal device – the black-stockinged and cocked leg as the stylistic gambit – proffers itself as the meaning of the new art both Seurat and Toulouse-Lautrec were in the business of fashioning.[19] Social historians of art have probed the further meanings of the formalism that became so apparent at this historical moment by suggesting a second connotative or mythic level of signification, in which form signifies, if not actual ideological content, at least the historical conditions of the practice and its ideologies.[20] Thus flatness, stressing two-dimensionality and the materiality of the canvas and paint, was a polyvalent stratagem, which allowed modernist painting to allude to its conditions of existence in the myth of capitalist modernity. 'The circumstances of modernism were not modern, and only became so by being given the forms called "spectacle."'[21] Feminist social historians of art have also advanced ideological readings of the semiotics of modernist space as the staging of gendered

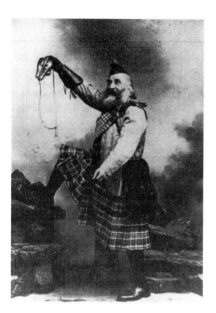

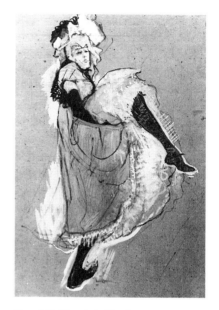

Fig. 4.4 *Comte Alphonse de Toulouse-Lautrec Dressed as a Highlander*, photograph. Paris, Bibliothèque Nationale

Fig. 4.5 Henri de Toulouse-Lautrec, Study for *Jane Avril au Jardin de Paris*, *peinture à l'essence*, on cardboard, 99 × 72 cm. Private Collection

gazes in order to identify the spaces of modernity as arenas of sexuality and the forms of modernism as formal significations of sexual difference.

Toulouse-Lautrec's stylistic gambit – condensed in the black leg, cocked and dancing, a fantastic shape set starkly against its simplified coloured surrounds which detaches it from the body and yet makes it stand in for the body – is what Freud would call 'overdetermined'.[22] It could signify a double charge of artistic difference – the modernist gambit – and sexual difference – the paradox of masculine sexuality. To be more psychoanalytically precise, it is in the register of the fetish that Toulouse-Lautrec's formal device functions as both aesthetically possible and culturally significant.

Within classic Freudian psychoanalysis, fetishism creates a substitute for the penis that appears to be lacking from the mother's body. Its theoretical significance and curiosity lies in its function as a psychic device by means of which reality can be repudiated. It thus becomes a model for all beliefs which survive contradiction in experience. Its major structure is that of disavowal: the oscillating assertion – 'I know but I do not know'. Fetishism is, according to Freud, a peculiarly masculine tendency to which, in some form, all masculine subjects are susceptible, although only a minority become clinical fetishists, having to use fetishism for their only sexual gratification. Fetishism is described by Freud as a defence against the 'discovery of' a woman's lacking anatomy. Feminist readings of the psychopathology of the formation, however, revise the Freudian proposition and argue that fetishism is one of the key

psychic procedures by which masculine subjects defend themselves against the discovery of *their own* lack, which is created by late-coming and by language itself. Masculinity is formed by projecting this symbolic lack away from the male body, embedding it in the body of the other, woman, who thus comes to signify both lack and the threat of 'castration'. Language determines sexual difference by separating child and mother, creating a psychically charged cleavage that does not precipitate merely a division between child and the primary caretaker who sustained its life, but that thereby initiates the fear of death in the separated, differentiated masculine subject, who is now cast adrift from what hithertho represented, in his fantasy, life and its sustenance. Castration by submission to language produces a new fantasy, the fear of non-being, which is also fascinatingly desirable because it is associated with a return to the mother.

Castration anxiety becomes focused on the male genital only through a complex conjuncture. These anxieties around separation and submission to the father's law via language come into focus at a point of psychic development when the genitals are acquiring a stake in symbolic signification, as well as a place in narcissism by producing a surplus of pleasure unrelated to eating or defecating. As body part, locus of pleasure and token in an evolving syntax of both the psychic and social body, the male genital becomes the bodily sign of a primary narcissism, the necessary stage of using one's own body as an object of sensual pleasure and value. In so far as the male child invests its own libido in part in itself via the pleasure of this organ, the penis is raised to the level of *approximating* to the signifier, the [always paternal] Phallus, and the apparent absence of the male genital on the body of the mother becomes a condensed sign for an anatomically unrelated fantasy, the fear of death or non-being, which derives from the human fate of alienation in language as the condition of access to sociality, subjectivity and sexuality. The threatening conditions of the emergence of masculine subjectivity must be disavowed (a primary, and symbolic, fetishism aided by the use of language in which this danger is hidden in the word *woman*) or projected on to the female other, who then figures difference as *disfigurement* – itself necessitating a secondary or literal fetishism in which a visual substitute is sought for the imagined anatomical insufficiency of the female body.

My argument about Henri de Toulouse-Lautrec requires us to unpack this matter of fetishism a little more. For Freud, fetishism is the disavowal of the physical fact of sexual difference. Seeing an absence, the male child is saved from full acknowledgement of this threat which could equally overwhelm him, by finding a substitute, which is the mechanism by which belief in female difference can be both maintained and disavowed at the same time. Thus fetishism allows the statement: 'she has a penis despite the fact she has not got one, in the form of the substitute.' Significantly, Freud[23] showed that fetishism never really works:

> Something else has taken its place, has been appointed as a substitute, as it were, and now inherits the interest which was formerly directed at its predecessors. But this interest suffers an extraordinary increase as well, because

the horror of castration has set up a *memorial to itself in the creation of this substitute* [my emphasis]. Furthermore, an aversion, which is never absent in any fetishist, to the real female genitals remains a stigma indelible of the repression which has taken place. We can now see what the fetishist achieves and what it is that maintains it. It remains a token of triumph over the threat of castration and a protection against it.[24]

John Ellis points out, usefully, that the meaning of the absence/presence polarity results from the cultural formation and its signification of sexual difference, thus definitively brushing aside any residual anatomic essentialism in Freud.[25] The penis is only a stand-in, a token for what institutes meaning in a phallocentric system, namely the Phallus, which is nothing and everything, a signifier. Fetishism is not just as a disavowal of a lack of maternal penis; it is to be understood as a contorted form of masculine resistance to the whole system, the phallic structuring of sexual difference. As disavowal, fetishism appears to confer – via the substitute – a phallus on the woman who is woman, however, by virtue of its lack. This imaginary restitution maintains thereby the significance of the phallus, and hence constantly reminds the subject of the possibility of difference. Because fetishism is already a matter of signification via substitution, it bridges fantasy and language. Language – the whole system of meaning based on symbols which in the form of words and signs stand in for the real – castrates us 'symbolically', that is separates definitively from what, in retrospect we then fantasise as an unqualified corporality and intimacy with the Mother. Language, however, as the script of specific cultures and social orders, signifies the universal fact of symbolic castration differentially to us according to whether we become, under its law, masculine or feminine.

Ellis also subjects the case study with which Freud opened his essay 'Fetishism' to further Lacanian deconstruction. Freud's patient, who was brought up in England, used the shine on a woman's nose as his fetish. This fetish functions, in fact, linguistically. The boy was bilingual and the word *Glanz* in German means 'shine' but sounds like the English word *glance*, which was probably the original substitute for this patient, the child looking into the nursemaid's face for reassurance before or after the traumatic 'sight' or encounter with her difference. Ellis breaks open Freud's narrative to reveal two looks: the boy's look traversing the woman's body for the comforting 'nevertheless', the substitute; the woman's look itself as that reassurance which becomes then a phallic gaze. This must be disavowed and itself overlaid by the boy's perpetually curious gaze, again and again seeking out the forever *before, the tendency to freeze an image of a woman's body at the moment before the sight of sexual difference might be exposed*. The chronology of seeing and knowing is stymied, refusing the narrative movement of seeing and seen which would constantly lead to inescapable knowledge, that is, acknowledgement of castration as a necessary fact and fate.

I have stressed this reworking in order to be able to specify theoretically what might become an aesthetic investment in the still image of dancing bodies. In the case study of Henri de Toulouse-Lautrec certain recurring features of his work can be read as

such a frozen glance, where fetishism works as both a necessary denial and a repeated 'memorial' to the complex moment of fascination and dread.

Fetishism can now be understood as a structure of substitution of signifiers determined in relation to the phallus/language/difference/power. It is not exclusively tied, as Freud wished it to be, to a physical location and a moment of the perception of sexual difference, which for Freud established an absolute distinction between masculine versus feminine. Following a Lacanian reading, fetishism is opened out as a semiotic regime of representation which dramatises the predicament of the subject in relation to knowledge and the possibility of any assumption of identity. As such, fetishism reveals a moment where Freud and Foucault might meet jointly to elaborate the sexualisation of subjectivity at social, institutional, symbolic, familial and psychic levels. With the emergence and dispersion of Western bourgeois familial forms and their attendant psycho-symbolic formations, the issue of the mother moved out of religious discourse to press upon all areas of subjective formation, and in none so complexly or fundamentally as that of sexuality. Under a system that so radically simplified, or exposed so dramatically, the Law of the Father, and produced in Freud and his followers those who would name and analyse the paternal function of this system, it is perhaps the Mother, who escapes her frozen presence in cultural representation as iconic Madonna, to structure, even *in absentia*, the representational activities of her modernist sons.[26] Using this psychoanalytical tracing of the paradoxes of fetishism, I can suggest that the Mother is not displaced by a secular culture that no longer relies on a visible iconography of the maternal. Rather she is transfigured in the modernist culture Freud's contemporaries fashioned and signified by her fetishised substitutes.

WHEN SMALL IS NOT ENOUGH

Henri de Toulouse-Lautrec remained smaller than his parents, physically marked by their intermarriage with a body that itself signified its permanent insufficiency. Could this allow us to speculate for some moments on why his art increasingly found its urgency and energy in a fascination with the manipulation of body parts, especially legs in the dance, in the exuberance, in the athleticism, in the unnatural flexibility that made *La Goulue* and Valentin le Désossé – the boneless man – so famous? From their fame Henri borrowed an image of energy which significantly fell prey to the fetishisation of not only the still but the graphic, printed image. Frozen and flattened on the page, the fantastic body, imaged as radically free in movements which defy credibility in their motility and inventiveness, is deprived of precisely what made it fascinating for those who witnessed its mobility. It thus becomes even more intensely fetishised as a lost, absent, impossible object of desire, or site for the constant, inconsolable process of the convoluted displacement of desire.

If we compare a Toulouse-Lautrec poster with the publicity photograph of the dancing troupe of Mademoiselle Eglantine (*c.* 1896) which included Jane Avril, and

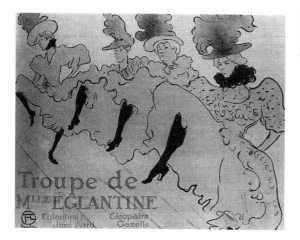

Fig. 4.6 Henri de Toulouse-Lautrec, *Dancing Troupe of Mademoiselle Eglantine*, 1896, lithograph. London: Victoria and Albert Museum

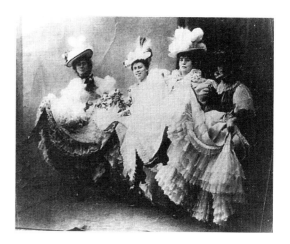

Fig. 4.7 *Dancing Troupe of Mademoiselle Eglantine*, photograph. Albi: Musée Toulouse-Lautrec

from which Henri worked in making the poster she commissioned for the tour to England in 1896, we can begin to see the process of fetishisation at work – even across two representational systems, photography and the painted or printed imaged, both of which are typical of a fetishistic regime of representation (Figs 4.6, 4.7). The difference, to which I want to point, lies in the distillation, as it were, in the poster image of the black-stockinged leg to function as the dominant and repeating motif, set off against a graphically simplified version of the busy-ness and 'frou-frou' of layered petticoats so evident in the undiscriminating inclusiveness of the photo. At once a piece of mundane publicity, it is an occasion for the emergence of the motif of the cocked leg. Exposure is promised, but the risk of seeing is denied because the image of movement is frozen. Unlike the photograph, snapped as a moment taken out of time, promising the possibilities of seeing in the next frame, or the next, the materiality of the printed colours block the fantasy, staying vision at a moment of eternal *before*, promising that here there is, in fact, nothing to see but the manufactured image, which itself is the substitute, the fetish. The dance pictured in the photograph proposes

that all might be revealed. Photography displaces this threat by the multiplication of petticoats as modern pubic veils. In its indifference, photography can register everything or, should we say, its tonality becomes a rhetoric of a certain form of fetishism, associated with fashion. Toulouse-Lautrec's poster discards and reverses the whole semiotic structure of the photograph and the dancing gesture it represented for the audience – watching the perpetual movement of the dancers and the swirl of petticoats for a glimpse of the forbidden and the dreaded. Toulouse-Lautrec's images fix the dance, freezes the suggestion of movement by the repetition of the leg, the black shape with its pointed toes and heels standing out in stark contrast to the unmarked paper which only residually implies the skirts and petticoats through the curvilinear outlines which bound otherwise unmarked, blank space.

In Freudian terms, the leg is fetish for the missing phallus restored to the woman so as to make her bearable to look at as a heterosexual object. Yet, as Laura Mulvey has argued of Alan Jones's work, the black-stockinged leg with feet in narrow pointed and heeled shoes also signifies punishment of the woman through bondage in a Western form of the sadism.[27] Henri's own legs had been broken on the verge of puberty and then they suffered the worst effects of the condition pyknodysostosis caused by the fact that his parents were first cousins, limiting his subsequent growth. Diminished stature could have profound implications in relation to the identification with paternal masculinity (though Alphonse himself was not tall and Henri a good 5 feet 3 inches) But one can see how size relates to notions of who seems to possess the phallus. Someone suffering from reduced growth may feel thereby 'castrated' – and thus the legs become an overdetermined sign not only of a fetishism functioning around standard Freudian narratives of heterosexualising sexual difference, but in relation to the equally crucial relation of men to men, especially through the symbolic function of fathers for sons.

WHOSE [WHO'S] MISSING [THE] PHALLUS? WHAT'S IN THE GLOVES?

Contrary to existing theses on fetishism, I want to suggest that in this specific instance it is the phallus of the aristocratic father which is denied to the diminished son. The trace memory behind the Jane Avril poster of 1893 and the Eglantine poster of 1896 with their overdetermined stylistic signature of the black-stockinged leg is Comte Alphonse's cocked leg (Fig. 4.4) and that for which it stands in slang, which can be signified only in a displaced form through projection on to these unfeminine yet female bodies (i.e. not maternal yet sexualised). The chain of identification and displacement which this series of photographs allows us to glimpse runs from a man in a Scottish skirt to a woman in a similar pose with Henri occupying what Kaja Silverman identifies in Freud as a dual Oedipal position, both positive and negative.[28] He wants to be in the passive position to his father, but that, as we know, evokes the threat of castration. Through masquerade he can occupy a position of desire for the father

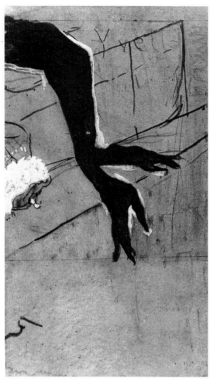

Fig. 4.8 Henri de Toulouse-Lautrec, *The Gloves of Yvette Guilbert*, 1894, *peinture à l'essence* on cardboard, 62.8 × 37 cm. Albi: Musée Toulouse-Lautrec

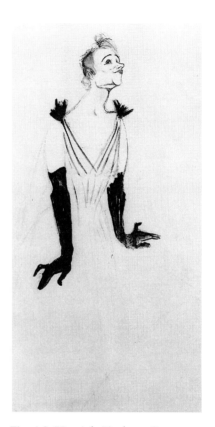

Fig. 4.9 Henri de Toulouse-Lautrec, *Yvette Guilbert*, 1894, charcoal, *peinture à l'essence* on tracing paper, 186 × 93 cm. Albi: Musée Toulouse-Lautrec

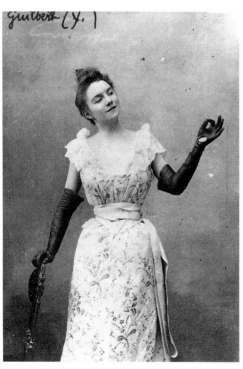

Fig. 4.10 *Yvette Guilbert*, photograph. Paris: Bibliothèque Nationale

through identification with Jane Avril, but, in so far as she is re-equipped with the phallus through her fetishised visual repetition of his father's phallic posture, the identification with the feminine and thus his Oedipal desire for the father can be accommodated while castration is disavowed. The structure of representation itself allows precisely of fetishistic reading because it permits the co-existence of mutually contradictory beliefs or desires spread across and camouflaged by the series of cross-dressings and masquerades played out by both aristocrat and working-class woman performer.

A different element of the photograph of Comte Alphonse (Fig. 4.4) – the gloved hand – is a tripwire for yet another level of fetishism, characteristic of Henri's work, this time in relation to another of the women stars whose body, art and masquerade he colonised in order to make his name more than just that of an heir apparent.

Henri was first trained as a painter by one of his father's many artist friends, and riding companions, René Princeteau (1839–1914), a noted horse painter, who drew father and son together *à cheval* in 1874 (Albi, Musée Toulouse-Lautrec). Henri's early sketches are of things horsy and thus of the world he and his father shared as part of the masculine rituals of their class. These were, however, already a partly nostalgic activity. Their once chivalric or utilitarian function was rapidly being parodied in the development of hunting as a new bourgeois leisure activity. Horses and the horsy life as the signifiers of aristocratic manhood became an impossibility for Henri as a result of his congenital condition. Not just his stature, which was not all that small, but the weakness of his bones made the solace of horses, hounds and hawks – *fauconnerie* – in the open spaces unavailable to him. Henri moved to Paris and sought other spaces for his artistic practice, as I suggested above, and other hunts: *faux con-eries*. There, in place of the hawking glove, he found a substitute (Fig. 4.8). So famous are the black gloves worn by Yvette Guilbert that they now signify 'Toulouse-Lautrec' rather than Guilbert and the calculated authorship of her own performing costume and its trademark. Guilbert had commissioned a poster from Henri, for which this image is a preparatory drawing. She disliked the image because it made her so ugly and she refused to let Henri circulate her around Paris in this form (Fig. 4.9). Yvette Guilbert's gloves (Fig. 4.8) signify that which they absent. Fetishistic in themselves, these strange almost animate things become the fetish substitute for the woman artist who had made them her own artistic trademark. Woman artist/performer is reduced to the limp but fantastic shapes which, none the less, trail down the steps like some hydra or multi-headed snake. Empty, they still gesture. They form not into a five-fingered hand, but a kind of webbing produces a grotesque almost inhuman shape. The gloves become a nasty image, sinister and deadly.

These black gloves are the site of conflicting desires and histories. We have a record of why Yvette Guilbert chose them as her hallmark. She recalled in her memoirs a schoolmistress, Mlle Laboulaye, who wore long black gloves which were only once removed to expose to the seven-year-old child a life-transforming view of her 'marvellous hands with nails of pink coral . . . hands like the Virgin Mary'. Guilbert commented:

> Who knows if the impression those long black gloves made in my tiny childhood did not come back to influence my choice when I was looking for a *silhouette* that should be both unusual and cheap? I was so poor in my early days, and black gloves were more economical, so I chose them! But I took care to wear them with light-colored dresses, and to wear them long so that they exaggerated the willowiness of my arms, and made my shoulders and my neck seem even more slender and slim.[29]

Yvette Guilbert also indicates another facet to the use of the gloves: 'And, finally I put the gloves on my own audacities'; she was noted for singing pretty *risqué* songs – 'My black gloves were a symbol of elegance which I introduced into an atmosphere that was a trifle *canaille* and lacking in wit.'[30]

If we allow ourselves to listen for and to the voice of the working-class woman who authored herself as performer and singer to become a star, the gloves remain attached to the subject who made them signify, the body she fashioned as the vehicle of *her* artistic practice, the site of her memories and identification with another woman, perhaps of another class, certainly from another femininity which she could pastiche as part of her intervention in the ambiguous and fluid arenas of cross-class mingling which formed the sites of leisure and made them the spaces of modernity. Her gloves, or her masquerade for which they were a sign, were her gambit as a modernist.

On Toulouse-Lautrec's cover for the album on Yvette Guilbert, written in 1894 by Gustave Geffroy,[31] the gloves slither down imaginary steps (Fig. 4.8). The sign of her masquerade is endowed fetishistically with the power to signify not Yvette Guilbert the author, but the artist who appropriated her image to refashion it as his own, as his passport to future fame. He 'kills' that woman, signifying her by the empty shell, her name attached to a mere commodity and a cheap one, itself a debased imitation of an elegance belonging to a woman nearer to his own, rather than her class, nearer to his incestuous and forbidden object, his mother. Yvette Guilbert's name, beside what in fact reads through its modernist self-assertion as flat shapes of colour, becomes a decorative adjunct, while the male artists, Gustave Geffroy and H. de Toulouse-Lautrec, assert their authorship and presence by their names and emblems.

A lone publicity photograph of the singer brings the fantasies artistically conjured up around Yvette Guilbert and her gloves back to the deadpan undiscriminating facticity of its medium (Fig. 4.10). We see a slight woman, with a characterful face, lithe, elegant arms and a sculpted neckline better to insist upon that graceful cast of head and shoulders. While not in any sense suggesting this is the truth of Yvette Guilbert – the photograph represents the star according to a photographic rhetoric – the image stands in startling contrast to those produced by little Henri which, in their aggressive difference, reveal the specificity of his work as a vicious caricature. Toulouse-Lautrec ages Guilbert's face, exaggerates the sharpness of the features which her dress and gloves were intended to harmonise into the graceful lines of an elegant

sheath. He reproduces the chance effects of footlights and the radical recasting of the human face and its expression that such unkind lighting surprisingly produces.

DECONSTRUCTING THE *DERRIÈRE*: THE PHYSICAL OTHER

I could argue that his is an art enacting a wilful but vicarious cruelty, which delights in the power Toulouse-Lautrec enjoyed to demonise his social others. The debasement for which this art found so popular a vocabulary can, however, be read for a more complex ambivalence between sadism and longing which is the condition for the disavowals which such demonising signifies. The paternal-homosexual facet I discern in Toulouse-Lautrec's work finds its place in representation through images of men, mostly predatory, in black top hat and frock coat. It is significant that this is also the costume of Valentin le Désossé, whose elastic legs and remarkable feats doing the splits earned him this nickname of 'the boneless'. He appears as a shadowy presence, for he was the dancing partner and discoverer of Louise Weber, also known as *La Goulue*, an interesting nickname, 'the greedy one'. Louise Weber as I prefer to name her, in her social identity, was the body which reputedly made Toulouse-Lautrec's name in his famous poster for the Moulin Rouge of 1891 (Fig. 4.11). Both cocked legs and sinister hands sheathed in black are part of this emerging vocabulary. But the centre of the poster, when we examine it carefully in the knowledge of the structures of fetishism and sexual difference, exhibits a critical absence. We think we are looking at her bum.[32] But what is there to see?

In a study for the more famous but more cluttered image on the poster (Fig. 4.11) we can track the process by which Toulouse-Lautrec's distinctive vocabulary was formed. The viewer is positioned close to, but behind, the dancing figure of Louise Weber. She is, however, partially screened by the massive figure of Valentin le Désossé in the foreground on the right. His sharp profile with top hat repeats the shapes made by his gigantic gloved hands formed into a dramatic but uncanny gesture (yet another link in the metonymic chain back to the gloved phalluses of the Father). Beyond this figure, and set off against the darkly shaded figures of other spectators, who are defined only in *contre-jour* and *silhouette*, forming an uneven row of waving feathers and top hats, we see the fragmented components of *La Goulue* – blonde hair curling to her topknot, face in profile, cut off at the neck by a velvet band, spotted blouse and then... a subtle nothingness that is the centre of the picture. We read it, for most of us are trained to thicken the thinnest of graphic suggestions to make them refer and even connote. We fill this vacancy, as a vision vouchsafed to us, privileged spectators, a sight of what the other spectators do not see: the woman with her skirt raised, her knickers revealed, her leg cocked.

But there is no danger in looking. The drawing provides the comfort of there being, in fact, nothing to see. The void is not the woman's sex, which Western art has been at such pains to erase. Constantly wanting to peer up women's skirts, the neurotic form

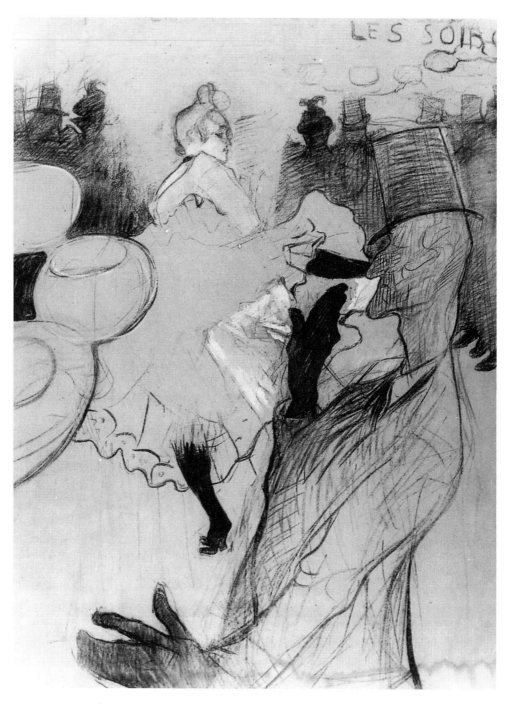

Fig. 4.11 Henri de Toulouse-Lautrec, Study for *Moulin-Rouge: La Goulue*, 1891, charcoal, stump, pastel, wash and oil on paper laid on canvas, 154 × 118 cm. Albi: Musée Toulouse-Lautrec

of the nude reassures itself by always finding nothing that proves the issue one way or the other. This is the strange paradox of the nude and sets it apart from pornographic 'honesty', which both punishes woman by revealing her castration and displaces the anxiety by its fetishisation of the body as a whole or by the function of the woman's glance at the camera/spectator.[33]

In *Moulin Rouge – La Goulue* (Fig. 4.11) the drawing hand creates and stages a fetishistic moment which re-enacts that moment of the 'glance', where looking 'glances off' the veiled sex, to rebound around an image sprouting its phallic fetishes that both frame and distract attention from the empty hole at the centre of the image. But lest we get too rhetorical about this absence, let me note the active censorship at the time of a magazine cover which showed a woman swinging on a crescent moon, attired in a frothy tutu, black stockings and garters. This image, the cover for *Fin de Siècle* designed by Alfred Choubac, was legally banned in 1898. Although in the original image one knee was firmly placed to veil her probably only partially dressed sex, this central area of the figure was censored. The cover was printed with a large legend across her lower body reading: this part of the design is forbidden. What was left was an effect not at all dissimilar to those produced as the decisive aesthetic signature by Toulouse-Lautrec, in his images and posters of Jane Avril or Mademoiselle Eglantine's troupe. The distracting fussiness of undergarments, however frothy, was eradicated, to be replaced by the stark simplicity of the juxtaposition of legs suspended from what is, in effect, an extraordinary absence. Lautrec enacted his own censorship and this is what ironically exposes the incomplete repression.

But I am called away down the sliding pathways of my own fantasy by one other image of a backside – that of another famous and gymnastic dancer, Chocolat. For this performer of African descent no proper name is recorded in this archive. 'Chocolat' with his co-star 'Footit' were popular performers at the Nouveau Cirque in Paris in the 1890s. Their fame was further spread by their appearance in an unabashedly racist advertising campaign for a brand of chocolate which punned on one of their stage names: 'You dirty darkie, you're not chocolate . . . There's only one chocolate . . . and that's Chocolat Potin.'[34]

In Toulouse-Lautrec's drawing of *Chocolat Dancing* prepared for the journal *Le Rire* in 1898 (Fig. 4.12) the body parts which are fetishised – that is, arrested and fixed to distract attention by emphasising seemingly trite points of physical difference are the face and the hand. As the major point of difference from Toulouse-Lautrec, these elements underline the darkness of Chocolat's skin, belittlingly underlined by his stage name. Both confirm Homi Bhabha's interesting argument that we can apply psycho-analytic concepts of fetishism understood as the defence mechanism against the encounter with difference to colonial discourse and its epidermic racism.[35] Skin colour becomes the fetish to petrify and yet displace the threat of *cultural* difference between men.

Fetishism is always a play, involving a vacillation, Bhabha writes, between 'an archaic moment of wholeness and similarity', when it was possible to believe that all are the same, *and* the shock of difference interpreted in the terms of dominant

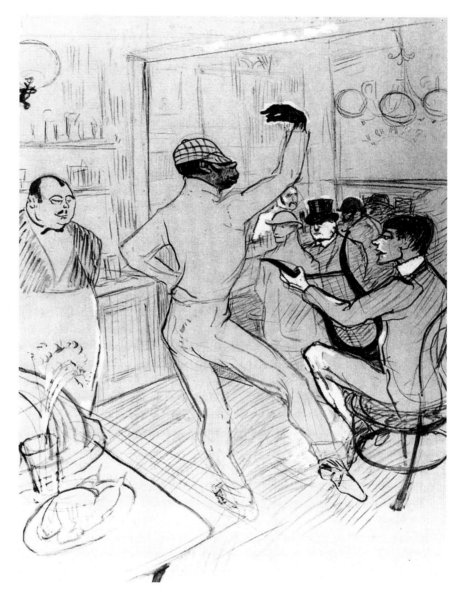

Fig. 4.12 Henri de Toulouse-Lautrec, *Chocolat Dancing*, drawing, paint and pencil, 65 × 50 cm. Albi: Musée Toulouse-Lautrec

culture as lack (some people do not have penises; some people do not have the same culture/skin/race). 'Within discourse, the fetish represents the simultaneous play between metaphor (masking absence and difference) and metonymy (which contiguously registers the perceived lack).'[36]

Toulouse-Lautrec's stylistic gambit involved the use of stark contrasts of bold blacks against almost unmarked paper (though he often used coloured grounds). In

unfinished drawings, which allow us to see what attracted maximum attention in the original working up of an image, and to note the places of both aesthetic and psychic investment, black areas are heightened and framed by bold use of white, for instance following the contours of the African man's hand, or just visible around the other major focus of the draughtsman's energy – the profile of his face, part obscured beneath the close-fitting and low-set cap. Toulouse-Lautrec reduced colour to its boldest of contrasts and fiercest oppositions. These arrest attention but they also aesthetically distract us from that which is represented, insisting upon the means of its appearance – the fetishism at the centre of modernism's privileging of the signifying process itself.

The drawing *Chocolat Dancing* reproduced in a comic magazine, *Le Rire*, formally mimics the compositional arrangement of the primal scene staged at the Moulin Rouge (Fig. 4.11). As viewers we are placed so as to see the backside of Louise Weber, while Chocolat's face is almost obscured by the *képi* drawn low over his eyes, an effect exaggerated by the caricature of the features of a supposed racial difference. It is now not the black leg that attracts our look away from the body's sex, but the blackness of his skin as exposed on (transposed to) his face, and of that extraordinary, 'cocked' hand, solitary, isolated in the top part of the drawing, and carefully contained inside its thick white outlines. What happens to our reading of this image when we juxtapose it to two self-portraits by Henri? I am struck by the similarity of the artist's own profile to that in the drawing of Chocolat dancing. In the descriptions of Toulouse-Lautrec in most biographies and art history books, much is made of the apparent disfigurements he endured as a result of his congenital disease. Art historians and biographers cite weakened, bandy legs, a huge chest, protuberant, drooling lips. It is hard to see any of the extremes of these fictive descriptions in the photographs which are now also a part of the archive. There are even some photos of a naked Henri bathing from a boat (Fig. 4.13). Admittedly he seems small, but perfectly formed and in no way seriously out of proportion. We could speculate that he wore unflattering clothes to disguise the simple fact that he hated being relatively short for a white man of his time. The descriptions of him by art historians use a racist vocabulary to express his apparent distress, or perhaps to register the author's own imaginary anxiety about the artist's so-called deformity. Nowadays, with our height-ened awareness of the language used about disability, we have to drop all reference to deformity and its signification through africanisation, while rightly acknowledging the potential importance of Toulouse-Lautrec as a possibly disabled artist, suffering slight motor impairment.

In most self-portraits by this artist we are not looking at an accurate likeness, but a projection of a self-hatred which found expression through the physical marking of the graphically assembled and hated body/self with the signs of culturally debased and impaired 'others', working-class women or performers of African descent (for instance *Self-portrait* (*c.* 1887), location unknown, *Toulouse-Lautrec* (1991) 218a). Henri envied dancers like Louise Weber or Chocolat most for the physical freedom and exuberant agility he himself could not enjoy. He could never dance or be as supple as

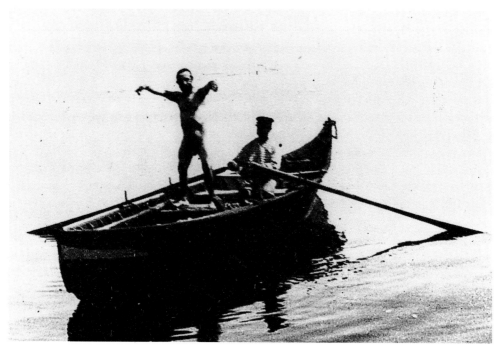

Fig. 4.13 *Henri de Toulouse-Lautrec in a Boat with Viaud*, *c.* 1899, photograph. Albi: Musée Toulouse-Lautrec

they. But, as significantly, he could not want to be completely like them. Their freedom was ultimately trivial, for, as Louise Weber's history shows, it provided no security against impoverishment. It was only a freedom imagined for these performers by an aristocrat as momentary liberation from the constraints he experienced in the upper-class etiquette and decorum to which he had been schooled. Theirs were the antithesis of bodies disciplined to emit the signs of a ruling, dominant, elite class, with its ideal of self-mastery as the alibi for domination of those represented as less controlled and more physical. In the self-portraits of 1887 or 1897 Henri colours himself with the 'fetish' of black skin, representing himself as *other* to his own class's ideal self.[37] The changes to his physiognomy transcode for the disability of his legs, corresponding to the way in which it is Chocolat's motility he envies and yet represents as the colour of his face. Yet he is also dressed in a bowler hat, a tight collar and a monocle, which all reassert the costume – the decorum – of his privileged class and race. In these images the polarity which I defined between the iconically still, corseted containment of his representations of his mother La Comtesse (Fig. 4.3) and the physically unregulated exposure of the prostitute awaiting medical inspection (Fig. 4.4) is condensed and, as it were, is introjected, or displayed across his masculine, classed body. Its deficiency, its 'castration' *vis-à-vis* the ego-ideals of class and gender are signified by *incorporating* the signs of a carnivalesque figuration of his social others.[38]

LOVING WOMEN

As Walter Benjamin revealed in his readings of the poetry of Baudelaire, the alter egos of the modern hero were women in that specific costume of modernity's gender systems – the prostitute, but also the lesbian.[39] In her analysis of Benjamin's own writings on gender difference and modernity, Sigrid Weigel has argued that the 'whore' and the 'lesbian' functioned as historically significant identifications for the artist as figures on the threshold. They signify the antithesis of the mother, that is, as the non-procreative woman.[40] Although the play-off of mother versus 'whore'[41] clearly operates within classed formations, it resonates in other registers. The denial of the mother through the idealisation of woman in her function as sexual being who is not procreative allows the modern hero as artist to appropriate a liberated creativity, assimilating masculine sexuality to a surrogate, aethestic (pro-)creativity. But the elision of whore and lesbian – made possible through class and gender exploitation in the socio-economic institution of the brothel – created the possibility for yet another twist in the play of identifications, that gave the *autogenetic* artist/modern-hero imaginary access to the forbidden, incestuous object, and to the desired but tabooed proximity to the mother's body. Perhaps, I should say, to a mother's body, to the body of one, a female person, who had 'mothered' his own body in the daily rituals of childcare, for we should remember the social division in which the natural mother and those who ministered to the child were not only different people but representatives of different social positions and body systems. In this matter this archive is both typical and revealing.

Unlike the other artist who died at the age of thirty-seven and thus offered his life story as the stuff of modernist legend, Vincent van Gogh (1853–1890), Henri de Toulouse-Lautrec did not suffer mental disability. Van Gogh's psychologically induced tragedy has always been rendered sexlessly. His is a chaste and unhappy life, so the myth tells us, suppressing details of his gonorrhoea and frequenting of brothels. Henri's disability, as disability in general, is by contrast typically imaged in terms of the demonic and grotesque. The fantastic but masculine other of the Western man is endowed with an exaggerated sexual potency, which, when performed by a supposedly physically abnormal male, supplies a titillating fantasy. Toulouse-Lautrec seemed himself to permit this fantasy. Apart from one published image of his being fellated, there is little explicitly sexual in his art. None of his images appeared in the official lists of prosecuted obscenities.[42] What I am arguing is that, far from being a work that signifies what the art historical and popular legend of the artist has produced as the image of an oversexed man, the work of Toulouse-Lautrec exhibits the signs of the psychical impotence of which Freud wrote in his study 'The Universal Tendency to Debasement in the Sphere of Love'.[43] Its structures are for the most part fetishistic in character, accompanied by shifting and unstable identities.

In the series of paintings of the women who worked in the *maisons closes*, the regulated brothels of Paris, beginning about 1891–2, there are, however, explicit representations of women's sexuality. There are pastels and drawings of women

making love to each other. Most books I have found delicately illustrate the drawing of a woman giving her lover an orgasm. The composition, showing the active woman leaning on her elbow over her companion, screens the specifics of this sexual act from the viewer, and again the viewing position is behind the main protagonist (*Two Friends*, 1895, Private Collection). There are other images, most of which are produced in a style more akin to the naturalism Toulouse-Lautrec adopted in the early 1880s, perhaps the style in which his mother was portrayed. These drawings were exhibited in November 1892 at the gallery Le Barc de Boutteville, and many of them found their way into collections of literary and intellectual contemporaries, Roger-Marx, Gustave Pellet, Maurin. The pastels show women actively kissing and embracing (*In Bed*, Private Collection; *The Kiss*, Private Collection, reproduced *Toulouse-Lautrec* (1991), 428).

I find these images hard to look at. They were probably the product of Toulouse-Lautrec's money buying the spectacle of lesbian lovemaking as part of the erotic services women were paid to perform in the brothel. The images are painted for some man who will occupy the place the artist used to sketch the subject, if not to execute the final painting. They make women's sexual pleasure and intimacy yet another voyeuristic commodity. There was an extensive use of lesbian imagery in decadent literature and pornography in the later nineteenth century. Thus these images are not to be read as private fantasies but yet more symptoms of a larger cultural market of images to titillate masculine sexuality.[44]

Yet the images are compelling, none the less, in their representation of the active women-to-women sexuality. Lesbian lovemaking does not appear to be mere prelude, as is often the case in pornography, to the phallic sexuality of the male viewer. Moreover, the lovers in Toulouse-Lautrec's paintings are not, like Courbet's famous *The Sleepers* (1866, Paris, Musée du Petit Palais), post-coitally asleep. Henri's representations imagine a space of autonomous female–female sexuality driven by desire, and they differ from those Courbet painted for his patron Khalil Bey, in what was invested in the proximity Toulouse-Lautrec fabricated for himself, and for the viewer, to scenes which do not exhibit the typical components of male pornographic – voyeuristic – use of lesbian lovemaking. They offer the viewer visual access to a female intimacy of sensual as well as sexual pleasure.

Voyeurism is always dependent on keeping a certain distance.[45] Toulouse-Lautrec is reported to have said: 'The body of a woman, a beautiful woman, mind you, is not made for lovemaking . . . It's much too good, eh? To make love, it doesn't matter what you're with – anything will do.'[46] Sex may never have been all that gratifying for Henri. But something about watching women make love to each other, or lying in the enclosing intimacies of a private bed, and the vicarious access to women's sexuality it provided, was worth looking at repeatedly. It motivated him to recreate that scenario in his own studio and prolong it in and through his art. What pleasure did it yield its author and the male bourgeois collectors who bought such images? Are there possibilities of identification across class and gender which seemed to offer a fantastic, if momentary, escape from the confines of a classed masculinity? Or was it instead

Fig. 4.14 *Henri de Toulouse-Lautrec with his Mother the Comtesse Adèle de Toulouse-Lautrec at Malromé, c.* 1899–1900, photograph. Paris: Bibliothèque Nationale

another matter of class surveillance and the voyeuristic sexualities that serviced it? Watching working-class women make love was not dissimilar from watching Louise Weber dance, throwing up her skirts and flashing her bum at the crowd or thrilling them with unholy thoughts as she did the splits. All these deregulated bodies enjoyed physical, sensual and sexual experiences censored out by the bourgeois codes of bodily decorum, sexual distance and architectural segregation. They were thus both envied and disdained, the matter for art's artifice, the raw material of an artist's calculated professional gambit, which was, by turns, envious and sadistic.

It is not only the fact of the lesbian lovemaking but the fact of the class of the women in the brothels that brought these women under Toulouse-Lautrec's *glance* as just another facet of the otherness, the fascinating but discomforting sight of the freedom, which is at the same time a form of deviance, enjoyed by his social others. Montmartre, 'the metropolis of anarchists, artists and all those irked by society's laws, became the great lesbian centre of Paris', so Philippe Jullian tells us in his book on Montmartre.[47] Perhaps it was not as lesbians that the bodies of working-class prostitutes making love signified. The images of lovemaking women, engulfed in the isolated, contextless enveloping softness of their intimate beds, allowed men like Toulouse-Lautrec, Maurin, Roger-Marx and so forth a way around the censorship which barred them

from the idealised, beloved and thus desired maternal body. Thus his own artistic oeuvre, the very emblem of the modern hero's liberation from his own history, that is from his mother, is inverted in the images which that artistic individuality generated, to place that absent but still structuring maternal figure as the trace which determines the delusion of masculine modernity. At the bio-historical level she, his mother, La Comtesse Adèle was there to nurse him as his physical strength declined. It was to his mother he returned to die in her presence. In the photograph (Fig. 4.14) that so contradicts the legends of Toulouse-Lautrec, the elderly Countess sits once again in her garden, but dressed in an apron like the other women who actually tended him as a child.

CONCLUSION

The expanded archive 'Toulouse-Lautrec' may be read as an episode in a history of a classed heterosexuality and its formation at a specific historical moment. Freud's theses provide a structure for reading the spread of works in this archive as traces of a historical process of subjectivity which is no return to the biography – psycho- or otherwise – of the man. The work does not constitute the expression of a tortured disabled genius, as art history's celebratory monographs would want us to believe. We need to talk about both the matter of a lived life and the energies and drives which structure and generate the ambivalent pleasures of an aesthetic practice. The inter-sections of these are the psychic bodies inhabited in the social and historical fabric of France in the 1890s, and those fantasised through the graphic and painting practices of representation in an emergent modernist idiom. As the symptom of a specific social formation which entered representation mediated through an individual social sub-ject's psychic trajectory through it, the archive is read then for its stresses, emphases, absences, habits and patterns. These become significant at the intersection not just of the signifieds and signifiers of a general semiotic system but of surface and subject, as Fred Orton and Charles Harrison have defined the problematics of modernism,[48] the textual specificity where, within modernity, the rhetorics of modernism were generated.

But while I am arguing that there is a point in looking at this archive, and that it is about the cultural formation of modernism, I want to refute any suggestion that this adds up to the refounded claim that Toulouse-Lautrec is yet another father of modern art. Produced in the matrix we call Western modernity and its metropolitan social experience, his project was, none the less, a thoroughly realist enterprise. The works exhibit a pressure for figuration in which the stylistic and formal inventiveness of avant-garde art and its *musée imaginaire* was raided for means to produce a *pornography*.

The word means 'writing about prostitutes'. Toulouse-Lautrec certainly drew and painted prostitutes – but not at work. Toulouse-Lautrec's whole project is not the picturing of an erotic practice but rather picturing *as* a kind of displaced and stymied

erotic practice, and more importantly, picturing as the stasis and failure of sexuality typical of that era and its class and racist regimes. I am suggesting that it is the symptomatic register of the psychic impotence which Freud discerned in his patients. Hence the art of the fragmented body of the social, sexual and racial other: the art of fetish and of stereotype. I have used the portraits or photographs of Comtesse Adèle and the photographs of Comte Alphonse as heuristic devices to figure Freud's theory of the Oedipal drama as the matrix of *modern* heterosexual masculinity. From the interplay between the two – the parental imagoes and the son's artistic products – I discern the pattern of repetitions signalling conflicting desires that provide one scene for the psychic determinations upon this project. But in the still, iconic, desperate portraits of the mother we also find the sources of invention. Around her body, absented for the most part from the popular part of the oeuvre, and its fetishised substitutes – so massively present as the virtual synonyms for the artist – circled a fatal ambivalence.

Let me be clear at this point. The tragedy of this structure was clearly a masculine one, but one that had sufficient compensations constantly to lure men to sustain it. The tragedy is, however and more importantly, ours. I dare to use that unqualified inclusive 'ours', for it is here that we can posit the structural links between the diversified collectivity *women*, divided as we are by race, class, sexuality, disability. 'Ours' refers not to the real social diversity of our lived experiences which makes a mockery of any given community between people called women. It summons an imagined *us*, produced as a negative difference from the dominant class, race and gender's fantasy of the white, angelic ideal mother. As female subjects injured by class and racism, as female subjects equally delusively empowered by class and race, we can identify a fragile but common cause in the critical analysis of the modern masculine tendency to debasement in the sphere of love and its inscription into hegemonic, Western culture as the syntax of the art of the modern era. The point of feminist analysis of representation is to deconstruct the subject–object relations of the dominant culture, to place a historical subjectivity under a critical, analytic gaze as the site of the formation of a dominance which is as much about a racial, as a class and gender hierarchy.

The images produced in modernist culture are the representational scene in which the fantasies which characterise that hierarchy were played out. Feminist theorisation of the visual image is thus defined at the critical point where it contests the processes of art history's normalisation of the relations of power and sexuality that these images embody in their processes of production, consumption and canonisation.

NOTES

1 I cannot take any credit for establishing this supplementary archive. I found the photographs 'always already' there, in the exhibition catalogue, in Bernard Denvir's new monograph for the *World of Art* series, waiting to be read, waiting to become a part of a semiotic chain, which would lead to ways of producing a historical, feminist analysis of what the graphic or painted image might be – not of, but about.
2 *Unpublished Correspondence of Henri de Toulouse-Lautrec*, ed. Lucien Goldschmidt and Herbert Schimmel (London: Phaidon Press, 1969), letter 102, p. 115.

3 Griselda Pollock, 'Modernity and the Spaces of Femininity', in *Vision and Difference: Feminism, Femininity and the Histories of Art* (London: Routledge, 1988), pp. 50–90.

4 Sigmund Freud, 'On the Universal Tendency to Debasement in the Sphere of Love' [1912], in *Standard Edition* (London: Hogarth Press, 1953–74), 11, pp. 177–90 and in *On Sexuality, Penguin Freud Library*, 7 (Harmondsworth: Penguin Books, 1977) pp. 243–60. This essay was first translated into English in 1925 by none other than Joan Riviere.

5 *Ibid.*, p. 81 (*Sexuality*, p. 250).

6 *Ibid.*, p. 182 (*Sexuality*, pp. 250–1).

7 *Ibid.*, p. 183 (*Sexuality*, p. 251).

8 Sigmund Freud, 'A Special Type of Choice of Object Made by Men' [1910], trans. Alan Tyson, *Standard Edition*, 11, p. 171.

9 Freud, 'Universal Tendency', p. 183 (*Sexuality*, p. 252).

10 Michel Foucault, *The History of Sexuality, Volume I: An Introduction* [1976], trans. Robert Hurley (Harmondsworth: Penguin Books, 1979).

11 Mark Poster, *Critical Theory of the Family*, (London: Pluto Press, 1978), pp. 171–8.

12 Leonore Davidoff, 'Class and Gender in Victorian England', in *Sex and Class in Women's History*, ed. Judith L. Newton *et al.* (London: Routledge, 1983), pp. 17–70; Jane Gallop, *Feminism and Psychoanalysis: The Daughter's Seduction* (London: Macmillan, 1982).

13 On identification see J. Laplanche and J. B. Pontalis, *The Language of Psychoanalysis* (London: Karnac Books, 1973), pp. 205–7. For the larger point I am drawing on the work of Julia Kristeva and Kaja Silverman, particularly the latter in *The Acoustic Mirror* (Bloomington: Indiana University Press, 1988).

14 Bernard Denvir, *Toulouse-Lautrec* (London: Thames & Hudson, 1991), p. 18.

15 Abigail Solomon Godeau, 'The Legs of the Countess', *October*, 39 (1986), pp. 65–108.

16 The identification is provided through the 1991 exhibition catalogue, Claire Frèches-Thory, Anne Roquebert and Richard Thomson, *Toulouse-Lautrec* (New Haven: Yale University Press, 1991).

17 Frèches-Thory, p. 296b.

18 I must acknowledge my debt to Adrian Rifkin for his discussion of the raised leg in nineteenth-century dance. In his paper at the Toulouse-Lautrec Conference, Courtauld Institute of Art, London 1991, he made the important point that it was originally a masculine trope: kicking up the leg was part of men's dancing, which was belatedly taken over by women, especially with the can-can. This relatively recent transition from male to female performer serves to support the suggestions I shall be making about the oscillations in identification across male and female bodies.

19 Griselda Pollock, *Avant-garde Gambits: Gender and the Colour of Art History* (London: Thames & Hudson, 1992).

20 T. J. Clark, *The Painting of Modern Life: Paris in the Art of Manet and His Followers* (New York and London: Knopf and Thames & Hudson, 1984).

21 *Ibid.*, p. 15.

22 Overdetermination has two meanings. It refers to the fact that formations of the unconscious, i.e. dreams, symptoms and fantasies etc., can have several determining factors. The most common understanding of Freud's concept is not just plurality, but rather 'the formation is related to a multiplicity of unconscious elements which may be organised in meaningful sequences, each having its own specific coherence at a particular level of interpretation.' Laplanche and Pontalis, p. 293. The value for cultural analysis of such a concept is that it means that signs cannot be reduced to a single meaning, social or psychic. Instead we are dealing with processes of condensation, the formation of nodal points at which complex patterns and layers of meaning converge to give the resultant image its distinctive form as a configuration of meanings, not as a symbol, signal or reflection of its own conditions of existence.

23 Sigmund Freud, 'Leonardo da Vinci and a Memory of His Childhood' [1910], *Standard Edition*, 11, pp. 59–137; 'Fetishism' [1927] *Standard Edition*, 21, pp. 147–54.

24 Freud, 'Fetishism', p. 148.

25 John Ellis, 'On Pornography', *Screen*, 21, 1 (1980) pp. 81–108 (p. 100).

26 And of course of her daughters, but that is the topic of the next two sections of the book. See also Griselda Pollock, 'Critical Critics and Historical Critiques or the Case of the Missing Women', in Griselda Pollock, *Looking Back to the Future: Essays from the 1990s* (New York: G&B Arts International, 1999).

27 Laura Mulvey, 'You Don't Know What is Happening, Do You Mr Jones?' [1973], reprinted in *Visual and Other Pleasures* (London: Macmillan, 1989), pp. 6–13. Kaja Silverman writes of foot binding as a prime exemplar of fetishism, where the foot is bound to signify woman's castration and submission, but it is then idealised as if the women with bound feet were being praised for having accepted their castration and punishment, deflecting the threat from the male subject (Silverman).

28 Silverman, *op.cit.*

29 Yvette Guilbert, *La Chanson de ma vie* (Paris: Grasset, 1927), English version: *The Song of My Life: My Memories*, trans. Béatrice de Holthoir (London: George Harrap & Co., 1929), p. 87. For a fuller account of Guilbert and the context of her work see Adrian Rifkin, *Street Noises: Parisian Pleasure 1900–40* (Manchester: Manchester University Press, 1993). Thanks to Adrian Rifkin and Lisa Tickner for this.

30 Guilbert, *op.cit.*

31 Gustave Geffroy, *Yvette Guilbert* (Paris: Marty, 1894).

32 Yvette Guilbert recalls that Louise Weber had a heart embroidered on her knickers which was suddenly exposed when she 'disrespectfully bowed to the audience'. Guilbert, p. 74.

33 See Ellis, *op.cit.*

34 Quoted in Frèches-Thory, p. 57.

35 Homi Bhabha, 'The Other Question: The Stereotype and Colonial Discourse', *Screen*, 24, 6 (1983), pp. 18–36.

36 *Ibid.*, p. 21.

37 When I first presented this paper, Tamar Garb usefully pointed out the other presence in this racialisation of his own features, which would equally confirm this dialectic of the projection out of the hated self on to the culturally defined 'other'. The features he devises could also be read within the visual representations of anti-semitism. On Toulouse-Lautrec and a Jewish Other see Gale B. Murray, 'Toulouse-Lautrec's Illustrations for Victor Joze and Georges Clemenceau and Their Relationship to French Anti-semitism in the 1890s', in Tamar Garb and Linda Nochlin, ed., *The Jew in the Text: Modernity and the Construction of Identity* (London: Thames & Hudson, 1995), pp. 57–82.

38 For a discussion of the uses of body image in the discourse of class and the bourgeois social imaginary see P. Stallybrass and A. White, *The Politics and Poetics of Transgression*, (London: Methuen, 1986).

39 W. Benjamin, *Charles Baudelaire: A Lyric Poet in the Era of High Capitalism*, trans. Harry Zohn (London: New Left Books, 1973). See also S. Buck-Morss, 'The Flâneur, the Sandwichman and the Whore: The Politics of Loitering', *New German Critique*, 39 (Fall 1986), pp. 99–140; Christine Buci-Glucksman, 'Catastrophic Utopia: The Feminine as Allegory of the Modern', *Representations*, 14 (1986), pp. 221–9.

40 Sigrid Weigel, 'From Gender Images to Dialectical Images in Benjamin's Writings', *New Formations: The Actuality of Walter Benjamin*, 20 (1993), pp. 21–32.

41 The word itself is so hateful and ugly that I want to insist that I use it only to signal the dominant culture's abuse of women working in what its workers call the sex industry.

42 I am grateful to Adrian Rifkin for this information.

43 See note 1.

44 Thomson, in Frèches-Thory, p. 435.

45 This has been extensively argued in Christian Metz, especially in 'Story/Discourse: a Note on Two Kinds of Voyeurism', in *Psychoanalysis and Cinema: The Imaginary Signifier* (London: Macmillan, 1982), pp. 89–98.

46 Thadée Natanson, *Un Henri de Toulouse-Lautrec* (Geneva: Cailler, 1951), p. 52.

47 Philippe Jullian, *Montmartre*, trans. Anne Carter (Oxford: Phaidon, 1977), p. 88.

48 Fred Orton and Charles Harrison, 'Jasper Johns: Meaning What You See', *Art History*, 7, 1 (1984), pp. 78–101.

Part III

HEROINES: SETTING WOMEN IN THE CANON

This section addresses the emergence of a feminist canon by looking at a candidate for canonical status who has become a feminist heroine, Artemisia Gentileschi (1593–1653). Troubled by the losses incurred by tailoring her work to meet the criteria of the canon, I explore ways to read some of her paintings that displace the authority of art historical discourse in order to produce a feminist genealogy – reading 'back through our mothers' as Virginia Woolf put it. This re-vision is based on stories of the body, the woman's body, the body of the painter, the painted body, the viewing body and the dead body. The next few chapters take the form of an imaginary dialogue with other interpreters in which my aim is to draw into the field of reading the visual image a degree of feminist self-reflexivity. This is concluded by an engagement with a contemporary artist, Lubaina Himid, a painter exploring the possibility of a post-colonial feminist history painting, where that self-consciousness is inevitably political as much as it is aesthetic and post modern.

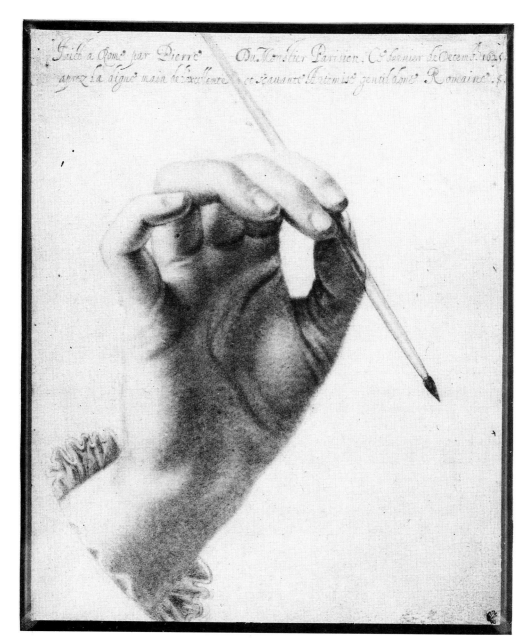

Fig. 5.1 Pierre Dumoustier Le Neveu, *The Hand of Artemisia Gentileschi Holding a Paintbrush*, 1625, red and black chalk with charcoal, 21.9 × 18 cm. London, Trustees of the British Museum

THE FEMALE HERO AND THE MAKING OF A FEMINIST CANON

Artemisia Gentileschi's representations of Susanna and Judith

If women set themselves to transform History, it can safely be said that every aspect of history would be completely altered. Instead of being made by men, History's task would be to make woman, to produce her. And it's at this point that work by women themselves on women might be brought into play, which would benefit not only women, but all humanity.

Hélène Cixous[1]

A few years ago I was contacted by a researcher in the BBC who was preparing a series of programmes about significant but overlooked women from history. One of their subjects was to be the seventeenth-century Italian artist, Artemisia Gentileschi (1593–1653). Artemisia Gentileschi was going to be the only artist in the series. I was very suspicious. With Frida Kahlo and Georgia O'Keefe, she is now one of the most famous of the recovered women artists – but her fame is more a matter of notoriety and sensationalism than of any real interest in or comprehension of 'Gentileschi' as a set of artistically created meanings (Fig. 5.1). Spoken of in art history as a 'lascivious and precocious girl', a woman addicted to 'the art of love' whose story is reminiscent of Fellini's film *La Dolce Vita*,[2] she has become, like the French sculptor Camille Claudel, the stuff of romantic melodrama at the cinema. A drama documentary about the artist would be bound to focus on the extraordinary trial that followed the rape to which she was subjected by her 'teacher', Agostino Tassi. She was nineteen at the time. The paintings they would focus on would be those whose apparent subject was sexual violence and violation, such as *Susanna and the Elders* (1610, Fig. 5.2), and that could be read as 'expressing' a women's vengeful feelings towards men as a result of a traumatising sexual assault, such as *Judith Slaying Holofernes* (1612–13, Fig. 5.4). Life would be mirrored in art and art would confirm the biographical subject – a woman wronged. Gentileschi's art would speak only of that event – indexing directly to experience and offering no problems for interpretation. These paintings were a predictable choice – apparently dealing with sexual assault and violence. I did not want to get involved.

SEEING THE ARTIST OR READING THE PICTURE?

There is a gulf between popular notions of 'art and artists' and the current critical edge of art historical feminist analysis. The programme-makers wanted to bring the biography of the artist to life through the works, whereas the feminist cultural analyst is wanting to make work itself vivid by decoding the dynamic process of how meaning is produced and exploring what kinds of readings its signs make possible.[3] In the traditional model, the artwork is a transparent screen through which you have only to look to see the artist as a psychologically coherent subject originating the meanings the work so perfectly reflects. The critical feminist model relies on the metaphor of reading rather than mirror-gazing. What we see on even the most figuratively illusionistic paintings are signs, for art is a semiotic practice. The notion of *reading* art renders the graphic marks and painted surfaces of art opaque, dense, recalcitrant; they never directly offer up meaning but have to be deciphered, processed and argued over.[4] In art, there is of course something to see. What the eye does in traversing a canvas and searching out its means and effects, however, is a processing of the signs that may produce meanings. Even in the most abstract of paintings the physical events of paint being applied to a surface involve us in some kind of narrativity. This may be only the narrative of the process of the painting's production, the sequence of the maker's marks, the way in which someone has been thinking out a canvas surface and its effects. At certain times in the history of Western art, however, there has been a more explicit narrative intention to make formal process co-operate in the production of narratively decodable meaning.

In this chapter I shall focus on a high point of that highly motivated production of narrative history painting of the Baroque period. I want to use it as a case study to look at the issues posed by a feminist analysis of Artemisia Gentileschi. It will enable me to address the problem – not what is *feminist art history* but what does feminism bring to art history when it intervenes in its discursive field? That depends on broaching another question: What does feminism desire in looking at work by *women* artists? Thus, beyond the critical screen of a semiotic reading, I want to reach back to Freudian aesthetics to discern not my projection on its imaginary screen but the traces of incompletely repressed psychic materials that might index a historical subjectivity, in the feminine, signified not expressed in its complex negotiations of the signs, meanings, fantasies and affects we might call, with Kristevan subtlety, aesthetic practices.

FEMINISTS AND ART HISTORY: WHAT WOMEN?

It is now over twenty years since the revitalised feminist impulse of the later twentieth century began to reshape the possibilities of knowledge in the name of women. But what 'women' are the topic of feminist analysis? White women, women of colour, Jewish women, Muslim women, lesbians, mothers, lesbian mothers, non-mothers,

disabled women, women of Europe, Asia, Africa, the Americas, the Middle East and all the diasporas that traverse these impossible geographies? Despite the necessity to insist on the specificity of, and even conflict between, women in the above lists, there remains the problem posed by the category 'women', created by the way societies treat those thus designated. Woman – capital W – is a fiction and a myth. But for the last decades of this century we have organised as *women*, imagining a political collectivity of women in their concrete, social relations. Even this has, however, been radically challenged. The term 'Women', tracked through diverse fields of history, sociology, philosophy, art history and literature no longer offers much security for the critical historian or cultural analyst. Texts, images and discursive practices have to be analysed historically and in their cultural diversity as sites where the category 'women' is *made* by the very discourses and practices which produce and speak this sign as part of the constitution of regimes of class and race as well as gender and sexuality.[5] Feminism does not speak for women; it politically challenges those constructions of 'women' by producing counter-constructions that are not based on a nature, a truth, an ontology. Thus what it is that we argue for and from is constantly *in the making*.

Analyses of 'women' based on theories of sexual difference refuse anatomy as a basis for the determining fictions of sexual identity. The female body, defined not essentially but as a resource for imaginative, psychological, experiential potentialities, can be invoked theoretically as the repressed source of our radical signification as '*not-women*-women'. Julia Kristeva defines the radical significance of femininity in phallocentric cultures by this negativity. We may have to use the slogan 'women' to advertise our demands for childcare, contraception and equality at work, yet, Kristeva argues,

> on a deeper level, however, a woman cannot 'be'; it is something that does not even belong to the order of *being*. It follows that a feminist practice can only be negative, at odds with what already exists so that we may say 'that's not it' and 'that's still not it'. In 'woman' I see something that cannot be represented, something that is not said, something above and beyond nomenclatures and ideologies.[6]

The feminist project aims to introduce an effective differentiation which would allow the *difference*(s) of women to be represented imaginatively and symbolically – on the planes of language, philosophy and art where the feminine traditionally signifies only the negative difference from man or his fantasy of his other. The female body has come to hold a privileged place in thinking about the material and imaginative resources for differential significations. Some feminist theorists attempt to explore the specific morphology of the female body (which is different from its anatomy) as a resource for the metaphoric invention necessary to a semiotic revolution on behalf of the unrepresented difference of *not-women*-women.[7] The sexually *jouissant* female body and the maternal body, the body as the site of drives and energy, pleasures and pains, its invisible sexual specificity, it is these *imaginary* bodily elements, which are,

none the less, in critical ways, recalcitrantly material and enigmatic, that fascinate feminist writers. In diverse fashion we have reclaimed the radical importance of corporeality in the struggle of 'not-women' to probe analytically, and to create from the possibilities of femininities that have a bodiliness, but one that is not defined or captured in the patriarchal discourses of philosophy, religion, biological science, art or even existing psychoanalysis.[8]

Such radical feminist theoretical propositions create the means to re-read the inscriptions of the feminine from the texts of the past. We can now, in retrospect, use theoretically conceived insights about femininity as another difference to decipher what women artists might have been doing in their art: i.e making 'women' in art's histories – creating a differentiation rather than expressing a pre-given difference. In the laboratory of the past, their texts and images offer us, in the present, experimental material through which to explore the differences of femininity(ies) in the pressure to articulate what the feminine might be both within, and in its perpetual transgression of, the phallocentric law of the Same.

Psychoanalysis, however, undermines the idea of the fixed subject with achieved sexual difference. Psychoanalysis hypothesises both the socially desired outcome of sexed subject formation – how most of us become women or men capable of making a range of sexual choices but it exposes in that very process the conditions of a perpetual disruption of such outcomes through the unconscious and fantasy. Psychoanalysis already imagines the inevitable negativity in subjectivity that allows the subject to be considered not as some robotic socially manufactured automaton, gendered and made sexual once and for all, but as a dynamic and contradictory *process*.

Feminist revisions of psychoanalysis argue that such structural and creative instability occurs because the phallocentric regime of the subject – the one Freud and his followers are in fact describing – is based on the repression of *the mother* and with her, the repression of the possibilities of *different* differences that the maternal body, voice and space come to represent in a phallocentric system. Such a mother-repressing system is organised around the authority of the Father, representing the Law that makes separation from the Mother the price of acquiring language, sexuality and thus subjectivity. Throughout our lived life histories we are being made and undone as subjects over and over again in our encounters with language, with others, with culture. The subject is, moreover, split and is, therefore, always undermined, or rather determined, from some other point, namely the unconscious within the individual's history and in the structure of language. This process and its regular instability are differentially configured for the feminine subject because of the asymmetry of the phallocentric regimes of sexual difference in most of our societies. The sign of this difficulty is the *disrepresentedness* of femininity as anything other than the *negated other* of masculininity: i.e. what the masculine is not. This emptied space that is, none the less, named femininity is appropriated as an image in the making of the masculine subject that masks a lack attributed to it and then, in a vicious twist of phallocentric logic, is made to stand for that which might cause the masculine subject to lack. Woman then signifies castration, monstrousness, fatality and so forth.[9] Thus, without

falling back into anatomical or biological essences, we can still talk about the specificity of femininity as something which already negatively exists as a figure in contemporary cultural representations. It gets pictured in these negating and dangerous guises. But it is also to be imagined as that which might be excessive to these limited significations of femininity as not-masculinity, offering *in potentia* another difference. Femininity is both 'nothing' (in phallocentric logic) and everything else that is not yet known in that economy.

One other major insight of psychoanalysis needs to be considered: the unconscious character of subjectivity based on the division of the subject into conscious and unconscious. In Lacanian theory the unconscious is formed by the subject's passage into language and the Symbolic order of culture. Its contents are all that has to be repressed for the subject to misrecognise itself in the positions and terms language offers us. What is repressed is the fantastic, that is, the imaginary relations of the infant to others, especially to the mother's body, voice, gaze and presence, and to its own archaic, fractured body and its polymorphous – as yet unchannelled and free-flowing – drives. Fantasy is the governing register of the Imaginary mode which theoretically precedes accession to the Symbolic, but is always defined by it and co-exists within its signifiers. The Imaginary is thus at once an alternative to Symbolic modes while operating within the subject as a co-present and competing register of meaning. The location of repressed fantasies of maternal and archaic corporeality in the unconscious means two important things. One is that the existing subject is split in the present – the unconscious being the contents of a past made ever present through a particular mode of signification and displacement characteristic of the unconscious which appears in dreams, daydreams, slips of the pen or tongue and jokes. The second is that the subject is always massively unknown to itself.

The analyst listens to and looks for signs of the unconscious traced across the speech and actions of an analysand, disturbing the conscious patterns with its own rhythms and meanings. In a similar vein cultural analysts might be said to read the texts and images of writers and artists to see the traces of this split in subjectivity and the varying registers on which we are able to produce meanings. Thus unconscious meaning is not expressed as, for instance, in a surrealist image by a conscious attempt to replicate or picture the unconscious's contents and modes. Unconscious materials subtly realign the consciously produced text by its own particular symptomology. Thus an image can signify both in a social semiotics of public artistic and literary production, and from this 'other scene', as Freud named the unconscious. In both classic Freudian and Lacanian psychoanalysis that 'other scene' is often identified with 'Woman', who thus remains repressed as the darkness of the dark continent, the enigma of the unconscious, the forever repressed but determining. But from a feminist revision, 'that other scene' is also a site for the traces of an *other* woman, an *other* femininity identified by feminist desire, interested in the specificity of femininity as something *other* than the cipher of masculinity's self-reinforcing yet monstrous and dangerous Other.

This conclusion poses serious problems for feminists in art history trying to reinscribe into cultural history the stories of women artists. Our whole project has

been committed to restoring to visibility women as artists whose significance for us lies in the difference they might bring to the existing stories of art: to the canon. But we are not on secure ground any more. I suggest we reformulate the project thus. Instead of reading 'for the woman' – for what we anticipate to be gendered experience – we read for *the inscriptions of the other otherness of femininity*, that is, for those traces of the unexpected articulation of what may be specific to female persons in the process of becoming subjects – subjected, subjectified and subjectivised – in the feminine through the interplay of social identities and psychic formations within histories. The latter are inherently complex and unstable and, most importantly, never known in advance or knowable until they achieve some form of articulation or signification.

Feminism, informed by such theoretical insights, becomes, therefore, a struggle around representation itself operating simultaneously on several registers. Commenting on Luce Irigaray's radical attempt to invent a metaphorics of the different female body that has been consistently misunderstood, Elizabeth Grosz argues:

> The 'two lips' is not a truthful image of female anatomy but a new emblem by which female sexuality can be positively *represented*. For Irigaray, the problem for women is not the experience or recognition of female pleasure, but its representation, which actively constructs women's experience of their corporeality and pleasures. If female sexuality and desire are represented in some relation to male sexuality, they are submerged in a series of male-defined constraints. Contrary to the objection that she is describing an essential, natural or innate femininity, unearthing it from under its patriarchal burial, Irigaray's project can be interpreted as a contestation of patriarchal representations *at the level of cultural representation itself*.[10]

The object is to challenge art history as a system of representation which has not simply lost our past but has constructed a visual field for art in which feminine inscriptions are not only rendered invisible through exclusion or neglect but made *illegible* because of the phallocentric logic which allows only one sex. To claim creativity for women is to do more than find a few female names to add to canonised lists in surveys of Western art. It is to transgress the major ideological axes of meaning in a phallocentric culture, to disorder the prevailing regime of sexual difference. For a long time it has been argued that challenging the cultural negation of women's creativity is *more* than a matter of historical recovery. But few of us have really thought through how impossible the task of doing that *more* actually is.

As feminists working in art history, we rediscover the work of women artists – but what do we then say about it? We could judge their art by existing criteria. But since these have been evolved to deal with the work of exclusively white male artists, they may not be relevant. If we then admit there is difference, what would be its signs? How do I know that what I take to be the signs of a woman's consciousness at work are not merely the imposition of culturally stereotyped ideas of social femininity that have shaped me, that define 'woman' in my own time and culture, in my own class and

ethnic background? So I must wonder about what I am looking for and what I see in or read into the work of artists who are 'women' when the feminist project is caught in the paradox of deconstructing the category 'women' in the name of 'women' as feminism's object.

When we are trained by canonical art history, we sit through many a class showing images of the sexual abuse of women: the Rape of Lucretia, the Rape of Europa, the Rape of the Sabine Women. I always felt sure that this must be another kind of 'rape' from that which I dreaded happening to me, that which friends had horrifically experienced, when they feared for their lives, and felt in that moment something irretrievably stolen from them and ruined within them. How could we politely discuss artistic genius, formal perfection, compositional innovation, iconographic descent or colour harmony when we were confronted with the crime by which most profoundly men police women?[11] Artistic rape was nice, a bit sexy, normal because men do desire women, especially when they sit about with their clothes falling off. But that is feminism for you: always so uncouth and insensitive to aesthetics, and, of course, always bringing things down to the personal level, not being able to keep things like art and society apart.

But in fact, the reverse is true. Art is where the meeting of the social and the subjective is rhetorically represented to us. It happens in ways which mystify that relation, giving canonical authority to a particular kind of experience of subjectivity and social power. What we are doing as feminists is naming those implicit connections between the most intimate and the most social, between power and the body, between sexuality and violence. Images of sexual intimidation are central to this problem and thus to a critique of canonical representation.

SUSANNA AND THE ELDERS

I want to explore – and take issue with – a *feminist* reading of a painting by Artemisia Gentileschi of the subject *Susanna and the Elders* (Fig. 5.2), signed and dated 1610, painted when the artist was seventeen.[12] Artemisia Gentileschi (1593–1653) was born in Rome to a painter father, Orazio Gentileschi, and Prudentia Montone. Artemisia was the only daughter in a family of sons, and the only one with any real aptitude in her father's profession. Like many women artists of the period, she acquired her training in her father's workshop and assisted him on major projects such as the decorative schemes in several of the new palazzi being constructed in Rome in the early decades of the seventeenth century. She worked in Rome, Florence, Genoa, Venice and even London and eventually died in Naples where she had settled in 1642. Her beginnings as an artist in Rome coincided with the inspiration provided by the new style and dramatic treatment of psychologically intense subjects by the painter Michelangelo Merisi (1571–1610), known as Caravaggio. Caravaggio made a major impact in Rome with extraordinary paintings in the churches of S. Luigi dei Francesci and Santa Maria del Populo. Two paintings from the early 1610s show Artemisia

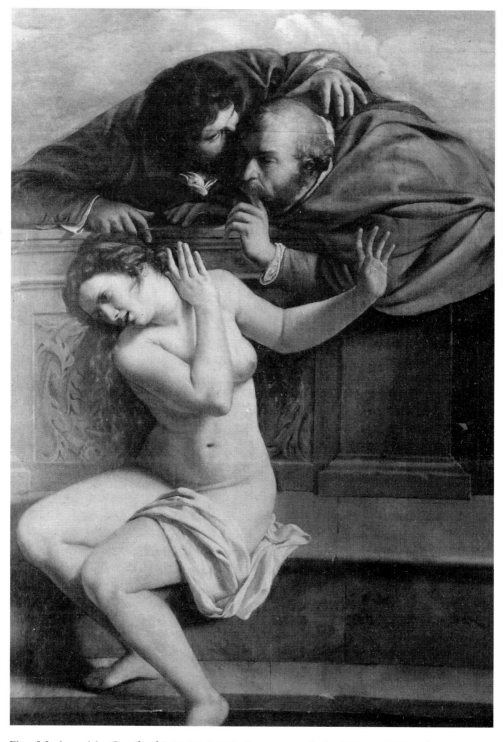

Fig. 5.2 Artemisia Gentileschi (1593–1653), *Susanna and the Elders*, 1610, oil on canvas, 170 × 119 cm. Pommersfelden, Kunstsammlungen Graf von Schönborn

Gentileschi working with a combination of her father's original Florentine manner and the stronger forms and dramatic simplification developed by Caravaggio and then espoused by her father. Orazio arranged for his talented daughter to study perspective with his collaborator on decorative painting, Agostino Tassi. Tassi raped Artemisia in May 1611, and in March 1612 (after nine months?) Orazio sued Tassi for damages. The trial involved Artemisia being tortured and a series of counter-allegations against the young woman's chastity. Tassi was briefly imprisoned, and Artemisia married and moved to Florence. She had a successful career in Italy and England, though her extant oeuvre numbers only around thirty-four attributed and signed paintings. Many portraits are lost. One of the major landmarks of feminism's challenge to art history is Mary Garrard's monograph on Artemisia Gentileschi which appeared in 1989.[13] Mary Garrard focuses on Artemisia Gentileschi's major narrative paintings of 'heroic women': Susanna, Judith, Cleopatra and Lucretia.

The biblical story of Susanna and the Elders tells of a young married Jewish woman living in Babylon during the first exile of the Jewish people (after 586 BCE).[14] Susanna is bathing in her garden. She sends her two maids into the house to fetch oil and perfumes for her bath. Two lecherous elders of the community spy on her, conspiring to force her to submit to them sexually. They threaten her that, if she refuses, they will denounce her for adultery with another man, adultery being, according to ancient Jewish law, a capital crime for women. Susanna refuses, preferring the fate of death to the sin they propose. She is then falsely accused by the elders and condemned to death. Daniel, of leonine fame, vindicates Susanna by exposing the elders' mendacity. Interrogating them separately, he asks them under which tree Susanna committed adultery. Each names a different kind of tree. They are then executed for the crime of false witness.

The story is a complex narrative of sexual desire and visual temptation, female chastity and masculine law. During the Renaissance the dramatic focus on the moment of the woman's nakedness while bathing exposed to a lecherous conspiracy emphasised the sexual, voyeuristic and visually violating aspects of the theme, while providing a biblical and even theological justification for the painting of an erotic female nude, a genre that was emerging in this period, shifting the connotations of the female nude from its traditional iconographic association with Truth towards its modern signification of (masculine) desire and its privileged visuality.

For Garrard, Artemisia Gentileschi's treatment of Susanna shifted the 'hard-core eroticism', 'blatant pornography' and 'rape, imagined by artists – presumably also by their patrons and customers – as a daring and noble adventure'.[15] 'By contrast to the cognate images, the expressive core of Gentileschi's painting is the heroine's plight, not the villains' anticipated pleasure.'[16] The basis of the difference is gender: 'In art, a sexually distorted and spiritually meaningless interpretation of the theme has prevailed because most artists and patrons have been men, drawn by instinct to identify more with the villains than with the heroine.'[17] 'Artemisia's Susanna presents us with an image rare in art, of a three-dimensional female character who is heroic in the classical sense, for in her struggle against forces ultimately beyond her control, she exhibits a

spectrum of human emotions that moves us, as with Oedipus or Achilles, to pity and awe.'[18] The artist's special affinity with this subject is both the fact that she was a woman,[19] as opposed to a man, and that she was this particular woman, herself vulnerable to unwanted sexual aggression at the time of painting the *Susanna*, a woman who was later raped as a result of that vulnerability, before she painted her first version of the theme of *Judith Slaying Holofernes* (Fig. 5.4). Thus Mary Garrard concludes her chapter on Artemisia Gentileschi's *Susanna*:

> What the painting gives us, then, is a reflection, not of the rape itself, but rather of how one young woman felt about her own sexual vulnerability in the year 1610. It is significant that the *Susanna* does not express the violence of rape, but the intimidating pressure of the the threat of rape. Artemisia's response to rape itself is more probably reflected in her earliest interpretation of the Judith theme, the dark and bloody *Judith Slaying Holofernes* . . . In this image – as even the most conservative writers have realized – Judith's decapitation of Holofernes provides a shockingly exact pictorial equivalent for the punishment of Agostino Tassi. No painting, of course, and certainly no great painting, is mere *raw autobiography*. Yet once we acknowledge, as we must, that Artemisia Gentileschi's early pictures are vehicles of personal expression to an extraordinary degree, we can trace the progress of her experience, as the victim first of sexual intimidation, and then of rape – two phases of a continuous sequence that find their pictorial counterparts in the Pommersfelden *Susanna* and the Uffizi *Judith* respectively. [my emphasis][20]

Why should we argue with this? Perhaps the distinctions I want to bring out are too fine to merit much attention. But I think that a great deal of what feminist interventions in art history are about is at stake. Mary Garrard's argument is very compelling because it seems to bring the seventeenth-century artist to life to see her work as a kind of personal testimony, witnessing her own traumas. But how does this differ from what we find in the normalised accounts of art history – the equation of the artist's biographical life with the art through the mechanism of expression? Nanette Salomon has pointed out that, while biography has held a privileged place in the modes of art history ever since Vasari initiated the heroic model with his *Vite* (Lives) of famous artists,[21] in regard to gender, biographical material works differentially:

> Whereas Vasari used the device of biography to individualise and mythify the works of artistic men, the same device has a profoundly different effect when applied to women. The details of a man's biography are conveyed as the measure of the 'universal', applicable to all mankind; in the male genius, they are simply heightened and intensified. In contrast, the details of a woman's biography are used to underscore the idea that she is an exception; they apply only to make her an interesting case. Her art is reduced to a visual record of her personal and psychological make up.[22]

Salomon claims that in art history, feminist and otherwise, Artemisia Gentileschi's works are 'reduced to therapeutic expressions of her repressed fear, anger and/or desire for revenge. Her creative efforts are compromised, in traditional terms, as personal and relative.'[23]

Biographical materials certainly provide significant and necessary resources for the belated production of women's *author*ity. But there is surely a difference between careful interrogation of the archive which includes materials on a lived life and the binding back of paintings on to the Western bourgeois notion of the individual within discourses on biography. Biography, moreover, can never be a substitute for history. We might do well to recall Marx's famous dictum in *The Eighteenth Brumaire of Louis Napoleon* (1852), suitably edited: 'Women make their own history, but they do not make it just as they please; they do not make it under circumstances chosen by themselves, but under circumstances directly encountered, given and transmitted from the past.'[24] When producing his historical biography of the nineteenth-century French novelist Gustave Flaubert, Jean-Paul Sartre tried to theorise how individuals within a class come to class-consciousness. Sartre argues that a bourgeois child, as Flaubert was, insulated from class awareness within the homogeneity of his (or her) family group, might, for instance, witness some major historical event, a riot, an uprising, a fight, a strike. In that momentary crystallisation of the antagonisms of classed society, the child is forced to see his or her bourgeois family 'from outside', as the object of proletarian hatred or aristocratic disdain.[25] By this conjunction of the personal perception of major public events that suddenly reveal the social forces shaping the individual, the latter is forced to know the necessary interface of the private and the public, the personal and the social, and to find himself or herself defined by it. Sartre concludes: 'In truth, to discover social reality inside and outside oneself, merely to endure it is not enough; one must see with the eyes of others.'[26]

In just such a way might we read the public ordeal of the Gentileschi/Tassi trial of 1612 as a moment crystallising the relations between sexuality and gender power in seventeenth-century Rome. The process of the public re-presentation of her sexual and indeed social trauma might have revealed – articulated – to Artemisia Gentileschi how she was placed as a woman as object of exchange between men in which her sexual violation signified less her personal suffering than the abuse of the legal rights of men over women's bodies to decide their social status in this sex–gender economy. Nanette Salomon analyses the structure of meaning the trial enacts in order to place the 'experience' within historical representation of gender relations.

> While the proceedings of the trial may or may not add anything to our understanding of Gentileschi's art, they can do so only when seen as part of the highly coded discourse on sexuality and the politics of rape in the seventeenth century. Perhaps more than anything, they emphasize the fact that Artemisia, body and soul, was treated as the site of exchange between men, primarily her father/mentor and her lover/rapist/mentor. . . . This process of exchange began when she was 'given' to Tassi as a pupil, and it continued

when he violently 'took' her, when her honour was 'redeemed,' and when she was given and taken again. The homosocial bonding ritual enacted and reenacted among these men make 'Artemisia' an historically elusive construct. If the testimony of the trial reveals anything, it is a person with an obstinate sense of her own social and sexual needs. Her paintings look less like 'heroic women' than like the nexus of a series of complicated negotiations between convention and disruption, between 'Artemisia' and Artemisia.[27]

What would a *cooked* autobiography look like?[28] Playing on Mary Garrard's own choice of words, raw autobiography, I am referring to Lévi-Strauss's image of the difference between nature and culture as a difference between the raw and the cooked.[29] Mary Garrard is saying that no art delivers unmediated elements of an artist's life, but her text offers us the image of art as a mirror: reflection, expression, 'pictorial counterpart' and pictorial equivalent. What is the cooking agent, the process by which what happens to us is transformed from event into experience, memory and thus meaning? I suggest that it is representation as at once a semiotic process and a filter to the 'other scene'.

TRAUMA, MEMORY AND THE RELIEF OF REPRESENTATION

Current research on trauma suggests that the more terrible has been the pain, the more difficult it is to speak of it or to deal with it. Cathy Caruth argues that the pathology of trauma is '*the structure of its experience* or reception: the event is not assimilated or experienced fully at the time, but only belatedly, in its repeated *possession* of the one who experiences'. The enigmatic core of trauma is the fact that a *raw* history inhabits the subject: 'the traumatized person carries an impossible history within them, or they become the symptom of a history that they cannot entirely possess'.[30] This creates a further paradox. In trauma the greatest confrontation with reality may occur as an absolute numbing to it: 'that immediacy, paradoxically enough may take the form of belatedness'.[31] This creates then, a crisis of truth.

In the testimony of a trauma survivor, occurring only when some transformation has been begun, the analyst hears not the event but the survivor's incipient departure from its raw and overwhelming presence. Caruth writes that studies of 'the in-accessibility of trauma, its resistance to full theoretical analysis and understanding . . . also open up a perspective on ways in which trauma can make possible survival, and on the means of engaging this possibility through the different modes of therapeutic, literary, pedagogical encounter'.[32] And, I would add, artistic, and even historiographic, encounter.

Psychoanalysis, the practice dedicated to the study, and hopefully the relief, of trauma, began with the young women known as hysterics, who were said to 'suffer from reminiscences', but of what they could no longer recall – they were traumatised

by events that were unspeakable. The young women diagnosed as 'hysterics' and treated by Josef Breuer and Sigmund Freud in the 1880s and 1890s were a bundle of symptoms in which these traumatic experiences of sexual abuse, betrayal and bereavement had been diverted from memory because the overwhelming immediacy remained undigestible by the subject's psychic apparatus. These experiences had undergone conversion into a language of body signs: aphasia, anorexia, paralysis, localised pain and dysfunction, blindness, recurring gestures which retained, even as metaphoric transpositions, a kind of telling literalness.[33] Relief was produced by restoring events to memory and thus delivering them into representation.

The expressive model of art history, which imagines a vicarious therapeutic violence in Artemisia Gentileschi's paintings fails in this primary understanding of the psychic mechanisms that defend us against the pain of trauma by symptomising it, and also by not understanding what it takes to 'work through' to representation of it. Michèle Montrelay, writing about the censorship of femininity and its necessary release through 'repression' in discourse, argues that, in order for us to have pleasurable and creative access to sexuality, we must undergo the structuring of discourse, the repression that is also known as symbolic 'castration'. Representation relieves us from the immediate 'real 'of the body (and traumatic events). It is thus a 'castrating' representation, while quite specifically not being a representation of castration. By aiding the analysand into discourse, the paradoxical liberation of repression occurs through the analyst's interpretation of the analysand and her symptoms.

> Here, therefore, pleasure is the effect of the word of the other. More specifically, it occurs at the advent of a structuring discourse. For what is essential in the cure of a woman is not making sexuality more 'conscious'; or interpreting it, at least not in the sense normally given to this term. The analyst's word takes on a completely different function. It no longer explains, but from the sole fact of articulating, it *structures*.[34]

What pleasure, Montrelay asks, can there be in the repression that is produced at the moment of interpretation? 'These words [produced in analytic interpretation] are *other*; the analyst's discourse is not reflexive but different. As such it is a metaphor, not a mirror, of the patient's discourse. And precisely, metaphor is capable of engendering pleasure.'[35]

I want to suggest this argument itself as a metaphor for art practice. Art practice can be thought of as metaphor, in order to interrupt the sliding of the artist under his or her own work which art history consistently effects. The work an artist makes is literally *other* because it is a product of the artist's labour and an external object. It is also *other* in so far as making a painting, for instance, involves participating in the public languages of the culture whose formal protocols, rhetorical conventions and supplied narratives might be said to *structure* the material which presses upon the artist, functioning as the drive, need and desire to produce. In addition to any conscious manipulation of semiotic conventions of the culture in which the artist is

trained, disciplined and operative, there is an exchange between the artist's as yet unformulated materials for discourse and the articulation made possible by its enunciation through the discourse of the other: the culture's given sign systems and stories.

But if these given conventions and stories are *other* in a way that provides only an alienating field of representation incommensurate with the shape and needs of the subject because the creating subject is feminine and the discourse phallocentric, there will be a contradiction. In that space between a necessary and an alien *otherness* we might begin to look for traces of a shift in the circuits of meaning, which might have served as the site of discovery for the creator's experience and the reader's realisation of historically distanced femininities.

The Biblical stories of Susanna and Judith so favoured in the Baroque period are exemplary (Fig. 5.3). I propose that we do not consider them merely the means by

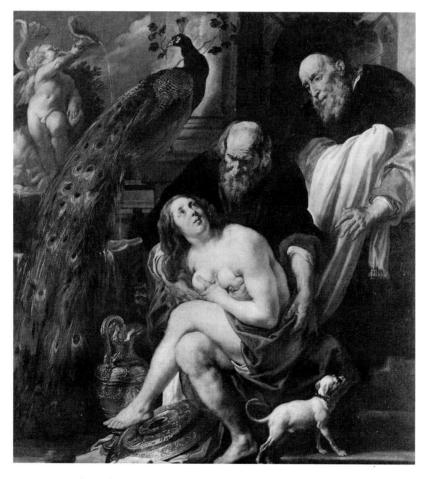

Fig. 5.3 Jacob Jordaens (1593–1678), *Susanna and the Elders*, *c.*1630, oil on canvas, 189 × 177 cm. Brussels, Museum of Fine Arts

which Artemisia Gentileschi 'expressed' her violated female self, which she 'knew' before its representation. The stories and the changing forms of their representation and hence of their potential meaning and affect provided metaphors through which, whatever the psychological impact of the event, her trauma may have found the relief of representation. The bar of repression is both the structural mark of entry into Language, the Symbolic Order, and the local boundary of a historically specific symbolic order. We cannot, therefore, assume we know what meaning these events had. We have the texts of the trial and we have the paintings done by the chief witness at the trial. Each of these is a socially mediated and semiotically framed site of 'articulation'; in specific ideological ways, these texts structured the meanings given to these events. If we assume that Roman courts in seventeenth-century Italy offered, even in their historical specificity, some aspect of a patriarchal logic with regard to sexual crimes, as well as both a class and a political logic, it may be that some of the affective trauma of the events as Artemisia Gentileschi experienced them could not be articulated in the representation of a female body in a legal dispute as damaged, previously soiled or still pristine goods. The metaphors were inappropriate to 'relieve' the woman, to give her the *jouissance* of allowing the pressure of traumatic injury to pass into discourse – to be put at a distance. Then should we not examine the paintings in detail for the ways in which creative work under certain pressures might deliver into artistic discourse meanings other than those already caged in existing metaphors?

The stories and the repertoire of the prior representations of Susanna and Judith are metaphors which might have to be turned and shifted in order to articulate the inarticulate material of the sexual violation and what it might have meant to this Roman woman in a semiotic universe shaped by existing legalities and cultural narratives. Thus the images need to be read at a distance from the artist – for the articulating distance that representation created for the subject who was the artist. I sever the two for a moment to insert the relation as problematic – and get away from the legendary form of biographically construed artistic subjectivity, which effectively collaborates with canonical devaluation of women artists.[36]

The *topoi* of Susanna and Judith were highly popular at the time with artists and patrons alike, and it would be the purest example of dehistoricising and over-personalising the work of a woman artist to detach her from that cultural context in which images of sex and violence were so imaginatively central. Rather, therefore, than imagining that we can read these images for the personal response to a trauma, we have to wonder how an artist could deal with a subject, such as sexual assault, that in its public currency in the artistic repertoire, represents situations which she has herself experienced, but from the position that the topic and its traditional artistic representations effectively objectify. How do you paint *for* and *as* the victim, on the way to becoming a survivor using an iconography that presumes a viewer who could not be the victim? These topics that were so central to Baroque narrative painting did present opportunities for some women artists because they apparently figure heroic women so prominently. Yet, by the same token, the meanings they traditionally signify are not in the end about women. 'Woman' as Susanna, Judith, Lucretia, Cleopatra is a

sign, communicated between men in their use of women's chastity or sexuality as the token of their relations to, commerce between and competition with each other.[37]

The conjuncture of Artemisia Gentileschi, the subject of that set of historical events and the author of a painting of the mythical subject Susanna which the events postdate, still poses the question of why this woman could and would depart from the dominant prototypes of the theme. If we read *Susanna and the Elders* (Fig. 5.2) as a painting by this woman, Artemisia Gentileschi – there is still debate about attribution, even though the work is signed and dated – we might then ask: What space was it possible to carve out of the iconographic repertoire by the reconfiguration of forms and bodies, colours and meanings on the canvas? Mary Garrard's reading of *Susanna and the Elders*, of the awkwardly twisting, and distressingly exposed body, surmounted by the anguished face in a painting that places us so close to the vulnerability of the naked woman with the men so menacingly near, is true to what we now see. But how do we understand what we are seeing, historically? If the work were so deviant, why would it have been painted, bought and hung? What are the conditions for its renovation or deviation other than in the positing of the artist as a woman whose experience we can safely assume we understand? Are there not other readings of the same material, in which such vulnerability and anguish might, for instance, heighten the sadistic pleasure offered by the painting? Is that body's exposure and titillation for a male viewer not as apparent as in the other paintings of this theme, when the naked body is there so directly in the foreground, exposed to us even while it turns to hide itself from the menace of the prying lechers whose view is obstructed all the better to facilitate ours?

Such paintings are a space in which possibly contrary meanings could vie with each other. While none is excluded, some may be preferred, according to the perspective of the reader or viewer, and whether or not they are reading within a dominant or subordinate cultural formation. At this level, the picture does not 'express'. It is a productive site for several possible meanings, where Artemisia Gentileschi worked over existing materials and conventions, reshaping them to permit certain inflections but without control of the range of meanings once her work entered the social contexts of consumption. It is, therefore, possible that a deviant reading co-exists with those that would sell the painting to a patron insensitive to these other possibilities of this artist's treatment of her subject. Which meaning will prevail ultimately depends upon the desire of the viewer. That desire is gendered, hence it is always political. Feminism creates the conditions of our wanting stories of ourselves, stories of women, of seeking clues to feminine traces in the dominant metaphors of sexuality in our varied cultures.

Yet we are still imagining the painting as Mary Garrard has represented it to us in terms of a scene of threatened male-inflicted sexual violence. The seventeenth-century viewer of the painting, knowing the story, might well have perceived this scene through the anticipated conclusion of the narrative. The elders are put to death for their transgression of the laws governing men's right of possession of women, regulating who is allowed to look at an already claimed woman: Thou shalt not covet thy neighbour's wife. The narrative is fundamentally about the legal versus the illicit

use of a woman's body by men. The story instates the husband's rights over the elders' desires, giving it an Oedipal dimension since cross-generational masculine desire is punished through the legally established status of the woman as a man's chaste wife; that is, a woman possessed only by one, younger man.

The late Shirley Moreno worked upon the emergence of the erotic nude in Venice in the sixteenth century in relation to the negotiation of marriage rules and kinship systems. In addressing the sexuality in play in paintings of the nude, she argued against a non-historical analysis of the nude in terms of modern conceptions of generalised male eroticism. In many of the Ovidian stories used by Titian in his cycle of paintings of the erotic nude for Philip II of Spain, a high-ranking woman, her nudity signifying her purity in the case of the chaste Moon goddess Diana, is watched illegally by a mortal man whose subsequent fate is death. Paintings such as *Diana and Acteon* (Edinburgh, National Gallery of Scotland) must be read as monitory: displaying the field of visual temptation while protecting the viewer against the due punishment for the transgression of illicitly seeing a prohibited woman's nakedness by locating a surrogate man within the painting, or the story, who would bear the pain of death.[38]

The painting *Susanna and the Elders* (Fig. 5.2) creates some singular effects. The most compelling is created by the radical compression of the space within the painting. Perspective is what Artemisia Gentileschi was to study with Agostino Tassi, her teacher turned rapist. Perspective, more than a useful skill, represented not merely a technology for the production of the illusion of space on two-dimensional surfaces; it was a discursive construction of a world and a way of establishing an ideological relation to that world, measured, mastered, displayed, legible, rational, mathematically calculable. Perspective rendered visually represented space symbolic.[39] There is very little space in the *Susanna*. This is probably a result of a lack of initiation on the part of the painter into the intricacies of establishing space according to this system. That lack, however, creates the painting's affective edge; it gives it its dramatic intensity and creates its profound ambivalence.

The viewer is offered a viewing position that is notionally in the bathing pool or mikveh.[40] That is to say, the viewer can have no rational relation to this space as an observer. We are too close to what is going on. This excessive proximity is repeated in the positioning of the over-large elders, who loom over the stone seating so close that they could reach out and touch the bathing Susanna, while they appear to behave as if they are lurking at a sufficient distance to conspire in whispers while merely watching her. In Rubens's near-contemporary version of the subject dated 1609–10, there is a similar compositional use of a formal garden setting with stone balustrade and ornamental bath. But one of the elders dramatically bestrides the balustrade and touches the naked skin of the woman from whom the other man is pulling away the drapery. As the Susanna figure leans away from their assault, the whole composition takes on a dynamic leftward thrust compensated by the woman's slightly astonished look back at the intruders.[41] Rubens strives to bring all the figures into a narratively created conversation, centralising the focus and using this centrifugal composition to signify the intrusive intimacy of the illicit scene.

In Artemisia Gentileschi's painting, the men and the woman exist in radically different zones. The elders are painted as a unit, blocked off over the balustrade, talking to each other. The plain, blue sky roughly forms a backdrop. Where are the trees so crucial to the narrative (the elders' deceit is revealed because each tells Daniel that he spied Susanna's adultery taking place under a different type of tree)? Where are the signs of the garden so common in other settings – creating an Edenic situation to displace the stark conflict of male concupiscence and female nakedness? Instead of a developed setting, the painting does not provide that implied narrative through detail and excess. In a simplicity that bespeaks the artist's immaturity (that is her only half-cooked training and induction into how to manage the conventions of her chosen models), the drama of the situation is revised to pose a doubled masculinity – one old, one young – against an anguished femininity – a young, naked woman. Unlike other versions of this theme, the painting does not correlate the viewers with the view of the elders, leching under the cover of trees while the young woman blithely carries on with her toilette, exposed to a view which embraces both the men within and those without the painting's fictional space (for instance in Jacopo Tintoretto's version of 1555–6 in Vienna, Kunsthistorisches Museum). Artemisia Gentileschi's painting is thus not a metaphor for viewing, for visual pleasure which is sexually inciting. Nor does it dramatise the men's intrusion and unwanted proposals. The exposed and the con-spiring are rudely juxtaposed within the awkwardly compressed space. The distance necessary to allow them to articulate into a narrative is denied. I suggest that Artemisia Gentileschi's paintings exhibit a tendency that undercuts the narratives of her selected *topoi* to reveal, in tableau form, the oppositions that underlie and structure the tale. In looking at her painting, we are made to ask: Why in this instance is Susanna so distressed given the stage of the story represented?[42]

There is an excess in the nude body, in its sharp body-creasing twist, the flung-out hands, the taut neck and the downcast head. The face of Susanna is also disturbing. Its expressive tenor is pitched almost too high and its position draws it away from the body, creating distinct registers of representation. This tension suggests two different exemplars for facial expression and for bodily gesture being used in dissonant conjunction in one painting, troubling the ideological freight that any template from contemporary art might be bringing with it. These elements of pose, gesture and facial expression, the grammar of historical painting bequeathed by the High Renaissance Academy, endow the female body that is the luminous centre of the painting with an energy, a pathos and a subjectivity that does indeed run counter to the figuration of the female nude as a display, and thus it undoes some of the genre's canonical mean-ings. That shift in effect is not, I would suggest, the result of Artemisia Gentileschi's knowing intention or of her experience. The painting might suggest the tentative beginning of a possible grammar, arising out of inexperience as an artist, resulting from difficulties in resolving the integration of elements and of managing space as a narrative device. The unexpected power and intensity of the image is the outcome of a working process through which the artist might have recognised a way of putting figures together that could be used again, knowingly, purposively, to be the signs by

which a feminine difference might be inscribed across the texts of a culture that provided only stories that rehearsed the exchange of women between men. Equally these same elements could be read sadistically through an identification with the elders against the woman. Yet the imagined masculine viewer would want to be detached from their fate and find a way to delight his vision while enjoying the protected distance of a known narrative where there is also the Daniel figure, the rescuer and redeemer of the terrorised woman.

Mine is only a tentative counter-hypothesis, one semiotic reading of the painting that seeks to trace the level at which I might look for the inscription of difference. The difference is thus both simply that which is other, not the same as the dominant masculine meanings embodied in narrative representations of Susanna, and that which is what those dominant meanings decree to be the feminine. The woman artist works in the dark, seeking a gap between those two. It is that space of possibility that, as feminists, we desire to see. The aberrant details in a painting that does not achieve resolution of its elements give me the clues I desire to find about how a woman artist might have found her difference through the very act of making art, which is the process of working the canon in the presence of which she seeks to find herself as an artist.

DECAPITATION OR CASTRATION: *JUDITH SLAYING HOLOFERNES*

The art historian and Baroque expert R. Ward Bissell writes: 'It was also natural that she should represent – even identify with – the famous heroine. Indeed her grizzly rendition of *Judith Decapitating Holofernes*, now in the Uffizi, makes one wonder, whether, consciously or unconsciously, Artemisia did not cast Agostino Tassi in the unfortunate role of Holofernes.'[43]

The subject of Judith and Holofernes is, however, not a revenge theme. Its biblical basis is the story of a political execution carried out by a widow[44] who puts herself at risk in the camp of the besieging enemy in order to kill the general, and thus to dishearten his troops and liberate her people from a deadly siege which her slain enemy has mounted. The story dates from a late period in Jewish history, around the second century BCE, and it would seem to be an allegorical reworking of older, historical texts in which women killed politically significant men in similarly critical politico-military situations. The biblical book of Judges provides us with the stories of Yael's murder of the General Sisera; Delilah's delivery of Samson to his enemies; and an anonymous woman's execution of Abimelech who was besieging the tower from which the woman dropped a millstone on his head.

Mieke Bal's feminist analysis of the man–woman murders and woman–man murders chronicled in *Judges* exposes what she names the structural dissymmetry between the motivations and meanings of cross-sex murders.[45] She examines the differences between the women as victims and the women as executioners and stresses

that, in these stories, women kill for political reasons, in the interests of their people. Although there may be sexual elements in each of the stories – Delilah, Yael and the anonymous woman in the tower they are subordinated to the larger cause and purpose of actions in a military context. Yet the later mythic meanings of Delilah and women created on that model overwhelmingly focus on sexuality, which is then endowed with a lethal danger to men. Sex, not politics, kills.

The biblical stories in *Judges* provided *topoi* for Christian art. In the secular art of the Middle Ages the seeming subversion of social order represented by women killing men became a popular theme for a monitory moral tale known generically as 'the power of women' or 'women on top'.[46] Through tales of the inverted state of relations between the sexes, the threat and anxiety associated with it could be both representationally acknowledged and, in the same act, presented as perversion.[47] The representation of 'women on top' works metaphorically to delegitimate women from any role other than of subordination since their uppityness signifies only disorder, an unnatural reversal of the divinely ordained hierarchy of the sexes.

In the Baroque period the stories from *Judges* provided rich resources for artistic representation. The biblical and canonised Yael and Delilah, so popular in medieval secular art, however, lost place to Judith. In the complex ideological projections for this figure, operating like Susanna in the spaces contradictorily emerging for sexuality in visual representation at the crossroads of Counter-Reformation Catholicism and modern formations of the secular nation-state, the *mythos* of Judith was reworked to elaborate a specifically sexual dimension to the events clearly stated in the Apocryphal text as having political not sexual meanings.[48] In an essay on Artemisia Gentileschi's painting of Judith, Roland Barthes reports the tale simply. Judith, a Jewish heroine, leaves the city under siege, goes to the enemy general, seduces him, decapitates him and returns to the camp of the Hebrews.[49] Barthes rehearses a number of modern versions of Judith which attribute complex psycho-sexual motives to her killing: Judith is willing to kill for patriotic reasons, but succumbs to Holofernes out of desire and recovers herself to kill him for personal revenge for this sexual awakening; Judith, still a virgin despite being a widow, wants to be famous. In his genuine love for her, Holofernes recognises this. He offers himself to her. She is overwhelmed and allows herself to be seduced, but recovers self-control to cut off his head. Barthes concludes his survey on what the transformations of the story tell us: the ambivalence of the bond, at once erotic and funereal, which unites Judith and Holofernes.

Even were we to allow this sexualisation of the drama, it would be important to stress that Judith's killing of Holofernes then results from a disturbance created by pleasure, sexual arousal, *jouissance* and not from rape. It is a narrative of imagined seduction and death in which the man is used sexually, and suffers punishment at the hands of a woman, made to signify only disordering sexuality. Not only does the theme bond Judith and Holofernes through the linking of the erotic and the lethal but it links female sexuality and death in direct opposition to the story's original elaboration of a *topos* of woman and political, altruistic and nation-saving execution.

In her study of Artemisia Gentileschi's contemporary Rembrandt, Mieke Bal argues that these stories can be treated as myths. Bal redefines myth as an empty screen on to which the user, viewer or reader projects. This projection takes place in the context of what she names a transference relation. In so far as painting or literature are themselves responses to other responses to mythic stories, there comes to be a sequence of transferences in which painter/writer and reader/viewer are part of the relay along with the texts they make or read.

> The difference between myth and literary text or artistic image, like that between primal and other fantasies, is to be situated on the level of the transferring subject and its relation to myth – to an empty screen. The *illusion* of the stable signified allows the user of the myth to project more freely onto the screen. But what s/he takes to be a signified, actually functions as a signifier . . . It has no meaning, but supports meaning, providing the subject's projection with a means of getting rid of its subjectivity and thereby granting subjective projections universal status.[50]

Transference as a hypothesis for analysing cultural texts and images liberates us from either the mastery attributed to the original text from which the subject matter derives or the mastery of interpretation as the finding of the true meaning projected onto the author to disguise the subjective investment of the interpreter. As Mieke Bal concludes, there is no story, just the tellings. Each time the telling opens up meanings and possibilities, unfixing, for instance, the meaning of the woman in the story. 'The importance of the telling reassigns responsibility, taking it from the teller, who disposes of the means to propose his or her own view, and assigning it to the viewer, reader or listener, who takes over by processing the works.'[51] In this light, I want to draw three conclusions.

Firstly, by focusing on the story of Judith and the varied projections the armature of this tale has sustained, I can get away from the tendency of psycho-biographical 'reading in'. Instead I shall be concerned to do detailed work on the 'tellings' of the Judith myth by Artemisia Gentileschi in order to trace through that actual re-signification of the mythic components the difference that might mark this subject's projections and create a screen for my own, different, feminist desires.

Secondly, this allows me still to have access to the particularity of a subject, Artemisia Gentileschi, but not as author and self-authoring artist. Rather she, like the analysand in the metaphor of analysis, is learning what she is through the analysis of her own transferences. The myth is the empty screen on which text or image incises a particular set of meanings shaped by the exchange between the projections made by the artist and the possibilities of misrecognition and projection offered by the myth. Artemisia is not Judith and is not identifying with Judith; she may, however, have found something of herself in the whole composition – its lighting, colour, scale, space, figures – that she carved on to this culturally provided screen.

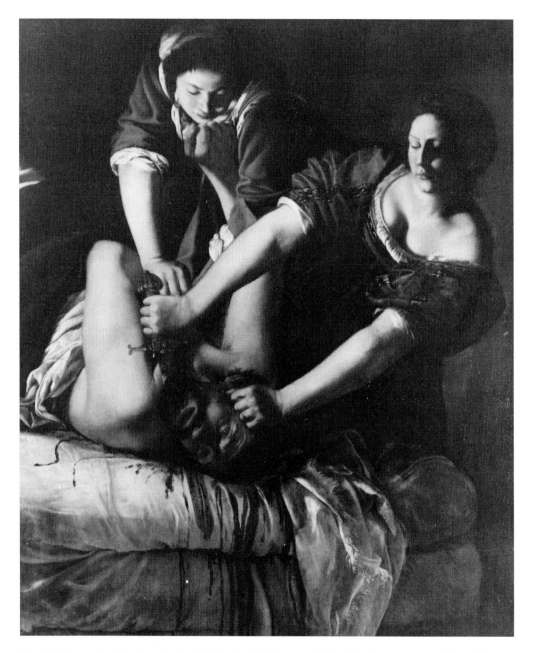

Fig. 5.4 Artemisia Gentileschi, *Judith Slaying Holofernes*, 1612–13, oil on canvas, 168 × 128 cm. Naples, Museo di Capodimonte

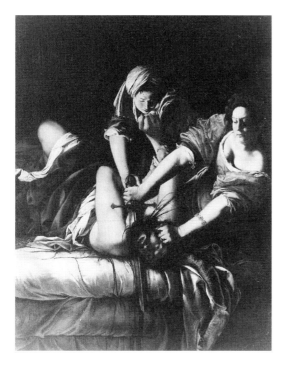

Fig. 5.5 Artemisia Gentileschi, *Judith Slaying Holofernes*, *c*. 1620, oil on canvas, 199 × 162.5 cm. Florence, Galleria degli Uffizi

Thirdly, if, having distanced myself from both biographism and authorship, I am, as a viewer, made responsible for both reading for the artist's transference and recognising my own, I discover yet another layer to the process which prevents this way of thinking from inviting a notion of 'anything goes'. This is not the royal road to relativism. Mieke Bal's term is *responsibility*, and it comes close to what I am offering in the notion that what motivates reading and interpretation is desire, and that we are responsible for recognising such desire. Thus the transference taking place when we look at paintings needs to be analysed. If not, we may misrecognise whose meanings we are playing before ourselves in an act of mastery that pretends to be mere discovery of a truth that inheres in what we see.

In 1620 Artemisia Gentileschi painted another version (Fig. 5.5) of *Judith Slaying Holofernes* (1612–13, Fig. 5.4). The slight difference between these two works is a measure of the claim, 'it's all in the telling'. The major difference lies in the effects created by the expanded space of the later painting. There are minor differences in the details: Judith wears a gold bracelet on her holding arm in the 1620 version. The coverlet is of a different colour. Blood spurts out of the wound. In the later version the colours are brought into an overall harmony of gold and deep red. But the whole composition is set back from the viewer by enlargement of the bed and the addition of darkness above the figures. The body of Judith leans further towards the right-hand edge of the canvas, loosening the dynamic thrust of her action. The whole scene becomes a static tableau that, for all the apparent recreation of the original elements, creates a far less intimate and dramatic effect.

The 1612 Judith (Fig. 5.4) derives its specific character from an intensity of pose and the spatial proximity of the characters to each other and the scene to the viewer. The dark enclosure of the background stands both for the narratively required tent and the growing interest in and competence at using a Carravagist lighting style. The viewer is made to feel close to the event. We are placed at the end of the bed or couch. Perhaps we feel placed as the object of appeal for the upturned desperate eyes of the suffering man. He looks out from that claustrophobic space in a gaze that is on the edge of living terror and encroaching death. The eyes of the two female figures are hooded by their lids as they direct their attention down converging lines of vision that form two sides of a triangle whose apex is that distorted, grimacing, ghastly masculine face.

Dressed in her wine-red garment, Abra, Judith's maid, peers with remarkable *sangfroid* over the outsized fist that should make violent contact with her blouse or dress, but doesn't. Abra's position towering over the supine general's torso creates the painting's sense of depth – promising a space from which she comes and creating further dimension by moving towards him and thus the spectator. Against this axis, Judith stands off-centre, on the right, dressed in a gold trimmed, low-cut, short-sleeved blue robe, calmly balancing herself to accomplish the tricky business of cutting through a man's neck. She is strongly modelled because of the powerful use of dramatic chiaroscuro which rounds her shoulders and arms and leaves half her face in shadow. The painting's style is the obverse of the 1610 *Susanna* (Fig. 5.2). Darkness and night replace overall illumination of a daytime scene. Interior replaces exterior. Rich robes replace female nakedness. Two women impose on one man, whereas, in the earlier painting, one women suffered the intimidation of two men. Death replaces concupiscence. Yet, in that use of the triangle of three figures, in the combination of two agents and one victim, one a woman in anguish, the other a man in mortal agony, we might discern a compelling structure that the artist found useful and able to rework.

The story and the means of representing it came to Artemisia Gentileschi through a sequence of masculine transferences and projections which constantly remodelled the mytheme of woman–man murder. Caravaggio had painted a *Judith Decapitating Holofernes* (Fig. 5.6). It lays the story out on a single plane, filling in the background with heavy drapery. A very young Judith, frowning in concentration, has already got a good way through Holofernes's neck. His mouth gapes, his eyes strain up towards his killer. His face is bearded. Judith holds his hair, which fringes through her fingers. Judith stands to the right of the painting, her arms forming strong lines of force framing his head. Abra is, however, an elderly woman peering with intense interest at the beheading from the extreme right. In suggesting, as we must, that Artemisia took much from this painting, I hope to bypass art history's favoured route of transmission: influence (which, in the case of women, is always detrimental). We could think of reference and citation as means to ensure the genealogy of the later painting, its belonging to the grouping founded by the man from Caravaggio. This would invoke on the painting's behalf connotations associated with that school. We could also think of more subtle transpositions. What if the artist takes over most visibly the awful

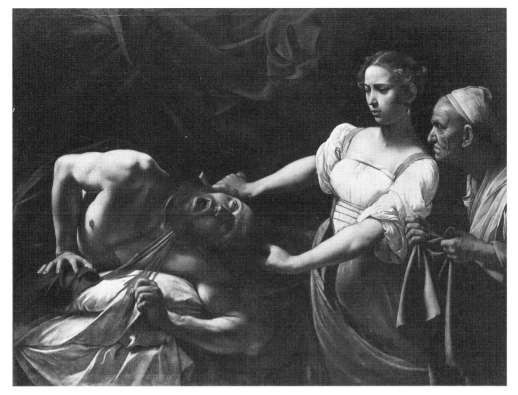

Fig. 5.6 Michelangelo Merisi da Caravaggio (1573–1610), *Judith Decapitating Holofernes*, *c*.1599, oil on canvas, 144 × 195 cm. Rome, National Gallery of Antique Art (Palazzo Barberini)

excessive grimacing face of the dying general, turning it round, making it appeal directly to the viewer? Does not the quotation from the Caravaggio painting function as a bit of 'Caravaggio', included in her painting, making clear her loyalties, her interests and where she shall make her difference?

Her father Orazio was one of Caravaggio's earliest Roman followers. He painted *Judith* (Fig. 5.7) in a very clear combination of Caravaggist simplicity and his own, purer colours. Orazio creates a classical composition with Judith and her young maid forming the two sides of a central triangle. Each looks away creating a centripetal force that frames but refuses to direct the look at the peaceful, unblemished head they cradle between them in a basket on Judith's knees, while she still holds the weapon. Caravaggio's version is about dying, killing, action. A woman versus a man and a spectator form his company of actors. Orazio's version takes places in the aftermath, two women together with the trophy, the token of absent manhood. Judith is made phallic with her sword but maternal with her bounty, the male baby-head. The drama of the scene is the attention the women are paying to what is beyond the scene depicted – a scenario Orazio's daughter would also take up and rework with Caravaggist intensity in 1625 (now in Detroit, Institute of Arts). Artemisia Gentileschi's *Judith*

121

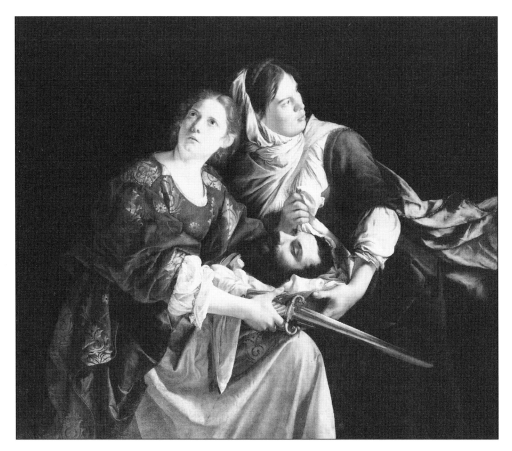

Fig. 5.7 Orazio Gentileschi (1563–1639), *Judith and Her Maidservant Abra with the Head of Holofernes*, 1610–12, oil on canvas, 143.9 × 154.3 cm. Hartford, Wadsworth Atheneum (The Ella Gallup Sumner and Mary Caitlin Sumner Collection Fund)

Slaying Holofernes incorporates, invokes, defers to and differs from Caravaggio through the obvious use of key elements of his version – Judith's arms, her furrowed brow, the expressionism of Holofernes's head. It also takes over the triangular composition of Orazio's work, but inverts it to create this focused, intense drama of action – Caravaggist – in opposition to the passivity of Orazio's frieze. Yet the action of Judith, doing the unpleasant work, which Roland Barthes suggests would have come more easily to the maid, used to gutting animals and dealing with dead meat, is enacted upon the most Caravaggist moment of the painting.

In a sense, therefore, the screen was not empty. For women artists it is already filled with masculine projections. Making a claim for oneself as the only daughter of an established painter and one of a still small number of women painters in Italy at this period would involve not only the murder of certain internalised prescriptions on femininity but also a symbolic killing of the fathers, who were both figures of necessary identification and professional rivalry. It required a specifically feminine, filial

engagement with the 'anxiety of influence', which Harold Bloom has insisted is what gives a work its edge and claim to accede to the canon in the face of which the artist is always a latecomer.[52]

My representation of Artemisia Gentileschi has to include her profound connection with her father, an identification with him as his favoured successor, the only bearer of his talent and profession in a family of sons. Like Shakespeare's Cleopatra, Artemisia Gentileschi claimed to have the soul of a man in the body of a woman – clearly a widely used defence at this time against spreading notions of women's feebleness.[53] Yet, as in the case of all other sons, the father is both idealised and to be removed so as to allow the rivalrous son some place in the light. Would we gain another perspective on these paintings were we to go beyond reversing the mainstream biographical trend represented by Ward Bissell, and the inversion of it by Mary Garrard? These paintings were a working through the place of being a daughter-painter – a woman in a genealogy of father figures, who have much to offer and yet must be vanquished for fear they deny the daughter her creative space. That space would have to be hollowed out from a visual world already occupied and figured by their artistic inventions and freighted images.

The painting *Judith* is not about revenge. Yet it is about killing. But it is a metaphor, a representation in which the literalness of killing a man is displaced on to a mytheme wherein the action is necessary, politically justified, not personally motivated. There would be my difference. Not in her tragic biography, 'expressed' in the violent scene of revenge on seducers and rapists. 'Judith' could become a means to structure a desire for a certain kind of artistic identity, that of an active woman who can make art, make herself in that action of entering representation, a kind of killing that is not just in the representation of a kill – a castrating representation that is not a representation of castration. 'Judith' as she is produced from this negotiation of the existing transferences called Artemisia Gentileschi's sources can become both a support for Artemisia Gentileschi's projection of her desire for agency in the world and a figuration of what that desire might be: the image gives it a structure, allows it into articulation, into artistic discourse.

Hélène Cixous wants to encourage women to make themselves women by producing women-texts. Her sense of what these might be involves a specific theoretical construction of femininity and its unacknowledged relations to female corporeality. Thus she writes: 'Let's not look at syntax but at fantasy, at the unconscious: all the feminine texts I've read are very close to the voice, very close to the flesh of language.'[54] This produces a feminine textual body as a trace of a *female libidinal economy*.

The possibility of this difference emerging into texts is created when access to another unconscious is pursued. There is a cultural unconscious which tells us old stories, composed of the repressed of the culture: myths. But when women go beyond the bounds of what that masculine cultural unconscious censors 'in that cheeky risk-taking women can get themselves into when they set out into the unknown to look for themselves', something 'not yet' will become possible. Cixous's call is a call to feminists writing in art history as much as in fiction and poetry. But it also allows us

to retheorise the whole venture of feminist interventions in art history which appears prematurely to know what woman is. To read the oeuvre of Artemisia Gentileschi 'for the woman' is to affirm notions of humanity that may in fact be of masculine origin, and at any rate fall within existing cultural fantasies of 'psychic liberation' (Garrard) and heroism. In my insistence on both a historicisation of the study of women artists, and an acknowledgement of the split and conflicted subject, on psychic structures, fantasies and desire, some readers may well mourn the loss of the celebratory and positive force of the feminism from which stems Mary Garrard's affectionate admiration for Artemisia Gentileschi. Where else lie the pleasures of feminist revisions to the histories of art?

In her essay 'Castration or Decapitation?' Hélène Cixous recounts the Chinese story of how General Sun Tse made his king's 180 wives into soldiers. When first the General drilled the women in rows with drums, the wives laughed and paid no heed. Deeming this mutinous, the general forced the king to agree to their being subjected to the punishment for mutiny: decapitation. The chief wife was executed. The rest of the wives then marched up and down as if they had been soldiers all their lives. Cixous concludes: 'Women have no other choice than to be decapitated, and in any case the moral is that if they don't actually lose their heads by the swords, *they only keep them on condition that they lose them* – lose them, that is, to complete silence, turned into automatons.'[55]

The significance of Gentileschi's paintings of decapitation lies only partially in their function as images offering a specific inflection of an iconography of heroic women. The point is their existence in the field of representation so powerfully dominated by the beat of men's drums, the economy of their desire, the projections of their fears and fantasies through figures such as Susanna and Judith who are turned into castrating women. The presence of an other enunciation from the place of a particular, historical femininity offers a shift in the pattern of meanings in a given culture. This presence of a difference had to be produced; these meanings are not alternative meanings but the effect of differentiations created at the level of textual telling and our reading. *Presence* is not expression but a production against the semiotic and psychic grain of those structures that would 'cut off *her* head', silence her difference as a woman and let 'woman' function only as a 'headless body' – the nude perhaps. Gentileschi's work in its specificity – topic, subject, treatment, syntax – can be read as a transposition of that imposed silence. In her *Judith* subjects as much as in *Susanna*, man is threatened with the violence that is typically, if metaphorically, enacted upon women in a culture that refuses and refutes their creative intellectual participation in it. Some of these images graphically show what that violence looks like, making it *visible* by inverting the gender of its executioners and victims. In that shock, that radical disorder, that world upside down which is the fascination and threat of the *topos* itself, but which her dramatic, bold Caravaggist treatment makes psychologically vivid, a woman's voice is made, speaking another *topos* for the mytheme she has borrowed.

NOTES

1 Hélène Cixous, 'Castration or Decapitation?', trans. Annette Kuhn, *Signs*, 7, 1 (1981), pp. 41–55.
2 All quoted from published art historical sources by Amanda Sebestyan, 'Artemesia Gentileschi', *Shrew*, 5, 2 (1973).
3 Mieke Bal, *Double Exposures* (New York and London: Routledge, 1996) offers some important readings of the Judith subject, especially Artemisia Gentileschi's treatments.
4 I am indebted to the work of Mieke Bal throughout this chapter and especially to her 'Reading Art?', in *Generations and Geographies in the Visual Arts: Feminist Readings*, ed. Griselda Pollock (London: Routledge, 1996).
5 This is the burden of Elizabeth Cowie's crucial article 'Woman as Sign', *M/F*, 1 (1978), pp. 49–64: 'I want to argue that film [or any other regime of visual representation] as a system of representation is a point of production of definitions. But it is neither unique and independent of, nor simply reducible to other practices defining the position of women in society' (p. 50).
6 Julia Kristeva, 'La Femme, ce n'est jamais ça' ('Women can never be defined') *Tel Quel*, Autumn 1974, reprinted in *New French Feminisms*, ed. Elaine Marks and Isabel de Courtivron (Brighton: Harvester Press, 1981), p. 137.
7 For instance, Luce Irigaray contrasts the metaphors of fixity and unity associated with fantasies of masculine bodies with images of plurality – two lips, self-touching – and fluidity associated with female sexuality, and considers the different philosophical implications of such differences. This is quite different from saying that, because the labia touch, women are therefore by nature more open-minded.
8 I wrote these sections before Elizabeth Grosz's important new text was published. To a great extent her arguments provide a profound philosophical support for this tendency in feminist thinking. I am greatly indebted to her work, *Volatile Bodies: Towards a Corporeal Feminism* (Bloomington: Indiana University Press, 1994).
9 I explain this at length in my 'Images/Women/Degas', in *Dealing with Degas: Representations of Women and the Politics of Vision*, ed. Richard Kendall and Griselda Pollock (London: Pandora, 1992; now London: Rivers Oram).
10 Elizabeth Grosz, *Sexual Subversions: Three French Feminists* (Sydney: Allen & Unwin 1989), p. 116.
11 Susan Brownmiller, *Against Our Will: Men, Women and Rape* (London: Secker & Warburg, 1975).
12 Mary D. Garrard, *Artemisia Gentileschi: the Image of the Female Hero in Italian Baroque Art* (Princeton: Princeton University Press, 1989). See also R. Ward Bissell, *Artemisia Gentileschi and the Authority of Art: Critical Essays and a Catalogue Raisonné* (Pittsburgh: State University of Pennsylvania Press, 1998).
13 Garrard, *op.cit.*
14 The story is told in the Book of Susanna, which is part of the Apocrypha but not a canonically accepted text within the Hebrew or Protestant Christian Bibles.
15 Garrard, pp. 188 and 192.
16 *Ibid.*, p. 189
17 *Ibid.*, p. 194
18 *Ibid.*, p. 200
19 'This is not to insist that all art by women bears some inevitable stamp of femininity; women have been as talented as men in learning the common denominators of style and expression in specific cultures. It is, however, to argue that the definitive assignment of sex roles in history has created fundamental differences between the sexes in their perception, experience and expectations of the world, differences that cannot help but be carried over into the creative process where they sometimes leave their tracks.' (*Ibid.*, p. 202).
20 *Ibid.*, p. 208.
21 Giorgio Vasari, *Le vite de' piu eccelenti pittori, scultori e architettori nella redazione 1550 e 1558*, ed. R. Bettarini and P. Barocchi (Florence: Sansoni, 1966–71, and Spes, 1976–87). On

Vasari and biography see also Patricia Rubin, 'What Men Saw: Vasari's Life of Leonardo da Vinci and the Image of the Renaissance Artist', *Art History*, 13, 1 (1990), pp. 34–46.

22 Nanette Salomon, 'The Art Historical Canon: Sins of Omission', in *(En)gendering Knowledge: Feminists in Academe*, ed. Joan Hartmann and Ellen Messer-Davidow (Knoxville: University of Tennessee Press, 1991), p. 229.

23 *Ibid.*, p. 230.

24 Karl Marx, *The Eighteenth Brumaire of Louis Napoleon* [1852], reprinted in K. Marx and F. Engels, *Selected Works in One Volume* (London: Lawrence & Wishart, 1970), p. 96.

25 Jean-Paul Sartre, 'Class Consciousness in Flaubert', *Modern Occasions*, 1, 2 (1971), pp. 379–89. A feminist version of this model, also transformed by dealing with a working-class girl's childhood, can be found in Carolyn Steedman's double autobiography, *Landscape for a Good Woman* (London: Virago Press, 1986). She also reworks Freud's legend of the little boy's traumatic glimpse of female genitals – read as lack and thus castration – to explore the discovery by a working-class child that her parents lack power in relation to bourgeois authorities.

26 Sartre, p. 381.

27 Salomon, p. 230.

28 In the following chapters I intend to question even more the issue of autobiography as even possible for women. Here we must keep the question open for it to be in play.

29 Claude Lévi-Strauss, *The Raw and The Cooked* (Harmondsworth: Penguin Books, 1964).

30 Cathy Caruth, 'Introduction', *American Imago*, 48, 1 (1991), special issue, *Psychoanalysis, Culture and Trauma*, pp. 3–5; reprinted as *Trauma: Explorations in Memory*, ed. Cathy Caruth (Baltimore and London: Johns Hopkins University Press, 1995).

31 *Ibid.*, p. 5.

32 *Ibid.*, p. 9.

33 Inability to walk, because a patient feared to go forward in life; pain in the face because a remark had felt like a slap on the cheek, and so forth.

34 Michèle Montrelay, 'Inquiry into Femininity', trans. P. Adams, *M/F*, 1 (1978), pp. 95–6.

35 *Ibid.*, p. 96.

36 See G. Pollock, 'Artists, Mythologies and Media . . .', *Screen*, 21, 3 (1980), pp. 57–96.

37 Luce Irigaray, 'Commodities among Themselves', in *This Sex which is Not One*, trans. Catherine Porter (Ithaca: Cornell University Press, 1985), pp. 192–7.

38 Shirley Moreno, *The Absolute Mistress: The Historical Construction of the Erotic in Titian's 'Poesie'*, unpublished M. A. thesis, University of Leeds, 1980. Shirley Moreno was working on a doctorate on this theme at the time of her death.

39 Michael Baxandall, *Painting and Experience in Fifteenth Century Italy* (Oxford: Oxford University Press, 1972); Hubert Damisch, *The Origin of Perspective*, trans. John Goodman (Boston: MIT Press, 1994).

40 Under Jewish rules of purity (*niddah*) women are required to bathe to mark the end of their menstruation. Thus the position of a woman at her bath might have acquired specific sexual connotations for it proved that she was both 'pure' and sexually approachable, i.e. that her husband could again have sex with her. The text, however, specifically mentions that Susanna bathed because it was hot.

41 An earlier painting of the subject by Rubens, probably painted during his sojourn in Italy, of 1607–8 (Madrid, Real Accademia de San Fernando) also used the device of placing the naked Susanna in the foreground against a balustrade. But in this painting she must twist round and look up at the figures looming over her into her space.

42 Tintoretto shows Susanna unaware and self-absorbed. Later versions that postdate Gentileschi's show Susanna cowering as the elders come forward to make their proposals.

43 R. Ward Bissell, 'Artemisia Gentileschi – A New Documented Chronology,' *Art Bulletin*, 50, 1 (1968), pp. 155–6.

44 Judith – Yehudit – the feminine form of the generic term Yehuda, a descendent of Judah, from which is derived the term *Jewish*. She is thus a representative daughter of Israel rather than a singular character in a story. Her widowhood is also representative: of a nation lacking the necessary male warrior-redeemer.

45 Mieke Bal, *Death and Dissymmetry: The Politics of Coherence in the Book of Judges* (Chicago: University of Chicago Press 1988).

46 Susan L. Smith, *The Power of Women Topos and the Development of Secular Medieval Art*, Ph.D., unpublished thesis, University of Pennsylvania, 1978.

47 Nathalie Zemon Davis, 'Woman on Top', in *Society and Culture in Early Modern France* (Stanford: Stanford University Press, 1965).

48 Judith goes to Holofernes's camp and offers to serve his King. For this she is rewarded with respect and protection. She is invited to dine with the general. She cannot eat his meat so must always bring her own in a bag. She also gets permission to leave the camp each night to pray. After a week, establishing these routines, Holofernes invites her to dine and hopes to seduce her. He gets himself hopelessly drunk and falls on to the bed. His servants have tactfully left Judith and the general alone. She singlehandedly strikes off his head and hides it in the bag her waiting servant carries her meat in. They then walk out of the camp – to pray as usual – but in fact return to Bethulia, the besieged town where Judith shows off the severed head. Judith lives to the age of 102, in honour, unmarried for the rest of her long life.

49 Roland Barthes, 'Deux Femmes/Two Women', in *Artemisia*, an issue of *Mot pour Mot/Word for Word*, 2 (Paris: Yvon Lambert, 1979), p. 9. I am grateful to Nanette Salomon for the reference to this text and the lengths she went to to enable me to read it.

50 Mieke Bal, *Reading Rembrandt: Beyond the Word–Image Opposition* (Cambridge: Cambridge University Press, 1991), p. 99.

51 *Ibid.*, p. 127.

52 Bloom stresses the relation of his arguments on the anxiety of influence to his notion of the canon in his *The Western Canon: The Books and Schools of the Ages* (New York: Harcourt Brace, 1994), p. 8.

53 Artemisia Gentileschi wrote to Don Antonio Ruffo on 13 November 1649: 'You will find the spirit of Caesar in the soul of this woman.' Cited in Garrard, p. 397. She also quotes as an epigraph Boccaccio's statment: 'I should think that Nature sometimes errs when she gives souls to mortals. That is, she gives to a woman one that she thought she had given to a man' (p. 141).

54 Cixous, p. 54.

55 Cixous, p. 43.

Fig. 6.1 Man Ray, *Virginia Woolf*, 1934, photograph. London, National Portrait Gallery

6

FEMINIST MYTHOLOGIES AND MISSING MOTHERS

Virginia Woolf, Charlotte Brontë, Artemisia Gentileschi and *Cleopatra*

To re-read as a woman is at least to imagine the lady's place; to imagine when reading the place of a woman's body; to read reminded that her identity is also re-membered in stories of the body.

Nancy K. Miller[1]

Re-vision – the act of looking back, of seeing with fresh eyes, of entering an old text from a new critical direction – is for women far more than a chapter in cultural history: it is an act of survival.

Adrienne Rich[2]

A FEMINIST MYTH OF THE TWENTIETH CENTURY: MURDERED CREATIVITY AND THE FEMALE BODY

In *A Room of One's Own* (1928) Virginia Woolf (Fig. 6.1) imagined a sister for Shakespeare and dramatised the problem of sexuality, gender and creativity in a patriarchal culture. She described the youth of William, a lively and wild boy, well educated – especially in the classics – at a grammar school, precociously sexual. Because of one escapade which led to an early marriage he had to go to London to seek his fortune on the stage. His imaginary sister, Judith, pined at home with the same poet's heart, yet she was deprived of any education to nurture it. Called from the secret reading of her brother's books to mend stockings, she was presented with the *fait accompli* of an arranged marriage by a loving father. Driven by this to run away, she too went to London but found the theatre's doors closed in her face by laughing men who 'bellowed something about poodles dancing and women acting'. She could get no training in her craft, although like her brother she had a gift for fiction.

At last – for she was very young, oddly like Shakespeare the poet in her face, with the same grey eyes and rounded brows – at last Nick Greene, the actor-manager took pity on her; she found herself with child by that gentleman and so – *who shall measure the the heat and violence of the poet's heart when*

129

caught and tangled in a woman's body? – killed herself one winter's night and lies buried at some crossroads where the omnibuses now stop outside the Elephant and Castle.[3]

'Judith's' suicide creates an image of women's internalisation of the social murder of the potential artist 'caught and tangled' in a *woman's body*. For Woolf the gendered corporeality of women can only be antagonistic to creativity in a way which sets her feminism apart from that of the later twentieth century, which has not been obliged to retreat so drastically from the coils of a bodily femininity. Instead we have embraced the problem, and, in diverse theoretical and imaginative forms, struggled to relate them. The contemporary poet Adrienne Rich asks 'whether women cannot begin, at last, to *think through the body*, to connect with what has been so cruelly disorganised – our great mental capacities – hardly used; our highly developed tactile sense; our genius for close observation, our complicated pain-enduring multi-pleasured physicality'.[4]

Virginia Woolf's image of women confined and constrained, isolated, embittered and embattled has, however, been immensely influential, shaping much subsequent feminist literary analysis in ways that have also been replicated in feminist art histories.[5] Thus the general consensus holds that it was hard, if not impossible, for a woman to be an author, or an artist, in this major, canon-forming period: the Renaissance. The accuracy, however, of Virginia Woolf's reading of women's relations to literary production in sixteenth-century England has been challenged, for instance by Margaret Ezell, who argues that in so far as feminist literary scholars took 'Judith Shakespeare's' death as axiomatic, their task became one of explaining the social forces that prohibited or curtailed women's literary activity. Thus scholars perpetually ask why women were *not* writers (or artists), and repeatedly answer the question with reference to patriarchal society's limitations on women. Since this approach collaborates with the masculine canon, Ezell has researched varying modes of literary production in the sixteenth century that reveal the presence of many women writers and poets.

Woolf's conceit of Judith Shakespeare can be read as a feminist myth which paradoxically confirms the canonical negation of women and creativity. I do not mean thereby to dismiss it. The myth and its continuing power to shape the ways we think of women's struggle for art is mythic precisely in so far as it does represent not a historical truth – as Ezell's research reveals – but a psychological one. In her reading of Virginia Woolf's struggle to write for herself and for women, Shoshana Felman places bereavement, and especially the early loss of her mother, in a significant place in the writer's biography. Felman sees 'Judith Shakespeare' as a figure for Woolf's painful search for an 'I' through which to articulate her own story as a writer.

> It is, indeed, a different process of en-gendering that Virginia Woolf is now involved in, in trying – through the interaction of theory, literature and her own life – to *give precisely birth* . . . to 'Shakespeare's sister' not merely as a

female genius but *as a writer of Woolf's own autobiography*; an auto-
biography that, not by chance, encompasses insanity and suicide as the figures
of its own impossibility and of its own annihilation.[6]

Shoshana Felman draws special attention to Virginia Woolf's vivid sense of the
psychological pain of her imagined forebear, Judith Shakespeare. Woolf wrote:

> This may be true or it may be false – who can say? – but what is true in it, so
> it seemed to me, reviewing the story of Shakespeare's sister as I had made it, is
> that any woman born with a great gift in the sixteenth century would certainly
> have gone crazed, and shot herself, or ended her days in some lonely cottage
> outside the village, half witch, half wizard. . . . For it needs little skill in
> psychology to be sure that a highly gifted girl who had tried to use her gift
> for poetry would have been so thwarted and hindered by other people, so
> tortured and pulled asunder by her own contrary instincts, that she must have
> lost her health and sanity to a certainty. . . . That woman, then, who was born
> with a gift of poetry in the sixteenth century, was an unhappy woman, a
> woman at strife against herself.[7]

Repeatedly conjuring up for her readers the image of the empty shelves whereon the
books of plays and poetry by women do not accumulate, Virginia Woolf historically
clothes a contemporary anxiety, her own struggle from within a particular English,
bourgeois family, and at a critical moment in European feminism – the book was
published in 1928, the date of full adult female suffrage. Woolf's powerful feminist
image of 'murdered female creativity', internalised as self-inflicted death – or
threatened sanity – embodied in the myth of Judith Shakespeare, therefore, needs to be
examined for what it reveals about the basis for its negative symbolism in modern
feminist as much as in other cultural historiography and criticism. By missing the
precise historical, psychological and autobiographical foundations for the myth, and
using a myth as a historically valid proposition, feminist criticism has helped to
conceal from us variant histories needed to comprehend women's activities in culture.
As historians we repeat the 'murder' and share in the loss of the missing mothers.

It is not sufficient, however, to disprove Virginia Woolf's negative myth of
prematurely dead or mad women poets. We need to retrieve from it Woolf's desire for
histories that enable women to write or paint without the destructive absences that
Woolf so tellingly witnessed in the displaced form of a myth of origin – a myth
that turns on trying to 'write back through our mothers': a maternal genealogy,
while, because of the canon and its masculinist cultures, everywhere experiencing
an absence so threatening and negating that the past seems but a dark void, a black
hole: death.

At the heart of Virginia Woolf's myth is mourning. Its unspoken knot of affect was
probably connected to her own mother, as Shoshana Felman has pointed out.[8] Re-
read, however, not for this void but for the desire for other histories, Virginia Woolf's

myth of Judith Shakespeare can be turned around to create spaces for the unexpected, a difference within the writing of history that allows these different histories to make a difference.

LUCY SNOWE MEETS CLEOPATRA: THE RESISTANT FEMINIST READER AND THE FEMALE BODY

To counter Woolf's depressing scenario I want to examine another 'figure' for feminist mythology: 'the resistant reader' who appears, at first sight, a more positive role model.[9] In her novel *Villette*, first published in 1853, Charlotte Brontë created a scene in which her leading character, Lucy Snowe, recovering from a breakdown caused by total personal, social and psychological isolation, visits the art gallery in Brussels and finds herself in front of a painting.

> One day, at a quiet early hour, I found myself nearly alone in a certain gallery, wherein one picture of pretentious size, set up in the best light, having a cordon stretched before it, and a cushioned bench duly set in front for the accommodation of worshipping connoisseurs . . . : this picture, I say, seemed to consider itself the queen of the collection.[10]

The introduction to her encounter with the painting reveals Brontë's acute insight into the strategic staging of the visitor's experience of great art – a management of the space of display and an orchestration of a specific gaze:

> It represented a woman, considerably larger, I thought, than the life. I calculated that this lady, put into a scale of magnitude suitable for the reception of a commodity of bulk, would infallibly turn from fourteen to sixteen stone. She was, indeed, extremely well fed: very much butcher's meat – to say nothing of bread, vegetables, and liquids – must she have consumed to attain that breadth and height, that wealth of muscle, that affluence of flesh. She lay half-reclined on a couch: why, it would be difficult to say; broad daylight blazed around her; she appeared in hearty health, strong enough to do the work of two plain cooks; she could not plead a weak spine; she ought to have been standing, or at least sitting bolt upright (275).

Lucy Snowe continues with her perusal of the painting, complaining: 'She ought to have worn decent garments; a gown covering her properly, which was not the case.' Out of vast amounts of material 'she' 'managed to make inefficient raiment' while 'she' allowed complete disarray of pots and pans – 'perhaps I ought to say vases and goblets'. Lucy Snowe concludes: 'Well, I was sitting wondering at it (as the bench was there, I thought I might as well take advantage of its accommodation) and thinking

that while some of the details . . . were very prettily painted, it was on the whole an enormous piece of claptrap.' (276)

Bold words! Few feminist critics today would dare to utter in public such unequivocal distaste and disdain for any of the 'great' pieces of Baroque painting for which this one image generically stands. That is to say, it stands for what the museum conserves as the great culture of the West, narrative history painting celebrating in its complex rhetorics and *mises-en-scène* the stories, myths and legends that sustain that culture and its self-image which are continually reworked, none the less, and refashioned to sanction the new in the name of the constant and unchanging. Brontë identifies the painting as a 'Cleopatra' – a subject that belongs to an extensive genre of image-making using stories and legends of famous women of antiquity to stage complex plays of sex and violence coded as moral allegories of fortitude, chastity, honour and loyalty (Fig. 6.2)

Brontë's biographers have suggested that the description of the painting in *Villette* is derived from a picture that Charlotte Brontë saw in 1842 at the triennial Salon in Brussels, *L'Almée* by Edouard de Bièfvre (Fig. 6.3).[11] The painting of a reclining, dancing girl is certainly an Orientalist work, but it is not a monumental figure and appears quite fully clothed. I cannot accept this identification. Charlotte Brontë was far too knowledgeable about art. The nudity, the scale, the daylight reference, the jumble of *objets d'art*, these all suggest to the art historian a knowledge of seventeenth-century painting: Guido Reni, Rubens, Jordaens and other Old Masters. Indeed, in order to save herself from a career as a governess or teacher, Charlotte Brontë had trained herself to become an artist, for which she studied paintings in the real and in reproduction.[12] In her lifetime she was an exhibited artist. Charlotte Brontë visited the National Gallery and the Royal Academy Exhibition in 1848 and saw the Turner exhibition at the National Gallery in 1849 while also collecting and copying a range of Old Masters from prints.[13]

One painting by an artist known to the Brontë children comes closest to being a specific model. *Cleopatra's Arrival in Cilicia* (1821) (6.4), one of the most renowned paintings by the Academician William Etty, was exhibited in Manchester in 1846 at the Royal Society of the Arts when Charlotte Brontë was in the city with her father for six weeks. The scale of the female body is, however, too slight despite the appropriateness of Brontë's strictures on the nakedness of a body in full daylight. What Charlotte Brontë evokes in *Villette* is, I suggest, an astute art historical conflation of a range of representations of Junoesque women from the seventeenth century whose Rubensian exemplars Brontë would also have seen at the National Gallery or during her stay in Belgium: for instance a *Susanna and the Elders* by Jordaens in the Museum of Fine Arts in Brussels displays some fine plates and goblets in the foreground as well as a well-fed female nude (Fig. 5.3). Charlotte Brontë does take over from de Bièfvre's *L'Almée*, however, the idea of Cleopatra being a woman of colour when she talks of the 'dark-complexioned gypsy-queen' despite the fact that, for the most part, Cleopatra is represented in Western art as a woman of milky whiteness (Fig. 6.2).[14] But the painting – or its subject – is given a highly charged title.

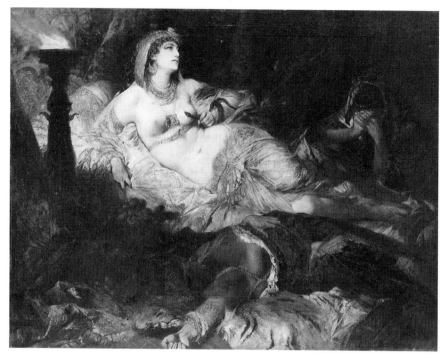

Fig. 6.2 Hans Mackart, *The Death of Cleopatra*, 1875, oil on canvas, 191 × 254 cm. Kassel, Staatliche Kunstsammlungen: Neue Galerie

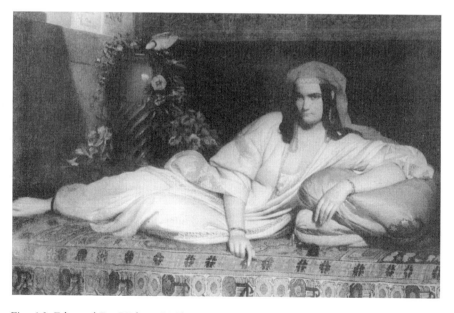

Fig. 6.3 Edouard De Bièfvre, *L'Almée*, 1842, oil on canvas, 41.25 × 181.8 cm. Sold Sotheby's, London, 19 April 1978

The move from dancing girl to Cleopatra is highly significant and needs to be explained.[15]

Historically Queen Cleopatra VII was of the Ptolemaic dynasty, descended from the Greek general Ptolemy who on Alexander's death took over Egypt from the empire the latter had created.[16] Mythically, however, Cleopatra has become a sign in Western culture for an Oriental otherness where both her sex and her culture functioned as a dangerous antithesis to Western ideologies of male dominance. As a ruling monarch who was a woman, from a culture which did not, like Greece and Rome, deny women either public power and authority (women in Egypt inherited property and ruled) or sexual self-determination (women in Egyptian society chose their own husbands), 'Cleopatra' was incorporated into Western culture to perform a complex of fundamentally misogynist roles which dramatise both the East/West opposition Edward Said has named 'Orientalism' and the woman/man conflict typical of a Greco-Roman legacy reclaimed and celebrated in the Renaissance and the Enlightenment.[17] Mary Hamer argues:

> The literal meaning of the name of Cleopatra is 'glory of her father'. But the connotations of the name do not endorse patriarchal authority. The term 'Cleopatra' speaks of the combination of public authority and responsibility with an active female sexuality. It locates political power in a body that cannot be coded as male. In any patriarchal system, it speaks of the transgression of the law. The act of evoking Cleopatra through representation calls that law into question and highlights the position of women within the social order.[18]

Cleopatra perhaps stands as a corrective to Virginia Woolf's pessimism. Here is desire 'entangled' in an empowered woman's body.

In the light of this modern, feminist reading of the sign 'Cleopatra', it becomes evident that Charlotte Brontë's image of Cleopatra as a form of gross physicality, indecency and indolence: coded signs of an unharnessed sexuality, were shaped in nineteenth-century Orientalist terms, confirming yet again that race and gender difference are complexly interwoven in the Western imaginary and that we are always determined by the social formation in which we are positioned as social subjects.[19]

With this important critical proviso, Lucy Snowe might be claimed temporarily as one type of the Western feminist art historian, but in a way that would immediately place 'feminism' exclusively on the side of European, if not imperialist, femininities. In place of awe and deference for the Western canon and its heroic language of narrative painting and sexual spectacle, Brontë's text offers what appears an iconoclastic literalness in demystifying the work, and in apparently wilfully misreading the codes of Baroque art. She refuses to contemplate uncritically the aesthetic beauty offered in representation, searching instead for a reading that brings the work crashing off its pedestal. She opens a way to explore the fissures in an official, sanctioned culture and its narratives by not participating in its games – the language of connoisseurial

consumption and heterosexual masculine scopophilia that the museum consecrates from within a sexually specific economy of desire.

Lucy Snowe's solitary and sceptical analysis of the paradigmatic Cleopatra is distracted by her own visual pleasure in 'some exquisite little pictures of still life: wild-flowers, wild fruit, mossy nests ... : all hung modestly beneath that coarse and preposterous canvas', and then even that pleasure is disturbed by the arrival of a teacher from her school, Monsieur Paul Emanuel. Shocked at her audacity at sitting 'coolly down with the self-possession of a *garçon*', to look 'at *that* picture' alone, he bids her remove herself to a corner of the gallery to study a series of four dreary paintings collectively representing 'La Vie d'une Femme' (The Life of a Woman; composed of Young Bride, Wife, Mother, Widow). These paintings have been identified with a trilogy of works exhibited at the 1842 Brussels Salon titled *La Vie d'une Femme* by Fanny Geefs.[20] Lucy Snowe is as dismissive of this 'sermonising' painting. 'What women to live with! insincere, ill-humoured, bloodless, brainless non-entities! As bad in their way as the indolent gipsy-giantess, the Cleopatra in hers' (278). Charlotte Brontë's text fashions Lucy Snowe's response to the *Cleopatra*, and to nineteenth-century painted ideologies of femininity to claim for her heroine another mythic identity, which is determined in its moment of production as part of the emergent bourgeois feminist consciousness which will later shape the writings of Virginia Woolf.[21]

As a fictional character in a novel, Lucy Snowe represents a claim for a woman to a specific kind of European bourgeois individuality,[22] created by a first-person narrative reliant on repeated uses of 'I thought' ... 'I say' ... 'I was wondering' that appears at odds with the conventions of femininity presented in the novel by the images in the art gallery. The figure of the connoisseur, ensconced on *his* comfortable couch before the 'queen' of the collection, suggests that the relations between painting and viewer mythically permit an imaginative representation of Queen Cleopatra for a specifically masculine and eroticising gaze in which her painted body is the sign of a dangerous yet an exciting sexuality – or sexual excess associated with the cultural other as well as the sexual other. From this exchange women – certainly unmarried women – are structurally excluded even though they may trespass into this space, as Lucy Snowe does by defiantly looking at the painting alone. Women may enter the museum space, but then they should stay at its margins where they can learn themselves through small, didactic paintings that trace the limited spaces of women's permitted place in patriarchy – as objects of exchange and use by men: Fanny Geefs titles her three moments of a woman's life Love, Pity, Sorrow. In that particularly dull corner, Lucy Snowe, an educated self-supporting and desiring woman, is directed to look at woman as only *Young Bride, Wife, Mother* and *Widow*. There she finds no flesh, no luxuriance, no disorder, not even the visual pleasure such as she garnered from the Ruskinian evocations of vital, abundant and natural beauty in the tiny still lifes nestling beneath the 'preposterous canvas'.

Men's access to Western culture is represented as one of vicarious sexuality and permitted visual pleasures; women are meant to look to art to learn their lessons in the

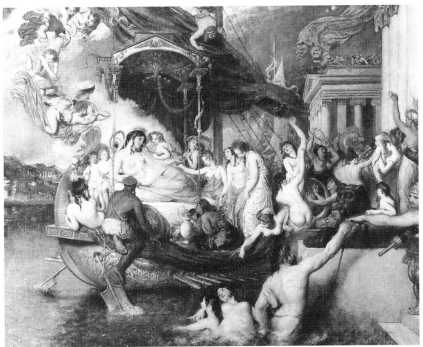

Fig. 6.4 William Etty (1787–1849), *Cleopatra's Arrival in Cilicia*, 1828, oil on canvas, 106.25 × 131.25 cm. Liverpool, Walker Art Gallery

Fig. 6.5 Angelica Kauffmann, *Cleopatra Adorning the Tomb of Mark Antony*, 1770, oil on canvas, 126.5 × 100.3 cm. Stamford, Burghley House, photograph Courtauld Institute of Art.

Fig. 6.6 Edmonia Lewis, *The Death of Cleopatra*, marble, 157.5 × 78.1 × 115 cm. Washington, D.C., The National Gallery of American Art

aesthetically restricted performances of a dull and dulling femininity. Lucy Snowe emerges as a *differencing* articulation of Western bourgeois feminine subjectivity in the textual distance created by yet another opposition – that between her character and the contrast of femininities for men and for women just outlined: Cleopatra, 'a gipsy-giantess', a fantastic, racially othered femininity produced as a masculine projection versus 'the good [white] woman', a mythic representation of the symbolically necessary 'woman-for-man.' But that *differencing* is historically specific and politically loaded, deeply contradictory and troubled – a product of its historical conditions and moment, bourgeois, racist, individualistic, Protestant, Ruskinian – deeply embroiled in the ideologies shaping the pressures and limits of that moment of European women's history and the novel form as the cultural stage for a limited, class-specific and race-specific self-articulation of the bourgeois subject.

This too is, therefore, ultimately a disfiguring myth that, none the less, like that of Virginia Woolf, gives access to the problem of women and culture to which neither tragically self-sacrificed nor self-possessedly resistant femininities provide simple solutions, though the texts in which they are inscribed offer images with which we must, none the less, work critically. The myth of woman in our culture is caught between the absent creator and the overpresent created – woman-as-image – whether produced for visual delectation of men or for the tedious instruction of women.

But what of the women producers, what of the women who painted or sculpted Cleopatra (Figs. 6.5, 6.6)? What would Lucy Snowe, 'the resistant reader', say about such works by women and their representations of femininity and the voluptuous, adult female sexual body? What equivalents might we find for a negotiating and surviving 'Judith Shakespeare' in the form of artists practising in or just after the Renaissance period who instead represented the rape, suicide or murder of women? Given the role of the body in the lexicon of Western Baroque painting, how will we read female bodies painted as imaginative constructions and projections of a feminine producing subject? Can we see difference? What would be its signs, bodies, formalities or poetics? The Italian Baroque painter Artemisia Gentileschi presents us with just such a case study to provide provisional answers to this proliferation of rhetorical and historical questions.

MISSING MOTHERS: INSCRIPTIONS IN THE FEMININE: *CLEOPATRA*

Two paintings attributed to Artemisia Gentileschi titled *Cleopatra* survive. One was painted in 1621–2 and is in Milan (Fig. 6.7), while there is also a later version, now in a private collection in Britain, dated tentatively to the early 1630s (Fig. 6.10).

I want, however, to use the precariousness of the attributions of paintings of *Cleopatra* to Artemisia Gentileschi as a feminist resource.[23] We cannot know as a certainty that these works are by *Artemisia* Gentileschi. But that doubt forces us to explore how we would make an analytical – not a connoisseurial – case for the works

to be by her. That is not to reinvent a heroine artist but to ask about inscriptions of the feminine in art, to think about texts that might offer, at some level, a feminine address, that might generate visual lures to feminine desire, that might open up the psychic and imaginative spaces of femininity, that might stage feminine anxiety or even aggression and ambivalence. The very lack of confirmed female authorship turns femininity into a question which will constantly hover between the text and the viewer, and only then between viewer and imagined historical producer. Whatever these paintings have to say about femininity, or to a reader 'in the feminine' will have to be produced through working with the signs the paintings offer. In that sense, the (gendered) author as mythic origin and coherent source of deposited meaning is banished. Instead of importing a baggage car full of assumptions about women artists and what women feel or say, the text will be interrogated for *inscriptions in the feminine*. We could use the case of the uncertainties around Artemisia Gentileschi's oeuvre to pose the question: How can you tell the difference?

The first version of *Cleopatra* was probably painted by Artemisia Gentileschi in Rome in 1621–2 for a Genoese patron, Pietro Gentile, whom she may have encountered on a visit to the important banking and shipping republic of Genoa with her father Orazio in 1621. Gentile also owned another painting by her, *Lucretia* (*c.* 1621, Genoa, Palazzo Cattaneo-Adorno), of which more later.

The painting (Fig. 6.7) shows a full-length totally nude female figure reclining left to right on a bed half draped with a red velvet cloth. In the background hangs a swag of deeper red drapery whose swathes form a U shape almost in the centre of the painting. In fact this significant movement of the backcloth is decentred by an opening at the extreme right-hand edge which is highlighted and shows up prominently in a black-and-white reproduction. Seeming to be sustained by its own inner structure, the curtain is raised and opened to reveal a rectangle of blank darkness. Perhaps it stands for a distant door, the door through which her enemy Octavian will soon come to discover her deadly triumph. The death of Cleopatra through the bite of an asp is one of the three main *topoi* from her life represented in paintings. (The others are her arrival by barge to meet Antony and the banquet at which she dissolved a precious pearl in vinegar and drank it.)

What would Lucy Snowe see? Another over-large woman for sure. This female figure is not a slight nude. Her torso is 'thick' according to Garrard but the pose, when compared with possible prototypes, makes the body do things that female bodies don't generally do in the erotic nude in Western art in the sixteenth and seventeenth centuries. Her back is arched. Her knees are raised. Her neck is stretched. Her grip is firm. Contrast Giorgione's *Sleeping Venus* (1505–10, Fig. 6.8) where the nude female body is one continuous flowing line from tip of the raised elbow to the disappearing curve of the calf as it is tucked under the left leg. There the viewer's gaze slips over to the other leg to follow another unbroken line flowing back up the body, only delicately interrupted by the profile of the left breast before returning to the sleeping head. Within these outlines the belly swells gently, the hand curves while fingers nestle in, as well as covering, the crotch. All is grace, smoothness and flow, soft, undulating and

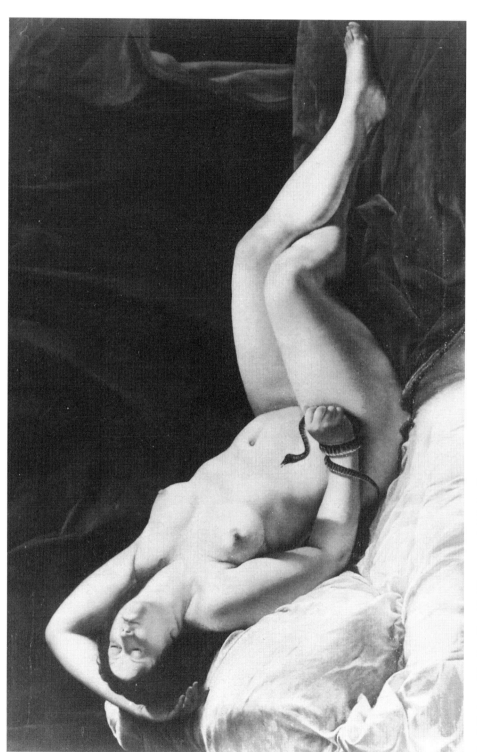

Fig. 6.7 Artemisia Gentileschi, *Cleopatra*, 1621–2, oil on canvas, 145 × 180 cm. Milan, Amedeo Morandotti

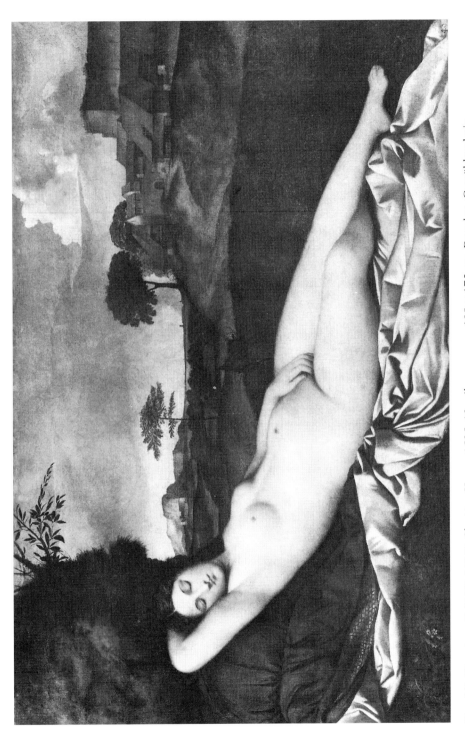

Fig. 6.8 Giorgione (1476/8–1510), *Sleeping Venus*, 1505–10, oil on canvas, 108 × 175 cm. Dresden, Gemäldegalerie

contained. The other major formal source for the reclining female figure is more ancient, as in the Hellenistic sculpture *The Sleeping Ariadne* (*c.* 240 BCE, Rome, Vatican Museum), which is not nude. It is a monumental sculpture in which the underlying flow of the reclining body is animated by the contraposing liveliness of the heavily worked drapery – its heavy folds and knotting underlines the contrast with the utterly relaxed sleeper's head resting on a full arm and weighted down by the other graciously curving over the head to end in a heavy fringe of fleshy fingers. Only one naked breast is alert and peers out from the generous veil of drapery to stress the femaleness of this body. As images of sleep and unconsciousness, these two images do excellent and effective representational work. The *Cleopatra* of 1621–2 (Fig. 6.7) does not.

Painted by an artist aware of these possible formal resources, the body in this painting is quite differently represented. The degree of incline of the upper body and the position of the legs creates a kind of tension at their join that makes the viewer feel as if the two parts are about to snap. Mary Garrard suggests that where there is now the difficult transition between torso and legs, there was once drapery, painted originally, or painted in later, but eventually removed leaving an uncomfortable join most noticeable where the left thigh abuts the curve of the stomach.[24] But this is not the only place the body refuses to co-operate with the conventions of artistic representation that command art to abandon the body's anatomical structure and serve instead as a form for aesthetic and ideological purposes. Instead of line performing a containing role holding a female body inside its artistically fashioned boundaries, it is sharp, discontinuous and disconcerted by effects of tensed or compressed flesh. The body is set against a backcloth that sharpens its left profile, broken by a carefully delineated flat nipple. The line from the raised elbow does not flow easily down into the torso; it descends into nothingness. It is displaced by another line that begins in an ugly darkness where the flesh of the shoulder is pressed against the raised arms. This describes the mound of musculature above the breast (what Western painter of white women ever allowed the presence of female pectorals to compete with the swell of a young breast?) before also pointing out a rib cage and the indentation of a waist. The rounded form of the lower abdomen is prominently punctured not by a gentle shadow but by an anatomically specific navel. On the other side of the body, the breast slips towards the viewer, obeying the gravity that seems too often defied by artistic will in the dominant versions of naked women. Above it a crumple of flesh again interrupts the lyricism of aesthetic form with the signs of the physical body which the artist has decidedly included here, where the contracted muscles of the near side of the neck collapse into the shoulder as the head's backward fall stretches out the farther limit of the woman's thorax, but not enough to erase its twin creases that insist that flesh is the sign of living and ageing.

What does all this mean? One reading would be to say that only a woman artist would refuse to idealise a woman's body in this way, insisting on its realities and oddities, known and lived from the inside. It's a possible way to explain it. But not a profound or interesting one. We have a conflict between two competing desires *vis-à-vis* the woman artist. Some want this artist to be a woman artist, and signal this

through a specific *realism* about the female body. I have no real idea, however, why, as women, we should favour the prosaic real of wrinkles over idealised perfection which is as much a fantasy we carry in our heads and discipline our own bodies to conform to – and, besides, we want her to be an artist able to compete on equal terms in the art world.

What I have been detailing are not competing representations of a real body – but two fictions. The Giorgione tradition represents a powerful drive to represent through a figuration of a body as female both the dangers of flesh, sexuality, nature, time and their containment.[25] The aesthetic conventions are not dishonesty about the really wrinkled, bulging and crumpled state of actual female flesh. They are fantastic figurations of the body as sign in a specific psychic economy serviced through the conventions of historically evolved regimes of representation.

Artemisia Gentileschi's painting interrupts such canonised conventions. But Mary Garrard's extensive iconographic research shows other paintings of Cleopatra with creases in her flesh and musculature and sundry disturbances of the beautifully smoothed out, unruffled perfection of the West's favourite high cultural pin-ups. So we have more of a problem of selective memory which shows, however, that Artemisia Gentileschi belonged very much in a community of image-makers.

Desiring difference

But I want, I desire her difference – otherwise Artemisia Gentileschi's painting is just another example in the file of Western representations of Cleopatra lying down with a snake. So we go back to the body created as a painted sign and wonder if and how the insistence on these facts of bodiliness is important. Mary Garrard draws our attention to the woman's face (Fig. 6.9). At first glance, the eyes appear closed as if death has already overtaken the queen. Closer examination reveals them to be still a little open, and this detail dramatically alters the whole image. A somnolent probably just dead body is one in which the subject is temporarily – or permanently – absent. The unconsciousness of sleep or recent death makes the image read as a body – the body of woman can be contemplated when thus dead or asleep, for in some ways that is precisely the best way for a woman to be.[26] Almost dead, still just conscious, or perhaps still contemplating her last desperate act of queenship – killing herself to remain in charge of herself instead of being reduced to being a piece of Octavian's booty – the asp gripped powerfully in her right hand, held at bay from the breast towards which its open mouth and licking tongue phallically gesture, the figure is now certainly held on the edge of a subjectivity that is, by declaration of that bodily body, female. Femaleness is marked by the specificity rather than the generic character of the represented body. It is not a 'female nude', a conventionalisation that is always a containment and generalisation of a masculine heterosexual image of Woman.[27] It is not the aestheticisation of death through its projection on to a soporific or mortal femininity. It becomes – through the refusal of these tropes – a painting of a woman who is here *portrayed*, and is given the status of subjecthood associated with the

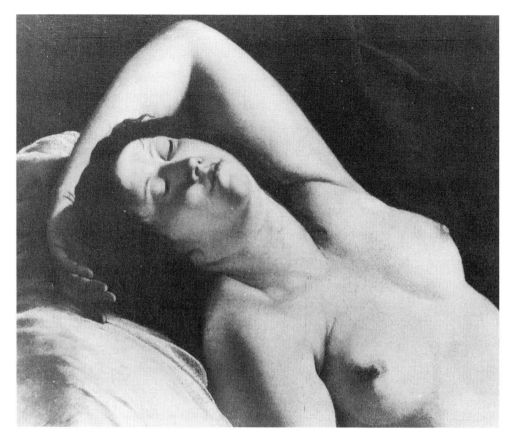

Fig. 6.9 Detail of face from Artemisia Gentileschi, *Cleopatra* (Fig. 6.7)

portrait. The marks of a lived body, a specific body, that is specifically a lived female body, disrupt what the aesthetically fashioned signs of a selectively idealised nude attempt to refuse: a feminine subject in its history signified by a 'writing of the body'. I am suggesting, therefore, that the blatant quality of this naked body is used against the category of the nude, conjugating differently relations between femininity, subjectivity and corporality.

The difficult passage in the painting where thigh meets stomach, whether once covered by drapery or not, works to stop the image being a Venus – and especially a Venus pudica. No gesture indicates and thus both emphases and erases the dangerous and fearful site of her sexuality.[28] Her sex is clasped between her legs. Instead the hand that usually feathers her sex in order to both point to and shield it, grips a phallic sign – the means of a death but also, as many commentators have argued, the sign of immortality, one that was a regular attribute of representations of the goddess in ancient pre-Greek and Semitic cultures.

The arched back, the tensed and slightly upraised legs, the gripping hand: each detail functions to create the absolute antithesis of the boneless, muscle-free, sleeping Venuses

144

and nymphs of the painting's prototypes. All these signs compound that almost over-looked but crucial detail, namely her continuing consciousness which firmly locates a subjective presence inside the body. The body becomes not merely its site but its articulation. Veiled by the drooping eyelids, yet once encountered, that momentary sign of consciousness polices any purely scopic relation to the body, making the body a site of being. Its tension, its gestures, its lonely and extreme nakedness provide it with a pathos of expressiveness that will not be found in chapters on the female nude in Kenneth Clark's connoisseurial review of the the nude in Western art.[29]

Some will probably be rightly tempted to see the languid head but tensed body as suggestive of female eroticism. Like those feminists who have read the self-possession and physical intensity of nudes by the nineteenth-century French painter Degas as representations of female pleasure, we could positively enjoy an image that allows some representation of female erotic physicality concerned with its own even deadly pleasure.[30] This may well be why the image is remarkable and was saleable. For while we seek to establish some difference for its representation of the female body and person which can justify our sense of a female authorship, we may turn the image into something it historically could not be.

The historical conditions of production are relevant here. For without acquiescing to a substantial degree with contemporary, and specifically elite masculine taste, Artemisia Gentileschi could not have functioned as an artist on the public market. Artemisia Gentileschi was attempting to function within the market. She lived off commissions and, as far as the evidence goes, most of her patrons were men. As much as we may seek and even find signs of difference, we may have to concede that they work all the better to make *Cleopatra* the object of a fantasising and sexualising gaze – for some men where the collision of eroticism and death forms part of a violent, or at least ambivalent, sexuality.

Could we, however, begin to trace the point at which conflicting interests were negotiated to create an image that simultaneously could be read in conformity – though creatively adventurous in its way of doing this – with dominant *masculine* taste while also insinuating into that official space the presence of competing *feminine* meanings depending on the interests or gender of the viewer? Might we then have to re-imagine Artemisia Gentileschi not only as a producer but as one of her own viewers, a resistant reader, a secret Lucy Snowe, providing herself as artist with an alternative, contesting audience for a work which, while it was calculated to signify her saleably unique authorship within prevailing markets and predominantly male-determined tastes and desires, none the less, offered traces of an other economy of meaning? I want, in fact, to have it both ways in order to see what the contradiction forces us to confront. I do not see a way out of this logically intolerably but historically necessary case of having my cake and eating it; indeed *feminist* interventions of art history may reside precisely in such a perverse desire.

By theoretically distancing the *producer* from the *author* I have gained a way of studying artists working in specific conditions of production, producing within specifiable determinants which shaped their practice within the larger field of artistic

culture while allowing that the producer does not know in advance what will be the meaning or affect of the work made under such conditions. The fiction of the author is bound up with notions of a coherent subject existing in advance of her or his work which is the deposit of his or her expressed meanings – ex-pressed, put-out-into-the-painting meanings. The notion of producer allows for historically located practice by biographically singular individuals. The work is treated, as Freud argued, as a text, where its riddle-like meanings are produced on many registers, polysemically, and only when they are processed by readers or viewers do they temporarily reach any, if always variable, cogency. For the producers, their own work is a text they must read in order to discover what they have produced and through that inscription, what they are, artistically.

Women live the conditions of artistic production differentially, according to the social as well as subjective structures of gender and sexual difference, economic and cultural positionality. Painting, or any form of cultural practice, not only is determined by social institutions and semiotic structures but is the site at which these are articulated, negotiated and transformed. Poetic language or artistic practices are specially susceptible to shifting the dominant scheme of meanings through their greater proximity to those resources of the pre-conscious and unconscious which the dominant order tries to harness, arrange and fix.[31] For Julia Kristeva, the renovative role of art depends upon mutually constructing and transformative relations between sign and subjects, and specifically the subject.[32] Julia Kristeva's formulation allows us to explore not a woman artist's intent, what she is expressing because she is a woman, but rather *feminine desire* and *feminine pleasure* that can be realised only by being inscribed somewhere and somehow, masquerading (or rather passing within the conventions) and transgressive (disturbing them) at the same time. This is why I find the argument, that male artists fashion fictional women for their visual pleasure but women artists are ruggedly prosaic or realistic *vis-à-vis* the body, is an impoverished way of looking at the art made by women. It does not allow for desire, or fantasy. It permits little ambivalence and less anxiety in the feminine subject in process. We can use Julia Kristeva's rather abstruse and gender-indifferent theories on 'the system and the speaking subject' to open up discussion of a feminine poetics of transgression – that is to say, a relation to the productivity of signs systems that speaks from and gives form to the specific unconscious formations of cultural and historical femininities. 'Artemisia Gentileschi' is then the name attached to a set of paintings that are not the expression of her being a woman – for woman does not lie on the plane of being. The author name refers to texts that can be deciphered 'in the feminine' by those who find some affinity with the enjoyment, the pleasure that such images make possible, while also finding in paintings such as that of a dying woman a structure for anxiety, or perhaps grief.

Artemisia Gentileschi's image of *Cleopatra*, therefore, had to have a currency in its own commercial and ideologically determined moment of production in the early seventeenth century. It would have achieved as much simply by virtue of being a large-scale, fully nude female body, dramatically set out on a bed whose luscious and saturated red velvet is set against a delicately managed effect of crumpled linen or

silk. Some of its power derives from the Caravaggesque simplicity of the setting: no fuss, no ornament, bold colour, high contrast, strong lighting and the superb management of pose, gesture and facial expression. The overall composition and its formal arrangements defer to the classical as well as the fashionable, contemporary repertoires, confirming the artist's knowing competence in handling both her artistic heritage and the current aesthetic debates in Rome. Yet these same referenced resources are managed to create the space for the difference the painting must accomplish to make this painting itself a value in 1621–2. Such value – the artist's singular definition of a generic topic: the deaths of heroic women – will be taken over by the patron, who as collector displays his purchase as *his* distinction in taste. The work's singularity is then to be admired as part of a collection, belonging to which will confirm its place in a contemporary and culturally approved tendency.[33]

So instead of reading for difference, in which what made the work distinct in its own times might be misread as the signs for our late twentieth-century assumptions about a generalised female authorship, we have to read for more nuanced signs of *differencing* in a game that already involves the subtle play of affinity and distinction. The body of Cleopatra as the obvious first sign of the painting as a monumental female nude is reconfigured as the viewer closely examines its apparently errant details. These culminate in that ambiguous face which sets a competing representation in place, allowing a shift of its range of meanings.[34]

So far I have been trying to establish a kind of social semiotics – an attention to the painting as a series of signs whose legibility is located in a historically specific set of conditions of artistic production, patronage and collection in early seventeenth-century Italy – specifically Rome and Genoa. Instead of setting artist against artist, male painter versus female painter, we have a more difficult configuration of ambitious painter who is a woman and her patrons who belong to an aristocratic male elite whose collections have public, ideologically and personally self-aggrandising purposes which exceed the mere interest in art.

I want to suggest that one way in which it is possible for us to see Artemisia Gentileschi's *Cleopatra* as both belonging to and effecting a particular kind of differencing because of what she brought to this subject as a woman, is by moving to what might appear to be the private domain retheorised via Julia Kristeva as the point of interface between the subject and the system of meaning within which the subject is signified and is able to signify. The represented body is not just a fictional body but an *imaginary* one. It is, however, a mistake to imagine that the psychic is less social or historical than determinations that can be as crudely calculated as commercial considerations. Like Julia Kristeva, I think that historical materialist and psycho-analytical theories can be, and indeed must be, put in joint harness in the analysis of cultural texts. Indeed any feminist project is to an extent defined by the necessity to traverse, theoretically and practically, the fields differentially theorised by Freud and Marx. It is in the very antagonism between these two major discourses or theories of modernity that anything transgressively named the feminine will become a theoretical object and a political possibility.

147

Pleasuring the look

Any painting asks us the question: Why do people look at pictures and why would certain people have wanted to look at this one in particular? What pleasures are there in seeing this image? When that image involves a representation of the body we move into another register where sexual pleasure and looking operate at the psychic level of fantasy. This is not because we all have a body, but because the image of the body plays so fundamental a role in the construction of the ego and thus subjectivity, and because the ways of the body – drives and energies rather than boundaried anatomies – are the very materialities out of which subjectivity is fashioned through the dialectics of negation and repression. Furthermore, when the body image in question appears to be coded as female, we are precipitated into that domain psychoanalysis has tried to chart – the processes of sexual difference in which an image – woman [*the body of lack*] – is a crucial but ultimately unfixed and unfixing sign in a phallocentric system of sexual differencing. For every image that we read as *woman*, at least two bodies co-exist in fantasy, as I suggested in my first two chapters. In an uneven continuum the representation of the female body can move between a pleasurable memory of the plenitude and potency of the maternal body to the punished and degraded or aestheticised and idealised fetishism of the female body as the sign of castration and the castrated or castrating other.

Let us return to Cleopatra. In the case of 'Cleopatra' as a sign the signifier is: ancient Queen of Egypt, woman and political authority. The signified is: transgressive threat to Greco-Roman-Christian patriarchy. In a crucial sense 'Cleopatra' functions as a sign of that which came before and was overthrown in the foundation of the West effected by the Romans. Mary Hamer writes: 'Cleopatra and her story have the weight of an originary myth in Western culture; and used in metaphor, they are specially disposed to illumine the place of women in the social order.'[35] For instance, in his influential anthology of the stories of 104 famous women, compiled between 1355 and 1359, Boccaccio introduced Cleopatra thus:

> Cleopatra was an Egyptian woman who became an object of gossip for the whole world. . . . She gained glory for almost nothing else than her beauty, while on the other hand she became known throughout the world for her greed, cruelty and lustfulness . . . Thus Cleopatra, having acquired her kingdom through two crimes, gave herself to her pleasures.[36]

Boccaccio effaces all traces of Cleopatra's role as a wise and economically astute ruler, an alliance-builder who managed Egypt through periods of agricultural crisis and political threat and who only ever had two relationships in her relatively short life.[37] Mary Hamer traverses the history of the West, tracing the different and contradictory functions of the sign of Cleopatra in the Renaissance and Reformation, in the eighteenth and nineteenth centuries right through to Hollywood's recycling and transformation of the image with Elizabeth Taylor in the title role. Beyond these historically varying representations lies another level of her appeal and signification

through the selective *topoi* associated with Cleopatra. 'By its status as originary myth the figure of Cleopatra is also aligned with an important component of the individual unconscious.' Thus the meanings of Cleopatra, a female figure 'put to sleep' at the 'opening of the constituting narratives of [Western] culture', inevitably overlap with the figure of the mother in individual history. 'The term 'Cleopatra', Hamer suggests, links the notion of a woman's body and the notion of authority in ways which evoke the figure of the mother in the unconscious, 'the trace of early experience when the mother's body is supreme and her body is the horizon of desire'. Hamer argues that it is helpful also to think of Cleopatra's body in terms of 'the multiple desires of the child which find their satisfaction and their emblem in the mother's body'.[38]

Mary Garrard approaches such a level of speculative analysis in her study of Artemisia Gentileschi's paintings of Cleopatra's death when she traces iconographic links between them and the images of ancient Egyptian versions of the mother goddess, notably Isis. Garrard interprets Gentileschi's version of *Cleopatra* as a theophany – the revelation of the divine in the mundane – and she suggests an interpretation of the painting's concept of Cleopatra as poised on the cusp of the return of the mortal queen to her eternal divinity. At the level of cultural analysis, however, we might be able to locate a less mystic explanation for the continuities by suggesting, as does Mary Hamer, that in such legends and myths we are seeing representations of aspects of human fantasies which bear witness to the psychic foundations of subjectivity as well as to the *longue durée* – the other temporality of which Julia Kristeva writes – of modes of *reproduction*, i.e. of sexual difference.

We enter here into difficult territory for it would appear that in making such a case I am falling into the worst of imperialising universalism – appropriating ancient Semitic and Egyptian cultures for modern bourgeois theories of the subject. Lévi-Strauss, however, discerned in myths the structure of the human mind. Myths and legends offer us culturally variant and historically specific representations of the structural process of subject-formation in relation to the perplexing questions all children must probe: Where do I come from? How do I – one – come from two? What am I if there is difference? Questions of life and death, of origins and ends, of the mother and the father, of sexual difference are recurrent. But the forms of the answers are not.

Thus the ancient Middle Eastern mythic systems celebrated woman as the Mother Goddess of both life and death, sexuality and procreation, in a variety of guises and mythic personae that may have reflected material possibilities in actual societies where women were granted a place in social production, given public or ritual authority and sexual self-determination. But they also configured psychic fantasies of the powerful mother of earliest infancy in pleasurable ways. And of course the obverse is also true. The cultural and social arrangements which respected women's power reflected the uncensored psychic status of the generative and sexual power of the maternal body. Cleopatra, a historical figure, was incorporated by the West into the history of the transformations from such a woman-favourable psychic economy. 'Cleopatra' may function as a sign on the cusp of the belated but still insecure defeat of the Egyptian

remnant of such a world view by the patriarchal Romans. According to psycho-analysis, the historical defeat of 'the age of the mother' is constantly re-enacted, and equally undone, in each individual's journey into subjectivity under the phallocentric law of the Father. This conflict may be seen to generate in cultural forms – art, cinema, literature – the necessity for the perpetual and always ambivalent replay of that loss.

Queen Cleopatra VII, although Greek by descent, actively took on the legends and myths of Egyptian heritage, identifying herself in public spectacles with the ancient cults of Isis, which would be ideologically supportive as well as psychologically affirming of her being as a powerful, sexual and maternal woman. It is this nexus of feminine meaning and imaginative status that was vanquished – at the political level by Octavian's victory in 30 BCE, and at the cultural level by the use of the image of Cleopatra not to signify that plenitude of the maternal body represented by the goddess she revered but to become the visible sign of the disorder, the transgression of the Roman paternal law by a woman now represented as monstrous, who had to be visualised over and over again as dying or dead. But, in having to represent this deadly negation in order to negate significations of power attached to the maternal figure, there is always the danger that its ancient fascination will assert itself, drawing out from the repression effected by submission to the law of the Father archaic fantasies, longings and desires which are as much a part of the proto-masculine psyche as of the proto-feminine subjectivity.

Thus any Western painting of Cleopatra contains in its topic contradictory interests and dangers. These can both confirm a phallocentric logic and threaten to undermine it in ways which open up images to other desires formulated in relation to the body of the mother and to the effect of maternal subjectivity. Thus, a woman could paint the theme in such a way that might both serve *masculine* ideological aggression against the powerful queen, shown dying, while also pleasuring infantile fantasies about the omnipotence and plenitude of a queenly, that is idealised, body of the powerful mother. Representation allows the staging – re-staging – of the very field on which sexuality, subjectivity and difference are construed in ways that temporarily undo the linear time that points to fixed gender identity and allow the play of archaic fantasies around the maternal body.

We are born into a culture that already anticipates us as sexed subjects. The subject is a composite of archaeological layers which contain the traces and memories, even if repressed and unconsciously censored, of the history of our journey to sexed, speaking subjectivity. So in that complexity of many times, layers and registers which compose a subject, always in process, there can be ancient pleasures and aggressions operating in the structuring presence of Oedipalised desire. The case of paintings of Cleopatra opens up exactly onto this ambivalent field of both the drive towards sexually differ-entiated subjectivities and the 'play' there will always be in that never accomplished process.

Women artists can be seen to be producing work that opens up different routes through the territory of the subject. Instead of the question: Is this image made by a

woman? – where the terms here have been thoroughly problematised – I ask: *In what ways might I read this text for signs of its play and pleasure for a feminine subject?* Drawing, furthermore, on the model Freud used repeatedly, the case study, in which he explored the structures of subjectivity through the specificities of particular individual's lived histories, I can ask also: What are the signs of this specific – rather than generic – feminine subject? Biography can thus play a role. It is simply what gives us access to a history of a subject through which we might be able to decipher the symptoms traced on the surface of the text.

Mourning the mother

Prudentia Montone died on 26 December 1605 at the age of thirty when her daughter Artemisia was about twelve. Artemisia Gentileschi has been discussed almost exclusively in terms of her father Orazio from whose oeuvre so much of her own has had to be disentangled. Father and daughter did have a complex personal and professional relationship, often working together and in significant ways sharing artistic interests and competing in their treatments of common themes and subjects.[39] But almost no one wonders about the artist's mother or the possible significance of early maternal loss for her daughter. In Mary Garrard's book Prudentia Montone's death is recorded in a footnote to the transcript of the rape trial of 1612.[40]

The absence of a mother placed the young girl in a socially vulnerable situation in early seventeenth-century Rome. It was because of the need for an adult female chaperone that it appears that Donna Tuzia, who seems to have been some kind of accomplice with Tassi in the forced sexual assault he inflicted on Artemisia Gentileschi in May 1611, was installed by Orazio in an adjoining apartment. Had the daughter been supervised by her own mother rather than a venal or treacherous stranger, the situation in which Artemisia Gentileschi was raped by Agostino Tassi might never have arisen. While the rape remains crucial for a study of this artist, I want temporarily to displace its trauma by focusing instead on another, unacknowledged in the studies on Artemisia Gentileschi: maternal loss.

In the context of the artist as a bereaved daughter, elements of 'Cleopatra' could stage a different relation between femininity and death when the fantasised mother is shown forever held by the painting 'before death', kept on the verge of leaving life, still just there. Is the powerful, mature and sexual female body that characterises this artist's work available to be described as a maternal body? Could it have been generated as a memory? Might it be the recreation of woman as a female child might fantasise her in compensation for a loss that is inevitable, when the Law of the Father or the Law of the Symbolic obliges us to separate from the maternal body? In this case, that obligatory severance and the desire thereby created was overdetermined by the premature death of the mother before the daughter had entered her own puberty and adult sexuality, before the repressed archaic mother–daughter relations could have been worked through in adulthood to assist the female child in her own accession to an adult femininity.[41] There is always a degree of arrest in a girl's development when a mother

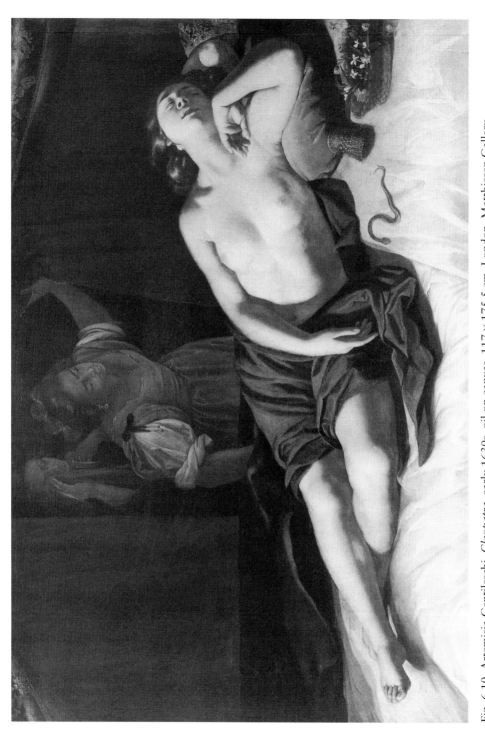

Fig. 6.10 Artemisia Gentileschi, *Cleopatra*, early 1630s, oil on canvas, 117 × 175.5 cm. London, Matthiesen Gallery

dies prematurely. It is unpredictable how this may inform the daughter's psychic life – but we must assume that it would have an effect. This effect might remain unknown to the daughter except as an excess that was suddenly exposed when engaging in thinking through a painting that served as a trigger for, and, at the same time, a structure to 'work through' a range of unfinished business in relation to maternal mortality.

Gentileschi apparently painted a second Cleopatra, in the early 1630s, possibly on her visit to London for it is now in an English private collection (Fig. 6.10). It is utterly different in conception and effect from the painting of 1621–2. The queen is dead, pale and still. The body is laid out on its side and it is heavily draped with a cloth of deep blue – the Madonna's colour. The head is thrown back so that the face is seen in fierce foreshortening making the viewer look up her nostrils, see the whites of her eyes rolled up under still half-open lids. The half-opened mouth is seen from below emphasising the thickness of the upper lip while revealing a row of teeth.

I am not in a position to adjudicate the attribution claims – but presented with the possibility of this painting being by Artemisia Gentileschi we can at least dismiss the idea that you can tell the painting is by a woman because of any continuity between this version and the previous one. It is a radically different treatment. By focusing on the moment after death, the viewer is forced into confrontation with a dead maternal body. In *Over Her Dead Body*, Elisabeth Bronfen argues that 'Culture uses art to dream the deaths of beautiful women', and adds,

> As my title indicates, the interstice between death, femininity and aesthetics is negotiated over the representation of the dead feminine body clearly marked as being other, as being not mine. To represent *over her dead body* signals that the represented feminine body also stands in for concepts other than death, femininity and the body – most notably the masculine artist and the community of the survivors.[42]

This trope of the beautiful, dead woman both is and is not what it appears to be. It can signify sexual difference because the image functions as the Other to, and yet the projection of, the producing and viewing masculine subjectivities in which it originates and for whose fantasies it provides an iconography. The trope offers a repertoire of representation for masculine narratives of death. If women represent death through the image of a female body, is there a difference of another order? Will the female producing subject and her putative viewer be masochistically over-identified with an image that mythically conflates femininity and death, or can she negotiate, from her specific psychic relations to the female body of life and death associated with the mother, a different space in which to realign the representation of death and femininity?

I honestly don't know. But it is an important question: death and sexual difference. I have tried to address it elsewhere using my own case history, my own experience of maternal loss in adolescence, of bereavement and the encounter with the dead bodies of loved ones, to question existing narratives of death and probe for difference within

those I can produce.[43] In the light of that work I see this image (Fig. 6.10) as the antithesis of the first Cleopatra (Fig. 6.7) whose fullbodiedness and death-resisting consciousness manage an image of female subjecthood and corporality which combines both in a compensatory fantasy that has to be articulated through reference to the sexuality of woman – where indeed she experiences both life and death. In this later painting of *Cleopatra* (Fig. 6.10) the phallic attribute of the snake is abandoned. It turns away from the body which is thin and lifeless. It is rather poorly and prosaically painted. Breasts defy gravity and there is precious little in the body to engage the viewer. Two sites of active painterly interest – the hand and the awkward, disturbing face – draw our attention to this portion of the canvas where we notice a huge pearl (the other of the one Cleopatra is said by legend to have dissolved in a cup of wine which she drank at her famous banquet?) and a tumbling mass of silky brown hair.

I find myself confronted uncompromisingly with the ghastliness of death. I am tempted to suggest that, were it by Artemisia Gentileschi, that harshness of the unrelenting, unaestheticised representation of a dead face is perhaps a haunting and haunted memory of her own looking on the dead face of her mother. In my culture few of us see dead people much. This image does not balk at showing that death is not at all like sleep. Here we have the sudden relaxation of muscle tension which makes the jaw droop, the eyes roll. Yet it also includes the effects of *rigor mortis* with that harshly bent wrist, locked in place while the hand itself falls lifelessly. The painting seems a bundle of inconsistencies – a pretty still life such as Lucy Snowe would appreciate at the elbow of the dead queen, and the shadowy figures of the still living maidservants who hold back a curtain and stand as discoverers of the death and its first poignant viewers. But we, the actual viewers whose place before the canvas its composition assumes, must see the body in harsh, fierce light, and the long straight line of the cold, white body forces the eye to search for interest in the face and arm, only then to confront death as something done to a body that was once alive – as an absenting, a pallor, a coldness and a violence that, whoever painted that head did not flinch from seeing and making the viewer share.

In this *Cleopatra* (Fig. 6.10) death is itself embodied and thus represented as the negation of a life and subjectivity. Anyone who has watched over the death of a loved one – or anyone who has beheld the recently deceased – will know how difficult it is for the human mind and the emotions to comprehend the moment when 'life' leaves the 'body' behind and empties out the living substance of a person from what remains, reduced to an uninhabited housing. What remains is suddenly a mere simulacrum. The body grows cold, and the skin yellows. It is and and yet is not the person. At that moment we wonder what is life, what is it that we are as subjects in a body, that can disappear when its bio-chemical system ceases to function. No wonder we have generated so many myths of souls, and afterlife, rebirth and reincarnation to distract us from the sheer difficulty of seeing death as it seems to steal those we love from us, leaving that awful trace of a body that no longer provides a material access to the (im)material human processes: love, affection, desire.

The composition *Cleopatra* (Fig. 6.10) by Artemisia Gentileschi makes the viewer a witness to dying. Elisabeth Bronfen argues that, in aestheticising death through the image of the beautiful woman, death itself is misrepresented, or rather de-represented. By contrast, this painting seems to deprive death of such displacement. Hence the odd details, their disjunctive character, the snake here on its own bed of linen, the basket of spring flowers, the tassel of the cushion and the other scenario of the intruders painted in a different style and colour scheme.

Such details make possible a return to the first version, of 1621–2 (Fig. 6.7), to recall the empty aperture in that painting – the possible doorway, the threshold between Cleopatra's chamber and the outside world – which has to be spoken of in metaphoric terms as a displaced representation of the passage that is birth and death, entry and exit. Lusciously painted, vividly (life)blood-red, folded, self-supporting velvet surrounds a rectangular blackness. There death lurks as nothingness, a remarkable oddity in a painting such as this which sets the fantasy created by the voluptuous self-inhabited maternal body against the stark and empty horror of death that is displaced into a signifying void.

Seeing into the dark core and not lying

With that phrase I find an uncanny connection between this strangest of all moments in a seventeenth-century Italian painting and the literature of women writing self-consciously as feminists in our century. In her essay 'Women and Honor: Some Notes on Lying', Adrienne Rich writes:

> The liar fears the void.
>
> The void is not something created by patriarchy, or racism, or capitalism. It will not fade away with any of them. It is part of every woman.
>
> 'The dark core', Virginia Woolf named it, writing of her mother. The dark core. It is beyond personality; beyond who loves or hates us.
>
> We begin out of the void, out of the darkness and emptiness. It is part of the cycle understood by the old pagan religion, that materialism denies. Out of death, rebirth; out of nothing, something.
>
> The void is the creatrix, the matrix. It is not mere hollowness and anarchy. But in women it has been identified with lovelessness, barrenness, sterility. We have been urged to fill our 'emptiness' with children. We are not supposed to go down into the emptiness of the core.
>
> Yet, if we can risk it, the something born of that nothing is the beginning of our truth.
>
> The liar in her terror wants to fill up the void, with anything. Her lies are a denial of her fear; a way of maintaining control.[44]

Virginia Woolf, whose phrase 'a woman writing thinks back through her mothers'[45] is quoted here by Rich, argued for a kind of maternal genealogy for women artists or

155

writers. Yet, as Shoshana Felman has pointed out, this was a legacy of death. 'Marked by the trauma of early loss of her own mother, Virginia Woolf can think back through her mother autobiographically only insofar as her mother . . . is in essence a *dead* mother – dead as a result of fulfilling only too perfectly . . . "her woman's duty".'[46] Lucy Snowe was also a motherless daughter, as indeed was her creator, Charlotte Brontë. Virginia Woolf's image of the 'murdered' Judith Shakespeare functions as both mirror of and resistance to her own predicament and fear of the relation between death and maternity. Lucy Snowe's dilemma in the art gallery between what she finds monstrously sensual in the giant maternal body and the tedious and deadly images of 'woman's duty' also speaks the conflict which Charlotte Brontë the artist lived. Seen through the shifted prism of Artemisia Gentileschi's paintings, Woolf and Brontë read differently. Both writers present us now not so much with feminist myths but with feminist images of the fears and conflicts that assail those who have tried to conjoin creativity and femininity within patriarchal culture.

A tenuous chain of associations between dark cores, dead mothers and 'the poet's heart entangled in a woman's body' breaks both disciplinary boundaries and the policed frontiers between different historical periods. In this fluid space I suggest we can read feminine inscriptions in the field of seventeenth-century Italian narrative paintings. This 'feminine' derives from no biological or trans-historical essence. By the term I name the hieroglyphics of difference, that, until this point in our feminist century, we have had few means to decode. The feminist movement in modern times breaks the canonical silence that has repeatedly murdered women's art and words, silencing them, forcing them beneath the threshold of canonical interest and intelligibility. I am not tracing an essential link between Rich, Woolf, Brontë and Gentileschi. Retrospectively I am creating a feminist genealogy. I am adding one name to a chain established by Shoshana Felman and her study of women and writing, *What Does a Woman Want?*, a book she calls an autobiography. Felman makes an important claim about what women write for and what feminism is:

> Feminism, I will suggest, is indeed for women, among other things, reading literature and theory with their own life – a life, however, that is not entirely in their conscious possession. If, as Adrienne Rich acutely points out, reading or 're-vision – the act of looking back, of seeing with fresh eyes, of entering an old text from a new critical direction – is for women more than a chapter in cultural history: it is an act of survival', it is because survival is, profoundly, a form of autobiography.[47]

She warns us, however, that 'reading autobiographically' is not to be confused with the recent trend of 'getting personal'. All of us are already possessed by the culture within which we live, have been trained and educated, and practise as cultural analysts. We become 'personal' with implanted ideas and beliefs. We are trained to see canonically, and may, as she says, speak with a borrowed voice, not even knowing that we do, and from whom the voice is borrowed. Like Lucy Snowe, we resist only from within ideologies that already frame that resistance.

I will suggest that *none of us, as women, has at yet, precisely, an auto-biography*. Trained to see ourselves as objects and to be positioned as Other, estranged to ourselves, we have a story that by definition cannot be self-present to us, a story that, in other words, is not a story, but must *become a story*.[48]

For this, as yet unowned, story to become one, it needs what Shoshana Felman names the bond of reading, a kind of covenant between the *story of the Other* and the women who read it, the women who read stories of other women, stories told by other women. Thus she concludes,

> Rather, I will here propose that we might be able to engender, or to access our story only indirectly – by conjugating literature, theory and autobiography together through the act of reading and by reading thus, into the texts of culture, at once our sexual difference and our autobiography as missing.[49]

Here is the huge difference from looking at paintings by women with the assumption that they express something about women that either the artist or we can spontaneously know. What we encounter are stories – legends perhaps – that require the bond of reading in order to become a story for us, that is a meaningful representation of us. The materials on offer in art by women can be read variously, misread or not seen at all. Feminist reading is the active desire for that difference, that possibility of the discovery of something about ourselves that we don't know, that requires some articulation, some form of representation for what it is that we are to become available through its conjugation of lived experience, unconscious repositories of memory and fantasy, and theory, namely a representation of all of that in the Symbolic.

Thus I lend my own grief and sense of motherless daughterhood to a series of texts that pleasure me in so far as I can discern that they articulate some of the unnamed complexity of that condition through the legends of Cleopatra and the rhetorics of Italian Baroque and specifically Caravaggist painting. This is not to generalise a womanhood or even a femininity across time and space. For I do not claim that my interest in these two paintings of Cleopatra by Artemisia Gentileschi exhausts their range of meaning. I am identifying something that is missing – in the literature, in the art historical analysis, though it may be there in the painting: the mother.

As Adrienne Rich has suggested, women's fate has been to fill the void – the dark core that was the mother – with children, a displacement of a loss that, when used like this, compounds the lying culture of women, the lies women are bound to tell themselves, so that they do not tell their own stories for other women to possess and thus become women in that covenant of 'partners-in-difference'. Creativity in symbolic forms, the making of texts and images, the mythical figurations made possible through discourse and representation, do not compensate for or erase the real loss of a mother. But they give it a symbolic field in which the feminine subject can participate in making itself, in a kind of symbolic generation of meanings. The specific character of this symbolic generation as feminine lies not in a single voice, a monolithic content,

Woman, but in the diverse articulations of variant trajectories through culturally, socially, historically and biographically specific femininities. What contemporary feminist art, poetry, literature and theory offer us are the clues by which to begin to read these historic inscriptions, these stories of the Other woman. The female body and the mother are crude markers at the gateways to inscriptions in the feminine.

CODA: RAPISH SCENES AND LUCRETIA

During a seven-month trial which began in March 1612, Artemisia Gentileschi testified under oath that in May 1611 she had been raped by Agostino Tassi, a painter colleague of her father's. Once deflowered, like Judith Shakespeare, she was, however, subjected to repeated sexual relations on the promise of marriage which alone would save her from the dishonour which a woman without her chastity would suffer according to codes of sexual practice and kinship in seventeenth-century Italy. Being already married, Tassi did not fulfil this promise and, nine months after the initial rape, Orazio Gentileschi brought a suit against Tassi, exposing his daughter to a second trauma: a rape trial which included her being tortured.

In the same year as the first *Cleopatra* was begun, 1621, Artemisia Gentileschi painted a picture of *Lucretia* which was also bought by Pietro Gentile of Genoa, where it was taken by Orazio in 1622 (Fig. 6.11).[50] The subject of Lucretia was widespread in sixteenth- and seventeenth-century culture. As with Judith Shakespeare, the sexually exploited and suicided body of a woman was the token of theoretical and cultural communication between men. Like Cleopatra, Lucretia is also an originary myth in Roman culture. The rape of the chaste Roman matron Lucretia by the son of the ruling Tarquin dynasty leads to their overthrow and the foundation, led by Brutus, of the Roman republic. The crux of the story is, however, that Lucretia, having been raped, kills herself to prove her chastity in the presence of her husband, father and Brutus, who raises her blood-stained dagger as the sign of the revolt against the corrupt monarchy. The Lucretia myth makes the woman's violated and dying body serve the purposes of masculine political power.

In her study of the issue of rape in the two versions of the Lucretia theme by Rembrandt –1664 (National Gallery, Washington, D.C.) and 1666 (Minneapolis Institute of Arts) (Fig. 6.12), Mieke Bal argues that rape is a language that uses the body of a woman as a sign to effect and publish hatred, competition and revenge *between men*.[51] Bal argues that rape itself is hardly ever visualised in painting – not because it would be too horrible to show but because what rape is is not visualisable in the mere depiction of a sexual assault. Rape is a metaphoric form of murder.[52] There are a few paintings which focus on the moment of sexual intimidation, for instance by Titian (Fig. 6.13), but they tend to show the moment before the actual rape and thus confirm Mieke Bal's point about the invisibility of what rape does as an intersubjective act of semiotic as well as physical violence. Mieke Bal states that rape makes the victim invisible:

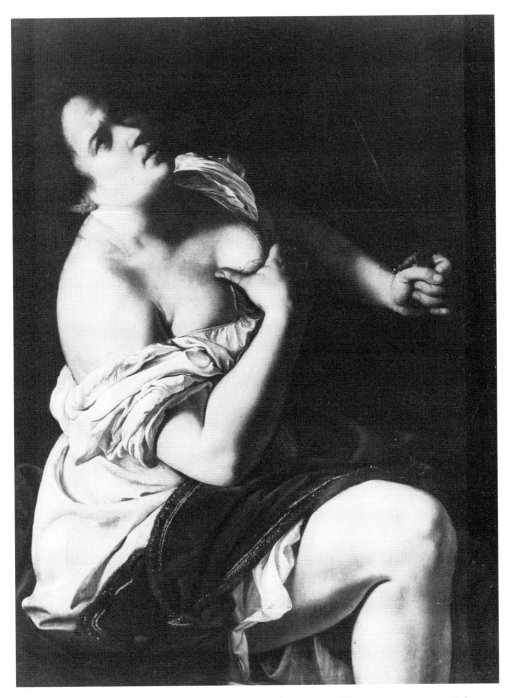

Fig. 6.11 Artemisia Gentileschi, *Lucretia*, *c*. 1621, oil on canvas, 137 × 130 cm. Genoa, Palazzo Cattaneo-Adorno

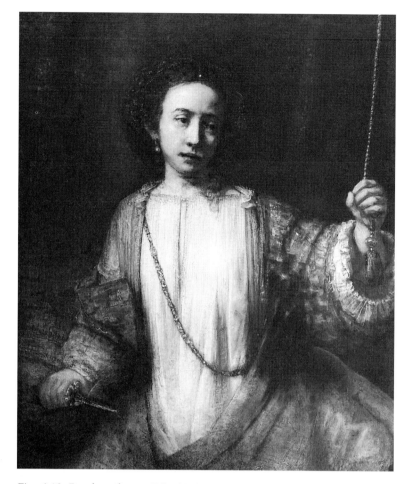

Fig. 6.12 Rembrandt van Rijn (1606–69), *Lucretia*, 1666, oil on canvas, 105.1 × 92.3 cm. Minneapolis, Minneapolis Institute of Arts (The William Hood Dinwoody Fund)

It does that both literally – first the perpetrator covers her – and figuratively – then the rape destroys her self-image, her subjectivity which is temporarily narcotised, definitively changed, and often destroyed. Finally rape cannot be visualised because the experience is, physically as well as psychologically, *inner*. Rape takes place inside. In this sense, rape is by definition imagined; it can exist only as experience and memory as *image* translated into signs, never adequately objectifiable.[53]

From this perspective it would seem not at all straightforward for a woman, having experienced this process of 'murder of the self', to take on a subject that visually represents just that. How could a woman artist negotiate this negatively freighted theme?

160

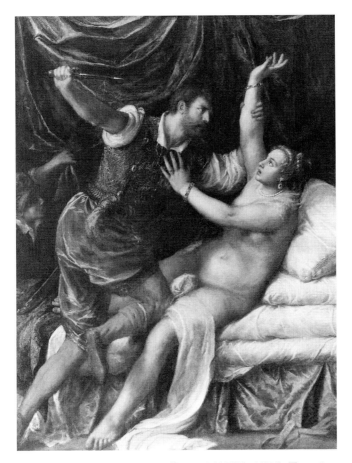

Fig. 6.13 Titian (Tiziano Vecellio, *c.* 1487/90–1576), *Tarquin and Lucretia*, 1568–71, oil on canvas, 182 × 140 cm. Cambridge, Fitzwilliam Museum

Artemisia Gentileschi's *Lucretia* (Fig. 6.11) positions the viewer close to a large-scale, single figure of a seated woman in profile, looking sharply upward and thus seeming to recoil from something threatening above her and out of our line of vision. Although there is only one figure in the painting, the shallowness of the space and the position of the body imply either the viewer's almost intrusive intimacy with the woman or the presence of a menacing other. In neither case are we the viewers comfortably able to participate in this imaginary staging. The necessary distance for voyeurism is breached without a surrogate within the painting to relieve us of this intense proximity. With her right hand the figure of Lucretia grasps her left breast, while, unexpectedly, her left hand holds erect a large dagger, visible against the dark background only because of a lightly painted highlight along its sharp edge. The grip is strange. A person does not hold a dagger thus if she is about to stab herself. To make Lucretia left-handed would indeed be novel.

With Lucretia neither undressed as the almost naked and thus conventionalised nude figure in the painting of the rape by Titian (Fig. 6.13) nor fully clothed with loosened garments as in the painting of the suicide by Rembrandt (Fig. 6.12), the state of the clothes in this painting is one of disarray. The chemise slides down over shoulders and breast, the petticoats are lifted above the knees while the remains of the overgarment of red velvet have slipped down beyond her waist. Narratively this state of the garments suggests either the violent undressing of a woman during a rape or her disordered condition immediately after it. The chaos of the woman's clothes heightens the effect and the vividness of violent activity and gives to the event of rape a kind of immediate temporality. It has just happened.

This needs careful reading. The presence of the dagger would at first sight link the scene iconographically not with the rape – when the Tarquin would hold the weapon – but with the suicide.[54] Incorporating the vivid disarray of the immediate aftermath of the rape with the moment of Lucretia's suicide would collapse the traditional narrative sequence into a single image, superimposing the suicide on the rape to produce the patriarchal meaning that Mieke Bal's reading of Rembrandt's versions releases into recognition. Yet, in Artemisia Gentileschi's painting the dagger does not point at Lucretia's body but upwards, following the direction of her look. This detail allows me to argue that the painting resists the canonical logic in which suicide must come to complete the murder rape initiated, confirming rape as a murder of the self *ab initio*. The dagger directs the violence back against the violator.

Artemisia Gentileschi's image breaks open the logic of the patriarchal *doxa* that once a woman is unchaste through being possessed illegally and by more than one man she should die. This makes death the logical and necessary conclusion to the event. *Suicide*, however, makes the woman the keeper and executor of the patriarchal law. Mieke Bal has argued in her reading of the Rembrandt paintings that sequence, metonym, is broken by the way the scene is staged so that the rapist, none the less, becomes a part of the later scene, a presence that reverses the suicide and renders the representation a confirmation of a murder of the woman's self that the rape has already perpetrated. The Gentileschi painting appears to make us witness to a recent event in which the dagger with which Lucretia was threatened by her rapist is now in her hand, standing in for the rapist, for his penis and for the instrument of her culturally prescribed, self-inflicted death *in which as yet this female figure is not collaborating.*

No passive acceptance or stoic resolution is expressed by this body. The dramatic conception of the body is all tension, bent knee, and elbow, firmly gripping hands on breast and dagger. Pressure is placed on the swelling breast held protectively, possessively and yet in a possibly painful grip. The face is upturned and is painted in an expression of concentration and anguish. There are obvious prototypes in antique art which associated such an extreme position with anguish. Recast through Caravaggist realism as an unidealised and individualised portrait, the face brings a poignant immediacy to the mythic drama that prevents us from really getting too far into the traditional Lucretia myth. Fantasy is stayed by the forcefulness of this

embodiment of a ravished woman faced with an awful choice, which she has not yet made.

If rape is psychological death – a theft of one's personhood – in legal terms, it is also a social death, for a woman's status changes. Patriarchal cultures have a specific term for the unmarried woman which implies her chastity, *parthenos*, virgin, or *zitella* in seventeenth-century Italian. It was this status that went on trial as Agostino Tassi and Donna Tuzia attempted to suggest that Artemisia Gentileschi was already sexually active, already not *zitella*. Sexual status is also legal status in Greco-Roman cultures where woman is conceived of only as the object of exchange between men and where her value lies in the passage of that property – her chastity, her status as unused goods – from one man, the father, who preserves it, to another man, who uniquely uses it.

Artemisia Gentileschi did not die as a result of the rape by Agostino Tassi. She did not kill herself as a result of the trial. She is not Lucretia of the legend. She survived. To paint Lucretia from that experience of survivorship is to question the legend. Where is that 'difference'? One possible place in the painting for identification with the victim of rape and a resistance to the representation or narrative of that murder of the female self by 'translation' of the text is the way in which the body of the woman is negotiated.

In striking contrast to the total nudity of *Cleopatra* (Fig. 6.7), this painting uses the relations between being dressed and undressed to allow the body to produce a representation of the action of the theft of her identity. To have Lucretia almost nude as does Titian would be to collapse her into the category of her sexuality for man (Fig. 6.13). To have her dressed as does Rembrandt (Fig. 6.12) is to lend her dignity and pathos but to lose the sexual site of subjectivity and its erasure by rape.[55] Rape both is and is not sexual; it uses the bodies' genital sexes as its grammar and has its effects through that violating intimacy of two bodies. This painting shows a woman whose clothes are drastically disarranged, leaving her exposed but not, as Mieke Bal has argued, even with Rembrandt's 1664 version of the painting, 'published'.[56] She holds her garments to cover her breasts and we see her leg. A carefully calibrated balance between the body and the garments signifies the violence of what has taken place while leaving some degree of self-possession to the woman.

I am struck by an element in the transcript of the trial, where Artemisia Gentileschi states that, as soon as she broke away from Tassi after the rape, she reached for a dagger and threatened to kill him for the dishonour he had done to her. Indeed she threw it at his chest and wounded him. The dagger in the painting is certainly not held as if to hurt Lucretia herself and equally not to attack another. It has the look of being held like Cleopatra's asp – in a staying motion, while she resolves on resistance? swears revenge? To be able to fight back reveals a resurgence of subjectivity, a refusal to be contaminated and annihilated. Gentileschi was a survivor, finding her way through the trial and the publicity and a quick marriage to the creativity with which she established herself as a commissioned artist and supported herself and later her daughters.

Lucretia, an image that parallels Virginia Woolf's mythic figure of the murder of women, also resists that myth. Artemisia Gentileschi's painting refuses complicity with

both patriarchal and feminist myths. Able to dramatise visual anguish through the semiotics of a female body, the work refutes the dichotomy of the modernist feminist's image of a poet's heart mortally *entangled* in a woman's body. Equally the Victorian individualist Lucy Snowe would not see the rhetorical meaning of so much cloth making so inadequate a raiment, and I fear she would dislike the *largesse* of the powerful female corporeality. Perhaps it was the historic conjunction of this seventeenth-century Roman woman's dramatic encounter with her culture's definition of woman – at the trial – with a repertoire of cultural stories dealing with heroic women's entanglement in masculine imaginations that created the semiotic spaces for a particular negotiation, a specific differencing of the canon.

Text by text, case by case, we read for the story of the other woman, to find through it not a 'great woman', a heroine and idealised mother, but, in Freud's phrase, 'a [woman] like ourselves to whom we might feel distantly related'.[57] For Artemisia Gentileschi it was Susanna, Judith, Cleopatra and Lucretia; for us it is the painter's reworking of her culture's iconography and mythology of these historic women. On the screen of representation that her culture projected, the artist worked into visibility for herself as much as for us, the late-coming viewers, possibilities that shift the canonical meaning of her themes. In both *Cleopatra* and *Lucretia* we can discern traces of the artist's story. But the elements of that story are different from those which have made Artemisia Gentileschi notorious in art history. Bereavement, maternal loss and post-traumatic survival are not the usual stuff of patriarchal gossip. Feminist desire makes a difference precisely in theoretically re-visioning women's experiences to produce ways of articulating the specificity of feminine psychic formations, sexuality and ways of negotiating a murderously gynophobic culture. Where contemporary feminist theoretical creativity and political consciousness meets the inscriptions of the feminine in the past, there is a creative covenant of reading which allows us to begin to discover our own stories.

NOTES

1 Nancy K. Miller, 'Re-reading as a Woman: The Body in Practice', in *The Female Body in Western Culture*, ed. Susan R. Suleiman (Cambridge, Mass. and London: Harvard University Press, 1988), p. 355.
2 Adrienne Rich, *On Lies, Secrets and Silence* (London: Virago Press, 1980), p. 35.
3 Virginia Woolf, *A Room of One's Own* [1928] (Harmondsworth: Penguin Books, 1974), pp. 49–50.
4 Adrienne Rich, *Of Women Born: Motherhood as Experience and Institution* (New York: Norton Press, 1976), p. 284. The novelist and philosopher Hélène Cixous writes: 'To write. An act which will not only "realise" the decensored relation of woman to her sexuality, to her womanly being, giving her access to her native strength; it will give her back her goods, her pleasures, her organs, her immense bodily territories which have been kept under seal . . . A woman without a body, dumb, blind, can't possibly be a good fighter.' Hélène Cixous, 'The Laugh of the Medusa' [1975], *Signs*, 1–4 (1976), reprinted in *New French Feminisms*, ed. Elaine Marks and Isabel de Courtivron (Brighton: Harvester Press, 1981), p. 250.

5 Margaret J. M. Ezell, 'The Myth of Judith Shakespeare: Creating the Canon of Women's Literature', *New Literary History*, 21, 11 (1990), pp. 579–92.

6 Shoshana Felman, *What Does a Woman Want?: Reading and Sexual Difference* (Baltimore and London: Johns Hopkins University Press, 1993), p. 148.

7 Woolf, pp. 51–2.

8 Felman, p. 147.

9 See Judith Fetterly, *The Resistant Reader: A Feminist Approach to American Literature* (Bloomington: Indiana University Press, 1977). Clearly the first act of the feminist reader must be to become a resisting rather than an assenting reader and, by this refusal of assent, to begin the process of exorcizing the male mind that has been implanted in us.' (p. xii).

10 Charlotte Brontë, *Villette* [1853], ed. Mark Tilly (Harmondsworth: Penguin Books, 1979), p. 275. All subsequent page references in the text are to this edition.

11 Their conclusions are based on the findings of Gustave Charlier, 'Brussels Life in *Villette*', *Brontë Society Transactions*, 12, 5 (1955), pp. 386–90.

12 Christine Alexander and Jane Sellars, *The Art of the Brontës* (Cambridge: Cambridge University Press, 1995). Although Charlotte was taken to see two Shakespeare plays, it appears she did not see the success of that year, Isabella Glyn in the title role in a rare and new performance of Shakespeare's *Antony and Cleopatra*. It is hard to believe that she did not hear or read about Glyn's statuesque rendering of the Egyptian Queen. In 1851, again in London, Charlotte visited Somerset House as well as the private collections of the Marquess of Westminster and the Earl of Ellesmere. She was taken to see the great French actress Rachel in London, Rachel having had a play about Cleopatra written especially for her in 1847.

13 Inge-Stina Ewbank 'Transmigrations of Cleopatra', *University of Leeds Review*, 29 (1986/7), p. 72.

14 *Ibid.*, p. 65.

15 I shall be publishing a paper on Brontë and Cleopatra and the question of identification.

16 I am indebted for the following information and interpretation to Mary Hamer, *Signs of Cleopatra* (London and New York: Routledge, 1993).

17 Edward Said, *Orientalism* (London: Routledge, 1978) and Hamer, pp. 1–23.

18 Hamer, p. xix.

19 A subtle Orientalist reading of this scene in Villette is provided by Reina Lewis, *Gendering Orientalism: Race, Femininity and Representation* (London and New York: Routledge, 1996), pp. 35–43.

20 Charlier, p. 387. I am grateful to Dr Valerie Mainz for her assistance in tracing works by Fanny Geefs.

21 For examples of feminist literary criticism which reads this novel in terms of its attempts to construct the female writing subject, see Judith Newton, '*Villette*', in *Feminist Criticism and Social Change*, ed. Judith Newton and Deborah Rosenfelt (New York and London: Methuen, 1985), pp. 105–33; and Mary Jacobus, 'The Buried Letter: Feminism and Romanticism in *Villette*', in *Women Writing and Writing about Women*, ed. Mary Jacobus (London: Croom Helm, 1979), pp. 42–60.

22 Gayatri Spivak, 'Three Women's Texts and a Critique of Imperialism', *Critical Enquiry*, 12 (1985), pp. 243–61. Spivak writes about another book by Charlotte Brontë, *Jane Eyre*, and points to the way in which what some Western feminists read as a progessive moment in women's struggles for self-definition is premised on white women's dream of participating in a kind of self-possession – individuality – which is specifically denied the 'native' women, reminding all feminists of the need for acute attention to the historical and ideological specificities of historical and contemporary feminisms.

23 Some scholars attribute the *Cleopatra* of 1621–2 to Orazio, although Morassi and Bissell give Artemisia the authorship, as does Mary Garrard, *Artemisia Gentileschi: The Image of the Female Hero in Italian Baroque Art* (Princeton: Princeton University Press, 1989). R. Ward Bissell 'Artemisia Gentileschi – A New Documented Chronology', *Art Bulletin*, 50, 1 (1968), pp. 153–68.

24 Garrard, pp. 244–5.

25 This tradition is celebrated by Kenneth Clark, *The Nude: A Study in Ideal Art* (Harmondsworth: Penguin Books, 1956); and critically analysed by Lynda Nead, *The Female Nude: Art, Obscenity and Sexuality* (London: Routledge, 1992).
26 Elisabeth Bronfen, *Over Her Dead Body: Death, Femininity, and the Aesthetic* (Manchester: Manchester University Press, 1992).
27 This is powerfully argued by Lynda Nead.
28 On the history of this form and the meanings of the gesture see Nanette Salomon, 'The *Venus Pudica*: Uncovering Art History's "Hidden Agendas" and Pernicious Pedigrees', in *Generations and Geographies in the Visual Arts: Feminist Readings*, ed. Griselda Pollock (London: Routledge, 1996), pp. 69–87.
29 Pathos is a category of the nude in Clark's text; its major figure is the crucified Christ.
30 Eunice Lipton, *Looking into Degas: Uneasy Images of Women and Modern Life* (Berkeley: University of California Press, 1986).
31 Julia Kristeva, 'The System and the Speaking Subject' [1973], in *The Kristeva Reader*, ed. Toril Moi (Oxford: Basil Blackwell, 1986), p. 30.
32 *Ibid.*, p. 29.
33 As Garrard writes: 'The Gentileschi paintings took their places in the palazzi of an art collecting aristocracy, among works by Van Dyck, Guercino, Guido Reni, Rubens, Sebastiano del Piombo, Correggio, and Titian.' (p. 56).
34 Yet, even here, there is a danger that I am saying no more than Kenneth Clark, when he called Manet's *Olympia* of 1863–5 (Fig. 9.17) exceptional because 'to place on a naked body a head with so much individual character is to jeopardise the whole premise of the nude.' Clark, p. 153.
35 Hamer, op. cit, xvii.
36 Giovanni Boccaccio, *Concerning Famous Women [De Claris Mulieribus]*, trans. Guido Guarino (London: George Allen & Unwin, 1964), pp. 192–3.
37 Lucy Hughes-Hallett, *Cleopatra: Histories, Dreams, Distortions* (London: Bloomsbury, 1989).
38 *Ibid.*, p. xviii.
39 Eva Menzio, 'Self Portrait in the Guise of "Painting"', in *Mot pour Mot/Word for Word No. 2 Artemisia* (Paris: Yvon Lambert, 1979), pp. 16–43, discusses this relationship with considerable insight. I am grateful to Nanette Salomon for bringing this book to my attention.
40 Garrard, p. 419.
41 I have drawn upon the work of Dina Wardi, *Memorial Candles: Children of the Holocaust*, trans. Naomi Goldblum (London and New York: Routledge, 1992), for insights into the effects of early maternal death or traumatic separation on the development of the sexuality and capacity to mother in young girls.
42 Bronfen, p. xi.
43 Griselda Pollock, 'Deadly Tales', in Griselda Pollock, *Looking Back to the Future: Essays from the 1990s* (New York: G&B Arts International, 1999).
44 Rich, *On Lies, Secrets and Silence*, p. 191.
45 Woolf, p. 96.
46 Felman, p. 147.
47 *Ibid.*, p. 13.
48 *Ibid.*, p. 14.
49 *Ibid.*
50 Garrard, p. 56.
51 Mieke Bal, *Reading Rembrandt: Beyond the Word–Image Opposition* (Cambridge and New York: Cambridge University Press, 1991).
52 *Ibid.*, p. 91.
53 *Ibid.*, p. 68.
54 In Guido Reni's many versions of nude women the iconographic sign that distinguishes Cleopatra from Lucretia is that in the former the asp is aimed at the breast and that in the latter the dagger is.

55 Although in the 1666 version, the bloody wound that stains the white chemise exposed as the gilded dress falls from her shoulders metaphorically incites the viewer to see a sexualised and violently damaged body.
56 Bal, p. 71.
57 Freud, 'Leonardo da Vinci and a Memory of his Childhood' [1910], in *Art & Literature*, *Penguin Freud Library*, 14 (Harmondsworth: Penguin Books, 1985), p. 223.

Fig. 7.1. *Lubaina Himid*. Photo: Sam McClaren

7

REVENGE

Lubaina Himid and the making of new narratives for new histories

The correlation of melancholia and mourning seems justified by the general picture of the two conditions. Moreover, the exciting causes due to environmental influences, are . . . the same for both conditions. Mourning is regularly the reaction to the loss of a loved person, or the loss of some abstraction which has taken the place of one, such as one's country, liberty, an ideal, and so on.

Sigmund Freud, 1917[1]

After Mourning comes Revenge.

Lubaina Himid, 1992[2]

A POST-COLONIAL FEMINIST REVENGE ON THE CANON?

Revenge was the title of an exhibition held at Rochdale Art Gallery in 1992 of *A Masque in Five Tableaux* by Lubaina Himid, an artist born in 1954 in Zanzibar and currently living in the north of England (Fig. 7.1).[3] It comprised nine paintings, sixteen studies, an installation and texts. In their analysis of *Revenge*, Jane Beckett and Deborah Cherry note that masques were an important cultural form in the early seventeenth century. Those at the English court were designed by Inigo Jones as a 'spectacular manifestation of power'. They argue that, far from being a celebration of imperial expansion and absolutist political authority, Lubaina Himid's twentieth-century invocation of a seventeenth-century cultural form is 'a lamentation, a monument to the survival of African people and the transformations of African culture. It is a visual spectacle about the history of power and the power of history.'[4]

Lubaina Himid studied theatre design at Wimbledon School of Art (1973–6). The reference to the masque in *Revenge* indicates a transformative appropriation of themes of staging, performance and theatricality as well as the undoing of illusions created by the stage prop derived from experience as an artist working with these aesthetic resources. *Revenge*, however, is a major, and calculated, re-engagement with *painting*, via the *tableau* – a pun both on the use of tableau-vivant in masque, theatre and later cinema, and on the French word for the most achieved and, therefore, highly esteemed

level of academic painting: the history painting. The history painting was the pinnacle of the academic system because its successful practice required the integration of both intellectual ambition and a highly educated conceptualisation of subject matter with the fullest command of the grammars, rhetorics and practices of art: drawing, composition, gesture, expression, form, colour, perspective and narrative space. Although displaced, if not deconstructed, by modernism in the hands of painters like Manet after the 1860s, there are modernist *tableaux*, Picasso's *Demoiselles d'Avignon or Guernica* for instance, which form the anchor works in the spatialised discourses that are our museums of modern art.[5]

Thinking about Lubaina Himid in the context of this book, I imagine a lineage that finds, at one end, the dying but heroic Cleopatra – the Egyptian queen. In the middle would be Artemisia Gentileschi and her recurrent use of a doubled woman composition of Judith and Abra engaged in political assassination and national liberation. At the other pole are the intellectual and artistic black women couples in the spaces of modernity painted by Lubaina Himid. The modernist settings on Columbus's boat (Fig. 7.2), at the opera (Fig. 7.4) or in some Parisian café of the 1920s (Fig. 7.6) banish defeat, death and danger to propose the strategy I specifically dismissed as a psychological explanation of Artemisia Gentileschi's Judith paintings: *revenge*. Unlike Lucy Snowe as resistant 'feminist' reader who, none the less, enacted the Orientalism of her British cultural and class positionality, Lubaina Himid may be named a 'resistant *creator*' who, as a latter-day Cleopatra, the Egyptian woman and queen in a non-patriarchal and anti-Western culture, turned Artemisia Gentileschi, the painter, refuses to perform the imposed otherness and prepare ever more for the death the West must inflict on what the other/woman represents. Instead Lubaina Himid paints a multiply demythicising series of pictures that demand of the diverse viewers a radical shift in their own understanding of who and where they are in relation to the picturing of differencing historical narratives.

Located at a historically distant point from the seventeenth-century moment of Britain's colonial expansion, *Revenge* takes up the dominant themes of seventeenth-century drama – revenge and mourning – to rework through them the dire legacies of the very colonial project so celebrated in the seventeenth-century courtly masque. Differencing the canon needs to be opened out to this historical plane on which relations between painter and painter, art form and art form, can become the site not of Harold Bloom's retrospective formation of the canon by Oedipal invocation of ancestral figures but of its deconstruction in the name of the desire for a different reading of history. Lubaina Himid's work is about narratives and histories in which the themes of mourning and revenge are inevitable, not only because of individual pain but as a result of a historical trauma of terrifying magnitude whose repercussions are manifest in contemporary societies of the African Diaspora. Trauma is, however, not confined to those who, as its 'victims', struggle to be its survivors. All the descendants of a Europe whose political and economic dominance was fuelled by the slave trade are bearers of unmourned trauma.

Creative and transformative difference is an effect, not a condition. *Differencing* is

produced as a disturbance to the dominant tendencies of available semiotic systems. This problematic faces the post-colonial artist working across the hybrid fields of cultural domination and resistance created in the three hundred years since the beginning of Europe's economic and cultural exploitation of Africa. How does this work make difference signify differently? Perhaps by taking revenge on the cultural canon in which the colonial relations have been aesthetically inscribed.

As an active element of contemporary hegemonies, the canon polices the entry to the pantheon of art by contemporary artists. Writing about living artists exposes its selectivity, exclusivity, partisanship. Working to difference the canon involves questioning divisions: between the historically proven, or those validated by the market and museum, and artists whose work demands attention the criteria for which are generated elsewhere, but without betraying their claim for being considered 'artists'. Artistic practices have strategic significance as well as aesthetic power and affect according to the different communities and constituencies they address. This is, however, a dangerous argument. Th appraisal of art by means other than what the canon proposes are universally acknowledged aesthetic grounds is easily used to disqualify the work as art at all. The canon operates by valorising the art of and for one elite community while labelling art that speaks from or to any other geo-ethnically. Lubaina Himid's work has developed an aesthetic vocabulary for challenging the pigeonholing that is so much part of maintaining the exclusivity of the Western canon.

Modernist art never simply turned its back on history, as a purely formalist Cold War art history tried to have us believe during the 1950s. Encountering, evading or disavowing (which is, nevertheless, a fetishising acknowledgement) modern history's horrors, obscenities and violence necessitated artistic research for an extended repertoire of symbolic-aesthetic production.[6] Through the racist and colonialist perspectives, however, of the 'discovery' of non-Western cultures that furnished modernism with its new vocabularies at the beginning of the twentieth century, the non-Western cultures of Africa and Oceania were themselves distorted and misread. Thus, whether 'borrowed' or colonially misappropriated, symbolic and representational systems of early periods of Western art and of all periods of world art were enlisted to enable modernist artists in the West to rework their own ambivalent relations to Western history in the modern era. The very languages of modernist art are thus doubly historical: a symptomatic response to the dismal underside of Western modernity and an aesthetic appropriation of cultural resources available to artists and framed for them by the colonial expansion of Western modernity. This has produced a perplexing kind of visibility for cultures beyond Europe. 'Worlded' and framed, they become either 'modernised' in European artistic togs or confined to the anthropology and ethnography museum where they must mutely display only their timeless difference. Extended even to contemporary artists, the strategy of 'geo-ethnic mapping', identity politics and a false demand for 'authenticity' maintain the canonical separation between Western art practices and those that are non-Western. Jean Fisher writes:

Above all, from my point of view, it evades the complex negotiations which must take place between European aesthetic languages and those of the rest of the world. For the West to frame and evaluate all cultural productions through its own criteria and stereotypes of otherness is to reduce the work to a spectacle of essentialist racial or ethnic typology and ignore its *individual insights and their universal applications* – a treatment not meted out to the work of white European artists.[7]

Can understanding historically mean a tactical insertion of the present into a historical field by means of a critical quotation from art's histories to signify the historical formation of the present? In its worst moments, postmodernism appears to authorise the collapse of historical distance in the voluntarist aesthetics of contemporary pastiche. Fredric Jameson identified pastiche as one of the devices of postmodernism's cannibalisation of the past which produces an historicism that, in effect, eclipses history – or undermines any historical understanding.[8] He concludes 'that this mesmerising new aesthetic mode itself emerged as an elaborated symptom of the waning of our historicity, of our lived possibility of experiencing history in some active way'.[9] Lubaina Himid's project, however, challenges this tendency. *Revenge* involves a form of quotation and reconfiguration that aims precisely to make possible a historically informed practice of *painting* in the 1990s – a new form of *history* painting necessitated by the urgent need to explode the Western myth of Africa which contributes to the erasure of a creative subjectivity for the artist of African descent. Her practice engages in a highly articulate and self-conscious work with and on the canon of Western art in the creative presence of the complex array of cultural forms and histories of the African peoples. One of the striking results of this playing the museum that is canonical art history is the explicit revelation that there is, embedded in its significant moments and major monuments, a discourse as much on race as on gender. No feminist interrogation of canonicity can claim historical pertinence unless it confronts 'gender *and* the colour of art history'.[10]

Symptomatically, and often without full understanding, modernist artists registered what Theodor Adorno would call 'the negative dialectic' of modernity.[11] The idealised face of modernity – progress, enlightenment, freedom, democracy and rationality – masked a terrifying capacity for inhumanity, violence, exploitation, mass murder and genocides. The classical tradition had created a grammar of representational form cut to the measure of Western Man's self-idealisation. The legacies of modernity and their revealed 'barbarism' have demanded new aesthetic forms because that delusion became unsustainable – except when fascist regimes attempted the perverse resurrection of classicism as their official cultural vocabulary.

Revenge resists postmodernist pastiche and its erasure of history, while yet actively citing and referencing artistic codes associated with historical moments within modernity that are stamped by the colonial rape of Africa. In this, Lubaina Himid's work invites both a modernist and a postmodernist label. Discussing exactly this problematic in her study of the work of three black women artists in Britain, Gilane

Tawadros concludes that 'black cultural practice cannot be defined in terms of post-modernism or postmodernity', precisely because such practices do not try to separate themselves from 'the historical and political configurations of modernity'.[12] Tawadros has carefully argued against seeing postmodernity as a break with modernity; rather she sees it, following Habermas, as a reaction against some of the effects of social modernisation, even while maintaining an underlying continuity with hegemonic Western hierarchies of knowledge and power. In this context, she states: '"populist modernism" of black cultural practice, I would argue, signals a critical reappro-priation of modernity which stems from an assertion of history and historical processes.'[13] Gilane Tawadros identifies an aesthetics of resistance in the artistic practices of artists like Sonia Boyce, Sutapa Biswas and Lubaina Himid, a resistance which contradicts Fredric Jameson's suggestion that postmodernism makes it impossible to map subjectivity within the fragmenting and dehistoricised world of the postmodern: the new myth of late twentieth-century culture and its theories that so often proclaim both the end of the subject and the end of history. 'Rather, the world of these artists attests to the importance of charting individual and personal subjectivity within the material structures of history and politics.'[14]

An artistic practice with the underlying aim of creating narratives and histories for those erased by both their enslavement and murder and their mythic assimilation as muted other into imperial narratives and colonial art histories, may, paradoxically, find in the artistic icons of the Western story and their modernist aesthetic tools the very materials with which to articulate an inscription of a historically resistant subjectivity.

ON SOME PAINTING IN *REVENGE*

Between the Two My Heart is Balanced (Fig. 7.2) places two women in a boat on the high seas. The high horizon line is clear and the way is open. One woman is dressed in a brilliant, saturated red; the other in a plaid fabric with bold lines of grey, pink and black on a white background. She is seen in profile and the head is clearly Egyptian, reminiscent of the fashion for elongated heads known to us through the sculptures named after the Egyptian Queen Nefertiti. Both figures perform key gestures. One tosses small pieces of torn-up maps from hand to hand; the other stretches up to remove a coloured volume from a pile of maps and navigation charts to cast them overboard. With its intense colours, bold painting and Matisse-like economies of drawing, especially in the rendering of the faces, this is a knowingly modernist painting – or a knowing use of painting to invoke modernism as both ways of painting and systems of meaning rooted in a specific historical relation of Europe and Africa. Yet, at the iconographic level, the painting establishes a dialogue with a painter and etcher banished from that canon, a French artist, who also worked in England, James Tissot (1836–1902). A contemporary of Manet and Degas, Whistler and Stevens, Tissot was a genre painter of scenes of everyday bourgeois boredom and languid sexual intrigue

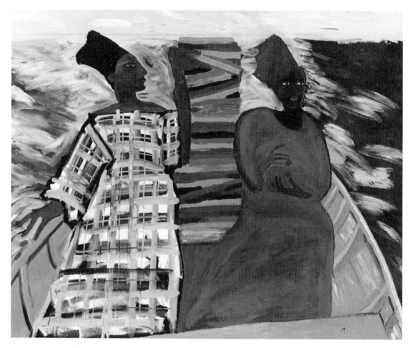

Fig. 7.2 *Lubaina Himid* (b. 1954), *Between the Two My Heart is Balanced*, 1991, acrylic on canvas, 150 × 120 cm. London: Tate Gallery

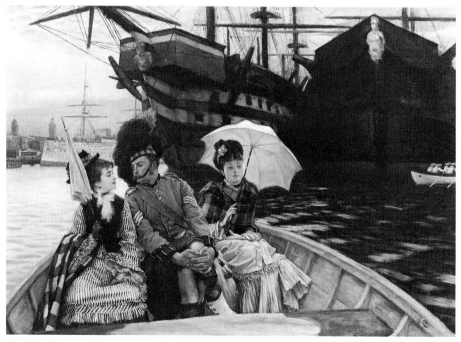

Fig. 7.3 James Tissot (1836–1902), *Portsmouth Dockyard*, 1877, oil on canvas, 38 × 54.5 cm. London: Tate Gallery

always made interesting by a psychologically complex ambience. His painting style and representational language are rarely discussed, for this moment of Victorian painting falls out of modernist canonical histories of urban modernity and its representation.[15]

Not only is Tissot a painter of the modern bourgeoisie, but his paintings locate their intrigues within a socio-political field. Tissot understood the 'language of fashion', the coded signs of dress, before Roland Barthes tackled this cultural vocabulary through semiotics. Lubaina Himid takes dress style, fabric, pattern and cut and makes it a signifying system just as Tissot did both to make his paintings interesting visually and to make them intelligible while always seeming to avoid any pretension to rhetorical effect.

Take for instance *Portsmouth Dockyard* (Fig. 7.3) which is a referent for *Between the Two My Heart is Balanced* (Fig. 7.2) The phrase is, in fact, the title of the etching (Providence, Museum of Art, Rhode Island School of Design) that Tissot made after his painting to bring out the uncertain sexual and personal relations between the Highlander and his two companions as he is rowed back to board the waiting troop ship. Lubaina Himid's painting quotes the cut-off boat that has the effect of placing the viewer not at a theatrical distance but right in it with the other passengers. The viewer must sit with the rowers, the power propelling the craft to its unspecified destination. Tissot used this compositional device several times. In an earlier version, *The Thames* (1876, Wakefield City Art Gallery), two women recline in the bows of the boat. The imperial flag, the Union Jack, flutters from the stern overlapping with the prow figurehead of a huge ship looming up behind the pleasure boat. A white, white-clad half-dressed female figurine with hand shielding her eyes watches for the ship's progress through the water. The Thames's banks are dense with shipping of every kind, steam and sail, pleasure and commercial. Beyond the rigging and the masts are chimneys and warehouses. Smoke fills the air and clouds the horizon. This is London, the centre of Empire, and here are the ships that make Britannia rule the waves. Tissot places a trio of casual and ordinary members of the British *petit bourgeoisie* on the small pleasure craft in the heart of Britain's shipping empire. A bold and striking sense of composition and design creates a minor narrative interest by placing two young women and a smartly dressed young man together in the boat for a picnic. The incongruity of British modernity – pleasure and commerce, sexuality and empire – jostle in this unpretentious yet striking painting.

Tissot's language has become illegible or uninteresting to most modernist art historians.[16] Its particular combinations of painterly boldness and implied narrative make invisible its startling and unadorned juxtapositions of sexual desire and imperialist celebration. *Portsmouth Dockyard* (Fig. 7.3) brings out another element of the same components, since that harbour was home to the British navy. The male figure is a soldier. It is the embodiment of the military force that secured the Empire that Lubaina Himid expels from her painting, replacing him with the pile of maps and charts. These refer to both the forms of knowledge that made colonial and imperial conquest possible and to the forms of knowledge – the epistemic violence – that

colonial and imperial expansion laid over the conquered territories, demanding that the inhabitants should now recognise themselves in the imperial representations made of them. Gayatri Spivak calls this complex manoeuvre the making of the Self-consolidating Other. Through imperial representation the native inhabitant becomes an other that can know itself only in terms which consolidate the sovereign subjecthood of the European colonial master.[17] The mapping of Africa, or, in Spivak's phrase derived from Heidegger, the 'worlding' of another's cultural space in terms which estrange the occupiers from themselves and install a master discourse, has to be strenuously contested. For this to be done, it must first be seen; Lubaina Himid's paintings create a narrative space that provides what the artist calls 'clues to events'.

Lubaina Himid's knowing and strategic extrapolation of elements of the composition and painterly language of the mundane painter at the heart of Empire, Tissot, activates her intervention in the historical elements his painting so casually, but effectively, configures. That indifference is itself the index of the naturalisation of the ideology of Empire in British culture by that date. Lubaina Himid's painting not only demythifies that ideology: it also abolishes in one gesture the heterosexual triangle and the exclusive whiteness of the scene. Lubaina Himid places two black women in conversation and companionship with each other. The place of the missing third becomes that of the spectator, invited to be part of a journey uncharted by empire and capitalism.

> With these works I want to say I know your game, I know what I want to say with my medium and my tools, I want to show my truths, my illusions and my prophecies and my legends. Colour is a vital element in a wild bold and tumultuous brushing on of a wide palette. I am not interested in mimicking the self indulgent techniques in abundance, rather, I am interested in the power that a painting, however small and seemingly domestic, can have. I engage with location; public space, private space, the obsession with the control of space, of land, of the sea and of people.[18]

On the double canvas titled *Act One No Maps* (Fig. 7.4) two women sit in a box at the theatre or opera. One wears a stiff-collared black-and-white dress borrowed from a portrait of European royalty; the other wears flowing robes in printed gold-enhanced fabric that suggests African textiles, another kind of royalty and culture. Fragments of maps fall from their hands as they gaze at an empty, classically designed stage. The painting might evoke for certain viewers the theatre paintings of Impressionists like Auguste Renoir and Mary Cassatt (Fig. 7.5). With the activation of that reference come questions of class and gender that have been identified as critical to a feminist reading of the spaces of metropolitan modernity. Like Tissot's, Mary Cassatt's paintings critically inscribed a class and gender dimension to the aesthetic politics of modern urban space. The privileged spaces of modernity – theatre, café, street or brothel – were the sites of the novel urban experiences of a bourgeois masculinity while

the spaces of femininity – including the home, garden and suburban park – appeared to be without significance because of the ideological conflation of women and domesticity. Urban modernity became synonymous with the public spaces of bourgeois masculinity constructing itself as master of the social and the public. Feminist re-readings of the canon of early European modernism exposed the ideological freight of this public/private division, the separation of the spheres for Man and Woman, and enabled us to read the specific meanings of paintings of modernity made from the newly visible spaces of bourgeois femininity signified in paintings by the American Mary Cassatt or her French colleagues Berthe Morisot, Eva Gonzales and Marie Braquemond.[19] In such an argument, the invocation of women at the theatre (a possible public space for chaperoned bourgeois 'ladies') speaks also to the masculine spaces of modernity – such as the prostitute's boudoir, where, uniquely, a modern black woman appeared, in Manet's *Olympia*, for instance (Fig. 9.17).

In *Act One No Maps* (Fig. 7.4) two black women assertively occupy these highly symbolic spaces of both the contested histories of modernity and the histories of modernism. Their presence at the theatre of modernity – as its privileged audience and its oblique representatives – is a gesture that inserts itself both into a history of modern painting and into a conversation amongst feminists about painting, gender, class and race and their intertwined histories. Lubaina Himid writes:

> These paintings are as much about the stuff in which they are painted as they are about the events which they remember and evoke. I have taken when and what and where it has seemed appropriate, from whom I wished to borrow and reinterpret. There are references to Turner and Tissot, Hockney and Hodgkins, Riley and Bell, Sulter and Laurençin. Quilting, weaving, tapestry, printed textiles, performance, masquerade. Paintings are at the centre of the dialogues about art, they are the tool with which the artist can enter the arena of illusion and prophecy. Why then should women not enter the arena wielding this weapon?[20]

Jill Morgan writes of a third painting in this series from *Revenge* (Fig. 7.6):

> *Five* represents two Black women sitting at a table in a domestic interior, the style of their clothes and the reference to modernist interiors suggests Paris in the 1920s. The table is the arena for their strategy to be worked out, across the plates, recalling the plates tumbling down the wall [in another piece included in the exhibition]. Different strategies are debated, the atmosphere is highly charged and reflected in an avant-garde yellow. Looking into the eyes of the flowers on the table we see that they are Egyptian, African depictions, so the yellow becomes the colour of Africa, an interior constructed in the manner of modernist painters but with the fabric of Africa acknowledged.[21]

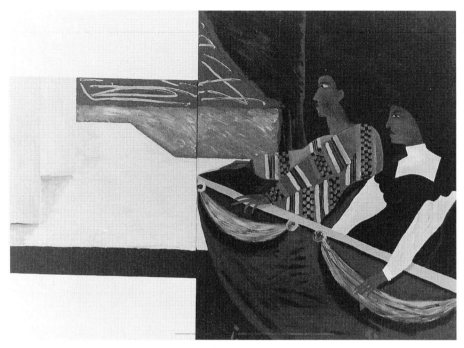

Fig. 7.4 Lubaina Himid, *Act One No Maps*, 1991, acrylic on canvas, 210 × 160 cm. Collection of the Artist

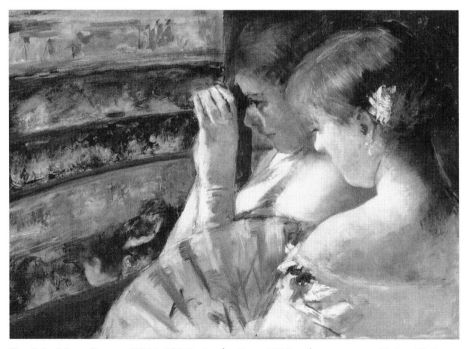

Fig. 7.5 Mary Cassatt (1844–1926), *In the Box*, 1880, oil on canvas, 42.5 × 72.5 cm. USA, Private Collection (photo: Courtesy, Sotheby Parke Bernet, New York)

Jill Morgan writes of colour that 'flows, crashes, dances and stalks' and sees the striking juxtapositions of earthy colours, ermine blacks, reds, turquoise blues, oranges and yellow as both a re-claiming of the colour palette of Africa and a dipping of the brush into the palette of European modernism.[22] The bold colours specifically remind the art historian of Post-impressionist, colonialist palettes – Gauguin for instance – and those of the Fauves and Die Brücke: all movements historically indebted to the cultures of Africa or Polynesia for their radical aesthetic innovations. In the case of Kirchner's didactic representation of the symbolic space of the modern artist's studio, these also expose the paradox of the modern woman in her relation to the colonial objectification and sexualisation of both woman and Africa (Fig. 7.7).

In *Five* (Fig. 7.6) two figures sit at a round table. They are perhaps at home, having their own post-colonial feminist dinner party. They are not, however, represented by sexualised plates; the women want to be seen as historical agents who think and talk, and not as symbolic bodies. The plates in this painting have maps or flags on them, stars and stripes, Africa. Perhaps these women are in a café, a public and very modern space and sociality which Picasso and Braque made the very substance of Cubism's formal reconstructions. The iconography suggests Paris in the 1920s, a city that was host to an extraordinarily dense population of modernist women – artists, poets, writers, journalists, dancers, publishers, booksellers. This was the decade of an intense struggle to modernise sexual difference, a still unfinished project that contemporary feminism has resumed with renewed intellectual and artistic energy. Excavating the forgotten histories of artistic and sexual radicalism, Sheri Benstock notes how almost all of her key players – Djuna Barnes, Nathalie Barney, Sylvia Beach, Kay Boyle, Bryher, Colette, H. D., Janet Flanner, Mina Loy, Anaïs Nin, Jean Rhys, Solita Solano, Gertrude Stein, Alice B. Toklas, Renée Vivien, Edith Wharton – have been considered marginal to canonical stories of modernist art and literature. If at all, they have been allotted merely supporting roles. Sheri Benstock writes:

> The roots of the misogyny, homophobia and anti-Semitism that indelibly mark Modernism are to be found in the subterrain of changing sexual and political mores that constituted the *belle époque* Faubourg society . . . The story . . . writes the underside of the cultural canvas, offering itself as a countersignature to the published modernist manifestos and calls to the cultural revolution. This female subtext exposes all that Modernism has repressed, put aside, or attempted to deny.[23]

Andrea Weiss's documentary film and book of the same era is titled simply *Paris was a Woman*.[24] The book's cover shows two women seated at the table of a street café – a scene which, in Mary Cassatt's time, would have signified only the women's prostitutional status in the Paris of the 1870s,[25] but by the 1920s suggested the social revolution associated with women's sustained re-invention of themselves (Fig. 7.8). New Women claimed their place in the conversations of modernity and the spaces of urban social life as its actors not its tropes. The two female figures in Lubaina Himid's

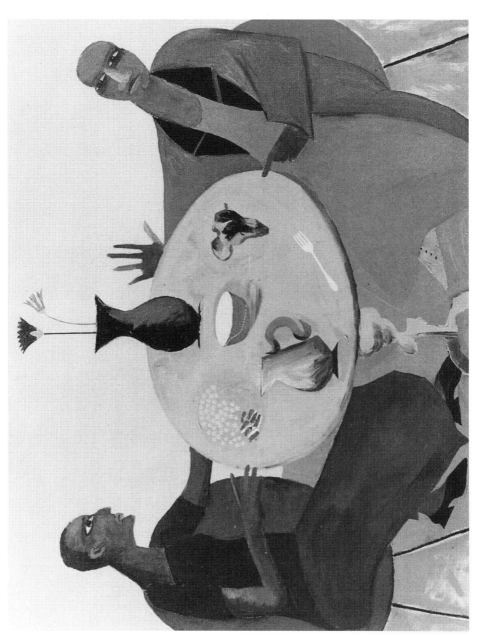

Fig. 7.6 Lubaina Himid, *Five*, 1991, acrylic on canvas, 150 × 120 cm. Leeds, Griselda Pollock, on permanent loan to Leeds City Art Gallery

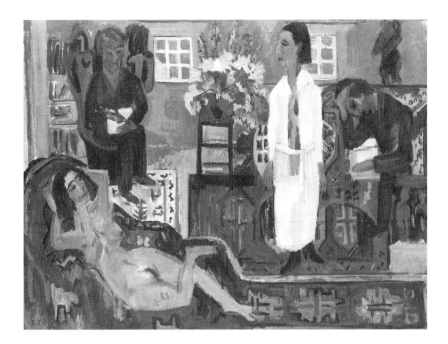

Fig. 7.7 Ernst Kirchner (1880–1938), *Modern Bohemia*, *c.* 1925, oil on canvas, 123.1 × 162.8 cm. Minneapolis, Minneapolis Institute of Arts

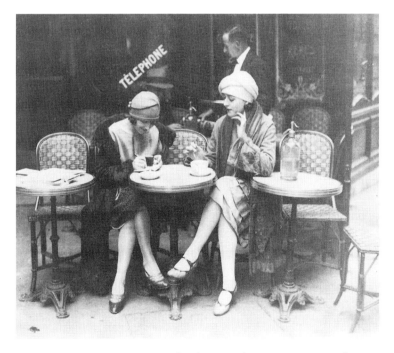

Fig. 7.8 *Two Women at a Café*, photograph, 1920s. Paris, Collection Viollet

paintings break through from trope – sexualised, muted other – to the representation of historical subjectivity within that re-visioned field of a densely populated feminist modernism.

The space in *Five* is not closed off to the viewer. Others may pull up a chair. Two women occupy the painting's visible space in the modernist dress of the early twentieth century. They fill the painting with their gestures, the intensity of their imaginary exchanges. Their gestures signify engagement, argument, conversation, discussion. They are 'black'. This is at once a misnomer for their actual colour in the painting. The word designates a historical identity – a burden and a political assertion of resistance. Despite all the politics of post-colonial self-naming, the term *black* as applied to persons has to be confronted in art in so far as the meanings of this term are so embedded in the Western imaginary. As Christopher Miller has argued, blackness, associated with the name 'Africa', signifies an absence of meaning – blank darkness.[26] The immense significance of the representation of two black women, talking, filling the imaginary space of the brilliantly luminous canvas, self-determining in the spaces of the capital of Western modernity, Paris, cannot be underestimated.

These two 'painted ladies', black women artists and intellectuals, modernists and strategists are both the descendents and the revolting daughters of a genealogy of black women represented in the canon of Western art and the radical dissidents defying that legacy to demand a different script for their future. This painting strikes its difference within the canon by the representation of black women as philosophers, theorists, revolutionaries, artists, conspirators – not as serving slaves or exhibited booty, not as exotic spectacles or consolidating others, not as naked, sexualised or labouring bodies exotically outside of history. They difference their own genealogy by being clothed in garments that claim complex relations to space and time, to history and location, to modernist culture, art and literature, by talking to each other, by finding their world in each other's minds, thoughts and being, by sitting at a Parisian café table where others might serve them whose historic role scripted by Western slavery and colonialism was servitude.

In her autobiography Josephine Baker, the famous African American dancer and singing star, described her arrival in Paris in 1925. As an African American woman from East St Louis, carrying the scars of America's virulent racist society which erupted in 1917 into a traumatising pogrom which the singer witnessed as a young girl, Josephine Baker writes of her amazement – and pleasure – the first time a white man served her at a café in Paris and called her *Madame*.[27] She embraced Paris as a city in which she could experience herself outside the appalling racism that dehumanised and desexualised her in the United States. Modernist Paris in the 1920s was, however, ambivalent in its cult of 'negrophilia' that carried Josephine Baker to stardom in the *Revue Nègre* on 2 October 1925. But it was a space of cultural possibility that sustained the creativity of many black sculptors like Augusta Savage, who studied in Paris in 1930, or Meta Vaux Warrick (1877–1968), who exhibited at the Salon of 1903 a piece called *The Wretched*, or the designer and painter Lois Maillou Jones (b. 1905), who studied at the Académie Julian in 1937.[28]

The painting *Five* is, moreover, as radical in what it absents as in making visible black women in modernist Paris. There is no white woman in the picture. This is the breach with the colonial text. The black women are not there to consolidate the sovereign European subject, or to be admitted on sufferance in the delusory tolerance of liberalism, which merely cloaks the dagger of its underlying racism. They claim and occupy a space, and they do it as two. It takes only this minimal severality to refute the stereotype, the fixity that might allow one token woman, a Josephine Baker, to represent the totality of otherness in a form that can never threaten. The token black woman – like Josephine Baker made to perform the white public's fantasy of Africanism despite her being a modern American – allows the dominant group to relieve its conscience while even more effectively closing its eyes to the many, each in her own unique way, seeking to be an artist, a writer, a creator in a modern world she claims as also and indelibly hers.

There is a series of famous photographs of Gertrude Stein and Alice B. Toklas, perhaps the most famous couple in Paris. One by Man Ray domesticates this famous couple for they are photographed 'at home', seated across a table in their apartment at 27 Rue Fleurus in 1922 (Fig. 7.9). The homy setting is transformed, however, by the presence of two women in a loving and companionable relation to each other that sustained the literary creativity of the writer in the couple. Their home was a salon, a gallery dedicated to contemporary art that must find its place on walls that also reveal a love of flowers. Another photograph, taken in London in 1936 by Cecil Beaton, simply places Alice B. Toklas and Gertrude Stein facing each other across the empty studio (Fig. 7.10).

These are important and challenging representations. The representation of two anythings, as Marjorie Garber has shown in her study of bisexuality, incites the underlying heterosexual binary that unconsciously organises the heteropatriarchy.[29] We see two things, even two pieces of fruit, and they fall into a narrative. The viewer projects a couple in the stereotypical terms of man and woman, husband and wife, and we discover that the basis for that assumption lies in an imagined hierarchy between the two. In Beaton's photograph (Fig. 7.10) two figures of comparable size are positioned on the same plane, directly confronting each other. The implicit heterosexing binary is formally forestalled, forcing a semiotically novel possibility for the lesbian couple to suspend the binary of sexual difference and intimate 'sexuality otherwise', independent of gender and thus of hierarchy. Women can signify difference and desire without reference to the terms of phallocentric sexual difference. It is in this sense that the lesbian materialist thinker and novelist Monique Wittig argued that lesbians are not 'women'. This is not to fall back on to early twentieth-century theories of a third sex, or of men trapped in women's bodies. Following Hegel, Monique Wittig – a linguistic descendant of Gertrude Stein – argues that 'woman' is a not a natural given description. As in the master/slave dialectic Hegel defined, 'Woman' is a term within the patriarchal and heterosexual economy: woman signifies the economic, ideological and political power of a man, just as the slave is necessary for the master to exist as master. For Wittig, the lesbian refuses the definition of 'woman' that derives

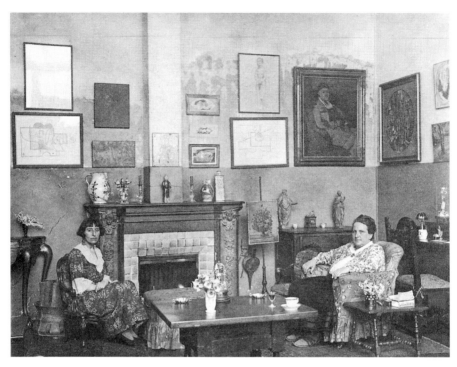

Fig. 7.9 Man Ray, *Gertrude Stein and Alice B. Toklas*, photograph, 1922. Yale Collection of American Literature, Beinecke Rare Book and Manuscript Library, Yale University

Fig. 7.10 Cecil Beaton, *Gertrude Stein and Alice B. Toklas*, photograph, 1936. Sotheby's, London: Cecil Beaton Archive

its meaning from the sexual, economic, political and ideological pair, 'man over woman'.

> To destroy 'woman' does not mean that we aim, short of physical destruction, to destroy lesbianism simultaneously with the categories of sex . . . Lesbian is the only concept I know which is beyond the categories of sex (woman and man), because the designated subject (lesbian) is *not* a woman, either economically, or politically, or ideologically. For what makes a woman is a specific relation to a man, a relation we have previously called servitude. We are escapees from our class in the same way as American slaves were when escaping and becoming free.[30]

These paintings by Lubaina Himid work with the doubled representation of black women on several semiotic and conceptual levels. *Five* creates a double exclusion: of the white woman who would, because of the still operative colonial legacies, reduce the black woman to her servant, her white supremacy-acknowledging other;[31] and of the man who would deprive both women of their possibility of signifying any other than his supplementary, servile other, Woman. Since the 1920s feminists have been struggling with the terms of the transformation of gender that I name 'the modernisation of sexual difference'. The question of sexuality is as critical as that of language, for the two have been revealed to be in intimate correlation in structuring not only our minds, and our bodies, but our social possibilities and imaginations: the very horizons of meaning and being. The 'lesbianisation' of this couple is not to re-index them to masculinist and heterosexual culture's appropriation of the lesbian as exotic sexual sight – evident in canonical modernism from Courbet's *The Sleepers* (1866, Paris, Musée du Petit Palais) to Henri de Toulouse-Lautrec's lesbian brothel scenes discussed in Chapter 4. It is to signal a feminist reconstruction of language and visual signs that allows 'not-women women' – to recall Julia Kristeva's neologism discussed in Chapter 1 – to signify as desiring subjects, subjects of both personal and historical desire that cannot be imagined, thought or imaged within the phallocentric system where woman is a sign only of and for Man.[32]

So what is the woman wearing Gertrude Stein's coat planning with her colleague in her modernist European yet also African modernist interior – painted so brilliant a yellow that no one could understand how their world was ever called the Dark Continent – except in an ignorance the West inhabited and projected?[33] Jill Morgan writes:

> Our conversation with these paintings then is also through the psychologically loaded palette of colour. Juxtapositions, chosen of earthy colours, ermine blacks, reds, turquoise blues, oranges, a re-claiming of the colour palette of Africa and a dipping of the brush into the history of Western art. Lubaina has understood the importance of colour in the control of meaning. Within modernism colour has been used to represent, to own, entire civilisations, or to take colours sacred to a way of seeing and use them as a mirror, or a cipher for 'new' ways to see.[34]

In this series of paintings, therefore, Lubaina Himid deploys a semiotic and aesthetic procedure that knowingly conjugates both Western artistic traditions from the Renaissance through to modernism with what she is inventing as signs of an African women's history in revolt against European mapping, appropriation, disinformation and visualisation. Their collision on the canvases of a late twentieth-century figurative painter is both shaped by, and shaping of, what can be realised by a self-conscious negotiation of inherited rhetorics which generate a special kind of referentiality in the arena of painting and the dialogues about art. The signs refer to the histories of art, drawing in their aesthetic and cultural freight to create the possibility of post-colonial meanings in their current painterly re-configuration. No longer attached to time and place, to artist and intention, they become elements in an invented language that can now be read by those who share the *musée imaginaire* of the differencing of the canon. These signs from the art of the Western and African pasts are, however, turned through the prism of a material history that makes each modernist element – brush-stroke, colour, costume, place, gesture, composition – yield up the historical, and the political, determinants that generated it at its first appearance on the cultural canvas: namely, those inevitable relations between the aesthetic and the social which modernist art history tries to erase in the white, boxed spaces of the museum – the institutional repository of the canon.

Lubaina Himid's work has never received adequate critical acknowledgement in the mainstream art press, even when it has entered the exhibition spaces of the museum. At times the silence has been deafening. In 1993 *Revenge* was exhibited at the Royal Festival Hall, London, while next door, at the Hayward Gallery, Georgia O'Keefe received her first major showing in Britain.[35] A long-lived American 'old Master/Mistress' of the modern school? A reclaimed but self-disavowing feminist? Georgia O'Keefe was the object of a barrage of frankly misogynist attacks from the newspaper art reviewers while *Revenge* received almost no notices. There was, it appears, an imaginative link between what the guardians of the canon could now say in the 1990s negatively about an old white woman artist and the negation by silence of a younger black woman showing nearby. The impolite absence of commentary on the major *paintings* displayed in *Revenge* seemed to permit the even more un-controlled abuse of Georgia O'Keefe, whose work was consistently interrogated about the quality and ambition of her painting because of her allegedly unmerited reputation as a *painter*.[36] This revealed so clearly the still potent symbolic investment in painting itself and the need to protect this practice at all costs from 'women'.

HISTORY PAINTING

Lubaina Himid defines her project: the creation of myths, the questioning of history and the invention of new narratives. These are necessary strategies of re-vision to make possible an answer to the question: how can black people salvage a future from the devastation of their past? At one level the work has consistently staged, in a series of

individual works, installations and exhibitions, the problems of loss, mourning, absence. Yet, by figuring them through interventions in a reworked concept of 'history painting', artistic practice becomes strategic, indexing representation both to its own cultural histories and to the historical field which has conditioned and determined cultural representation. Artists place themselves in histories of art, using the store-house of the past of many cultures to furnish means and ambitions, support and directions for their own practices. Canonical art history may be defined as a kind of border police, monitoring the visibility of which links, which borrowings, which genealogies are to be acknowledged, while others become aberrant, ignorant, incorrect or plain invisible. So there must be mourning for history and there must be artistic revenge on the canon which is the symbolic and aesthetic support of a too selective and always selecting history.

The history of women artists of African descent in Western art history was a blanked-out page in art history until the 1970s. Edmonia Lewis (Fig. 2.3) was the only African American to figure in Eleanor Tufts's initial salvo for a feminist rewriting of art history, *Hidden from History* (1974).[37] In 1876 Edmonia Lewis produced *Death of Cleopatra* (Fig. 6.6), recently rediscovered in a Chicago suburb where it had been abandoned after having served as the tombstone of a racehorse bearing the Egyptian monarch's name. Cleopatra was an inspiration to many of the American sculptors who were Edmonia Lewis's contemporaries – including Margaret Foley while Anne Whitney created a monumental allegorical figure simply called *Africa* (1863–4), which, none the less, recalls the iconography of the dying or dead Cleopatra. The political message of *Africa* is that this great people or continent is awaking from a long slumber. Yet 'Africa' is feminised. Powerful as this large-scale statement was, and motivated as it was within the liberal limits of nineteenth-century white abolitionist and feminist politics, the recumbent posture of the sculpted woman erases the dynamic history of transformation and concurrent resistance in a real place, collapsing it into the Western trope of femininity as nature, passivity, sleep and death which Cleopatra repeatedly signified in the West. The transcoding of territory to body, of Africa to woman, abolishes any historical meanings for African peoples, revealing the deep hold on the Western imaginary of the tropic condensation of racialisation and gender. The feminisation implies, however, deep in the recesses of the allegorical move, a sexualisation of Africa, invaded, raped, enslaved, muted and made the pretext for colonial salvation: castration and decapitation.

Cursory as this review must seem, it serves to expose the gulf that divides the white feminist art historian from the black artist in terms of the desires that rediscovery of the past might nourish. However much I have suggested that we must trouble the wish for an ideal ego in a rewritten history of 'great women artists', they are at least there for those white feminists who want that comfort. Lubaina Himid must find herself in a different relationship to even the slowly forming feminist canon. Her history does, of course, include Artemisia Gentileschi as forerunner, for all of the Western canon belongs to her as a contemporary British artist and as an artist of the post-colonial deter-ritorialisation. Yet, in those moments when a special desire arises for representational

support of her historical, cultural and social specificity, she must also negotiate disappearance, absence and a more structural trauma of loss and mourning occasioned by the historical crime of slavery and the ruthless economic exploitation created by the nineteenth-century 'scramble for Africa'. The loss concerns both a 'beloved person' through personal biography and a country, cultures, possibilities and an ideal. The work of making one's own place in a history by at once claiming and challenging the canon as a resource finds an echo in the series called *The French Collection* (1991) by the African American artist Faith Ringgold. Using her redeveloped medium of painted and sewn quilts, Faith Ringgold places black women in the very spaces and images that constitute both a white and a male canon. *Dancing in the Louvre* (Fig. 1.2) joyously places a young African American in the hallowed gallery where the *Mona Lisa* perplexingly almost smiles on hundreds of thousands of art lovers and tourists.

Is this what Lubaina Himid means by *Revenge*?

This call for both a renewed collision of history and painting might seem a paradox if not a dead end when feminist cultural criticism has been sceptically cautious about the co-opted spaces of the renewed heroic tradition of great painting as well as the ironic pastiches of history painting – the return to a market-led valorisation of painting and its authoring subject in general.[38] Feminist criticism has also viewed painting with anxiety, given the exclusively masculine freight it has carried in the absence of appropriate histories of women and paint.[39] Lubaina Himid's practice in the 1990s forces us to confront a strategic value in claiming this territory of representation and the 'weapon' – painting – precisely because of all that ideological load and its immense symbolic status. Colours, spaces, figures, gestures, surfaces, ways of putting paint on canvas offer an invitation to read both reference to and difference from dominant representations of patriarchal colonial culture.

These paintings are both by and about a black woman artist in the spaces of (post)modernity and they pose the question: Who can in fact be pictured and seen in the spaces of art? To the degree that black women artists occupy the spaces of representation, intervening in art's social histories at the level of both image and sign, to produce meaning, white women have a concurrent obligation to engage in a dialogue with that work that can both acknowledge its difference and seek to recognise the specificity of the position from which it is enunciated while allowing that position to make a real difference to the radically new histories we are all in the process of creating. In the compositions of the paintings in the *Revenge* exhibition, as in Mary Cassatt's work, there is an implied position for the viewer – rowing the boat, elsewhere in the audience, at another table in the café. The calculated device of a 'space-off' or beyond yet implied within the represented spaces presupposes the many others to which the paintings are differentially addressed. That relation is not as master/ spectator. It is potentially dialogic and multiple.

This idea of history painting – and it must be kept at a distance from the theoretical and historical specificity of its theorisation in the academic theories of the eighteenth century – stresses the necessity for history as the basis of the drive to representation and the condition of any reading. A response is required. Silence would mean either

that the difference is made unspeakable or that the work is without significance. Reading is, as Mieke Bal has argued, a positioned response that is always an active processing of signs.[40] Reading is a way of engaging and animating the productivity of a visual text without denying the particular character of its visuality. In the racist context of contemporary culture, a failure to read – to process the signs – is worse than a mistaken reading. It is a cultural murder, denying the work any effect and refusing to acknowledge the need for mourning the past that has defiled us all.

ON MOURNING AND MELANCHOLIA

> After Mourning comes Revenge.
> Lubaina Himid

Sigmund Freud analysed mourning as being quite akin to melancholia, that is, depression. 'Mourning is regularly the reaction to the loss of a loved person, or to the loss of some abstraction which has taken the place of one, such as one's country, liberty, an ideal and so on.'[41] Diaspora is a condition for grieving. History gives us much to mourn.

Freud wrote about 'the work of mourning' (*Trauerarbeit*), the process of adjusting slowly and painfully to the reality which tells us that the loved object, place or ideal no longer exists – or cannot be regained. So intense can be the refusal to give up the libidinal investment that the subject can turn totally away from reality, clinging to the lost object with hallucinatory zeal. Slowly, painfully and bit by bit, with a great expense of time and energy, prolonging the existence of the lost object all the while, the libido attached to the object is brought up and hypercathected, detached and released, making the ego 'free and uninhibited again'.[42] Depression follows a similar path but there is a difference: 'in mourning the world has become poor and empty; in melancholia it is the ego itself'.[43] In depression, therefore, the ego internalises the loss and the anger associated with the violence of loss. Directed at the ego itself, this can result in extreme situations in violence against the ego: suicide.

To remain trapped in incomplete mourning and fall into depression is to turn the sense of loss against oneself, to degrade and devalue the ego, to allow oneself to remain the victim. To mourn the loss, however, is to examine the meaning of what is felt as lost, and to free the creative subject for action – for a future, escaping entrapment within a depressing past. That does not mean minimising the violence or horror: rather it calls for separating it off from oneself and refusing, as the melancholic cannot, to feel responsible for the loss that has been inflicted. Artistic practice is thus more than a therapeutic process. It requires mourning to be accomplished – for there to be departure from the trauma – for the artist to release her creativity. Art then re-stages as a public, historical act a process which must be publicly, i.e. symbolically, articulated after *Trauerarbeit*. Thus, *after* Mourning comes Revenge.

Melanie Klein went further than Freud, and generalised the human psyche's struggle

with loss as a founding condition of subjectivity. All of us must deal with the loss of objects which were once felt to be part of us, for instance, when the child must recognise the autonomy of the parents who have hitherto functioned as part-objects that could be incorporated within the infant's archaic world. This very early encounter with loss produces what Klein named the 'depressive position', which is structural to the formation of subjectivity. Contemporary with the depressive position, however, is the compensatory emergence of a fantasy of being able to repair the loss and restore the violent destruction that the infant subject imagines it has inflicted, in fantasy, on its lost objects. The balance between depressive anxiety and the capacity to repair can be maintained only if the ego is being at the same time securely constituted in such a way that it can tolerate the depressive anxiety occasioned by realising loss and releasing vengeance. If the ego can withstand the anxiety without undue dependence on manic defences which detach the ego from reality, the desire to restore and repair releases creative, productive energies. Melanie Klein describes mourning in later life as a re-living of these early depressive anxieties which can be consoled only by being able to 're-create' the internal objects that have been lost. Hanna Segal links the depressive/ reparative pair directly with the capacity to use symbols in general and with the drives towards artistic activity. Artistic creativity hinges upon this collation of managed depressive anxiety and the strengthened ego's capacity to re-create symbolically, vicariously through words or things.[44] Hanna Segal cites Proust's insightful writing on art's relation to the desire to restore the lost and ruined inner world. The capacity to deploy imaginary and symbolic means to fashion a surrogate world, representation, for the relief of trauma, arises as the subject 'departs' from the trauma. Here too questions of mourning and its resolution have to be distinguished from depression, from the ego becoming possessed by its suffering. Only if one is able to tolerate and overcome depressive anxiety, while drawing on its urgencies, can there be creativity, that is, revenge – a particular historically charged re-creation that is different from nostalgic longing for a lost plenitude.

The core of Lubaina Himid's exhibition *Revenge* was a projected memorial based on a fountain. The central idea was to evoke the loss of creativity caused by the atrocities of the Middle Passage: weavers, potters, sculptors, carvers lost at the bottom of the Atlantic during the the centuries of the slave trade. During the transportation of captured African peoples across the Atlantic in the eighteenth century to the Americas, only one in seven survived. The slavers were insured against loss, receiving payments of £30 per body. Thus ill and dying African people were often thrown overboard in order to save the supplies of fresh water. Of a study for a painting called after a historic case *Memorial to Zong*, the artist writes:

Water, deep water, salty. Wooden boats. Cloth wrapped around wounds, blood soaked. Water fresh the key to life. Sails flags english flags spanish flags, portuguese flags flapping. Sails straining. Splashing, body after body thrown overboard, too ill to be of use. Too ill to ever work. Dead. From shock, from beating, from wounding. Splashing body after body thrown overboard. £30 to

190

be claimed for each body. Insurance. Ill people are not worth wasting water on. Fresh water. Thrown overboard into the sea. Water salty.[45]

Just as Primo Levi insisted that those who survived the Holocaust must always bear witness to the atrocity enacted in Europe against the Jewish people, the Roma, the lesbian and gay communities, the political dissidents, so the descendants of those lost and enslaved Africans must ensure that the events of their trauma are not forgotten, that the atrocity is remembered and confronted by everyone.[46] The epigraph Primo Levi used to his last book and testament *The Drowned and the Saved* (a title with particular resonance in this African context) is relevant to this telling of tales, to what I would call both the talking and the painting cure:

> Since then, at an uncertain hour,
> That agony returns,
> And till my ghastly tale is told,
> This heart within me burns.[47]

After admission of responsibility before their memorial and monument, and after the full panoply of mourning which can only come when the deaths themselves are acknowledged, there is revenge. For Lubaina Himid this means an active intervention in history – strategies for the future which do not involve personal reprisals on individuals – but a mobilising anger against those historical forces which create racism, imperialism, class and gender oppression.

COVENANT VERSUS TERRORISM

In her study of anxieties around foreignness, *Strangers to Ourselves*, Julia Kristeva cites the biblical story of Ruth the Moabite, whose difference repaired the disaster afflicting the family of Naomi, and, on a larger scale, introduced a stranger into the legendary royal house of the people of Israel.[48] Ruth was a foreigner, who became an immigrant to the Land of Israel and joined its people, culture and religion through a covenant made with another woman, her bereaved mother-in-law Naomi. The Book of Ruth is a story about poverty, loss, death and mourning, while offering through this unique image of a woman-to-woman covenant a story of alliance that refuses the markers of self and other, insider and outsider, native and stranger. In the current European crisis about immigration – about confrontation with difference – in its current, global context, Kristeva uses this story of elective affinity to remark on the current xenophobia:

> The situation calls, of necessity, for what I define as a kind of personal mediation – through religion, or psychoanalysis, or simply work with oneself.

191

It would mean asking: why do strangers irritate me so much? Maybe there is something bizarre within me, some unsettled problem, something uncanny, *unheimliche* in Freud's German phrasing, which is upsetting me, and instead of resolving this problem within myself, I project it onto the outsider as scapegoat, a lightning conductor for all our . . . problems (fill in your own national space). Such individual microscopic self-analysis, which in fact means making peace with all our own inner demons, our own inner hell, might stop us from blaming the outsider/stranger for all our problems and might bring about some mutual understanding and aid which could contribute to human rights.[49]

What has this settling accounts with one's private demons to do with the political problems of racism and the new social phenomenon working such havoc in Europe today, neotribalism? Can psychoanalysis inform political and historical thinking about the threats posed by violence against peoples and the violent responses emerging in forms of identity politics and nationalist, even fascist, forms of neotribalism? Some people, it seems, are allowed to estrange their own unacceptable violence and self-hatred – their depression, as it were – and use those whom they 'other' as their scapegoats. But if we connect this thinking with a specifically feminist articulation of the problem in Kristeva's 'Women's Time', we can forge a feminist analysis of mourning, violence and the depoliticisation to which women's struggles have become susceptible.[50]

In a section called 'The Terror of Power and the Power of Terrorism', Julia Kristeva notes the contradictory responses of modern Western women to their historical exclusion from power within the nation-state: counter-power and counter-society. In one case formerly excluded women become over-identified with power systems in the existing white patriarchy now that it has allowed them honorary 'male' status within it. They embrace its rules and systems and make themselves its ardent defenders and executors: corporate women or bureaucratic apparatchiks. The obverse of this investment is the making of a counter-society imagined as the opposite of all that oppresses: a female world of idealised harmony, separateness and freedom. This latter tendency exhibits a strong tendency to scapegoat. Established on fixed binaries, the ideals of counter-societies require the expulsion of an excluded element, creating a guilty party, the cause of what is wrong. The scapegoat could be the foreigner, capitalism, other 'races' or, in terms of minority groups, whites or men.

Beyond this, however, Kristeva perceives the response of terrorism – the extreme revelation of the implacable violence which, in a solely phallocentric system, constitutes any symbolic contract. The two forms of modern feminism – assimilation to the nation-state and separatist counter-culture idealising an essential womanhood or an ethnic version of identity – are a means of 'self-defence in the struggle to safeguard identity' against the still violent exploitation of women. It is a controlled form of paranoia. But there is a danger when a subject feels herself 'excluded from the socio-symbolic stratum' and becomes 'the possessed agent' of the violence by which she feels her social and psychic being has been unbearably violated.[51]

These varied responses constitute those of one specific historical form of the stranger – 'woman' as a sign of violent estrangement within the white patriarchal systems – who, through historic migrations, becomes the bearer of multiple and interrelating estrangements. Women become ultimately strangers to themselves, others within the 'sign' woman.

In place of these often intolerable frustrations and oppressions we seek forms of escape. Many of these are regressive searches for archaic fulfilment in some fantasy of unity – of identity, of fixity, of wholeness, of the Mother/Homeland. Other solutions attempt to expel the violence done to us, while yet also trying to possess it. Without both a micro- and a macro-level of analysis of the subjectivity and the social systems through which we are articulated, we run the risk of being trapped inside both, imaginatively as well as sociologically re-enacting the power systems so that what we seek are only temporary solutions, identities composed of a shifting kaleidoscope of new estrangements. Seeming to counter the canon as the academic face and space of hegemonic patriarchal and colonial culture, special studies areas policed by notions of authenticity and the property of the self offer delusions of achieved identity which can be only momentarily held on to by othering someone else – which often means inverting the existing terms of estrangement: men are excluded from feminist studies, whites become the other of Afro-American studies (and, in Tom Lehrer's bitter song, 'everyone hates the Jews').

Feminism is not just the study of women or gender: it is the politicisation of issues of sexual difference as sexual oppression in all the configurations of its historical and geo-political specificity. The promise of feminism's political project is to address people across profound and obscene social divisions by calling to 'women', by naming as oppression the othering of the feminine and feminisation as a means of othering. At the same time feminism has to confront the question of strangeness, difference and violence inside itself – women are multiply violated by class and racism. That is to recognise the inescapable force of contradiction and antagonism which could not be idealistically wished away or escaped from into ever smaller subsets where unity could be temporarily enjoyed.

Julia Kristeva's point is that the phallocentric social order is predicated on sacrifice – giving up the archaic fantasy of unity or achieved identity in order to accede to language, sexuality and sociality. Sacrifice of our imagined wholeness and archaic corporality to the Symbolic, to language and to representation, is experienced as violent: this is the allegorical meaning of 'castration' – the only contract the phallocentric knows. But the social order usually tames and binds the violence it creates – through art, religion and its social institutions. Julia Kristeva warns: 'Refusal of the social order exposes one to the risk that the so-called good substance, once it is unchained, will explode, without curbs, without law and right, to become absolute arbitrariness.'[52] Fascism and Stalinism are modern examples of such arbitrary violence, and there are many examples of that eruption in contemporary Europe, India, America, Africa. A mere tolerance of difference taking the postmodern form of liberal pluralism does not confront this danger or its structural conditions: the

phallocentric construction of difference as a violent and violating separation, which it has been one of feminism's political projects to raise to a level of both theoretical and historical understanding as the condition of political work, change and knowledge.

In her radical theoretical and artistic move which takes us beyond the still phallic logic of Julia Kristeva's none the less significant analysis of the stranger, Bracha Lichtenberg Ettinger has identified the possibility of another stratum and structure for subjectivity 'in the feminine' which she names the Matrix. In the Matrix, difference is always already a dimension of subjectivity; it is not introduced as a violent severance ultimately signified by castration. The Matrix signifies the neither assimilated nor rejected, neither symbiotic nor aggressive co-emergence of fantasy associated with the intimacies of prenatal mother and *infans* which deposits within each subject an experience of the invisible specificity of feminine corporality as the resource for later fantasies of border links and shared subjective effects, good and bad. Bracha Lichtenberg Ettinger invites us to acknowledge a minimal and formative difference, active from the inception of the subject that is not based on cutting, severance and its attendant violence. Through moving the allegory of Ruth and Naomi to the level of late Lacanian psychoanalysis, she allows us to see a severality as 'always already' a stratum of subjectivity – the presence of an unknown non-I in my own making – the unknown non-I of the infant for the becoming-mother, and of the fantasising mother for the becoming-infant. It is this matrix of partners-in-difference that Bracha Lichtenberg Ettinger calls the feminine – not a derivative from any element or definition of 'women' in the phallocentric 'man and woman' pairing, and not a reference to anatomical determinism. The Matrix as signifier of the feminine in an expanded and pluralised Symbolic allows us to imagine and signify a future beyond mourning and beyond revenge, and it links with Lubaina Himid's paintings in that it works with an imaginary structure of subjectivity and difference in the *several* that, none the less, opens us to the dialectic of I and non-I beyond the current tropes of sexism and racism.

After Mourning comes Revenge. Lubaina Himid's work in and on the canvas of painting, of histories of representation, does a a job of historical intervention in knowledge as well as aesthetics. Her works use history to escape a neurotic attachment to both a lost past and a lost moment in the history of each subject. Given symbolic acknowledgement, and thus released through the memorial of cultural form, its pain can be refocused on creative revenge against the abject past that must imagine a future 'in a difference acknowledging feminine'. This is not the violence of the woman terrorist, who, like the depressive, interiorises her victimisation and becomes merely its 'possessed agent'. Revenge calls for strategists proposing woman-to-woman meetings and dialogues to refashion the maps of the world, of knowledge, of our subjectivities, to retrace the steps of colonisation and Diaspora, migration and invasion, to name the enemies – out there and in our different selves – to create the possibilities of alliance, of covenanting woman to woman across the historical enmities in an ethical politics that acknowledges the real contradictions of social and sexual difference but can imagine those differences as creative elements among 'partners-in-difference'.[53]

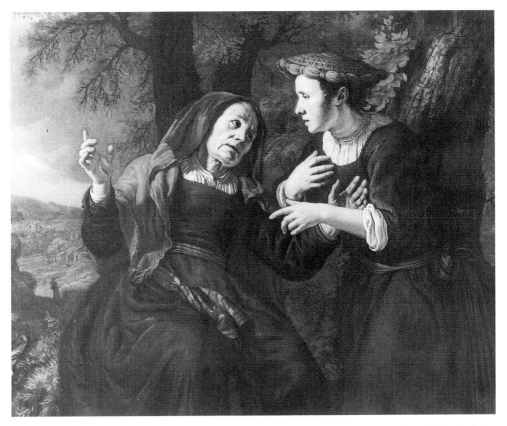

Fig. 7.11 Jan Victors, *Ruth and Naomi*, 1653, oil on canvas, 108.5 × 137 cm. New York, Sotheby Parke Bernet.

In this, Lubaina Himid's work as a history painter, as an artist making pictures with a bold intensity which vividly conjure up images dense with meaning – modernist manners refusing modernist escapism from the historical matter of postmodernity – provokes a specific set of meanings for 'feminism'. These index a political under-standing of the realities of violence, suffering, antagonism. Yet they also propose to those who mourn, that we should create strategies for change. I do not feel excluded from the dinner parties, boat trips or attendance at these radical cultural performances. As a white woman I cannot be visible within their frame without compromising the visibility of Lubaina and her black sisters on the stage of history. I can still, none the less, desire to be 'present' through identification – through a Ruth-like gesture of affiliation, inverting the colonial relations of who is strange – at these gatherings.

Feminism's long historical trajectory is confronted by new necessities in the articulation of 'women's' diverse and sometimes antagonistic needs and desires. It will be in the forging of alliances between the contradictory social groups who yet share the designation *women* that its political future must lie. The story of Moabite Ruth and Jewish Naomi (Fig. 7.11) represents from my own culture a narrative of both elective

195

cultural affiliation and a voluntary loss of originating 'cultural identity', a narrative which concludes with the birth of a child, an allegory of the creation of a living future in place of the sterility of a past marked by loss and displacement – estrangement. Both Ruth and Naomi with the child they shared, and the tactician couples in Lubaina Himid's history paintings with their future of created life, put before us – though a symbolic creativity – images of alliance, of identification-in-difference but *not of identity*. Artistically fashioned, they are historical allegories, their painterly and visual textuality requiring to be read like the stories that furnished the materials for Baroque history painting. The possible reading of the sexuality of the women engaged in debating the future functions precisely to refute the patriarchal sameness attributed to women. Lesbian love is the love not of the same but of a different person which can stand metaphorically within feminism for a model in which difference is not the line of violent demarcation but the necessary condition of desire, the basis of alliance in acknowledged difference within as well as in/of/from the feminine.

NOTES

1 Sigmund Freud, 'Mourning and Melancholia' [1917], in *On Metapsychology: The Theory of Psychoanalysis, Penguin Freud Library*, 11 (Harmondsworth: Penguin Books, 1984), pp. 251–2.
2 Lubaina Himid, *Revenge: A Masque in Five Tableaux* (Rochdale: Rochdale Art Gallery, 1992), p. 18.
3 For a major reading of this work *Revenge: A Masque in Five Tableaux* see Jane Beckett and Deborah Cherry, 'Clues to Events', in *The Point of Theory*, ed. Mieke Bal and Inge Boer (Amsterdam: University of Amsterdam Press, 1994), pp. 48–55.
4 *Ibid.*, p. 51.
5 Carol Duncan and Allan Wallach have mapped out the ceremonial and ritual function of the museum of modern art noting the strategic placement of key works in the modernist story of art that is spatially narrated in accordance with ideological notions of individual and social characteristics of capitalist societies. See their 'The Museum of Modern Art as Late Capitalist Ritual: An Iconographic Analysis', *Marxist Perspectives* 1 (1978), pp. 28–51.
6 This phrase is from the work of Gerardo Mosquera, who uses it to ensure an inclusiveness in discussion of world cultures for many of which the Western concept of art is inapplicable. I first encountered this point in a seminar at Bard College, on curatorship, in 1994.
7 Jean Fisher, 'Editorial: Some Thoughts on Contamination', *Third Text*, 32 (1995), p. 5.
8 See Fredric Jameson's early formulation in 'Postmodernism or the Cultural Logic of Late Capitalism', *New Left Review*, 146 (July–August 1984), pp. 53–93.
9 *Ibid.*, p. 68.
10 See my *Avant-garde Gambits: Gender and the Colour of Art History* (London: Thames & Hudson, 1992) for my own stumbling realisation of this issue.
11 Theodor Adorno, 'Commitment', in *The Essential Frankfurt School Reader*, ed. Andrew Arato and Eike Gebhardt (New York: Urizen Books, 1978), pp. 300–18.
12 Gilane Tawadros, 'Beyond the Boundary: Three Black Women Artists in Britain', *Third Text*, 8/9 (1989), p. 150.
13 *Ibid.*
14 *Ibid.*
15 The classic statement of this case is T. J. Clark, *The Painting of Modern Life: Paris in the Art of Manet and His Followers* (New York and London: Knopf and Thames & Hudson, 1984). Clark's argument is that mere representation of contemporary subject matter is insufficient

for the appellation 'modernist'. Modern art is a particular structure of representation of modernity which is modern only when it gives modernity the form of 'the spectacle'. Tissot's work apparently does not.

16 Tamar Garb, *Bodies of Modernity: Figure and Flesh in Fin de Siècle France* (London: Thames & Hudson, 1998), includes a feminist analysis of Tissot's series *Women of Paris*, and there is a forthcoming volume of essays from a symposium on Tissot at the Art Gallery of Ontario, 1997.

17 Gayatri Spivak, 'The Rani of Sirmur', *History and Theory*, 24, 3 (1985), pp. 245–72.

18 Lubaina Himid, cited by Maud Sulter, 'Without Tides, No Maps', in *Revenge*, p. 31.

19 Griselda Pollock, 'Modernity and the Spaces of Femininity', in *Vision and Difference: Feminism, Femininity and the Histories of Art* (London: Routledge, 1988), and Tamar Garb, *Women Impressionists* (Oxford: Phaidon Press, 1986).

20 Cited in Jill Morgan, 'Women Artists and Modernism', in *Revenge* (Rochdale Art Gallery, 1992), p. 22.

21 *Ibid.*

22 *Ibid.*, pp. 22–3.

23 Sheri Benstock, *Women of the Left Bank 1900–40* (London: Virago Books, 1987), preface, n.p.

24 Andrea Weiss, *Paris Was a Woman* (London: Pandora Books, 1996).

25 See Hollis Clayson, *Painted Love: Prostitution in the French Art of Impressionism* (New Haven and London: Yale University Press, 1991).

26 Christopher Miller, *Blank Darkness: Africanist Discourse in French* (Chicago: University of Chicago Press, 1985). This will be further discussed in Chapter 9.

27 Jean-Claude Baker and Chris Chase, *Josephine*: *The Josephine Baker Story* (Holbrook, Mass., Adams Publishing, 1993), p. 4.

28 Lubaina Himid, 'In the Woodpile: Black Women Artists and the Modern Woman', *Feminist Art News*, 3, 4 (1990), pp. 2–3. Lubaina Himid did a portrait of *Gertrude Stein* (1986).

29 Marjorie Garber, 'Bisexuality and Vegetable Love', in *Public Fantasies*, ed. Lee Edelman and Joseph Roach (London and New York: Routledge, 1998).

30 Monique Wittig, 'One Is Not Born a Woman', in *The Lesbian and Gay Reader*, ed. Henry Abelove *et al.* (London: Routledge, 1993), p. 108.

31 Wittig also discusses racialisation as comparable to womanisation (p. 104); before the coming of the socio-economic reality of black slavery the modern concept of race did not exist. Seeing has becomes a means of naturalising imaginary and imposed identities such as 'black' and 'woman'.

32 For a comparable argument developed to a much higher degree see Teresa de Lauretis, *The Practice of Love: Lesbian Sexuality and Perverse Desire* (Bloomington: Indiana University Press, 1994).

33 The coat of Gertrude Stein suggests the mantle being passed from this avant-garde outsider, a Jewish lesbian, who came to be known as 'the Mother of Modernism' to women who will, as radically as she, realign our culture through what they make. Stein signifies one of the most radical modernist writers whose transformation of language corresponded with the Cubist revolution in the visual arts and broke with the traditional freight of romanticism, naturalism and lyricism to create through a radical modernist realism a means to speak that which Western culture had repressed. The acknowledgement and identification with Stein through the coat–mantle–garment–style–presence–art activates a visual and conceptual relationship between Lubaina Himid's black women and this historical moment of women's interventions in modernisation of culture and sexuality. For the importance of Stein as both intellectual and social presence in the mind and body of a woman see Catherine Stimpson, 'The somagrams of Gertrude Stein', in *The Female Body in Western Culture*, ed. Susan R. Suleiman (Cambridge, Mass: Harvard University Press, 1988), pp. 30–43; and *Gertrude Stein in Words and Pictures*, ed. Renate Stendhal (London: Thames & Hudson, 1995).

34 Morgan, pp. 22–4.

35 *Georgia O'Keefe: American and Modern* (London, Hayward Art Gallery, April–June 1993).

36 Beatrix Campbell, 'A Woman's Art that Men Refuse to See', *The Guardian* (9 June 1993), reviewed the criticism that called O'Keefe 'quite simply, not very good', 'Irredeemably amateur', kitsch, cosmetic in order to strip her of her craft. Sexist art criticism denounces an artist by 'womanising' her, making every sign of a specific gender a declared impediment to her being perceived as an important painter.

37 On Edmonia Lewis see Lynda Roscoe Hartigan, *Sharing Traditions: Five Black Women Artists in Nineteenth Century America* (Washington, D.C.: Smithsonian Institution Press, 1985).

38 Mary Kelly, 'Reviewing Modernist Criticism', *Screen*, 22, 3 (1981), pp. 41–62.

39 See my 'Painting, Feminism, History', in *Destabilising Theory*, ed. Michelle Barrett and Anne Phillips (Cambridge: Polity Press, 1992). See also Judith Mastai, *Women and Paint* (Saskatoon: Mendel Art Gallery, 1995). For a contribution to studies on women painters see my 'Killing Men and Dying Women: A Woman's Touch in the Cold Zone of American Painting in the 1950s', in *Avant-gardes and Partisans Reviewed*, ed. Fred Orton and Griselda Pollock (Manchester: Manchester University Press, 1996). See also Rosemary Betterton, *Intimate Distance* (London: Routledge, 1996) and Mira Schor, *Wet: On Feminism, Painting and Art Culture* (Durham, N.C.: Duke University Press, 1997).

40 Mieke Bal, *Reading Rembrandt: Beyond the Word–Image Opposition* (Cambridge: Cambridge University Press, 1991), especially 'Introduction'.

41 Freud, 'Mourning and Melancholia' pp. 251–2.

42 *Ibid.*, p. 253.

43 *Ibid.*

44 Hanna Segal, 'A Psychoanalytical Approach to Aesthetics', in *New Directions in Psychoanalysis*, ed. Melanie Klein (London: Tavistock Publications, 1955), pp. 384–406. I am grateful to Claire Pajaczkowska for bringing this paper to my attention.

45 Himid, *Revenge*, p. 11.

46 It is important to avoid all accountancy in the history of horror, and I make the association between the Jewish experience of the Holocaust and the African experience of enslavement at the level of historical witness, but not to compare the two as comparable events. Each has its own specific character and effect. For a careful, philosophical analysis of the difference see Lawrence Mordechai Thomas, *Vessels of Evil: American Slavery and The Holocaust* (Philadelphia: Temple University Press, 1993).

47 Samuel Taylor Coleridge, *The Rime of the Ancient Mariner*, lines 582–5, cited in Primo Levi, *The Drowned and the Saved* (London and New York: Simon & Schuster, 1988).

48 I have analysed the story of Ruth and Naomi in relation to Lubaina Himid's work in my essay 'Territories of Desire', in *Travellers' Tales*, ed. George Robertson *et al.* (London: Routledge, 1994).

49 Julia Kristeva, *Strangers to Ourselves* [1988] (London: Harvester Press, 1991); *Tales of Love* [1983] (New York: Columbia University Press, 1987). The quotation is from the interview with Jonathan Rée, broadcast and published as *Taking Liberties* (London: Channel 4, 1992), n.p.

50 Julia Kristeva, 'Women's Time' [1979], in *The Kristeva Reader*, ed. Toril Moi (Oxford: Basil Blackwell, 1986) 'when, for example, a woman feels her affective life as a woman or her condition as a social being too brutally ignored by existing discourse or power (from her family or social institutions); she may, by counter-investing the violence she has endured, make of herself a possessed agent of this violence in order to combat what was experienced as frustration – with arms which may seem disproportional, but which are not so in comparison with the subjective or more precisely narcissistic suffering from which they originate' (p. 203).

51 *Ibid.*, p. 203.

52 *Ibid.*, p. 204.

53 The phrase is derived from the work of Bracha Lichtenberg Ettinger, 'Matrix and Metramophosis', *Differences*, 4, 2 (1992), and *The Matrixial Gaze* (Leeds: Feminist Arts and Histories Network Press at the University of Leeds, 1994).

Part IV

WHO IS THE OTHER?

Moving decisively from what Gayatri Spivak names oppositional feminism – an inversion that aims to facilitate incorporation to the hegemonic form – this section explores what Spivak outlines as feminist practice as critique, one that provokes its own self-criticism. Differencing the canon requires modalities of analysis that yield meshes fine enough to catch the always interlacing relations of class, gender, sexuality and race that both were the historical determinants on the modernist enterprise and are the theoretical perplexity it delivered to us. Returning to the terrain of early European modernism, these final chapters use several narrative devices to chart relations of femininity, modernity and representation, *jouissance* and difference in paintings by Mary Cassatt and Edouard Manet. Themes that have surfaced throughout the book find a new alignment – the figure of the maid, the mother and the black woman – in the question that must always be asked: Who is the Other? The provocation is tracked using the conceit of the space of encounter – that of an exhibition in New York in 1915 and that of a studio in Paris between 1862 and 1872.

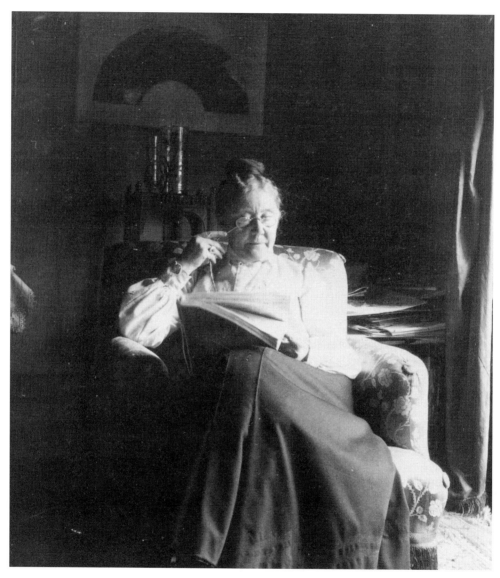

Fig. 8.1 Theodate Pope, *Mary Cassatt Reading*, Paris, *c*. 1905, photograph. Farmington, Connecticut: Hill-Stead Museum

SOME LETTERS ON FEMINISM, POLITICS AND MODERN ART

When Edgar Degas shared a space with Mary Cassatt at the Suffrage Benefit Exhibition, New York 1915

LETTER I: ON THE QUESTION OF I AND NON-I

Dear Curator,

I would dearly love to see the exhibition you installed of the colour prints by Mary Cassatt. (Fig. 8.1)[1] Her fellow exhibitor at Durand Ruel's gallery when they were first shown in Paris in 1891, Camille Pissarro, wrote to his son Lucien, also a printmaker, on 3 April 1891 full of excitement about her novel colour effects.

> It is absolutely necessary, while what I saw at Miss Cassatt's yesterday is still fresh in my mind, to tell you about the colored engravings [sic] she is to show at Durand Ruel's the same time as I. We open Saturday, the same day as the patriots, who, between the two of us, are going to be furious when they discover right next to their exhibition a show of rare and exquisite works. You remember the effects you strove for at Eragny? Well, Miss Cassatt has realised just such effects, and admirably: the tone even, subtle, delicate, without stains on the seams: adorable blues, fresh pink, etc.[2]

Even though he was a highly politicised artist, Pissarro made no comment about the 'content' of Mary Cassatt's prints. Perhaps it could not have been commented upon in 1891. Pissarro's own work was clearly focused elsewhere, in the fields and peasant communities amongst whom he lived in and around Pontoise.[3] Pissarro's anarchist respect for the social otherness of the rural workers he portrayed as the antithesis of a parasitic and exploitative urban bourgeoisie had stimulated his own formal experiments. In another letter he asked in some anguish, could a bourgeois like himself paint peasants without being one of them? T. J. Clark has argued that the singular qualities of Pissarro's more difficult paintings lie in the pictorial solutions he attempted to create to resolve this dilemma. How could he represent social difference without condescension, sentimentality or political bad faith?[4]

It is rare to find anyone asking such questions – about politics and class – in the work of Mary Cassatt, whom Achille Segard dubbed for posterity 'Peintre des Enfants et des Mères'.[5] Her paintings, pastels and prints seem to belong so completely to a feminine bourgeois world of afternoon visits and domestic intimacies that the idea that they might also engage us with issues of social difference through their formal dispositions simply never occurs to art historians, feminist and otherwise. But, as you know, the bourgeois household was itself a complex of social relations, porous to the working class because the bourgeois family was dependent on the labour of its social others at every level for hygiene, food and childcare. I was prompted, therefore, to think about the relations between politics and this uncanonised site of modern art – etchings by a woman artist – through the prism of a feminism challenged to understand issues of sexual difference in the broader field of social relations of class.

An exhibition, *The Splendid Legacy*, at the Metropolitan Museum in New York in 1992, was dedicated to the Havemeyer Collection, whose donations of old and modern masters as well as oriental ceramics form the basis of the museum's extensive holdings in these areas.[6] Henry Osborne Havemeyer (1847–1907) was the owner of a sugar-refining business and had a passion for the arts of Asia. Louisine Waldron Elder (1855–1928) was already a keen collector of modern art before she married Henry. As a result of her meeting with the American painter, Mary Cassatt, in Paris in 1874, Louisine Elder Havemeyer became one of the first American collectors of the work by a group of independents we now know as Impressionists. Her first purchase in 1875 was a pastel by Degas. It was Mary Cassatt who advised her on it. Over their long friendship Mary Cassatt became responsible for helping to shape one of the most important collections of early modern art ever formed in the United States.[7]

Louisine Elder Havemeyer was also, like Mary Cassatt, a feminist. After the death of her husband in 1907, Louisine Havemeyer rose in the National Women's Party, becoming one of the most active and prominent campaigners for women's right to vote. Through her activities in the suffrage movement, Louisine began to speak in public and write, leaving us two sets of memoirs, one about her art collecting and a later article of 1922 called 'The Suffrage Torch: Memoirs of a Militant' (Fig. 8.2).[8]

At Knoedler's Gallery in New York in 1912 and 1915 Louisine Havemeyer organised two shows from her collection as benefits for the suffrage cause.

> It goes without saying that my art collection had also to take part in the suffrage campaign. The only time I ever allowed my pictures to be exhibited collectively was for the suffrage cause . . . Furthermore, the only time I ever spoke upon art matters was for one of these exhibitions . . . I spoke upon the art of Degas and Miss Mary Cassatt, whose work was for the first time creditably exhibited in America and formed about half of the exhibition, while the other half was made up of an unusually interesting collection of Old Masters. To contrast the old with the modern gave me a most attractive programme; but nevertheless, probably on account of the enthusiasm it excited and the wide publicity the exhibition received, I was very much

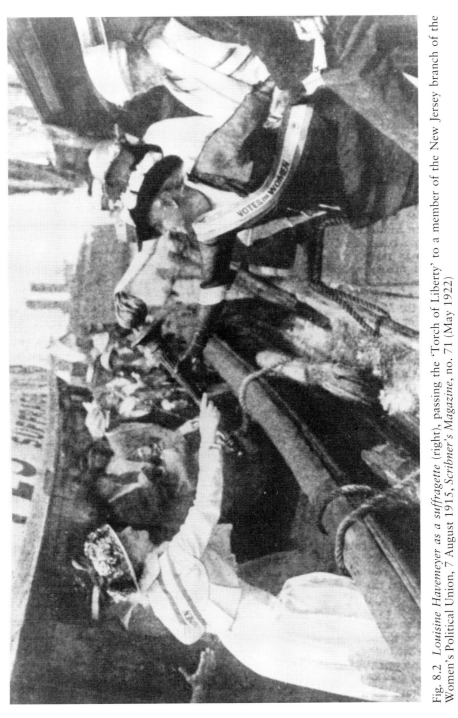

Fig. 8.2 *Louisine Havemeyer as a suffragette* (right), passing the 'Torch of Liberty' to a member of the New Jersey branch of the Women's Political Union, 7 August 1915, *Scribner's Magazine*, no. 71 (May 1922)

frightened at this new venture into a new field of oratory so different from anything I had attempted before. It was an easy thing to talk about the emancipation of women, but art was a very different and difficult subject.[9]

This is perplexing. How can we make sense of the juxtaposition of Rembrandt, Vermeer and De Hooch with Degas's dancers, exhausted laundresses and snub-nosed milliners, and again with Mary Cassatt's sun-filled paintings of healthy rubicund babies, pensive little girls and their wholesome caretakers?

Visible in the installation shot is *Young Mother Sewing*, bought by the Havemeyers from Durand Ruel in Paris in 1901, and also known as *Little Girl Leaning on Her Mother's Knee* (Fig. 8.3). When I discussed the project of writing about the 1891 exhibition of the colour prints with you, and we were flicking through the catalogue, I was surprised at your coolness towards this image. You are not alone in finding Mary Cassatt's representations of mothers and children egregiously sentimental and romanticised, or simply too celebratory and thus insensitive to the complexity of women's experiences of maternity, mother–daughter relations, childlessness or the decision not become a mother. I always feel defensive about criticism of her work since I love these paintings of mothers and daughters by Mary Cassatt very much. I am drawn to them. I buy reproductions and hang them on the walls of my daughter's bedroom.[10]

It is more than probable that what I see in them is, in part, a projection from my own fantasy and desire; or else they offer me, a motherless daughter, compensation for my lack of what they appear to make permanently present: a maternal gaze. Thus my reading runs the profound risk of unconscious idealisation as well as untrammelled projection. Your ambivalence toward this painting thus charged me to analyse my investment in it.

Louisine Havemeyer was herself a mother and she appears with her daughter, Electra, in a pastel made by Mary Cassatt in the summer of 1895 when Electra was just seven and Mary Cassatt's mother lay on her deathbed (Fig. 8.5). The pastel, owned by Louisine and then Electra, is now in a public collection. I want to look at these two images by Mary Cassatt for a moment.

The *Young Mother Sewing* (Fig. 8.3) brings to mind *Big Woman's Talk* (1984) by a contemporary British artist, Sonia Boyce (Fig. 8.4). In this pastel from the 1980s Sonia Boyce seems to share with Mary Cassatt a bold use of pastel as a means to achieve a monumental figure style created through saturated colour. Pastel creates a very tactile surface that stresses the represented women's *embodiment* and thus generates a powerful effect of presence despite the fact that we see only a fragment of the adult woman's body. Sonia Boyce's image avoids the threat of sentimentality by the use of scale and the boldness of drawing in pastel with its richly patterned colours. The ambience of her image of the young girl's comfort and security within the acoustic envelope of the big mothers' voices, which is represented by the dense facture as an almost tactile space, is balanced by the psychological separateness of the child listening in to a conversation and a world of adult femininity of which she is not yet fully a part.

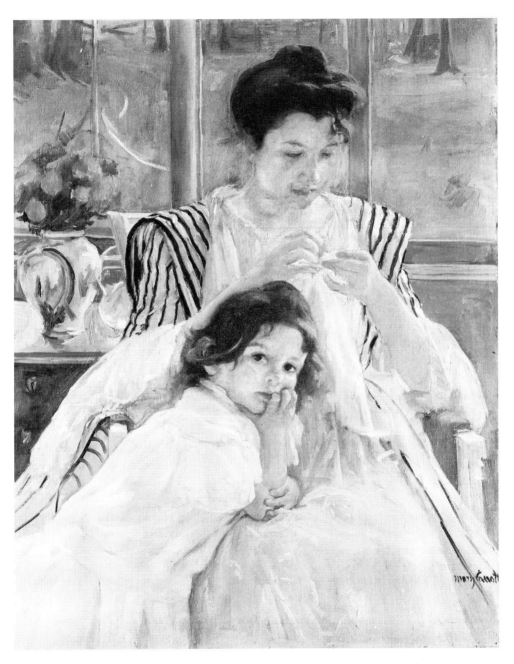

Fig. 8.3 Mary Cassatt, *Young Mother Sewing* or *Little Girl Leaning on Her Mother's Knee*, 1902, oil on canvas, 92. 3 × 73.7 cm. New York, Metropolitan Museum of Art (bequest of Mrs H. O. Havemeyer, 1929)

Fig. 8.4 Sonia Boyce, *Big Woman's Talk*, pastel and ink on paper, 1984, 148 × 155 cm. London, Artist's Collection

Mary Cassatt's painting *Young Mother Sewing* (Fig. 8.3) creates that soft, domestic space within which the child resides, so simply connected by physical proximity and contact to the mother's body that the child casually but absolutely claims, using it as a prop. The child confronts the viewer with a gaze freighted by its iconographic evocation of the pose of thought, rendered childlike and mundane by the attention to the pucker of her skin as her fist presses up to her face. The girl's intent look outwards breaches pictorial space and questions the viewer whose own, returning, gaze is invoked by the directness of the child's regard. So often in Mary Cassatt's paintings a figure looks away from the space represented symbolically by the painted space of the canvas. In this painting the child's gaze breaks the ideological seams of that space to project a space not so much beyond its frame as before its plane. In that space there is another person. Initially, at the point of production, which is so often

206

commemorated in the actual work that Cassatt produced, that other was the artist, who thus inscribes herself into her work as its imaginary interlocutor.[11]

The viewer of *Young Mother Sewing* must take up this position, the place from which the representation was made, in order to be a reader of it. Through this action of looking at the painting from where the painter made it, and then looking back through the child's gaze, there is an implied reminder of the artist whose looking and working the child once regarded while she was being painted. On this axis the painting sets up a potential relationship between the female child, born in the 1890s, and the woman artist, born 1844, and any viewer, man or woman, who takes up that active, creative and female-gendered and historically located position in order to see the painting.[12] Because of this axis between represented space and the place from which the representation was made, I don't think we are looking at an idealised dyad of the so-called 'Mother and child' – contained and fetishised – within the painting, a closed icon that regressively restores us to a fantasy of the mother and child as a unified entity.[13] I read in this one image some intimations of that archaic fantasy of the maternal envelope of space and sound within which a child exists, even after birth. But I also see pointers towards a puncture of that often dangerous fantasy by the developing subjectivity of the child whose separateness and singularity was, however, always already part of what needs to be grasped as the relationship between the two.[14] I want to propose to you that we can intimate such a possibility in the formal rather than thematic (often misread because of inattention to the former) structures of Mary Cassatt's repeated exploration of this topic: two figures (subjects) in one space.

The critical core of the painting *Young Mother Sewing* can be read, therefore, as something quite other than the fictional unity 'mother and child'. At its literal centre is that young femininity – the place of the daughter in a structural ambivalence that is also a structural duality. She is represented both in her 'being with her mother' (the mature woman through identification with whom she will make her contradictory way to her own adult femininity) and in her 'separate being', a difference which she must acknowledge in order to become an independent creative femininity like the artist she sees before her, at work, both other to her mother and yet comparable to her as both adult women are both busy and absorbed – their desire is both there and elsewhere in the fabrication of their own subjectivities. Thus the triad the painting generates is not the culturally implicit Oedipal triangle with the determining Other as the Father. Instead a woman as creative artist, a New Woman, functions as the lure of this twentieth-century child's reflective gaze while the little girl's look away out of the picture's notional space also makes the child an other to the mother who is released from an identity solely created and symptomised through the child's desire to be one with her, that is through the child's role as figure of her maternal desire.

In the portrait of Louisine Havemeyer and her daughter Electra (Fig. 8.5) Mary Cassatt posed a known mother and daughter together on a red sofa. The seven-year-old Electra is seated on her mother's knee, one arm draped over her mother's shoulder, while the other, on her own knee, is partially sheathed by her mother's hand. This sequence of gestures and positions creates a circle within which the girl child is held.

Fig. 8.5 Mary Cassatt, *Louisine Havemeyer and her Daughter Electra*, 1895, pastel on wove paper, 61 × 77.5 cm. Shelburne, Vermont, Shelburne Art Museum

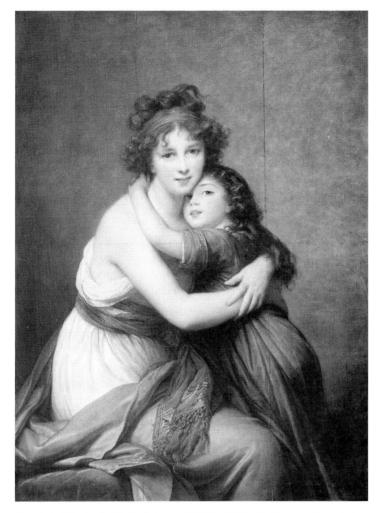

Fig. 8.6 Elisabeth Vigée-Lebrun (1755–1842), *Self-portrait with her Daughter Julie*, 1789, oil on canvas, 130 × 94 cm. Paris, Musée du Louvre

Mother and daughter appear intimately connected, bonded. It is interesting to compare, or rather contrast, the painting with Elisabeth Vigée-Lebrun's self-portrait with her daughter Julie of 1789 (Fig. 8.6). This painting finds its formal solution to the bonding of two figures in the classical perfection and harmony of its pyramidal composition.[15] Read ideologically, however, that formal reciprocity and circularity suggests to me femininity as mere repetition across the generations. The painting was historically innovative in giving a form to a mother's intense pleasure in her daughter's body and touch. Elisabeth Vigée-Lebrun's painting represents the promotion of motherhood as both sensuously gratifying and psychologically fulfilling.[16] Mother and daughter appear bound into both a circle of identity and a circuit of reciprocal desire.

The painting belongs to a moment of massive sensualisation of femininity and specifically of maternity which was part of the ideological programme of modern bourgeois society and its intense constructions of motherhood as the governing identity for women.[17]

No such physicality and sensuality pervades the late nineteenth-century image by Mary Cassatt, whose figures are stiffly encased in the costume of a decorporealised femininity typical of the late nineteenth-century bourgeoisie (Fig. 8.5). While the circle of hands and arms entwines the two bodies, it is broken by the clashing direction of their looks. The woman and the child look neither at each other nor directly out towards the spectator. Such a configuration might seem to resemble the dissonant images of the family painted by Mary Cassatt's friend Edgar Degas, paintings which Linda Nochlin has argued produce an effect of tension and alienation in the heart of the bourgeois family.[18] Linda Nochlin refers to the well-known *Portrait of the Belleli Family* (1858–67, Paris, Musée d'Orsay), a scene of severe marital discord, and the lesser-known *Portrait of Giovanna and Guilia Belleli* (1865–6, Los Angeles, County Museum of Art). In this painting the two sisters have been positioned at a sharp angle to each other. One looks at the viewer while the other looks away. This divergence creates a powerful dynamic, pushing against the frame of the represented space and seeming to insist upon the fracture of any relationship between the two sitters.

Mary Cassatt's painting is quite different. There is indeed a managed pictorial tension – in the bodies, central to the painting's space, curving round each other in gestures of casual intimacy while simultaneously appearing psychologically detached. Although the direction of their gazes cuts across each other and the picture's central core, the implied movement of these looks works to expand the space and to allow us to imagine that it is at the level of consciousness, thought and thus subjectivity that the two women, at different stages of their lives, define their specificity, rather than their identity with one another. Furthermore, the mother–daughter relation appears not to belong simply to a state of being, an automatic connection which was so much the ideological aim of contemporary propaganda about motherhood and maternity.[19] In Mary Cassatt's painting the mother–daughter relation is a frame, a space within which two beings co-exist, at ease, yet their current thoughts are unknown to each other. It might be described as a *matrixial* space.

The theory of the Matrix allows me to approach Mary Cassatt's work in the light of matrixial subjectivity, a project not without historical justification since critics of the early twentieth century consistently acknowledged her, the older contemporary of Sigmund Freud, a painter not only of aesthetic modernism but of psychological modernism.

The term *Matrix* has been proposed by Bracha Lichtenberg Ettinger, who is both a feminist psychoanalyst and a painter. From insights gleaned from painting as a child of survivors of the Shoah, reseeded in the terrain of Lacanian psychoanalysis, Bracha Lichtenberg Ettinger has made a decisive move to theorise feminine difference. In traditional psychoanalysis it is believed that subjectivity is only an effect of the dialectic of *the one* versus *the other* that gradually takes shape as the child is forced to

distinguish itself – a mass of inchoate sensations and impulses – from the surrounding world, and from other beings in it, especially and fundamentally represented by the Mother. The first act that is said to precipitate the journey into subjectivity is, according to mainstream psychoanalysis, some form of oral aggression which is metaphorically a rejection – the biting of the nipple. This is both the opposite of, and yet structurally related to, the process of incorporation, taking in, that now becomes one of the two formative modes – incorporation or rejection – that define the emerging subject across a physical frontier, the mouth, that becomes, conceptually, a binary opposition: inside/outside. Without this imaginary division, it is argued, there would be no space or gap for a subject to come into being. Biting and sucking are physical activities that begin to draw a boundary, and in this emerging sense of space a subjectivity can begin to demarcate itself. So the necessary distinction upon which to construct subjectivity has a topography that opposes the *one* to what is *other* to it. This is the basis of phallocentric logic – the logic built on absence/presence that alone raises the phallus to the singular and sovereign status as the signifier. If the story of the subject always begins with these acts that make possible the *one*, the *other* is then positioned to be aggressively rejected or to be assimilated via identification. What we can define as the phallic logic of the subject is built upon archaic intimations of meaning – theorists call these earliest ways of grasping the world *pictograms* – composed of this on/off, either/or system of difference. Thus we get an archaic infantile world ordered by *rejection* or *incorporation*, *repulsion* or *assimilation*, and, later, *love* or *hate* and so forth.[20] And when these primary modes are made the basis of subsequent discoveries of sexual difference, the difference can be imagined only in the same logic of presence/absence, man/phallus versus woman/lack. The difference of the feminine cannot be signified, imagined, used.

Bracha Lichtenberg Ettinger has used her own explorations as a painter to come into contact with, and theorise another register of, subjectivity that co-exists with and realigns subjectivity, which she names a *matrixial* stratum of subjectivity. The radical implication of the concept of the Matrix is that subjectivity does not start with *one* created in opposition to its *other*, but with the *several*, paradigmatically represented – though in no way biologically determined – by the relational position of mother and post-mature foetus in very late prenatal moments. She uses the image, and I stress the *image*, though the bodily contiguity is the real substance of later sensational memory, as the metaphor for the co-presence of the still proto-subject *infans* in the uterine space and the pregnant maternal subject to stand for the co-existence of two within one notional space – the mother's body in fact, but, in effect, her projective psychic realm: her fantasies. Bracha Lichtenberg Ettinger theorises a level of subjectivity in which the *several* exist in a space that has radical effects on the constantly modified – retuned – subjectivities which are then defined not by a gap and either rejection or assimilation, but by a creative – or traumatic – joint border space. In this border space are two unknowns to each other, lacking the drive either to assimilate or to destroy the other. I stressed at first the image of the later stages of pregnancy in order to allay immediately the terrors awakened in all feminists of the idea of 'reducing' the feminine to

the body and its sexual organs. I agree entirely that there is not much for us at the level of imagined biology. But that is not the same as saying that there is nothing for us at the level of the corporeal, its drives and sensations, once passed through the prism of their psychic translation into representation as fantasy. For the becoming mother, as for the becoming infant, the corporeal registers of sensations of *co-emergence* and *partnership in difference* – the pictogrammic way of articulating this matrixial border space – store up the materials for a retrospective fantasy, that is the means by which the invisible sexual specificity of the feminine body can find a way into the shapes of our subjectivity and the forms or our imaginings (fantasy) and, if it finds a signifier, like the matrix, into thought (signs) and knowledge.

Bracha Lichtenberg Ettinger is suggesting that the Matrix be thought of as a kind of *sub-symbolic* filter, which will allow certain 'vague, blurred, slippery internal and external traces which are linked to non-Oedipal sexual difference' to escape from foreclosure. 'Passing through the matrixial filter, particular unconscious non-phallic states, processes and borderlinks concerning the co-emerging *I* and *non-I* can become meaningful.' Matrix is thus not the opposite of the Phallus; it is rather a supplementary perspective. 'It grants a different meaning; it draws a different field of desire.'[21]

As a painter Bracha Lichtenberg Ettinger 'discovered' the Matrix through contemplating what was happening in her own work: its recurrent images, the pulses and affects of mark-making and colour and her relation to it as its first viewer.[22] This gave rise to a second concept to define the mechanism for the production of meaning in difference from those tropes associated with Lacanian definitions of language, metaphor and metonymy, that is, meaning created by substitution or contiguity. Her term is *metramorphosis*. The figures of the phallocentric order are metaphor and metonymy, figures of substitution and displacement. In the Matrix: 'Subjects and elements can co-emerge in contradiction and not only in harmony, and yet take care of one another and provoke changes reciprocally'. The aesthetic mechanism of the Matrix is metramorphosis:

> the process of change in borderlines and thresholds between being and absence, memory and oblivion . . . The metramorphic consciousness has no centre, cannot hold a fixed gaze – or if it has a centre, it constantly slides to the borderline, to the margins. Its gaze escapes the margins and returns to the margins. Through this process the limits, borderlines and thresholds conceived are continually transgressed or dissolved, thus allowing the creation of new ones.[23]

Something of that curious and difficult-to-articulate register of matrixial subjectivity seems possible to imagine when looking at pastels by Mary Cassatt. A matrixial reading of painting concerns a different kind of attention paid by this viewer to the affects as well as the effects of a material process of representation which concerns meanings that emerge and fade at the point of this viewer's encounter with what is other – the painting and the imaginary field it can evoke through the working of its semiotic resources and material substances.

Mary Cassatt's use of medium, in its constant bleeding of colours into each other across the boundaries of distinct forms, in the particular balance between the overlap of bodies with their mutual use of each other for pleasure and comfort, and in the piercing of that corporeal intimacy by a non-aggressive look away, beyond its frame, a look which bears a particular meaning – the presence of the consciousness to itself – thought, curiosity, reflection, melancholy, memories, dreams: all these features find in Bracha Lichtenberg's theories a means to be articulated as indexes of a possible inscription of, in and from the feminine.[24] What is crucial, of course, is that such a registering of what can be called 'the feminine' is not the identification of an essential element, a given femininity, but femininity as that which is the site of resistance to the existing phallic order of the Symbol. It is this which allows us to recognise the historical conjuncture of feminist revolt and the modernist avant-garde that was put into the art historical frame at Knoedler's galleries in 1915.

<div align="right">Yours, etc.</div>

LETTER II: ON THE SOCIAL OTHER

Dear Colleague,

Amongst the spectacular colour prints by Mary Cassatt exhibited in 1891, there is a print of a woman writing a letter (Fig. 8.7) that called to my mind Jane Gallop's short paper on Annie Leclerc's essay 'The Love Letter'. In typical Jane Gallop fashion, her paper slides down a seemingly arbitrary chain of coincidences that ultimately reveal a hitherto hidden set of significant relations.

The front cover of Elizabeth Abel's edition of a series of feminist studies on *Writing and Sexual Difference* published in 1982, featured Mary Cassatt's print *The Letter* (Fig. 8.7). The back cover featured a Quentin Matsys portrait of the Renaissance humanist scholar Erasmus of Rotterdam. Jane Gallop points out the perfection of these choices to illustrate the theme of writing and sexual difference. The man writes a book; the woman a letter. He holds a pen, stressing the instrument of writing as an extension of his body; she is licking the envelope. There before us is the classic instance of masculine writing as a phallic paradigm and a feminine relation that can be described only as oral. This takes Jane Gallop to *l'écriture féminine* – from the phallic imagery of the pen to the oral sexuality of the woman licking her paper, kissing the envelope, communicating with her body.

From there to a French feminist exponent of *l'écriture féminine*, writing the female body, writing from the female body and making writing write of that uncharted and unrepresented fantastic terrain of female sexuality, its rhythms, cycles, fluids, flushes, gestations, sensations, memories, desires: writing by and for women. French feminist Annie Leclerc's 'Love Letter' is written to a woman after a night of lovemaking.[25] Jane Gallop draws out from the text Annie Leclerc's refusal to see homosexual love as an 'expression of a lack of sexual differentiation . . . In truth I only love in the perspective of difference.'[26] Let me quote Jane Gallop:

<div align="center">213</div>

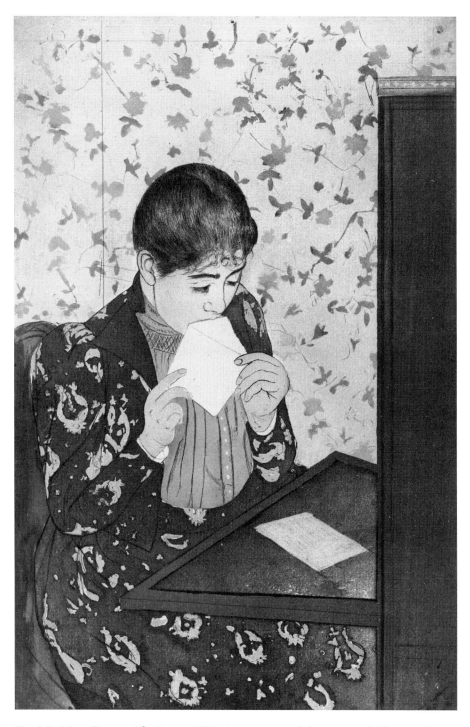

Fig. 8.7 Mary Cassatt, *The Letter*, 1890–1, aquatint and drypoint on laid paper, 34.5 × 22.7 cm. Worcester Art Museum (bequest of Mrs Kingsmill Marrs)

After the blatant heterosexuality of *Parole de Femme*, we may be surprised that in 'Lettre d'Amour' Leclerc writes as a lesbian. But the quotation I just read prepares us for the particular quality of Leclerc's lesbianism, an acute sense of the otherness of the other woman. Leclerc's love letter is not an essentialistic affirmation of the universal, anatomy-based identity of all women. In its assertion of difference within lesbianism, it in fact recalls for me a crucial point Gayatri Spivak makes in her article, 'French Feminism in an International Frame': 'However unfeasible and inefficient it may sound, I see no way to avoid insisting that there has to be a simultaneous other focus: not merely, who am I? But who is the other woman?'[27]

Annie Leclerc also keeps pictures she loves on her wall. Her own love letter drew inspiration from a painting by the Dutch seventeenth-century artist Jan Vermeer, who often painted scenes of women writing letters. In several of Vermeer's paintings there is another woman, the maidservant, who will be the bourgeois letter-writer's messenger and go-between, for instance *Lady with a Maidservant Holding a Letter* (*c.* 1666, New York, Frick Collection). In Vermeer's *Lady Writing a Letter with Her Maid* (Fig. 8.8) the maid waits in the background with her hands crossed in front of her waist. It is a posture of self-containment but her gaze breaks the boundaries of her body as she looks towards the window and beyond.[28]

The inside/outside axis is so important a trope in northern European painting and in the iconography of women. In the images of the Annunciation in particular, the message comes to a woman, from outside, a phallic message whose entry pierces the enclosed space where the Virgin waits like a shaft of light. This symbolically represents her physical penetration by the word/seed of the Father whose divine child she will simply and innocently bear as the 'Holy Vessel'.[29] Her desire has nothing to do with it; fixed in an enclosure which figuratively represents what woman is, she receives the message just as her body itself absorbs its fertilisation without any participation in the process of insemination. In the secular trope of the Dutch bourgeois interior in the seventeenth century this difference took on sexual dimensions in terms of which spaces women were pictured in, and whether or not they were enclosed or partially open.[30] In Vermeer's painting of 1671 (Fig. 8.8) the woman writes her letter in a closed interior. She writes a love letter, a letter that writes her body and its sexuality and the letter will break the boundaries of the interior by carrying her desires beyond the domestic space to its possibly illicit object outside. That trajectory is dependent on the maid's ability to move between inside and outside, and this feature is underlined by the gaze of the maid, who will deliver the letter, out of the window. This gaze, centred in a poised, balanced and complete body, also has other significations. Leclerc reads the maid as a site of knowledge – echoing Jane Gallop's own work on Freud's famous case history of the hysteric Dora, the source of whose sexual knowledge is revealed to have been her governess, the working woman, who like the maid, is a liminal figure crossing the threshold of the bourgeois family and breaching the boundaries of the repressed bourgeois feminine body, forcing economic and social difference to disrupt the contained, familial imaginary.[31]

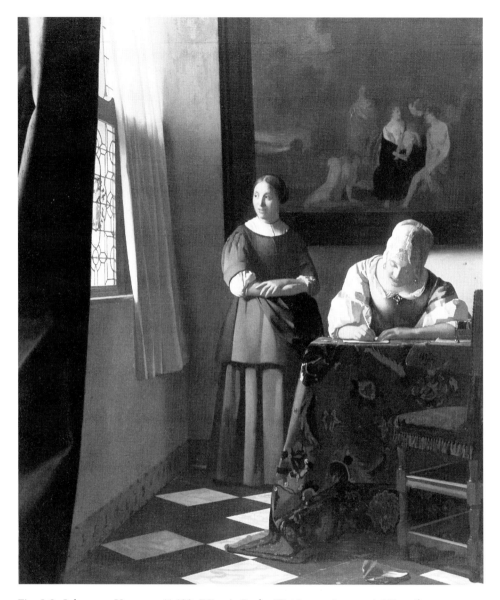

Fig. 8.8 Johannes Vermeer (1632–75), *A Lady Writing a Letter*, 1671, oil on canvas, 71.1 × 60.5 cm. Dublin, National Gallery of Ireland

Jane Gallop's final point is the ironic discovery of the original cover of the book in which Annie Leclerc's 'Love Letter' was published, *La Venue à l'Ecriture* (1977), on which Vermeer's painting (Fig. 8.8) was partially reproduced. The book jacket's designer had been selective. Only the bourgeois letter writer was illustrated. She was isolated from that other feminine figure of sexual desire and knowledge, in a move that erased the significant axis of class difference in the dispersed relations of feminine desire.

216

Thanks to this cover, I realize that the problem of *écriture féminine* is not as some would have it, its insistence on sexual difference at the expense of the universal humanity, but rather, to my mind, its effacement of the difference between women in view of some feminine essence – in this case, the literal effacement of class difference — so as to represent woman alone at her writing table.

The difference between women, the question of the other woman, the rifts in feminist plenitude are extremely difficult to confront and even more difficult to hold on to. The temptation to essentialize is powerful, not so much in our texts where difference is allowable, but on the cover, where we would like to encompass difference and get it altogether. In our desire to make a book of it – a real book and not just letters – let us not forget the other woman.[32]

Let me now come back to Mary Cassatt's *The Letter* (Fig. 8.7). The print represents a single figure, but it implies another. For the very image of the woman sealing the envelope moves her from the act of writing to that of sending. As we know from Benvéniste, every use of language is an intersubjective act, implying the other as the addressee of the message, the need, the demand, the desire.[33] There is no sign of writing in this print. The page has been left blank as has the envelope. There is no phallic pen in hand or on the *escritoire*. The title and the gesture of the main character, however, allow what is represented both to function within the space of the representation and to project an outside for it, the place of the other. In psychoanalytic theory, the place of the Other is initially the Mother and all subsequent occupants are her surrogates. This is so even in the radical negation of the Mother when culture, as Language and the Symbolic Order, takes over her place as the subject's structuring Other, and the Father is erected as the guarantor of meaning in language, which then represents the Mother as a lost, silent, forbidden archaic body, that is now an empty place, the site of lack and the threat of castration. The question feminism poses to this formulation is a challenge to make the place of the Other more complex and diversified, less bound only to the legend of sexual difference. Mary Cassatt's prints provide an opportunity to read for yet another form of feminine otherness.

In *The Letter* the focus is on the single figure, occupied in what has to be called an intellectual activity – as opposed to manual work. This is a recurrent theme in Mary Cassatt's oeuvre. Women writing – or as frequently reading – could be read as ordinary scenes from middle-class life but, as in the case of this print, the minimalism of the composition, the excision of all anecdotal clutter that might provide what Barthes called 'the effect of the real', such as we find in scenes of family domesticity by Monet or Caillebotte, projects this work onto another level of symbolic possibility.[34] The process of formal distillation of the composition to create that difference is evident in other prints in the series.

Let me use another of the prints to make this case that Mary Cassatt's images are not merely genre scenes of modern bourgeois feminine life. *In the Omnibus*, one of the 1891 colour prints (Fig. 8.9), suggests that Mary Cassatt knew something of English

painting, for there are some interesting treatments of this subject by William Maw Egley (*Omnibus Life in London*, 1859, London, Tate Gallery), and John Morgan (*Gladstone in an Omnibus*, 1885, Private Collection), and the most interesting, which postdates Mary Cassatt's work, by George William Joy, (*The Bayswater Omnibus* 1895, London Museum). There is also *Egalité* of 1886 by Henry Bacon, a fellow American in Paris, and Mme Delance-Feugard's print *Un Coin de l'Omnibus* at the Salon of 1887. The omnibus was the site of much interest in the nineteenth century, for it represents a hybrid space – a public space where people of several classes and both sexes are thrown into confusing proximity and potentially 'exciting' situations.[35]

In a preliminary drawing for her plate *In the Omnibus*, Mary Cassatt appears to have planned a similar scene of popular travel (1891, Washington, D.C., National Gallery). The bourgeois lady, her child and the nanny are seated on the bench. Beside her is sketched a top-hatted gentleman with cane. The bourgeois lady's decided look in the opposite direction to this man creates a tension in the composition that focuses attention on the juxtaposition of lady and gentleman. He remains remarkably faceless at this stage of the artist's thinking. The gentleman was soon excised, however, from the composition. The early states of the print consistently focus only on the all-female group. What does this do to the print? and to our readings of it?

Extraneous signs of the hybridity of the omnibus are banished, and we find ourselves contemplating three female figures – though the child could be a boy given the undifferentiated apparel of boys and girls of that age in contemporary French bourgeois custom. The maid or nanny holds the child and seems to look, if not at it, towards it. Her dress is interesting, for it is more than a little reminiscent of the outsized garment worn by the maid in Manet's *Olympia* (1863) (Fig. 9.17) – perhaps this was standard servant's uniform. The formal comparison is telling, with the overdressed child replacing the floral bouquet in Manet's painting.

The maid and the child are connected by gesture and placement. The mother (?) and the child are not engaged in any act of mutuality or interaction yet they both face in the same direction and there is more than a hint of family resemblance in their aligned profiles. Against the backdrop of the Paris of the Seine and its bridges, Mary Cassatt has staged, with all the cryptic economy of the drypoint etched line and soft ground applied colour, a tiny incident of class in the bourgeois household: the complex patterns of similarity and difference, of intimacy and relatedness – which are true to the fact of women's overwhelming involvement in childcare due to the sexual division of labour and the conventions of reproduction.[36] While these 'facts' were increasingly being used by promoters of the ideology of maternity in both France and the United States at the time to naturalise the sexual division of labour, and secure a particular fixing of the meanings of gender, an iconography of *maternité* exploded in paintings both at the Salons and by the Independents. Renoir led the way amongst Mary Cassatt's associates with his grandiose images of *maternité*, while many women painters, such as Elizabeth Nourse or Virginie Demont-Breton, embraced the call for *l'art féminin*. Its key icon was the mother and child – among the peasantry, the fisherwomen or the bourgeoisie.[37]

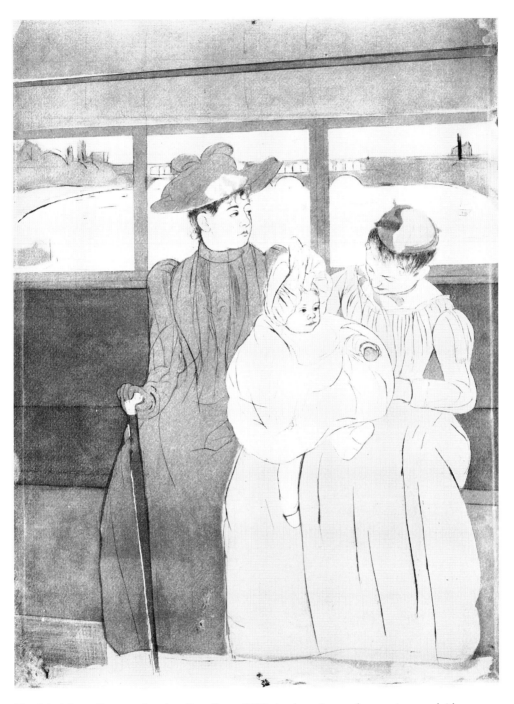

Fig. 8.9 Mary Cassatt, *In the Omnibus*, 1890–1, drypoint and aquatint on laid paper, 36.4 × 26.6 cm. Worcester Art Museum (bequest of Mrs Kingsmill Marrs)

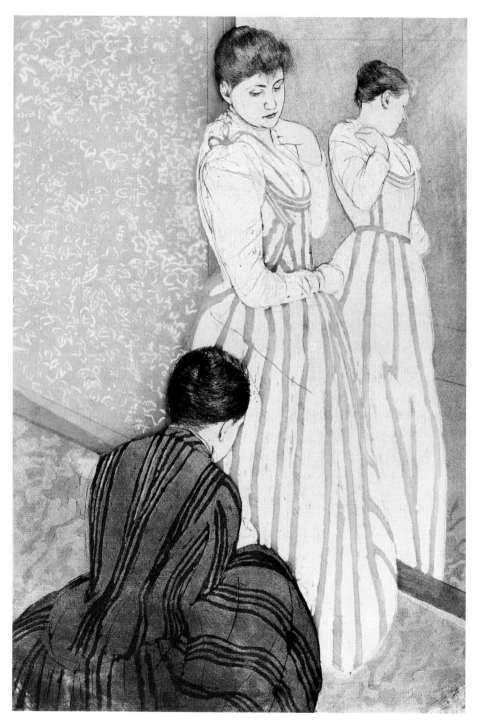

Fig. 8.10 Mary Cassatt, *The Fitting*, 1890–1, drypoint and aquatint on laid paper, 37.5 × 25.7 cm. Worcester Art Museum (bequest of Mrs Kingsmill Marrs)

Mary Cassatt's images are troublesome in this context. She could not deny the bond of mother and child, not only 'given' but lived by her sisters-in-law and her employees, both of whose maternal situations she painted with curiosity and interest. But her formal inventiveness, her long study of the iconography of the topic in the art of Renaissance Italy during the early 1870s, gave her resources with which it seems she worked to create a complex image of the situation of femininity, class and the generations which radically resists all that was ideologically packaged by contemporary images of maternity.[38] Rather than presenting the mother and child as a state of being and ultimately nature, Mary Cassatt's works represent relationships which are the site of sometimes intense and often uneasy negotiations.

In the Omnibus presents us with a tiny fragment of modernity: a scene of public transport in the city, an image rather closer to the formalism and hence the symbolic possibility characteristic of paintings by Vermeer. A precisely defined space, a social space that we can identify and recognise within a specific history and social geography, is occupied by two women and a child, whose sex at this point is not an issue. One is a working woman whose job it is to occupy herself with the child. The child also has a relation to the other woman who does not hold it, but shares intimacies, here unexhibited, with this small body so overdressed and cluttered. The child functions as a mediator – like the letter – between two women without any necessary affection or connection other than that generated by money and familiarity. Social relations between women, and between women and children, are there in some of their perplexity. Difference and otherness of all three are part of this image. Indeed I wonder if, at the level of the effect, achieved through her exploration of this trio and this space by means of the devastatingly difficult discipline of the revolutionary etching technique Mary Cassatt was investigating in 1891, that is what caught her interest and led her to forget the gentleman and concentrate on the unexpectedly rich possibilities of this simple juxtaposition of modern femininities.

It is not hard to imagine how, in some kind of social reality, the working woman might be for the bourgeoise a fantasised subject of knowledge, free to come and go between bourgeois interior and city exterior, between upstairs and downstairs, front rooms and back passages. The knowledge imputed to the maid in Vermeer by Annie Leclerc is, in one sense, sexual. It comes to stand metaphorically for a kind of knowledge of female sexuality that is at once denied to bourgeois women yet passed between women across the boundaries of class.

Mary Cassatt grasped the point of Courbet's radical refusal of bourgeois condescension when he painted social beings other to himself as unknowable but not therefore inhuman. I am reminded of T. J. Clark's argument about *The Stonebreakers* (1849). He suggested that Courbet found forms for the effects of social class as terrible deprivation upon the bodies of the working men without intruding his class guilt through either sentimentality or heroisation.[39] In Mary Cassatt's print *The Fitting* (Fig. 8.10) the young bourgeoise turns towards the dressmaker kneeling to attend to her hem. We see both her profiles as she is reflected in her self-consciously elegant pose in the mirror. Her body is being dressed for its display – and it is schooled in the choreography of

bourgeois femininity.[40] The radical moment of Cassatt's print, I suggest, is that crouching working woman, the dressmaker, the woman who moves in and out of the bourgeois interior. Her pose is observed so carefully to convey the concentration of her skilful work without exposing her face.[41] Think by contrast of Degas's pert milliners (exhibited in the 1915 suffrage show at Knoedler's) represented with his class and gender prejudices written upon their semi-caricatured faces (Fig. 8.11). The *profile perdu* of the working woman speaks volumes about a discretion in which social difference can be admitted with respect.

The lost face of the dressmaker also introduces into Cassatt's print a remarkable image, a point of fascination with a woman who will not look at us, the viewers, who will never meet our gaze, who remains preoccupied with her own work. This does not read as a violent rejection or a negation of our presence. The print offers an image of that other, an unknown, of whom Bracha Lichtenberg Ettinger writes, who is not tantalising because she might acknowledge us, and restore us to our place as both the master and the object of the look, reassured that we are the point of an exchange. This unknown other must be allowed to remain in her unknowability, determining her own movements and purposes.[42] What is interesting is the degree to which this alterity is figured through a woman who is working. In the actual process of the household and her artistic practice, the upper-class Mary Cassatt may be assumed to have behaved with some respect towards her working-class employees. The social relations of class, however, here became the opportunity for figuring the working women as a *more* rather than as a *less*, as subject, rather than, as is the case in masculine imaginary, a lower body figure on the very edges of humanity, animality and identity.[43] Perhaps here is (social, sexual, aesthetic) difference making a difference.

Another of the 1891 series, *Woman Bathing* (Fig. 8.12), is one of two occasions (the other is the print *The Coiffure*) on which Mary Cassatt grappled with the partially unclothed adult woman. Both the topics of a woman's intimate toilette and her coiffure also echo Degas's preoccupation with this territory (for instance *Woman Bathing*, monotype, 1878–83, Williamstown, Massachusetts, Sterling and Francine Clark Art Institute). Feminist art historians have disclosed the social conditions from which Degas's representations were produced – private rooms in brothels or, as Heather Dawkins's research has revealed, peep holes at the Turkish Baths.[44] There can hardly be any comparison with Cassatt's observation of a servant's bedroom from which she then invented her image, adding carpets and colour which would not be automatic furnishings.

The space represented is not the privileged other space of the city in its masculine urban geography, the house that is not a home, in Linda Nochlin's phrase, a brothel.[45] It is the reconstructed upstairs attic of the bourgeois house, a working woman's bedroom in which a working woman's body could be represented by a bourgeois woman artist. This body is not offered for sexual observation, despite the fact that the display of any female body cannot ever defend itself against those wishing thus to use it. There is a politics of the female body in which this transaction between two women, artist and model, of different classes takes place. The bourgeois woman's body is

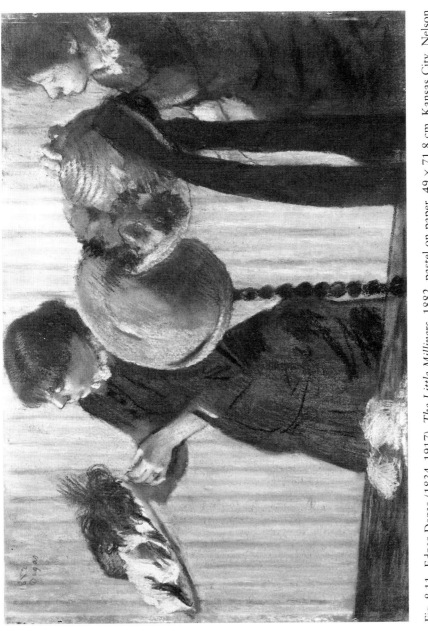

Fig. 8.11 Edgar Degas (1834–1917), *The Little Milliners*, 1882, pastel on paper, 49 × 71.8 cm. Kansas City, Nelson Atkins Museum of Art

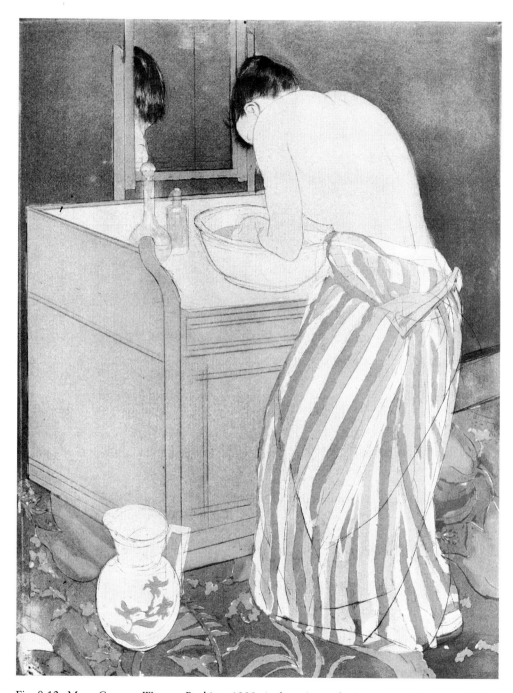

Fig. 8.12 Mary Cassatt, *Woman Bathing*, 1890–1, drypoint and aquatint on laid paper, 37.9 × 26.8 cm. Worcester Art Museum (bequest of Mrs Kingsmill Marrs)

dressed for its purposes, its femininity is the masquerade, as is shown in *The Fitting* (Fig. 8.10). For the bourgeois woman artist, there might be imaginary access to the female body in its simple bodiliness, its facticity as a body, by observing the simple acts of personal hygiene performed by an other, who is both woman and yet, within the cultural codes dominant at the time, different because of the possibility of the representation of her nakedness.

T. J. Clark has argued, however, that the shock of the painting *Olympia* (Fig. 9.17) when exhibited in 1865, lay in part in the failure of the artist to erase the signs of class from the painted female body for whom a working-class woman so evidently modelled. Manet's legacy was, however, unavoidable for the group of Independents. This led in the case of Degas and, later, Toulouse-Lautrec to the widespread prostitutionalisation of the modern nude as the most vivid site of class and sexuality in a masculine economy.

For an artist like Mary Cassatt, however, the female body could not become such a sign. As an ambitious member of this self-selecting artistic fraction, she would have to take on the implications of *Olympia*, in terms of the modern body being also a sign of class. But the marking of social difference on a female body as nude would always be ambivalent because of the shared gender of artist and model as well as because of the rigorous strictures of class regulation upon the formation of bourgeois femininity. Through the contemplation of the body of the other woman, the only female body she would be allowed even partially to see, there might always be a moment of self-discovery where curiosity about femininity might suspend or displace the force of class difference. Although not a Catholic, Mary Cassatt may well have been subject to the extreme caution surrounding bourgeois women's relations to the sight of their own bodies. In Catholic France, middle-class girls and women would wear a shift when bathing.[46] Class etiquette thus determined that a bourgeois woman could not be knowingly represented thus; the scenes of a boudoir would signify either sexuality or a courtesan's parodic establishment. In these circumstances we must acknowledge that there is a degree of exploitation in the bourgeois artist's use of a paid working woman's partial nakedness which arises out of the class relations between the model and her employer. But there is also another kind of connection here, in which the working woman represents an access for a bourgeoise to a femininity beyond bourgeois censorship on middle-class feminine corporeality.

The fact that these images have to be imagined as being made from a social relation and social space that is marked by the boundaries of white bourgeois femininity demands a reading of them different from those images they might formally resemble – be that Japanese prints or Degas's monotypes. They bring us back instead to Vermeer, Annie Leclerc and Jane Gallop. Thus the maid – the domestic servant – is not an incidental figure in these prints. Indeed the fact that two prints are devoted to her space and her body invites me to make that imaginative leap back to the woman in the background of Vermeer's painting that Annie Leclerc loved: a figure, within the middle-class world that included different femininities, who is an Other who knows – knows as a woman and knows on behalf of her bourgeois social other. Within the

constraints of the body as lived by a bourgeois lady in the later nineteenth century, the partially unclothed form of an other woman, the maid, is the nearest we can get to a trace of the fantasy that might be called Cassatt's vicarious pleasure in that knowledge.

Since this is a letter about writing a letter, I wonder what you will think of my rambling thoughts about social difference in Mary Cassatt's prints, the site of her engagement with what we now take to be the central problematics of metropolitan modernist culture in the later nineteenth century.

Yours etc.

LETTER III: ON THE *JOUISSANCE* OF THE OTHER

Dear Sister,

I find myself empathetically entering the spaces of Mary Cassatt's colour prints as I study them. I sense and feel constrained by the bodily decorum which is so marked in many of them that deal with the social spaces of the bourgeoisie. As I struggle to put into words what I feel when I look at them, I am captured by the discipline and formal dignity of many of the bodies in these images. But then, as I turn the pages of Adelyn Breeskin's 1947 *catalogue raisonné* of Mary Cassatt's printed work, I feel a sudden release of almost palpable *jouissance*. It is when my glance falls upon one of the prints in the series that figures the mother and child, *The Mother's Kiss* (Fig. 8.13). There I see a joyous nakedness at the centre of the page as the seemingly boneless flesh of the young infant straddles the mother's arms as she swoops it up to her face to kiss it. I can remember that game and how much my own children loved the swift strong movement of our early play. I loved to bury my face in that exquisitely soft, sweet-smelling flesh. I am almost shocked by the intensity of physical pleasure in this unlimited intimacy with another's body, which could also revive memories of my own infancy. There can be no doubt that, for some of us, the early months of motherhood bring a new dimension of sensuality which is anything but cloying and sentimental. This print offers to those who want to see it an image of that awakened passion. The positions of the heads of the woman and her ungendered child are those of lovers about to kiss. The woman's eyes are closed as are those in the other print in the series, *The Maternal Caress* (Fig. 8.14). Here the mother hugs the naked baby to her with an intensity that is almost painful. Its little face, by contrast, registers only joyous delight in being there.

In her study of 'the semiotics of the maternal metaphor' in nineteenth-century American literature and art, Jane Silverman van Buren reads Mary Cassatt's work through modern studies of infant–caretaker relations from Winnicott to Stern, passing briefly via Lacan.[47] For most theorists of infant development the mother is the instrument for the child's proper evolution as a 'subject'. Good mothering equals happy, well-adjusted child. On the other hand, the French psychoanalyst Jacques Lacan produced a much more tragic script about the formation of human subjectivity in a drama of irreparable loss and separation. His theories offer a way to read these

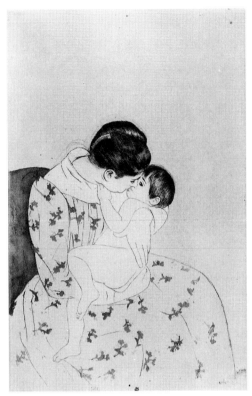

Fig. 8.13 Mary Cassatt, *The Mother's Kiss*, 1890–1, drypoint and aquatint on laid paper, 34.5 × 22.7 cm. Worcester Art Museum (bequest of Mrs Kingsmill Marrs)

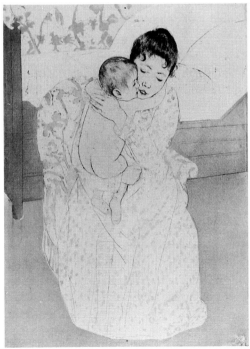

Fig. 8.14 Mary Cassatt, *The Maternal Caress*, 1890–1, drypoint and aquatint on laid paper, 36.7 × 26.8 cm. Worcester Art Museum (bequest of Mrs Kingsmill Marrs)

images of maternal situations that touch on pleasures so intense and unnameable – *jouissance* – that they are almost akin to suffering. *Jouissance* stands for a sense of deepest satisfaction the child imagines it once enjoyed, but from which it is now separated. Much psychic organisation aims to recover it: this is how Lacan defines 'desire', an impossible search for some imagined moment of total unity that is lost, a search that is doomed to failure, yet it drives along our being as a result of our immersion in language. Crucially, there will be a gap or a difference between the experience we think we originally had, imagined in retrospect as a kind of unity with the 'mother', and the search to recover this retrospectively charged intensity. In this gap there is a kind of commemorative mark – an ineradicable trace of loss itself. To these traces of loss – associated metaphorically with moments and elements of the imagined once-experienced fusion via the mother's voice, her touch and her gaze which once functioned like an enveloping embrace – Lacan gave the formula 'object "a" ' which marks the human subject as a creature that does not simply mature into independence from the mother but is severed from a fantasy of her as space, sound, touch and the envelope of the life-sustaining gaze and thus precipitated into the life-long tragedy of desire.

From the cultural highpoint of European Christianity in the fifteenth and sixteenth centuries, we can read in the widespread image of the mother and (male) child the combination of both that sense of loss and the effort to reinscribe a place in, near, as part of, the mother's monumental body. Reading 'Motherhood According to Giovanni Bellini', Julia Kristeva draws attention to the often distracted gaze of the Madonna and the formal function of the field of blue – the Virgin's cloak – which stages that dream of fusion and *jouissance* into which the child, or the viewer might imaginatively dissipate even though the still and distant mother is clearly no longer 'ours'. Such images, read this way for the fantasies that underpin their religious iconography, are not representations of a real, social relationship. They are the pictorial realisation of a fantasy about a feeling or a space, and not about an actual person. The persistent ideological role of images of women as mothers with babies is precisely to confuse that distinction, to make a psychic fantasy which inhabits our unconscious merely appear to reflect the social roles of women in the real, sexual division of labour in society. That is, to conflate The Mother of my unconscious with you, my mother, her mother, any woman who parents.

The mother is, for the boy child, both a desired place and an overwhelming presence from which to be distanced so that the child can find its way to a subjectivity in the world of language. Yet for the girl child, the mother, from whom she must separate by the same token to become a separate, speaking subject in the world of language, is also a figure with whom she must identify in the internalisation of a model for her own feminine subjectivity. By means of the triangular structure Freud named the Oedipus Complex, the masculine subject can sever himself from the Mother, identify with the Father and, using this gap, find himself as an empowered speaking being in society and language 'in the Name of the Father'. The residue of this passage is a passionate fantasy about what has been lost – which focuses on bits of the mother and the

maternal as place – which is raised to the fantasy of the feminine either perpetually sought in idealised images or aggressively punished in debased sexualised ones. From Manet to Picasso, we can see how these twin faces of masculine fantasy – the ideology of motherhood and the fascination with prostitution – haunted the new art of modernism.

The feminine subject, however, has a different relation to the lost mother because the fantasy can be relived in becoming a/the mother. If, however, the lost pleasures associated with, and the infantile rivalry with the mother can also be imaged in the world of language, called the Symbolic – since language substitutes signs and symbols for real things so that they can be spoken about, and thus be found in the realm of representations – there is a way that desire and language can function creatively for the woman subject. But only if we stop keeping the Mother in the half-light of infantile fantasies. As female subjects, we also need to create a Mother figure in the realm of desire and the Symbolic, not just keeping mother as a mute bodily remnant of nature – like a great Nature Goddess. Artists and writers of the later nineteenth century – the 'New Women' daughters of women who educated and supported them in a more out-going social activity – explored this problematic of finding a way to represent the productive role of the maternal image without merely falling into a regressive nostalgia for fusion with her by a feminine idealisation of *l'art féminin*. The strategic representation of generational transmission and historical change shaped by women for themselves was at the core of Mary Cassatt's mural *Modern Woman* – but that's another issue.

Feminist film theorist Kaja Silverman has argued that being able to imagine how the feminine subject relates to the fantasy of the mother – not before language and thus art, but through it – gives women access to what Kaja Silverman calls 'a genuinely oppositional desire'. It enables us to speak 'about a desire that challenges dominance from within representation and meaning rather than from the place of a mutely resistant biology or sexual "essence"'. Artists and poets can activate that desire which 'the [phallocentric] symbolic does its best to cordon off and render inactive by denying it *representational support*'.[48]

The phrase 'representational support' offers important insights into the role of women's interventions in visual culture. Mary Cassatt's paintings and prints were produced at an art historical moment of women-led political but also semiotic renovation – we call it the avant-garde – of that visual tradition in which the Madonna and Child and her secular offspring had been so important an iconography. One might even say, more categorically, that modernism was a radical displacement of the trope of Virgin and Son as a whole, reflected in the widespread interest in prostitutional images by rebel son-artists from Degas to Toulouse-Lautrec and later, Picasso and De Kooning. The mother image, apart from Renoir's utterly conservative *maternité* paintings, usually focused on large-breasted working-class women nursing guzzling male infants, if possible situated in nature, so as to reinforce the bonds of woman, nature and their timeless servitude to Man, tended to be part of the official not the independent art world. But Mary Cassatt, with Berthe Morisot, herself a mother, challenged that exclusion and forced a covenant between the new art and a 'representational

support' for exploring pictorially a nineteenth-century feminine relation to the maternal *and* to the feminine unconscious framed both by desire for the lost mother *and* by a creative identification with her.

The image of the Mother allows the artist to create a space for the representation of feminine pathos, tragedy, anger, as well as the contemplation of pleasure or access to a sexualised, Oedipalised *jouissance*, as we would now be able to name it. That is what I trace on the face of the mother-figure in *The Maternal Caress*, an exquisite moment of bliss experienced via her other, the child, which, through mobile identifications, she can also imagine to be herself. In the transitivity of psychic processes we can be both doer and done-to, active and passive, giver and receiver. As viewers of an image we can move between the positions offered through the depicted figures in the relationship. By dint of precise observation of those aspects of body language, translated into art as gesture and expression, through which our repressed desires hysterically speak themselves, a figurative artist can invent a set of signs which create the space for a glimpse of that *jouissance* that is lost yet perpetually sought.

The maternal and its accompanying feminine *jouissance* traverse, via the diffusion of the colour, the entire print, its bodies, its gestures, its faces, its filled and intimate spaces to create the trace of a place, the place of the once found, then lost and always desired and desiring feminine Other, whose presence in the actual biography of this artist functioned as a perpetual embrace and support for her daughter's decisive, artistic ambitions.

Thus the disciplines involved in the turn to printmaking, sustained by accompanying investigations of a textured space of bodies and places, in the pastels of the early 1890s, open on to this new intensity in Mary Cassatt's work. The images of the relations between child and adult, staged in the mundane routines of the work of childcare and education, between nursemaids, working-class women and their own or others' children, hinge both to a commentary on the social spaces of femininity and child-rearing and to a deeper tracing of fantasies and desires for which the just emerging contemporary discourse of psychoanalysis would provide a theoretical, explanatory vocabulary. The most demanding of artistic modernisms traversed the territories of the most controversial of psychological modernisms. It is in their interesting conjunction that Mary Cassatt's contribution to femininity and the spaces and mentalities of modernity may now be deciphered.

Yours etc.

LETTER IV: ON THE MORTALITY OF THE OTHER

Dear Mother,

Katherine Kelso Cassatt (1816–95) lived with her daughter throughout much of Mary's active artistic career, joining her in Paris in 1877 where they lived together until her death in 1895. She is traced in so many ways in the work of that artist daughter. I

suspect that the importance of the the maternal metaphor in the work of Mary Cassatt is an indirect reference to her own vivid relationship with her mother, who was her most important and intimate companion until she was fifty-one. I feel sure that if we set these images of Katherine Kelso Cassatt in place within the project and practice of her daughter, the work that was hung at the Suffrage Benefit Exhibition in 1915 from the Havemeyer Collection might become legible as something more than banal images of 'mothers and children' when compared with the formally innovative images of the mother's modernist antithesis – the prostitutes, ballet dancers and laundresses represented by Edgar Degas, which hung on the opposite walls (Figs 8.17, 8.18).

There are four major paintings in which Mary Cassatt actually portrayed Katherine Kelso Cassatt. A small portrait of just her head and shoulders is dated 1873. Then there is a major three-quarter-length painting called *Reading Le Figaro*, in 1878 (Fig. 8.15), and a painting of 1880 showing Mrs Cassatt reading to her grandchildren, *Family Group* (USA, Private Collection). The last major oil was painted in 1889, showing Mrs Cassatt wan and drawn after a dangerous bout of near-fatal illness (Fig. 8.16). There are various drawings for these paintings and prints made after them. Finally there are some etchings of scenes of reading newspapers and knitting in which the bespectacled figure of Katherine Cassatt can be identified.

Nothing about these images really marks them as representations of a mother in terms of traditional cultural codes. The conjuncture of maternity and intellectuality embodied in a portrait of one's educated mother reading is echoed at a deeper level by the daughter's creative act of 'bringing her mother into being' on the canvas through the gift of her own skill. If we draw on Luce Irigaray's concept of a maternal genealogy, a line of descent from women in creativity which challenges cultural legends of women bound only into an endless chain of procreativity, this painting seems to give credence to Irigaray's comments:

> It is also necessary for us to discover that we are always mothers once we are women. We bring something other than children into the world, we engender something other than children: love, desire, language, art, the social, the political, the religious, for example. But this creation has been forbidden to us for centuries, and we must appropriate this maternal dimension that belongs to us as women. If it is not to become traumatising and pathological, the question of whether or not to have children must be asked against the background of another generating, *of a creation of images and symbols*. Women and their children would be infinitely better off as a result.[49]

The possibility of using the notion of the maternal metaphorically works both ways. The woman who was in reality the mother, Katherine Kelso Cassatt, is represented reading, thinking, using the symbols of her modern culture. She is not symbolised by a child that ties her back to an ideologically fabricated maternal 'nature' and monumental timelessness. There is another woman also represented by the painting (Fig. 8.15), albeit indirectly, namely its painter. Her gaze and touch are 'embodied' by the

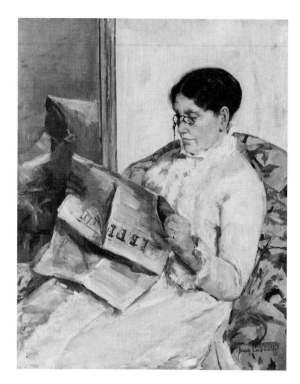

Fig. 8.15 Mary Cassatt, *Reading Le Figaro*, 1878, oil on canvas, 104 × 83.7 cm. Washington, D.C., Private Collection

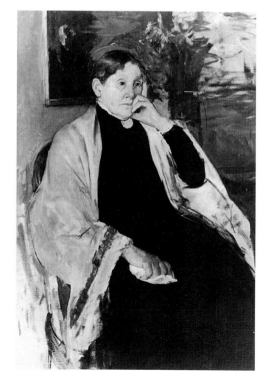

Fig. 8.16 Mary Cassatt, *Portrait of Katherine Kelso Cassatt*, 1889, oil on canvas, 96.5 × 68.6 cm. San Francisco, Fine Arts Museum of San Francisco (William H. Noble Bequest Fund)

represented woman. She, the artist, can imagine her creativity through an image of the maternal that itself figures that situation as a subjectivity which goes beyond a care-taking relation to an infant and sustains itself intellectually. This image then does not cut the painter daughter off from her mother, through her decision not to reproduce herself, and in doing so not to replicate her own mother. Rather, in the artistic practice in which she engages, the artist can fulfil both women's interacting Oedipal desires. In giving her mother a gift, the *creation of images and symbols* in the fact of this striking portrait, the artist might lend Katherine Kelso Cassatt 'representational support' for her evident desire as an adult, intellectually active woman to be more than the lost other of her daughter's infancy. At a profound psychic level, imagined by Luce Irigaray in the citation above, we could suggest that, in the painting, the artist herself gives the mother a surrogate child in the form of her art. To propose such a reading is not to tie women back into a world in which whatever they do is ultimately a displacement or symbol of a founding motherhood. As Luce Irigaray seems to be saying, making maternity metaphoric of forms of exchange between women is a way to allow the resources of that element of our psychic foundation to play a role in our adult imagination and in the culture's Symbolic. Mary Cassatt creates in the presence and otherness of her own mother, who can be both a point of reference and a subjectivising other whom she touches across the borderspace of a feminine experience of both alterity and proximity.

The last image of Katherine Kelso Cassatt, painted by her daughter in 1889, can take us into ancient mythological as well as profound psychological territory (Fig. 8.16). It is a drained and exhausted image of someone who has just survived near fatal illness. It is monumental in a tradition of seated portraits that can be traced back to Raphael's painting of an elderly *Julius II* (1512, Florence, Uffizi). Yet it is also tender in its delineation of the woman whose stricken features are so gently traced. I would argue that this too is a maternal image, at the level of myth, for it conjoins both life-giving and death.[50]

Death had almost claimed Katherine Cassatt in the late 1880s. Her vulnerability is noted in this painting in the pallor of the face and in the carefully observed hand that nervously clutches at a handkerchief. It is not dread that the contemplation of this image inspires, but a soft sorrow and even a tenderness at the drawn and stricken features. Given that the artist did not regularly use her mother as a model, in the way she used her sister Lydia before her early death in 1882, we can assume that each painting made of her was an important event. Perhaps this portrait again uses the *creation of images and symbols* in their life-giving role. We might speculate on its motivation: in the anxiety of having almost lost her mother, the artist once again traces the lineaments of her mother's face and body, to capture them and yet to make herself look at death, just resisted, but surely not defeated.

As Jane Silverman Buren has argued, one motivation for making art is that pursuit of the '*petit objet a*', the lost *jouissance*, that we retrospectively invent as our beginning with the mother. But across that impulse falls the shadow of the Oedipal prohibition of the fulfilment of our desire – itself the registration of the impossibility of recovering

that *jouissance* we never had. Images as symbols can be the stage for the constant oscillation between these contradictory registers in the unconscious. Most patriarchal cultures, shaped to figure the desire of certain elite men, use the image of woman as the sign of its negative Other, displacing its confrontation with its own lack on to a body represented as anatomically insufficient and discursively impotent. Either fetishistically beautified or grotesquely monstrous, woman is a sign of this phallocentrism.

If we were to imagine for a moment that the combination of social and semiotic changes we call modernism created a possible space not just for political feminism but for a cultural articulation of the desires that fuelled that revolt, Mary Cassatt's work might be read for what Kaja Silverman named 'an oppositional desire' which had of necessity to examine every dimension of feminine desire, pleasure and its psychic trajectory. Such a project would have had to include images of an adult woman, who may or may not have passed through what Mary Kelly has called the 'brief moment' of 'being a woman', maternity, but who also lived long beyond that overdetermined crisis of femininity and faced her own mortality.[51]

Without an image in this oeuvre of a mature or an old woman, casually noted while seated reading, knitting or monumentally confronted when she has come close to dying, we might indeed misread Mary Cassatt's whole project. But such representations are there, and they create yet another representation of the feminine subject and a feminine other within femininity. Like Annie Leclerc's exploration of her lesbian love, Mary Cassatt's images explore the possibility of women as other to women in terms of age, and experience of that other pole of the trajectory of female life, death. This diversity ensures that women in her paintings are never an endless repetition of a universal sameness.

It is significant, I think, that, during the summer of 1895 when Katherine Kelso Cassatt was mortally ill, Louisine Havemeyer came to visit her friend Mary Cassatt, to sustain her. It was at this time that Mary Cassatt did a portrait in pastel of Louisine and her daughter Electra (Fig. 8.5). When Katherine Kelso Cassatt died on 21 October 1895, Mary Cassatt wrote to Louisine, '[I] was so bereft & and so tired of life that I thought I could not live.'[52]

Yours etc.

LETTER V: ON THE EXHIBITION WITH THE OTHER

Dear Feminist,

When I first leafed through the catalogue for the Metropolitan Museum's show on the Havemeyer Collection with its brief essay on the exhibition Louisine Havemeyer arranged in 1915, my attention was arrested by the installation shots of that 1915 show. They are so odd and provoking. I have kept thinking of what it would have been like to go into that room and sit on those gross sofas. Turning my head one way, I would see a line of Cassatt paintings of elegant women, of mothers and children in a

variety of astutely observed situations and telling moments of intimate interaction (Figs 8.17, 8.18). Turning it the other, I would see a display of Degas's straining ballet dancers, pert milliners, exhausted laundresses and naked women awkwardly washing themselves.[53] Might I have thought, as I regarded the Cassatt wall: 'Oh Lord! Motherhood! how boring and predictable!'? Weighing down my spectatorship now, but not necessarily then, there is a load of art history and art criticism that perceives only Mary Cassatt's subject matter and appraises it negatively at the limited level of an essential, feminine iconography: images of . . . mothers and babies.

The reverse is true of the Degas's bathers, laundresses, chanteuses and dancers. There is a volume of art historical scholarship telling me as I sit there: 'This is very interesting technically!' 'This is formally so inventive!' 'The subject matter is incidental to the drawing and the composition!' What would we have to do to the two walls of paintings to enable the formal brilliance and semiotic inventiveness of *both* to be acknowledged in a way which can also grasp the radical *difference* that motivated these utterly disparate bodies of work as both a historical configuration of sexual difference and thus, potentially, a matter of profound political difference?

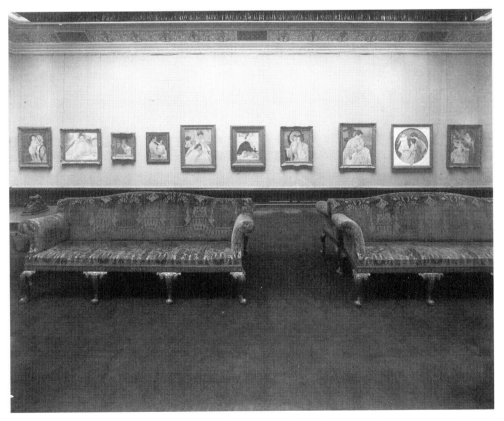

Fig. 8.17 Installation shot of paintings and pastels by Mary Cassatt at *Masterpieces by Old and Modern Masters*, held at M. Knoedler and Co., New York, 6–24 April, 1915 as a benefit for the cause of Women's Suffrage, showing the collection of Mrs Louisine Havemeyer

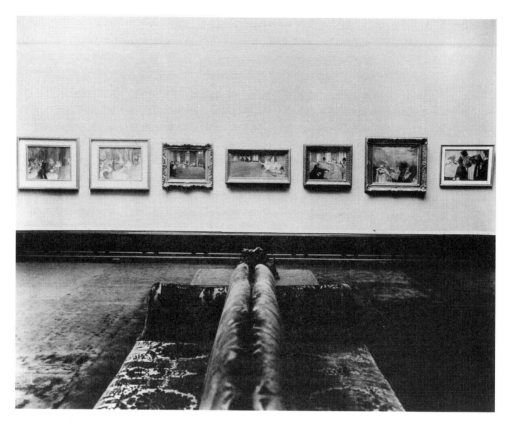

Fig. 8.18 Installation shot of paintings and pastels by Edgar Degas at *Masterpieces by Old and Modern Masters*, held at M. Knoedler and Co., New York, 6–24 April, 1915 as a benefit for the cause of Women's Suffrage, showing the collection of Mrs Louisine Havemeyer

I am sure that Louisine Havemeyer is the key. She it was who collected and owned most of both sets of images and set them within the frame of Spanish and Dutch seventeenth-century art so central to the renovation of French art by Courbet, Manet and Degas. But she had been encouraged to buy the Degas work by Mary Cassatt, who was probably one of the most important, if hardly acknowledged, figures in the shaping of American collecting and thus art historical and museum study of modern painting. The Cassatt–Havemeyer selection has formed the basis of knowledge of painting in Paris in the later nineteenth century for generations of American artists, students, curators and visitors. It is, in some profound sense, a women's collection, and, were we to study it as such, we might gain another insight into the history of women's relations to culture.

Mentioned here in passing, it allows us to raise the question of what these women saw when they looked at paintings. That question is as much about visual pleasure as it is about what we might extract from the conditions of material existence and semiotic figuration and call subject matter. Ironically, in the lecture given by Louisine

Havemeyer on the occasion of the exhibition in 1915, Degas's work is discussed entirely in terms of its subject matter, while Mary Cassatt's is appraised for its compositional inventiveness and colour.[54]

Undoubtedly Mary Cassatt looked as a painter and saw in Degas's work wonderful painterly things that she wanted to understand, to use, to learn from and to work through.[55] She was also his most astute critic. Thus I would want to argue that it is a feminist strategy to place Louisine Havemeyer and Mary Cassatt as major intellectuals who were historically important in the cultural valorisation of early modernist painting. They did this not as 'women' but in those activities in which modernising, revolting women like them transcended and thus challenged the ideological feminisation of women in the nineteenth century. Thus, if we bring notions of feminist politics to bear on this history, we will have much more theoretical room to manoeuvre for understanding diverse strategies adopted by women intellectuals, negotiating, as we still do, the shoals of patriarchal cultures which present us with constantly shifting dilemmas as we seek to work out how to be women in a culture fundamentally unable and unwilling to recognise us. Sometimes we act more for women when we act less like 'woman'.

But when it came to the 1915 Suffrage Benefit show at Knoedler's, only two artists of the modern school collected by the Havemeyers were featured. Edgar Degas and Mary Cassatt were hung facing each other, as if in conversation or in some complex counterpoint. Was it radical difference or some possible complementarity that we would have seen had we been there in 1915?

The hanging of the 1915 exhibition presents the possibility of a historical space in which 'Edgar Degas' did not negate 'Mary Cassatt', in which these two worlds of bourgeois modernity could, as it seems they did in Paris, co-exist and converse. What she and Degas shared was a museum culture, a sense that you make art by working through art's resources and traditions. Both exhibit what today might be called a semiotic awareness of the conventionalism of art. But what I have been also trying to suggest is that Mary Cassatt could also take on Degas's subjects through a quite different perspective than that from which they were produced. His works could, therefore, function as images of 'the other woman'.[56]

The bodies of women in paintings sustain different economies of desire. If those desires are oppositional, in Kaja Silverman's terms, not simply because the reader is a woman but because she is a feminist as Mary Cassatt and Louisine Havemeyer were, we could imagine a way of seeing those paintings by Degas and Mary Cassatt which confronted each other at Knoedler's as each the other's social antithesis, and yet also each other's constructing Other.

The works by Degas on exhibition at Knoedler's were paintings and pastels of working-class women modelling for the French artist in his grimy Paris studio. They are representations of working-class women at work, posing as if dancing, ironing, selling hats, prostituting themselves, while the artist observed their postures and gestures, their tired faces and over-worked or over-trained bodies. These are female bodies working in spaces beyond the window out of which the maid gazed in

Fig. 8.19 Detail of Mary Cassatt, *Young Mother Sewing* (Fig. 8.3)

Vermeer's painting, that is, beyond the spaces of bourgeois femininity, spaces which a lady like Mary Cassatt could never know intimately, although she went to the theatre and often bought hats. Her fittings were done at home, and the only women bathing she could pay to see would be her maid or a hired model in her studio or the maid's attic. The studio set-up was never, however, a mock-up of the spaces of modernity and cross-class sexual exchange which her masculine colleagues could also know and reconstruct. Her studio exchange and process was marked by the constraints of class difference between women which lend to each woman's experience of her femininity an experience of otherness – an internal differencing between femininities which could, at times, also yield moments of recognition, if the politics of the participants allowed each to go beyond the confines of their own class ideology. Thus these bodies and activities of the other woman represented by Degas held an interest which we have seen reworked and inscribed in Mary Cassatt's 1891 prints in specific ways that have nothing to do with derivation or influence, but a great deal to do with puzzling over the determining issues of modernity – class – from a differential position generated by the play of yet another facet of modernity – gender and its sexualities.

Had the 1915 suffrage exhibition displayed the 1891 colour prints on the wall opposite the exhibit of Degas's paintings and pastels, we would have had no problem in seeing an interesting dialogue in which social and sexual difference would operate to make quite plain the difference between bourgeois men and bourgeois women.[57] The problem arises because, instead of that extraordinary set of studies of difference and *jouissance* represented by the colour prints of 1891, we have a barrage of mothers and children on the walls of Knoedler's.

I want to conclude by returning to the theme of reading for the other woman – the othernesses of which historical and social femininities are always comprised. In revisiting in my imagination Knoedler's showrooms at 19 East 70th Street in New York, I find that the other is there: in the bold portrait of Mrs Riddle, *Lady at a Tea Table* (1883–5, New York, Metropolitan Museum of Art), other in her age and station to the artist, other in class, culture and time to us now. She is there in the nursemaids or country women with their own or bourgeois children where Cassatt does not idealise as simply the *maternité* of women of another class, using class to conflate woman and nature. These are images of work, and engage that matrixial space which offers sites of the complexity of the relations between a child and an adult whose bonds are anything but 'natural'. The other is also there in curious and thoughtful daughters like the one who grasps the mirror so firmly to question us indirectly as her reflected face is turned outward to meet our gaze in *Woman and Child* (1905, Washington, D.C., National Gallery of Art). Of course she is there in the form of the historic artist whose presence I suggested cannot be ignored in the painting *Young Mother Sewing* (Fig. 8.19), for it was she and her work whom the little girl's direct gaze confronted then and commemorates now. The woman artist, the intellectual, the painter, the feminist, the daughter, the sister, the friend, the curator, she is for us now 'the other woman' who belonged to a historical moment of feminism whose archaeology is of such value to contemporary feminism. Not the lost maternal space of

good objects, beautiful paintings, tender friendships, it was a matrixially modernist moment when daughters could create without killing their mothers.[58]

Yours ever,
Griselda Pollock

NOTES

1 Mary Cassatt produced a set of ten colour etchings and exhibited them at the Galerie Durand Ruel in Paris in 1891. The main documentations and analyses of these prints are Adelyn D. Breeskin, *The Graphic Work of Mary Cassatt* (New York: H. Bittner & Co., 1948), and Nancy Mowll Matthews and Barbara Stern Schapiro, *Mary Cassatt: The Color Prints* (New York: Harry N. Abrams in association with Williams College, 1989).

2 Camille Pissarro, *Letters to his Son Lucien*, ed. John Rewald and Lucien Pissarro (Mamaroneck, N. Y.: Paul P. Appel, 1972), p. 158. Because both Pissarro and Cassatt had been born outside France, they had not been included in an exhibition of the French Société des Peintres-Graveurs which was to hold its exhibition in the main gallery of Durand Ruel's showrooms. Pissarro and Cassatt showed separately in a side room.

3 For an analysis of where Pissarro worked see Richard Brettell, *Pissarro and Pontoise: The Painter in the Landscape* (New Haven and London: Yale University Press, 1990).

4 T. J. Clark, 'Pissarro', TV programme for the Open University, *Modern Art and Modernism*, 1984, and lecture given at the University of Leeds conference *Work & the Image*, 18 April 1998, 'Time and Work Discipline in Pissarro'.

5 Achille Segard, *Mary Cassatt: Un peintre des enfants et des mères* (Paris: Paul Ollendorf, 1913).

6 Alice Cooney Frelinghuysen *et al.*, *The Splendid Legacy: The Havemeyer Collection* (New York: Metropolitan Museum of Art, 1993).

7 The first purchase was Degas, *Ballet Rehearsal* (*c.* 1874), pastel over monotype, now in the Nelson Atkins Museum of Art, Kansas City.

8 Frances Weitzenhoffer, *The Havemeyers: Impressionism Comes to America* (New York: Harry N. Abrams, 1986).

9 Louisine W. Havemeyer, 'The Suffrage Torch: Memoirs of a Militant', *Scribner's* (May 1922), p. 529.

10 This brought art to life in Laura Mulvey's film *Riddles of the Sphinx* (1976). There was a Cassatt image in the little girl's bedroom – a print that I in fact supplied to the film-maker, who had just read my 1978 book on Mary Cassatt. See also my book *Mary Cassatt* (London: Thames & Hudson, 1998).

11 Photographs of women artists at work in the later nineteenth century, such as that of Berthe Morisot in her studio in the 1890s or Cecilia Beaux painting Ethel Page, are a constant reminder of the proximity if not intimacy with sitters or models in the studio space of production in which women artists worked. This material fact of relations in space effects the resulting representation, giving rise to a rhetoric of proximity often so at odds with the detachment and 'voyeuristic' distance which predominantly structures and defines as *modern* works by these artists' non-female colleagues.

12 I have argued this point more fully in my 'Modernity and the Spaces of Femininity', in *Vision and Difference: Feminism, Femininity and the Histories of Art* (London: Routledge, 1988). There I suggest that a particular feature of Mary Cassatt's paintings derives from the way in which her paintings incorporate the space – physical, social and psychic – from which the representation was made. To read the work – that is, to join in with its interest – requires the viewer to have some access to or sympathy with that position. The lack of both perhaps explains why art made by women in general falls beneath the threshold of the canonically trained viewer, male or female, and appears without interest, boring.

13 I am here drawing on the work of Julia Kristeva, who has offered a psychoanalytical reading

of the long-standing image of the Madonna and Child in Renaissance painting in her case study of the world of Bellini, 'Motherhood According to Giovanni Bellini', in *Desire in Language*, ed. Leon Roudiez (New York: Columbia University Press, 1980), pp. 237–70. Kristeva is only able to imagine the ways in which masculine subjects negotiate their relations to the mother of masculine fantasy through this artistic trope. Bellini lost his mother early, and Kristeva reads his work for the recurrent sense of the impossibly lost mother with whose *jouissance* the masculine artist identifies as the limit, boundary or beginning of the possibility of his aesthetic creativity. In these images, therefore, there is no sentimental dream of recovered mothers, but the intense engagement with an impossible blockage, on one side of which lies the possibility of creating at that edge, while beyond that edge would lie madness, the impossibility of finding oneself in any signification at all. The question then posed is: Could women take up the exploration of the mother in art only at the point of radical semiotic and cultural change, when the family, the state and religion realigned themselves as both the condition for the cult of secular motherhood and the condition for the growth of feminist revolt – both in fact based on the historically and culturally transformed possibilities for the expanded realisation of feminine subjectivity?

14 I shall explain this claim more fully in a moment.

15 This point was made by Anita Brookner in her presentation of the painting in BBC TV's series *One Hundred Great Paintings* in 1978.

16 Carol Duncan, 'Happy Mothers and Other New Ideas in Eighteenth Century French Art', in *Feminism and Art History: Questioning the Litany*, ed. Norma Broude and Mary D. Garrard (New York: Harper & Row, 1982), pp. 201–20.

17 See Paul Street, *Representations of the Family in Eighteenth-century British Painting*, Ph. D. thesis, University of Leeds, 1993, for a detailed study of the sensualisation of the mother in English eighteenth-century portraiture; and Duncan, 'Happy Mothers'.

18 Linda Nochlin, 'A House Is Not a Home: Degas and the Subversion of the Family', in *Dealing with Degas: Representations of Women and the Politics of Vision*, ed. Richard Kendall and Griselda Pollock (London: Pandora, 1992), pp. 43–65 (now London: Rivers Oram Press).

19 Writing of 'Renoir and the Natural Woman', Tamar Garb points out the connection in late nineteenth-century criticism between the artist's gross, languid nudes reclining in fantastic southern landscapes and the massive maternity images which made Renoir so popular in the late nineteenth century and so impossible in the radical anti-maternalism and anti-naturalism of Greenbergian modernism in ours. Tamar Garb, 'Renoir and the Natural Woman', *Oxford Art Journal*, 8, 2, (1985), pp. 3–15; reprinted in *The Expanding Discourse: Feminism and Art History*, ed. Norma Broude and Mary D. Garrard (New York: HarperCollins, 1992), pp. 294–311. On Renoir's impossible place in modernism see Fred Orton, 'My Ideas of Renoir Keep Changing', *Oxford Art Journal*, 8, 2, (1985), pp. 28–35. On Mary Cassatt's work in relation to contemporary discourses on maternity see Alison Bracker, *The Hand That Rocks the Cradle: Mary Cassatt's Images of Maternity*, M.A. thesis, UCLA, 1990; Nancy Mowll Mathews, *Mary Cassatt and the 'Modern Madonna' of the Nineteenth Century*, unpublished Ph.D. thesis, New York University, 1980.

20 Pictograms are 'the representation of the *originary* psychic space, considered closest to the body'. According to Piera Aulagnier, archaic sensory events can be considered as representations through this concept of pictogram. To each level of psychic structuration there is a specific form of representation attached or developed: the primary process uses the image of things, and as this develops it adds the images of words – fantasies; the secondary process uses 'images of words already interwoven in a cultural network, represented by *thoughts*'. 'Every experience, whether its source is internal or external, produces representations on several levels at once: in the *real*, in the *imaginary*, and in the *symbolic*: pictograms, fantasies and thoughts conjointly record any given event.' Bracha Lichtenberg Ettinger, 'Matrixial Borderspace in Subjectivity as Encounter', in *Rethinking Borders*, ed. John Welchman (London: Macmillan Academic, 1996), pp. 125–58.

21 *Ibid*.

22 This is documented in her artist notebooks, *Matrix – Halal[a] – Lapsus* (Oxford, Museum

of Modern Art, 1992) and, for a reading of the notebooks and the paintings see my 'After the Reapers', in *Generations and Geographies in the Visual Arts: Feminist Readings*, ed. Griselda Pollock (London: Routledge, 1996).

23 Bracha Lichtenberg Ettinger, 'Matrix and Metramorphosis', *Differences*, 4, 3, (1992), pp. 176 and 201.

24 In the work of Luce Irigaray, we also find a questioning of the deleterious effects of the exclusive identification of the Symbolic with the Phallus, as if it is the only imaginable symbol around which human subjectivity and sexuality could be organised. Irigaray has argued, also developing out of Lacanian categories, the need for a feminine Symbolic, which can be imagined only on the basis of a feminine Imaginary. In her writings the relation with the mother is crucial. She sees phallic culture as fundamentally matricidal. See especially 'The Bodily Encounter with the Mother' [1981], in *The Irigaray Reader*, ed. Margaret Whitford (Oxford: Basil Blackwell, 1991), pp. 34–47. Lichtenberg Etttinger starts from a point which challenges the phallic order at an earlier stage, before there is any recognition or fantasy of the mother for the child; before these nominations have any meaning. In the same manner as Lacan suggests that both masculine and feminine subjects are positioned in relation to the Phallus but that masculine subjects have an overdetermined stake in the phallic system through misrecognition of their penis as phallus – always for Lacan a signifier, not a thing, and certainly not the organ, though the latter inherits any embodiment of the signifier going – so masculine and feminine subjectivity can be organised also in relation to other symbols, like the Matrix, though feminine subjects will have an overdetermined relation to it. The specificity of feminine subjectivity and sexuality may be articulated in part through that 'difference' that arises from living in a body that gives access to this experience of matrixial co-existence from another point of view when pregnant. But, at a metaphoric level, or even sociologically, the feminine refers not biologically to women but to radically other possibilities from those a phallocentric regime permits. Thus the femininity of the Matrix can operate philosophically, as a way to characterise any social thought, image process, idea or practice that works with this kind of acceptance of the severality of difference, while masculinity, as phallic refers to that which operates by exclusion or assimilation, either/or, binary oppositions. Equally this idea can operate politically, to be claimed by women, in the active promotion of ways of organising socially and politically, or of analysing culture to break through the foreclosure, the denial of articulation, of representational support for any other imaginary, and earlier processes of subjectivity than that decreed by the phallus.

25 Annie Leclerc, 'La Lettre d'amour', in Hélène Cixous, Madeleine Gagnon and Annie Leclerc, *La Venue à l'Écriture* (Paris: Union Genérale, 1977).

26 Annie Leclerc, *La Parole de femme* (Paris: Grasset, 1974), p. 80.

27 Jane Gallop, 'Annie Leclerc Writing a Letter, with Vermeer', *October*, 33 (1985), p. 109; Gayatri C. Spivak, 'French Feminism in an International Frame', *Yale French Studies*, 62 (1981), p. 179.

28 This painting passed through Paris when it was part of the Secrétan Sale at Boussod, 1 July 1889 (no. 140). Vermeer was at that sale still a painter who aroused considerable interest because he was recently rediscovered and reconstituted by the researches of Théophile Thoré alias Willem Bürger. See Théophile Thoré, 'Van der Meer of Delft', *Gazette des Beaux Arts*, (1866), pp. 297–330; 458–70; 542–75.

29 For an analysis of this issue in the Mérode Altarpiece, *The Annunciation* by Robert Campin, see Michael Ann Holly, 'Witnessing an Annunciation', in *The Point of Theory: Practices of Cultural Analysis*, ed. Mieke Bal and Inge Boer (Amsterdam: University of Amsterdam Press, 1994), pp. 220–31.

30 I am drawing here on Nanette Salomon's important work on the sixteenth century representation of the brothel versus the domestic space in which the latter inherited the connotations of the annunciation, forthcoming in her collected essays for Stanford University Press, 1999.

31 See Jane Gallop, 'Keys to Dora', in *Feminism and Psychoanalysis: The Daughter's Seduction* (London: Macmillan, 1982), pp. 132–50. Gallop points out how the apolitical character of psychoanalysis appears when it colludes with the imaginary assimilation of

the nurse to the mother. In the first two chapters of this book I elaborated the masculine fantasy of that conflation within a model of psychic fragmentation and contradiction which resulted in an aggressive debasement of those figures who represented the working-class nurse while all good feelings were assimilated to a mother figure become remote but desired. This case explores a specifically feminine articulation of the relations of social difference in this family model, suggesting the possibilities of non-aggressive relations of difference – though these may equally still inscribe the real social and economic power of the bourgeoisie.

32 *Ibid.*, p. 118.

33 Emile Benveniste, *Problems in General Linguistics*, trans. Elizabeth Meek (Coral Gables: University of Miami Press, 1971). For a useful explanation of the relations between language and subjectivity in Benveniste's work, see Kaja Silverman, *The Subject of Semiotics* (Oxford: Oxford University Press, 1983).

34 Roland Barthes, 'The Reality Effect', in *The Rustle of Language*, trans. Richard Howard (Oxford: Basil Blackwell, 1986), pp. 141–8. For examples of paintings see Monet, *Le Déjeuner* (1868, Frankfurt, Städelsches Kunstinstitut) and Caillebotte, *Le Déjeuner* (1876, Private Collection).

35 For instance, during the period when crinolines were high fashion, no woman could board an omnibus wearing the boned frame which sustains the ballooning skirts. Special pegs were attached on the back of the omnibuses for these curious structures to be hung on, and women had to undress in public in order to board. Caroline Arscott has found cartoons and humorous writings which refer to the sexual treats available to young men travelling on the omnibus as a result of this particular lunacy of women's fashion. Caroline Arscott, *Modern Life Subjects in British Paintings 1840–60*, Ph.D. thesis, University of Leeds, 1987.

36 This image is not an interior, but, even outside the home, women occupied the spaces of the bourgeois family, which of course, was always permeated by 'an outside' in the persons of those who worked for the family but were not blood kin. The fact that those employed to care for children are mostly women in Western societies shows how the issue is not biological but an ideological arrangement which claims its justification from 'the facts', if not of reproduction itself, from lactation.

37 See Tamar Garb, and her *Sisters of the Brush: Women's Artistic Culture in Late Nineteenth Century Paris* (New Haven and London: Yale University Press, 1994).

38 For a fine discussion of this see Jane Silverman van Buren, *The Modernist Madonna: Semiotics of the Maternal Metaphor* (Bloomington: Indiana University Press and London: Karnac Books, 1989).

39 T. J. Clark, *The Image of the People* (London: Thames & Hudson, 1973).

40 This moment is critically staged in Sue Clayton's and Jonathan Curling's major film about working women and nineteenth-century representation, *The Song of the Shirt* (1978) in which a dressmaker comes to measure and then fit a young debutante for a ballgown. The debutante's relations to the exploited seamstresses who make up the expensive dress through which the debutante will be put up for auction on the marriage market is articulated through a romantic love story of a young bourgeois and a beautiful seamstress that was first published in a Chartist paper. The novella circulates from the seamstresses' workroom to the bourgeois drawing room via the dressmaker who inadvertently leaves it behind when she calls with the gown. The film subsequently dramatises the different ways in which women of different classes read the same sensational text, the working women 'knowingly', anticipating the inevitable abandonment of the pregnant working-class woman, the debutante 'breathlessly', i.e. discovering a sexuality through the text of whose meanings she remains fundamentally ignorant because, unlike the social understanding of the working-class women, she has no means to penetrate the codes of her own fabrication as the object of exchange and masculine desire.

41 The scene of the fitting appears also in the work of Paula Rego, *The Fitting*. Paula Rego's paintings also stage the interactions between women of different classes within the spaces of the bourgeois household, drawing on her own childhood history in Portugal. See John McEwan, *Paul Rego* (London: Phaidon Press, 1992).

42 In Bracha Lichtenberg Ettinger's own work, one of the recurring images with which she has repeatedly worked is precisely one of a woman looking away (for instance in *Woman – Other – Thing* no. 3, 1990–2). Her reflections on this figure's appeal and function helped to develop her analysis of the matrix. See Bracha Lichtenberg Ettinger, *Matrix Borderlines* (Oxford: Museum of Modern Art, 1993).

43 See Chapters 4 and 3 on Toulouse-Lautrec's and Van Gogh's fantastic uses of the working women's body in representation.

44 Eunice Lipton, 'Degas's Bathers – The Case for Realism', *Arts Magazine*, 54 (1980), pp. 93–7; and Heather Dawkins, *Sexuality, Degas and Women's History*, unpublished Ph.D. thesis, University of Leeds 1991.

45 Nochlin, 'A House Is Not a Home'.

46 T. J. Clark, *The Painting of Modern Life: Paris in the Art of Manet and his Followers* (New York and London: Knopf and Thames & Hudson, 1984).

47 Silverman van Buren, *op. cit.*

48 *Ibid.*, pp. 123–4.

49 Irigaray, 'The Bodily Encounter with the Mother', p. 43.

50 In this sense, this discussion should be linked back to the analysis of Artemisia Gentileschi's painting of *Cleopatra*.

51 Mary Kelly, 'Invisible Bodies: Mary Kelly's *Interim*', *New Formations*, 2 (1987), p. 11; and *Imaging Desire* (Boston: MIT Press, 1996).

52 Cited by Nancy Mowll Mathews, *Mary Cassatt* (New York: Villard Books, 1994), p. 236.

53 Rebecca A. Rabinow, 'The Suffrage Exhibition of 1915', in *Splendid Legacy: The Havemeyer Collection*, ed. Alice C. Frelinghuysen *et al.* (New York: Metropolitan Museum of Art, 1993), pp. 89–98, provides a complete list of exhibited works and identifies them through the Havemeyer collections or appropriate *catalogues raisonnés*. There were twenty-seven works by Degas, of which thirteen were in the Havemeyer Collection; there were twenty-one works by Mary Cassatt, of which ten were in the Havemeyers' possession. Because many members of her family supported the anti-suffrage cause, they would not lend to this suffrage benefit exhibition and thus a large number of her earlier works were not available. Most of the paintings in the exhibition were from the period after 1900, whereas the Degas exhibition concentrated on his work from the 1870s to 1880s. It included paintings such as *Bouderie [Sulking]* (1869–71); *Woman Ironing* (1873); *The Song of the Dog* (1876–7); *Woman Drying her Foot* (1885–6). The Cassatt exhibition included *Baby's First Caress* (1891); *Mother and Child*, also known as *The Oval Mirror* (1901); *Mother and Child* (1905); *The Child's Caress* (1891).

54 Mrs H. O. Havemeyer's 'Remarks on Edgar Degas and Mary Cassatt', 16 April 1915, pamphlet. I am grateful to Melissa De Medeiros of the library of Knoedler's Gallery for a copy of this speech.

55 See Griselda Pollock, 'Killing Men and Dying Women: A Woman's Touch in the Cold Zone of American Painting in the 1950s' in *Avant-gardes and Partisans Reviewed*, ed. Fred Orton and Griselda Pollock (Manchester: Manchester University Press and New York: St Martin's Press, 1996).

56 There is no way to document this assertion from Mary Cassatt's own statements. It is offered as a conclusion to this reading of her own work. Reading Louisine Havemeyer's memoirs on Degas, we find an interesting point of view in relation to his subject matter. There is clear recognition of the issue of class in the way she writes admiringly of his piercing vision of the café chanteuse or the adolescent ballet dancers and their mothers. Precisely the point I have been arguing about Cassatt emerges, namely that the sexuality of cross-class interchange – which I have argued before defines masculine artists' engagement in the spaces of modernity – can be displaced by a perception of class otherness which has no sense of sexual use, abuse or fantasy. The same images are read for the compositional complexity with which they manage to create a 'true' sense of another's social being. There is, of course, no way in which this means that the social being of working-class women is being or could be represented by Degas or recognised by a bourgeois lady. Class will distort their view. But I am suggesting that the bourgeois lady viewer saw difference as another way of being in the

body and the world, rather than as a figuration of a psychic split, which, in the case of masculine modernity, makes the dancer, the milliner, the laundress and the prostitute washing herself a fantasmagoric figure, as we have seen in Chapters 3 and 4. See Louisine Havemeyer, *From Sixteen to Sixty: Memoirs of a Collector* [1930] (New York: Metropolitan Museum of Art, 1961).

57 Some of these works may have been visible in New York at the same time, for Durand Ruel had an exhibition in April 1915 of *Water Colours and Drypoints by Mary Cassatt.*

58 For a full discussion of this claim and the comments about *Reading Le Figaro*, see Griselda Pollock, 'Critical Critics and Historical Critiques or the Case of the Missing Women', *University of Leeds Review*, 36 (1993/4), pp. 211–45; a version in *The Point of Theory*, ed. Mieke Bal and Inge Boer (Amsterdam: University of Amsterdam Press, 1994) and full reprint in Griselda Pollock, *Looking Back to the Future: Essays from the 1990s* (New York: G&B Arts International, 1999).

Fig. 9.1 *Berthe Morisot*, 1894, photograph. Private Collection

9

A TALE OF THREE WOMEN

Seeing in the dark, seeing double, at least, with Manet

> Feminist criticism can be a force in changing the discipline. To do so, it must recognize that it is complicitous with the institution within which it seeks space. That slow labour might transform it from opposition to critique.
>
> Gayatri Chakravorty Spivak[1]

INTRODUCTION: *LAURE, JEANNE* AND *BERTHE*

A photograph of the French painter Berthe Morisot taken in 1894 (Fig. 9.1) offers a ghostly trace of a once-present person. The image exerts all the allure of the photograph as the repository of lost plenitude that we dream is history. Berthe Morisot (1841–95) is a well-documented artist, with a *catalogue raisonné*, published if much edited correspondence, a few biographies, and some quite substantial exhibitions and conference proceedings published on aspects of her work.[2] She has attracted a great deal of feminist art historical interest since the early 1970s, and her work offers a significant field for the reassessment of 'modernity and the spaces of femininity' as well as of impressionist aesthetics and their relation to a range of possible historical significations of the feminine.

In the photograph, the artist – who died of influenza on 2 March 1895 at the age of fifty-four, a year after this photo session – is posed sitting, dressed in a loose-fitting, flowing white robe, on an upholstered settee, one leg tucked under the other, her head resting on one hand, dreamily, or in exhaustion. She is in repose. Her hair appears white. The photograph is either an uncanny, or a chance, or perhaps an intentional reprise of one of the most famous paintings of a younger Berthe Morisot made by the fellow artist who later became her brother-in-law, *Repose*, painted between May and September of 1870 by Edouard Manet (Fig. 9.2).

The photographic image of Berthe Morisot as an elegant if relaxed, prematurely aged woman bears both iconographic similarities to, and significant differences from, images of the same woman in her youth. There she appears in paintings and photographs as 'the dark lady', a dramatic woman, whose striking dark-eyed looks rhetorically fashioned by photographer or painter lent themselves to a contemporary recasting of that

Fig. 9.2 Edouard Manet (1832–82), *Repose*, 1870, oil on canvas, 148 × 113 cm. Providence, Rhode Island School of Art Museum (bequest of the estate of Mrs Edith Stuyvesant Vanderbilt Gerry)

trope. (Fig. 9.3)[3] The dark lady is one face of a cultural polarisation of femininity that sets up a domesticated, either virginal or maternal, femininity – the white lady – in opposition to a dangerous, sexually dominating or alluring figure that is always else-where, connected with the spaces of alterity and exoticism, and hence of unregulated sexuality. From the Renaissance to the modern period the trope of 'the dark lady' occurs in European culture without being tied to particular geographies or specific ethnicities. It originates in Europe's colonial excursions that began in the sixteenth century, when a Christian theology that had split femininity between Madonna and Magdalen was rotated through the poles of distant lands, while always being a projection into which any woman could fall, irrespective of her own cultural location or social origin. The loaded metaphorics of light and darkness in both the Christian and the classical Western imaginary layered on to the incidental degree of melanin in the skin of peoples of southern lands the weight of an allegorical confrontation with cultural difference that carried an even heavier misogynist and sexualised freight.

In the 1860s Berthe Morisot's features were fashioned by Manet into his singular modernist *combination* of 'dark lady' *and* 'woman in white', for instance when Manet used the young bourgeois artist as a model in his huge 1869 Salon painting, his homage to Goya, *The Balcony* (Fig. 9.4). Berthe Morisot recounted to her sister in 1869: 'In *The Balcony* I am more *strange* than ugly. It seems that the epithet of *femme fatale* has been circulating among the sightseers.'[4] In both *The Balcony* and *Repose* (Fig. 9.2), painted less than a year later, the combination of the artist's striking features, dark eyes and dark hair with white dress posed a demanding artistic test for an artist so constantly intrigued by the question of unmediated contrast between the two ends of the tonal scale, black and white, that is, by the point at which tonality can be liberated to function as colour.

In *Repose* there is but one figure, almost reclining on a sofa in the middle distance in such a way that her extended leg seems to cut right across any suggested depth almost to reach the lower edge of the canvas with the tiny white-stockinged and black-slippered foot the spectator could almost touch. The posture was, however, hard to read. At an exhibition at the Salon of 1873, where the painting was badly received in general, one critic first assumed she was standing up and, when corrected, complained that it was 'Neither painted, nor drawn, neither standing up, nor sitting down',[5] while another wrote of 'a woman dressed in white *thrown* on a sofa'.[6] Beatrice Farwell has argued that the connotations of a woman reclining on a sofa, or divan – themselves objects from Middle Eastern or North African society – were explicitly sexual, citing Manet's paintings of two women already marked by the sexual codes of the 1860s: *Baudelaire's Mistress Reclining* of 1862 (Fig. 9.5) and *Young Woman Reclining in a Spanish Costume* of 1862, for which the model was the companion of the photographer Nadar (Fig. 9.6).[7] Both paintings are more or less contemporary with his major Salon paintings of this time, which also share their exploration of contemporary sexuality, *Luncheon on the Grass* (1862, Paris, Musée d'Orsay) and *Olympia* (Fig. 9.17). Beatrice Farwell suggests, therefore, that the pose, even if modelled by a bourgeois lady of impeccable 'respectability', coded as such by her fashionable white

Fig. 9.3 *Berthe Morisot, c.* 1867, photograph. Private Collection

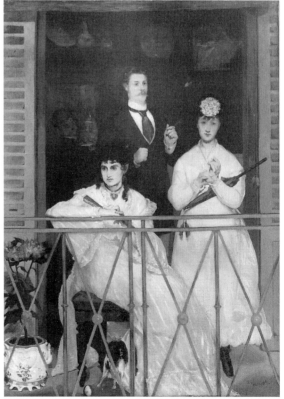

Fig. 9.4 Edouard Manet, *The Balcony*, 1868–9, oil on canvas, 169 × 125 cm. Paris, Musée d'Orsay

Fig. 9.5 Edouard Manet, *Baudelaire's Mistress Reclining*, 1862, oil on canvas, 90 × 113 cm. Budapest: Szépművészeti Museum

muslin day dress, acquires an element of 'impropriety' through the iconographic associations between the image of a woman lounging on a sofa and erotic imagery. The evidence of the critics' abuse of the painting at the Salon, where one critic called *Repose* an 'indecent and barbarous smear' and another used the explicit term 'slut', adds support to this interpretation.[8]

Farwell, however, writes, 'If this work has "none of the character of a portrait", and the features that make it so (the relaxed position, the air of reverie, the indirect gaze) relate it instead to the traditional representation of *Oriental* and erotic fantasy, then we confront the question of just how this kind of protocol and typology functioned in nineteenth century culture'[9] (my emphasis). This idea of an Orientalist connection embedded in an image of metropolitan bourgeois modernity strikes at the heart of canonical interpretations of Manet. Art historians carefully segregate Manet from the Orientalist *Salonnier* painters of the Second Empire, such as Gérôme (Fig. 9.25) despite the presence in his portfolio of the 1860s of a drawing later made into an etching entitled *Odalisque* (Paris, Musée d'Orsay), which may have been part of the early explorations that resulted in his Salon nude *Olympia*, and a full-length oil painting dated 1870 of a standing figure only just veiled in a semi-transparent white shift titled *The Sultana* (Fig. 9.7).

In *Repose* (Fig. 9.2) the figure, more opaquely clothed but with equally dark eyes, is, however, definitely seated on a piece of contemporary, upholstered furniture in a modern-day setting: it may even be Morisot's own studio.[10] Manet has established a distinctly modern, that is a bourgeois, *mise-en-scène* for an iconography that contemporaneously serviced Orientalising eroticism. The move – to invoke and undo – recurs in what might be considered this painting's antithesis, *Olympia* of 1863–5 (Fig. 9.17), where oppositions of dark and light, reclining and standing, clothed and undressed, labour and leisure, form the image's vacillating structure. But *Repose* evokes also, as a kind of reprise of that attempted modernisation of erotic images of the feminine, a reclining portrait of modern femininity – contemporary with *Olympia*, but titled *Au Divan*, and since known simply as *Baudelaire's Mistress Reclining* of 1862 – which has been assumed to be a portrait of a woman known as Jeanne Duval, who is known to art history only as a poet's sexual companion (Fig. 9.5).

Are these slippages – image to image, trope to trope – merely a function of my fantasy, allowed unlicensed free association in the museum of art history? Are they the kind of movement made possible by the critical reflexivity on issues of race, class and sexuality characteristic of contemporary feminist theory? They do, however, allow us to dismantle the fixed architecture of canonical discourse with its teleology of individual artistic development so as to permit a feminist intervention through the creation of its own perverse genealogies. They disrupt the stasis of ideology which imposes its authorising interpretations of the oeuvre of a modernist master. Finally, such interrogations of the archive provide access to a possible historical unconscious revealed through the patterns of repetition, return, repression and displacement.

I want to elaborate a narrative that might catch the tenuous, historical, yet also mythical threads that linked three women in one space in Paris in the 1860s. The time

Fig. 9.6 Edouard Manet, *Young Woman Reclining in a Spanish Costume*, 1862, oil on canvas, 94.7 × 113.7 cm. New Haven, Yale University Art Gallery (bequest of Stephen C. Clark)

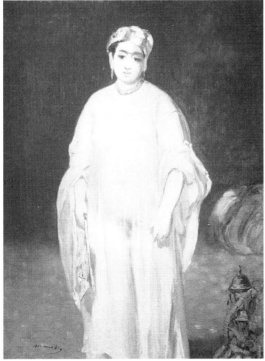

Fig. 9.7 Edouard Manet, *The Sultana*, 1871, oil on canvas, 95.5 × 74.5 cm. Zürich, Foundation E. G. Bührle

253

and place were the stage for the beginnings of canonical modernism. The threads that bind these three women lie on the surface of some paintings by one artist, Edouard Manet, who apparently painted them all. But their *relations* and thus their *differences* cannot be traced only in the painterly fictions of one canonical modernist artist from Paris. *Laure, Jeanne, Berthe* function as signifiers of the oeuvre that collectively creates the modern master, 'Manet'.[11] It is not just that women as artists, models or companions have been hidden from history, understudied or misrepresented. The complexities of the differences between femininities as they achieve visibility or disappear in representation are unacknowledged, as indeed are the structures – social and imaginary – which overdetermine their precarious place in representation.[12]

How shall I tell this tale of three women? Mieke Bal has advanced a theory of feminist reading that she calls 'hysterics', which asks: 'What kind of semiotic must we need apply in order to read the unsaid, to recover the repressed, and to interpret the distorting signs of that unspeakable experience? We need to account for the obliqueness of representations whose rhetoric aims at erasing women's experiences, yet which cannot entirely repress those experiences.'[13] Hysterics reads from the victim's perspective, calling upon 'visuality, imagination and identification'.[14]

My case study focuses on the relations between three women unevenly present, and repressed in whatever historical and social specificity they ever had, in the spaces of visual representation at the beginning of modernism. Art history becomes canonical not only by its construction of a canon, in which Edouard Manet is quite centrally placed, but by the canonisation of certain ways of seeing its materials and establishing authorised connections and networks. The social histories of art, feminist interventions and post-colonial theory applied to visual representation have already effected significant disruptions, one of which concerns the analysis of a genre of nineteenth-century painting now known as *Orientalism*. In mainstream art history *Orientalism* has been accommodated by a curatorial classification of paintings of Middle Eastern and North African subjects from Delacroix to Matisse that, from feminist and other quarters, have been subjected to a critical perspective framed by Edward Said's influential discourse analysis, in his book *Orientalism* (1978), of the governmental and imaginative troping of Islamic society by Western colonialism.[15] Detailed research has refined and even contested the crude outlines of Said's Foucauldian map at every level.[16] I shall merely add a feminist footnote in which I want to play with the tropes of *Orientalism* and a related, *Africanist* discourse, playing off their metaphoric evocation of relations between white and black, Europe and its others, against the problematic incision of both on the bodies and through the representations of classed and ethnically marked femininities.

As a feminist art historian I have loved to work on the rediscovery and restitution of artists such as Mary Cassatt and Berthe Morisot. But they are not simply *women* artists. They are *European* or *American* women artists. Moving slowly towards a reading of a painting not by any kind of woman artist, but which figures two *women* in a semantic relation that is premised on both difference and convergence through questions of class and race – namely *Olympia* (Fig. 9.17) by Edouard Manet – I want

to use anger at how art history taught me *not* to see 'in the dark' to rewrite an art historical 'love story' that fractures my feminist discourse with what I have before called 'trouble in the archives'.

Against Manet's painted fictions I imagine three historical persons: Berthe Morisot – easily established by conventional archives as a figure outside Manet's representations; Jeanne Duval (Berthe Lemer/Lemaire/Prosper), a radically unknowable figure who is, none the less, a major character in the archives around Manet's mentor, the poet Charles Baudelaire, with whom she was involved for almost twenty years; and a black woman named Laure: her Francophone name and African appearance are an index of European colonial exploitation of Africa.[17] Without a surname, however, it is hard to trace a civil subject whom one might research through censuses and postal directories. Laure promises not even the possibility of the kind of historical recovery which Eunice Lipton began to provide in her chronicle of her (re)search for the working-class woman who modelled for the white nude in Manet's *Olympia*, Victorine Meurend.[18]

But I am wrong. I have discovered that the name does indeed index a historically traceable civic identity. My research assistant, Nancy Proctor, and I have discovered a birth certificate for this name dated 19 April 1839 at 6 rue Hanôvre to parents unnamed. A baptismal certificate for 20 April 1839 provides names and addresses of godparents for the 'orphan' baptised Laure. Nancy Proctor also found confirmation of 'Laure' in an inscription in the rent registers for the fourth floor of the building at the Rue Vintimille, Paris 11, that is mentioned in Manet's notebooks for 1862.[19] We cannot be absolutely sure that this baptised orphan Laure and the woman working in Manet's studio in the Rue Guyot are one and the same. But the possibility is important. What would it do to our expectations of the painting to realise that a woman of African parentage was born in Paris and lived there all her life, bearing the Francophone name Laure, when perhaps most viewers imagine that this figure brings to the painting for which she modelled an otherness, an exoticism, a sexual freight, which this figure now may or may not support?

My evidence will be both visual – in the traditional art historical archive of paintings and drawings, and photographs – and verbal: the wealth of art historical and literary discourse generated by the canonisation of Edouard Manet and his poetic mentor and fellow dandy, Charles Baudelaire. By attending to a series of paintings by Manet, produced in marked relation to the poet Baudelaire and his theories of modernity and its melancholia, I want to offer a hysterical narrative that chases the links between the silenced icon of femininity across which their rivalry and relationship was signified: *Laure, Jeanne, Berthe*. Art historians stumble over the gulf that a canonically white and classed discourse maintains between the likes of *Berthe* and *Jeanne*. Beatrice Farwell calls the latter not only a *demi-mondaine* but a member of *le quart du monde*.[20] Yet the paintings themselves (Figs. 9.2, 9.5) formally establish a profound and significant continuity at the level of both a formal problem – black and white – and the imagery: reclining, clothed single female figure. These two paintings rhyme in a movement which both eroticises *Berthe* and lends the cloak of bourgeois femininity to

Jeanne. Why *Berthe* and *Jeanne* could co-exist in the same fictional, rhetorical space for the artist depends less, it seems, on the actual place of Berthe Morisot (1841–95) or Jeanne Duval (dates unknown) in the racialised hierarchies of sex and gender in France in the 1860–70s than on the instabilities of any woman's place in the fantasies of a metropolitan, masculine bourgeoisie. Yet Manet's paintings are more than mere repetitions of fantasies turned stereotype. Manet's modernism is the place where the tropes of the dark lady and the woman in white and its underlying Orientalist myth were worked over and through. The paintings suggest a struggle with and against the inherited field of erotic and 'respectable' representations. There is, none the less, a failure, or a contradiction, that leaves both paintings unresolved, though in different ways. While Manet could attempt to negate the trope of the dark lady in his imaginary portrait that, I shall argue, produced Jeanne Duval as an image of modernity, he succumbed to its thrall when he reworked that painting using a European, bourgeois model who allowed 'the dark lady' back into a displaced representation precisely because she, *Berthe*, was not 'black'.

Let me be clear. *Jeanne* was not 'black'. Any more than was *Laure* – the topic of the third part of my tale. It's a feminist commonplace nowadays that one of the two female figures in the painting that Manet called by only one name, *Olympia* has been grossly ignored by art history (Fig. 9.17). For the most part, the painting, produced between 1862 and 1863 and exhibited notoriously at the Paris Salon of 1865 (maybe with some retouching), has been treated as if only one of the female figures merited analysis.[21] One figure is nude. The unclothed reclining white female body is the site, as well as the permitted sight, of sexuality within the traditions of European art since the development of the erotic nude in Italian art of the sixteenth century.[22] The other woman, *Laure*, in the painting is clothed. And she is black.

'She is black' is not a description. It is a heavily encoded historical representation which says both more and less than it appears to. In a literal sense, blackness is not a colour. As a structure of racist inscription of difference (turned nowadays into the badge of resistance), 'blackness' rests upon what Frantz Fanon named 'the racial epidermal schema'. A 'corporeal schema' – an internalised image of and organisation of bodily sensations – is necessary for the emergent ego to be able to situate itself and develop relations with the external world of others. Racism interrupts and recasts this formation of subjectivity, negatively. Colonial culture does not positively mirror back the subject's body to itself as the basis for ego formation. Instead, it turns on to the racialised other a gaze in which s/he can only experience her/himself as *coloured* – as a thus negatively devalued *object* of a sovereign Other's refusal. Racist stereotypes are thus projected through a beam of blackening light directed at the colonialised subject who then perceives skin colour as the indelible mark and bodily sign of an internal otherness that becomes a self-alienation created in this subjection to the epistemic violence of racism: a racial epidermal schema.[23]

In his study of what he calls with careful deliberation *Africanist discourse*, Christopher Miller reminds us that, unlike white, black is not really a colour at all. It is its total absence. Whereas white is the effect of a luminous reflection of all spectral

colour, black is the absence of colour because it absorbs all rays. Colourwise, it is a nullity, a void. Metaphorically, however it is deeply caught up in Helleno-Christian metaphysics of darkness and light, so that any discourse collaborating with the terminologies of white/black will always say much more than its attempt to designate colour distinctions.

> Consider in passing the definition of black in French as that which 'does not reflect' (ne réfléchit pas), as the potential for a horrendous pun. 'Le noir ne réfléchit pas' means both 'Black does not reflect' and 'The black man does not think' . . . Africanist utterances, by hitching themselves to blackness and whiteness, become involved in polarizations and reversals.[24]

Blackness operates at the polar oppposite to whiteness, where whiteness is light, knowledge, civilisation, all that makes knowledge possible. Blackness becomes *blank darkness*, the unknowable time before civilisation, or a place which, if it has any civilisation at all, has it only as the result of the illuminating admixture of whiteness – the coming of Europe, the enlightenment of Christianity or modernity. Unlike Orientalist discourse, which at least identifies the Islamic world as a culture in order then to define it as spent and decayed, so that the West must master it, save and redirect it, Africanist discourse is shaped by the semiotics of a colour opposition which is utterly imbalanced. Whiteness is all possibility; blackness all nullity. And yet, the latter term, black, is necessary precisely to make meaning for the former, white, through the junction between a nothingness – blackness – and the beginning of meaning – whiteness/Europe/the West.

Thus the relations and differences provoked by attempting a 'hysterical' feminist reframing of three women involves both 'seeing in the dark' and 'seeing double'. A brief summary of the argument I shall be advancing may help the reader to examine the methodological as well as historical implications of this attempt to difference the canon. Firstly, in discussing *Olympia (Laure)*, I shall argue that Manet's specifically coloured use of two women of different ethnic origins worked to disturb both the Orientalist fantasy *and* the Africanist discourse in which women such as *Laure* were typically reconfigured in Western painting. He did this by enabling a woman of African descent to exist outside the rhetorical and semiotic positions of blackness within the genres and languages of painting he had inherited: the Orientalist canon. This intervention was, however, despite Manet, not able to secure the displacement of either Orientalist or Africanist frames, as paintings after Manet confirm in their reversion to the racist trope. As a result of the unfinished business of Manet's tactical semiotic failure, the figure of the servant in Manet's painting has since fallen beneath art historical notice, or been locked into Orientalist and Africanist stereotypes that art history willingly reconfirmed and which persist mythically into other forms of cultural representation.

Secondly, I shall propose that in the painting *Baudelaire's Mistress Reclining (Jeanne)*, the figure assumed to be Jeanne Duval is represented in direct opposition to

the demonised, exoticised, bestialised image produced by Baudelaire's contemporaries (and later repeated by his biographers), that is, she is painted as a figure of contemporary feminine *modernité/modernity*.[25] The realisation, however, of this equally de-Orientalising, de-Africanising representation is also flawed. Other texts will be needed to difference *Jeanne*'s place in the Baudelaire/Manet canon and give us, today's readers and viewers, relief in imagining an other history than that given so repetitiously and maliciously in the canonical literature.

Thirdly, I suggest that in *Repose* Manet in fact produced a subliminally Orientalist work, excising *Laure* and incorporating *Jeanne* in her specific hybridity as European and African. Eroticised, and yet veiled, by the romanticism of Baudelairean *modernité*, the features of *Berthe* [Morisot] positioned in a pose formally and iconically originating with the portrait/figure study of *Jeanne* [Duval] provoked a collapse of the binary terms which had structured *Olympia*, namely the 'nude' and the 'negress',[26] and the artist re-produced a modernised version of the 'dark lady'. Whiteness, displaced on to her dress, placed the fantasy in the contemporary present, while the dark and haunting features echoed those the artist had glimpsed in a photograph from which he painted an imaginary portrait of his poet friend's life-long passion and obsession, *Jeanne*.

To elaborate this tale of three women I shall start at its end.

BERTHE

Berthe Morisot's relationship with Edouard Manet remains the subject of speculation. It seems they met in 1860 or 1861 and there was already sufficient cordiality between the two families for the Morisots to attend the Manet soirées, where, possibly in 1864, Berthe Morisot played Wagner for the ailing Charles Baudelaire.[27] In 1868 Manet asked Berthe Morisot to pose for him, and, in the friendship that drew them extremely close over the next few years, Manet painted Berthe Morisot more often than any other model – eleven times.[28] When Edouard Manet died on 30 April 1883, a distraught Berthe Morisot replied to her sister's letter of sympathy:

> These last days were very painful . . . If you add to these almost physical emotions my old bonds of friendship with Edouard, an entire past of youth and work suddenly ending, you will understand that I am crushed . . . I shall never forget the days of my friendship and intimacy with him, when I sat for hours and when the charm of his mind kept me alert during those long hours.[29]

Manet's large painting of Berthe Morisot, *Repose* (Fig. 9.2), was badly received at the Salon of 1873.[30] It was lampooned as usual in the press, called 'dirty', 'slovenly' and 'in bad taste'.[31] It was also ridiculed in caricatures (Fig. 9.8) which rehearsed familiar tropes. Dirt is the coded means of signifying a dangerous sexuality, a slippage

Fig. 9.8 Caricatures of *Repose* at the Salon of 1873: Bertall, 'Revue Comique du Salon', *Illustration*, 24 May 1873; Cham, 'Le Salon pour Rire', *Charivari*, 23 May 1873; Cham, 'Promenande au Salon des Refusées', *Charivari*, 8 June 1873

from the careful respectability of its apparent bourgeois setting and subject. But what we see when we look at Cham's reprise is the blackening of the white lady, pushing her beyond the romantic *modernité* of the dark lady into a zone where blackness invokes the contaminating signs of class as race and race as class and where both are soiled by sexuality as well as by degrading labour. In the exaggerated simplicity of caricature, the face is a white shape punctuated with black blobs. It becomes almost a death's head.

Of *Repose* Françoise Cachin wrote in 1983 of Manet showing us 'a pensive, troubled young woman', subject to doubts and depressions. 'These doubts, the dark reveries, Manet expressed in the face, while in the pose, the dress, the coiffure he captured a mingling of high expectation and momentary dejection, of distinction and bohemian carelessness.[32] Nothing Cachin says seems inappropriate to the semantic possibilities of this image. Berthe Morisot was a complex personality, ravaged by depression and emotional suffering as a woman intellectual struggling with her creative ambition in a culture that structurally defined her femininity as the absence of both. She suffered many bereavements, one of which Manet marked in an extraordinarily vivid painting in 1874 after her father died, *Portrait of Berthe Morisot with Hat, Mourning* (Fig. 9.9), which Françoise Cachin names 'a portrait of extraordinary dramatic intensity that takes it almost to the brink of caricature'.[33] Here the boldness of Manet's paint places two dark saucers in a bleached face, hauntingly addressing the spectator from a field of black: hat, veil, gloved hand which almost punches into the face. Wild pain and shock register here in a visual language that draws its energy from the active handling of the paint, the unmediated laying of high contrasts of tone and brutal shadow. To anticipate myself, I want to raise a question: Why had it been possible to achieve this dramatic intensity with a face painted so swiftly yellow and black, and not introduce any such visual signs for 'human expression' in the so-called portrait of Jeanne Duval?

Berthe Morisot appears in Manet's oeuvre as both the white lady and the dark lady. Several images of her in black suggest that Manet loved the painterly challenge of

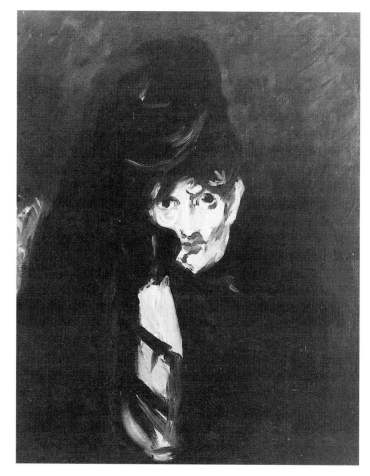

Fig. 9.9 Edouard Manet, *Berthe Morisot with Hat, Mourning*, 1874,
oil on canvas, 62 × 50 cm. Zürich, Private Collection

working with black as a colour.[34] Between light and dark lay the two faces of
modernity: its fashionable transience and its dark nights of the soul – its perpetual
mourning, as Baudelaire claimed in 1846.[35] Théodore de Banville, writing of the Salon
of 1873, called *Repose* an 'attractive portrait . . . that persuades through an intense
spirit of modernity – if I may be allowed that barbarous term, now indispensable.
Baudelaire was indeed right to esteem M. Manet's painting, for this patient sensitive
artist is perhaps the only one to echo the exquisite feeling for *la vie moderne* expressed
in *Les Fleurs du Mal*.'[36] Thus the white Morisot can become the site for articulating
the compelling confluence of Manet and Baudelaire. Manet's image of a dreamy
bourgeoise can become the very sign of this Baudelairean *ennui* and pain, the depres-
sive underside to modernity's frothy panache. In *Repose* this duality is played with
through the combination of detail and sketchiness. The face is painted in sallow tones
enlivened by warm pinks and framed by dark hair beneath which, a little vacantly,

dark brown eyes gaze mournfully into the middle distance. The painting displays the painter's competence and delicacy in matters of colour and touch. Barely marking the canvas, his brush can suggest the set of her mouth, the shape of the nostrils and the exact intensity of her reflective gaze. The overall posture and attitude of the body combined with this finely realized head makes the portrait invite references to melancholy and thus to the modern fascination with human subjectivity.[37] Writing in 1906, the Impressionist historian Théodore Duret confirmed the painting as a distillation of the Manet/Baudelaire representation of modernity through the conflation of woman, city and mood: 'The young woman with her melancholy face and dark eyes, her supple and slim body . . . gives the idealised representation of the modern woman, the French woman, *La Parisienne*.'[38]

But while *Repose* must take its place as one of eleven essays on Berthe Morisot in the oeuvre of Édouard Manet, its references to, and difference from, its specific prototype in Manet's earlier painting titled *Baudelaire's Mistress Reclining* (Fig. 9.5) need to be unearthed so that the former painting ceases to play an art historical role merely as a formal precedent for a more aesthetically realised statement, and may come before our examination as another moment of a complex articulation of subjectivity, colour, modernity and femininity in the Parisian studio of this 'father of modern art'.

JEANNE

In 1842 the twenty-one-year-old would-be poet and dandy Charles Baudelaire, accompanied by Félix Tournachon, alias Nadar, drunkenly went into the Théâtre du Panthéon in the Latin Quarter. In one of the mediocre plays which prefigured the later café-concerts of the Second Empire he saw a tall young actress. With the characteristic gallantry of the eighteenth-century courtesy which he affected, Baudelaire sent the actress a bouquet of flowers and graciously invited her to allow him to call at her pleasure.

When recounting this possibly mythic story of the beginning of Baudelaire's long relationship with Jeanne Duval that lasted almost all his adult life, Camille Mauclair is set dreaming about the bouquet that is sent to 'Olympia' in Manet's painting of that name, 1863–5 (Fig. 9.17).[39] Mauclair's daydream provides a link between *Laure* and *Jeanne* based in the mind of the author on the fact that both of them were supposedly women of colour. This sliding from Baudelaire to 'Olympia', erasing *Laure* on the way as Baudelaire takes on the role of flower-bearing 'gentle black messenger', is an emblem of the prostitutionalised status that the actress Baudelaire met in 1842 has in Western art and literary history. One of the main lines of interpretation of Manet in the 1860s is the correspondence between his images and the poetry and aesthetic posture of Baudelaire. The exchange between these modern men works across the body of another 'black' woman in Paris in the early 1860s, whom Gayatri Spivak designates an 'Afro-European'.[40] Her name was Jeanne Duval. Or was it?

Baudelaire scholars have also traced her under the alternative surnames of Lemer, Lemaire and Prosper. Some could be stage names, others those of her mother and father. Her mother's death certificate carries the name Lemer or Lemaire.[41] Claude Pichois in fact suggests that she was really called Berthe.[42] In 1859, when she was admitted to a workhouse hospital, a Jeanne Duval gave her age as thirty-two, providing a putative birth date of 1827.[43] Yet Nadar probably first encountered her as a young actress in a performance in 1838 so she must have been born about 1820.[44] No birth certificate has been traced in Nantes, the old slave-trading port from which her mother apparently came. No record of her death has been found.

Baudelairean comparisons with Manet's paintings in the early 1860s, the years of their close affiliation and friendship (they met in 1859), depend on being able to substitute one fictional woman for a historical one, and on making an African European whom Baudelaire loved and lived with on and off for nineteen years slip into the place of a fictive white Parisian prostitute from *Olympia*. Just as Jeanne Duval was erased from Courbet's *L'Atelier* (1852–5) but lingers to haunt us through the overpainting (Fig. 9.10), so, ironically, Baudelairean scholars use her to erase the gentle black messenger.[45]

Baudelaire did not marry Jeanne Duval, and never contemplated it. Jeanne was possibly the product of mixed parentage at some point in her history, and many such relationships were documented in France in the nineteenth century. The literary father-and-son pair of Alexandre Dumas were the progeny of African and European parentage, though Dumas *père* did not marry his son's mother.[46] The point is that such a marriage was not an impossibility in terms of 'race' in the mid-nineteenth century, except in the situation, which I think we face here, where race, class and gender conspire to position Jeanne as a *fille* and not a *femme*, a woman for sexual use but not family property. Technically Jeanne Duval remained what patriarchy would call Baudelaire's *mistress*. This term is inadequate to describe what was a long, complicated partnership, with several severances and reconciliations. Baudelaire could write to his mother in 1853, after Jeanne left him, a moment which he called the most shattering blow of his life, for they had been together for ten years: 'This woman was my sole amusement, my only pleasure, my only companion, and in spite of all inward shocks of a turbulent liaison the thought of a permanent separation had never clearly entered my mind . . . I have used and abused her; I have taken pleasure in torturing her, and now I have been torturing myself.'[47]

Their relationship resumed in 1855 and broke down in 1856 but they did live together again at Neuilly in 1860 when Baudelaire wrote: 'When one has lived for nineteen years with and for a woman, one always has something to say to her.'[48] They did not definitively separate until February 1861. When he began to fear his own death, Baudelaire requested that his mother would ensure that Jeanne Duval was cared for. Madame Aupick did not honour the request. Baudelaire's biographers agree that Jeanne Duval was one of the major experiences of his life, giving Baudelaire, perhaps through sexual gratification, and perhaps through other forms of companionship these scholars cannot imagine, access to an intensity of erotic and emotional experience out of which he wrote some of his most significant poetry.

In traditional terms this would make her again the silent muse – the beautiful or treacherous object that inspires the creative speech of the artist/man/lover. In modern feminist terms, that trope must be refuted because none of the assumptions that are made about how and why Jeanne Duval was so important to the creative work of Baudelaire depends upon anything that we can be sure concerns her. Both the poetry he produced and the way it is written is deeply encoded in a banal concoction of Western Orientalism and Africanist discourse. So much so that Christopher Miller's analysis of Baudelaire as an 'Africanist' dismisses any biographical reading of the so called 'Jeanne Duval cycle' of poems. Miller wants to create a distance between the poetic figures of black women in Baudelaire's writings and the historical character marked in the historical archive by the name Jeanne Duval.[49] Miller argues that the representation of an exotic, sensual and vicious woman is a trope of Western racism to which Baudelaire's modernist poetry gave renewed currency. Beyond that, the collapsing of a historical woman on to a poetic image makes 'her' – undecidable between real person and fictive image – the source of the blackness, hence the cause and origin of what Baudelaire's poem say about his sexual and raced other through the trope of colour.[50]

Moving from *Berthe* to *Jeanne* is to shift from the archivally recorded and historically corroborated identity of an artist entangled in a cultural trope to a figure whose historical co-ordinates did nothing but tighten the tropic noose around a vanishing – no, a 'disappeared' – black woman. The already unstable identity of Jeanne Duval's place in the modernist narrative has become even more precarious. Françoise Cachin writes that 'Jeanne Duval was not black, nor even mulatto, but simply a creole, and it was as a game that Baudelaire called her his Black Venus'.[51] The whole mythic structure around Jeanne Duval as the dark lady finally crumbles on the admission that it was a fiction of the poet's invention. The 'descriptions' of Jeanne Duval as a woman of colour become then a further evidence of the potency of the colonial trope of the dark lady, the collusion between the poet and his biographers in peddling the fantastic identity for this unfixable historical person whose name we cannot be sure of, whose origins and end we cannot discover, whose experience is as blank as the eyes Manet created for her.

After the 1983 Manet retrospective, Jean Adhémar disputed this painting's identification with Jeanne Duval completely.[52] For Adhémar, as for me, the dates don't work, and the logic of Manet painting such an image of Baudelaire's long-time partner in the early 1860s makes no sense. So Adhémar proposes that the title is right – *Maîtresse de Baudelaire*. The woman, however, who should bear that title has been misindentified. Instead the portrait has two candidates: Berthe or a woman called Adèle mentioned three times in the poet's notebooks and also named by Manet in a letter to Baudelaire: ' Je n'ai pas effacé *l'esquisse d'Adèle*'.[53] In 1994–5 Henri Loyrette maintains the radical doubt about the painting's link with Jeanne Duval but still dates it to 1863–4 and says it must be seen as a work akin to *Olympia* for certain structural reasons: the faded courtesan decked out in her finery, with eyes like shadowy pools.[54]

I suggest another tactic that attends to the historical effect and significance of the *fictions* of Jeanne Duval as one of the three women whose intersecting paths in the field

of modernist representation help to expose the Orientalist and Africanist structures within which the feminine is signified in this historically particular articulation of modernist patriarchal culture. As Christopher Miller suggested, none of this has anything to do with historical actuality in the first place and, in the second, relates not at all to whatever historical person may have once lived with Baudelaire or trod the boards under whatever name in Paris in the 1840s.

The title *Maîtresse de Baudelaire* is not the decodable sign of a promised identity – Berthe, Adèle or Jeanne; it is a space in the text of a masculinist modernist culture in which flourishes an Orientalising, Africanist fantasy that circulates between Baudelaire and Manet and on to their contemporaries and then their biographers and art historians in the twentieth century. Precisely because of this radical impossibility of knowing its sitter, the painting (Fig. 9.5), as I have located it within the circuit that passes through it to *Berthe* at one pole and *Laure* at the other, is part of the trope of the dark lady and the woman in white: where difference sexual and cultural made a modernist play.

So I am dealing with the fiction that the name 'Jeanne Duval' signifies in modern historiography, turning a feminist spotlight on the discourses in which 'she' is invoked. Yet this is not quite right. It does matter. Jeanne Duval – however ghostly a figure – was the support for these disfiguring fantasies and I must try, at least, for a hysterical reading, with no sense of the possibility of knowing any Jeanne Duval for sure. Against the assembled silencing and erasing of a woman I assert my feminist desire for some way to delineate her historical space and experience, even if that can occur only through a denunciation of the discourses which laid her, silent and ailing, on a couch.

What of the verbal and visual evidence? One image supposedly of our subject is visible only through the fading of the overpainting that blotted out the figure said to represent Baudelaire's companion in Gustave Courbet's *L'Atelier* (Fig. 9.10). Courbet's painting, completed in 1855, includes a portrait the artist had painted of the poet Baudelaire in 1847 – five years after Baudelaire's meeting with Jeanne Duval, according to Nadar. Behind the poet's head stands the figure identified as Jeanne Duval – a black woman in a painting whose central section prominently includes a European woman in the nude. Her erasure does suggest the continuing 'problem' of the presence of a 'black' woman in this attempted allegory of modern life: precisely the artistic, political and intellectual issue Manet would resume in his paintings of *Laure* and *Jeanne* in 1862. This recovered figure is of massive art historical significance because it provides us with yet another level of reference for Manet's *Olympia*: Courbet's conjunction of the white nude and the black woman – represented here in association with culture and art, and thus as other than mere 'stock character' (servant) or stereotype (odalisque). A certain violence inheres in painting her out, a gesture vicariously performed by the painter supposedly at the poet's request in 1855.

Baudelaire himself produced some drawings of Jeanne Duval that are not dated (Fig. 9.11). But Poulet-Massis dated one to 1858–60 and the other to 27 February 1865, on the basis of which Claude Pichois calls it 'un portrait-souvenir'. Do they constitute evidence for an appearance, and a bodily image with which to imagine a personality

Fig. 9.10 Detail of Gustave Courbet (1819–77), *The Artist's Studio*, 1855, oil on canvas, 359 × 598 cm. Paris, Musée du Louvre

– or was this yet one more of the translations to which this putative woman was subject?

Félix Tournachon, alias Nadar, friend and biographer of Baudelaire, met Jeanne Duval in the later 1830s and created this word 'portrait':

> In the consecrated costume of a parlour maid, the little white apron and the cap with flowing ribbons, a tall, too tall girl [*fille*] . . . is already something to surprise. But that was nothing; this oversized parlour maid was a negress, a real genuine negress, at least incontestably, a mulatto: the white powder you buy in packets would never manage to lighten the copper tones of the face, the neck, the hands. But the creature was none the less beautiful, of a special beauty about which Phidias would not enquire . . . Beneath the possessed proliferation of the curling swathes of her mane the colour of black ink, her

Fig. 9.11 Charles Baudelaire, *Jeanne Duval*, 1865, pen and
ink on paper, dimensions unknown. Photo: Claude Pichois

eyes, huge like soup bowls, were even blacker; the nose was delicate with
wings and nostrils sculpted with exquisite delicacy; an Egyptian mouth even
though from the Antilles ... All this serious, proud and even a little dis-
dainful. From the waist, the figure was tall, undulating like a grass snake, and
particularly remarkable for the exuberant, incomparable development of the
pectorals, and this exorbitance not without grace gave to the whole the tilting
allure of a branch that is weighed down with too much fruit. Nothing gauche,
and no trace of any give-away signs of a simian character that betrays and
pursues the blood of Ham to the end of generations.[55]

One of the originating texts of the myth of Jeanne Duval, Nadar's writing is heavy
with the freight of Africanist discourse, imagining for us a body that constantly eludes
its humanity, unrepresentable by the Greek artist Phidias, that is, unassimilable to the

Greek ideals of Western narcissism, that is obliged to borrow its parts from Eve's seducer, the snake, as well as from the tree of the knowledge of good and evil, i.e. sexuality itself, while its reference to an African identity comes via the cursed Biblical lineage of Ham, that slips outside a human frame.

Many writers were exercised by naming *Jeanne* racially. Théodore de Banville calls her a *'fille du couleur'* (1882), while in his *Lettres chimériques* (1885) he wrote that 'Jeanne was not black at all; she was in fact white'. He continues:

> Without doubt, she was a coloured girl; the creoles, who know about these things, confirmed this infallibly, by means of the pale white line on the nail which nothing effaces, and which is a disinctive sign; finally, she has the svelteness, the agile gestures, the indolent and seductive grace of those of mixed blood; but she was not glossy, neither like ebony nor black silk. The poet loved her for twenty years; he always loved her.[56]

Jeanne Duval is thus named in Baudelairean scholarship in contradictory ways. *Jeanne* has been called *négresse*, *mulâtresse*, *créole*. Nadar, to whom we owe the original story of Baudelaire's encounter, introduces her as *négresse*, but he quickly qualifies this to name her a *mulâtresse* before traversing her face and body with the pseudo-anthrolopological analytics of racialisation: a beauty that would not attract Phidias composed of Medusa-like coils of black hair, huge black eyes, full lips and breasts that threaten to overbalance a body like heavy fruits on an over-fertile tree. *Mulâtresse* is not a geographical term, but one that racialises, the word derives from the Spanish *mulato*, itself coming from their word for mule, a cross between a horse and a donkey. This signifies the notion of cross-breeding between species, and, every time such a word is used, it automatically inscribes a sense of hybridity on to a person, whose parents may have come from different parts of the world and different cultures, but who cannot by any stretch of any but the most racist imagination be considered of different species, like the horse and the donkey. To be called *créole* simply means being born in the colonies. None the less, the term registers the anxiety occasioned by contact with a non-European 'elsewhere'. It cannot but suggest transformation of the cultural point of origin – France – by transposition to the novel, colonial terrain and social relations of race that determine its specific character. Thus both European and African become *créole*, changed by their mutual co-existence, cultural exchange and conflict. The term is used of people of all backgrounds, but it always implies inherent or acquired alterity from Europe.

Jeanne Duval figures not as the field of 'blank darkness' of the full Africanist sign but as a hybridity that constantly aggravates. She cannot be fixed or firmly placed 'elsewhere' yet these writers want her somehow to embody the sensuous, living sign of an exotic alterity. In this we can trace the unconscious drag of the colonially created and desired trope of the dark lady that Cleo McNelly has shown runs through Western discourse from the Renaissance to contemporary social anthropology. The white woman, at home, mother, daughter, wife, is a sign of fixity, containment and

the timeless 'home' for the Western masculine Self. By contrast McNelly argues that the dark lady is 'sexual, savage and eternally other'. Yet she is also internally divided. At her best, she is 'natural woman': sensuous, dignified and fruitful, a benign fantasy of generous and exuberant Nature in contrast to disciplined formalities of white Culture signified by the 'white lady' – the lady in white – at home. At her worst, the dark lady is, however, a 'witch representing loss of self, loss of consciousness and loss of meaning'.[57] One of the most compelling and racist versions of this theme postdates Baudelaire. It occurs in Joseph Conrad's 1902 novel *Heart of Darkness*, where the author imagines the African companion of the 'creolised', gone native trader, Kurtz, thus:

> ...along the lighted shore moved a wild and gorgeous apparition of a woman. She walked with measured steps, draped in striped and fringed cloths, treading the earth proudly, with a slight jingle and flash of barbarous ornaments ... She was savage and superb, wild-eyed and magnificent ... Her face had a tragic and fierce aspect of wild sorrow and of dumb pain mingled with the fear of some struggling, half-shaped resolve ... She turned slowly away, walked on, following the bank, and passed into the bushes on the left. Once only her eyes gleamed back at us in the dusk of the thickets.[58]

In his incisive critique of this passage in Conrad's imperialist novel, Chinua Achebe insists on the contrast between the 'bestowal of human expression on the one [the white lady] and the withholding it from the other [the black woman]'. In Conrad's novel the fiancée awaiting Kurtz's return is represented with a delicacy of emotion and sensibility utterly denied to this fantastic, almost inhuman being. The dark lady has no language and even her proud carriage is represented only in terms of a magnificent but wild beast. The theme of animalisation is never far away.[59]

Baudelaire's friend and fellow poet Théodore de Banville – who so praised the *modernité* of *Repose* – gives this 'description' of Jeanne Duval: 'A young woman of colour, very tall, who carried her brown head, proud and ingenuous, with dignity. Her head was crowned with extremely tightly curled hair. Her carriage was regal, full of savage grace, and it had something of the divine and the bestial.'[60] Here is another comment by Prarond: 'Here ... my portrait of Jeanne, mulatress, not very black, not very beautiful, frizzy black hair, quite flat-chested [compare Nadar's opposite description of a full-busted woman], quite tall, walking badly.' And another by Jules Buisson: 'She had brilliant eyes, a yellow and dull complexion, red lips, abundant hair waving right to its frizzy end. I find her type in a head that comes to me often from the etchings of Tiepolo.' And by Reynold: 'A magnificent mass of hair was the unique beauty of this stupid and perverse animal.' Mauclair says that Baudelaire's drawings of Jeanne (Fig. 9.11) give

> the impression of a passionate bestial force ... Black eyes ... dark shadowy hair, unkempt, frizzy, a real mane: her nose was almost straight, thick lips,

fleshy, lewd; her breasts firm and upright on a thin chest, a fine and supple waist contrasting with copiously curving thighs. The true body of a vicious and insatiable prostitute, an animal of luxury having known all, dared all, surmounted with an indolent and deceitful face. Wit? None. Heart? None. *Voilà* the creature that captured the poet dandy.[61]

Finally Reynold again: 'She was to remain until the end the vampire of his existence. His vampire she was materially and morally'.[62]

In this literature, a woman of possibly mixed descent – the contemporary post-colonial critic Gayatri Spivak names Jeanne Duval an Afro-European – is represented mythically in all the cruel complacency of unquestioned racism combined with and articulated by a virulent misogyny. Her imagined blackness precariously projected on to her through the incantation of the racist terminologies is as much about sexuality as it is about geography or origin. We have no way of knowing what she was like – nor would it be for us to judge if we did – but there must be some means to distance ourselves from what passes for knowledge. We must name the tropes and, if we are white and European, we might hang our heads in shame for this is the language of our high culture which has coloured, bestialised, stupefied and hated Jeanne Duval, aligning her with the key images of night and of death, hence of imaginary blackness: the prostitute and the vampire. The image of the vampire contains the notion of a woman feeding off a man's blood[63] while another trope, sexual enslavement, also used in talking of Baudelaire's passion for Jeanne Duval, inverts the historical atrocity of slavery that may have been part of Jeanne Duval's family history.

In his moderate account of Manet's *Olympia*, Theodore Reff brings all this into the heart of modernist art history.

> Baudelaire had a source of inspiration closer to home, the mulatto woman Jeanne Duval, who was his *mistress and evil genius* for many years and the subject of a cycle of poems devoted to 'la Vénus noire' . . . It is perhaps significant for the visual and social contrast between the two women in *Olympia*, and for its origins in a picture of Venus, that the other major cycle of love poems in *Les Fleurs du Mal* is devoted to 'la Vénus blanche', the famous courtesan Apollonie Sabatier, who was also briefly his mistress but mainly his *intimate friend and muse* . . . It was Jeanne Duval to whom he was most *fatally* drawn . . . whom Manet had portrayed at his request, reclining on a sofa in a manner like Olympia's, the year before the latter was painted. Here . . . the recumbent *femme fatale* and her black servant were combined in a single figure. In that role the negress merely made explicit what was already implied in her subordinate role, a sensuality whose exoticism subtly reinforced that of the image as a whole.[64] [my emphases]

269

Black Venus

'Black Venus' is the title of a feminist short story by the late Angela Carter which offers its own counter-portrait of *Jeanne*. Three elements of the story are significant here. Angela Carter writes a narrative from the point of view of Jeanne Duval. Seeing through the verbally evoked imaginary scene, she makes the silence of the woman a sign that can be read; she imagines a discourse and an experience for the woman; she identifies with her against the phallic patriarchal norm of exchanges between men over the silenced and erased body of woman.

> The custard apple of her stinking Eden she, this forlorn Eve, bit – and was all at once transported here, as in a dream; and yet she is a *tabula rasa*, still. She never experienced her experience *as* experience, life never added to the sum of her knowledge; rather subtracted from it. If you start with nothing, they'll take even that away from you. The Good Book says so.
>
> Indeed, I think she never bothered to bite any apple at all. She wouldn't have known what knowledge was *for*, would she? She was neither in a state of innocence nor a state of grace. I will tell you what Jeanne was like.
>
> *She was like a piano in a country where everyone has had their hands cut off.*[65]

Read in the aftermath of Jane Campion's film *The Piano* (1993), this final image is shocking. It is an image of the displaced person who is forced to live in a place where nothing about her adds up to provide the mirror in which an identity can be lived, expanded, experienced and transformed. Like the instrument from which sound as beauty – music – might be culled, she is stranded with no other who can elicit the sound of her being, the scales of her emotions, the drama of her imagination, the rhythm of her history.

Thus Angela Carter tracks Jeanne Duval alias Prosper or Lemer, born either Mauritius, San Domingo, possibly Martinique, even Nantes, through her mismatched cohabitation with an exquisite but sexually troubled poet whose main gift to her was his syphilis. Angela Carter comments that 'it is essential to their connection' that while she puts on 'the private garments of nudity' he must retain his public dress: 'There's more to *Le Déjeuner sur l'Herbe* than meets the eye (Manet another friend of his). Man does and is dressed so to do. Woman is; and is therefore, fully dressed in no clothes at all, her skin is common property.'[66]

The third element I want to draw in here is Angela Carter's 'repetition with a displacement' of the legendary but unknown end of Jeanne Duval.[67] But there is no information on where and when she died. Jeanne Duval ends thus in Enid Starkie's biography of Baudelaire: 'Nadar is said to be the last person to have seen her in the distance, in 1870, dragging herself painfully along on a pair of crutches.[68] This is Angela Carter's version: 'Nadar says he saw Jeanne hobbling on crutches along the

Fig. 9.12 Photograph of workers at the Maison at 2 rue du Londres, *c.* 1900. This image serves to suggest that women of African descent were employed and advertised as one of the attractions of contemporary brothels. Paris, Private Collection

pavement to the dram-shop; her teeth were gone, she had a *mammy-rag* tied round her head but you could still see that her teeth had fallen out. Her face would terrify the little children. He did not stop to speak to her.'[69] Angela Carter, however, does not proceed to kill her off. She imagines life after Baudelaire, picturing *Jeanne* on board ship for Martinique with false teeth and a wig and a brother who had turned up in Paris in 1861. 'In a new black dress of black tussore, her somewhat ravaged but carefully repaired face partially concealed by a flattering veil, she chugged away from Europe on a steamer bound for the Caribbean like a respectable widow and she was not yet fifty after all.'[70] Brother and sister buy some property and then Carter's slip occurs, part of a poetic turn. Madame Duval becomes a *madam*. The prostitutional image cannot be held at bay. She continues to dispense – here is the feminist irony – 'to the most privileged of the colonial administration, at a not excessive price, the veritable, the authentic, the true Baudelairean syphilis'.[71]

So, even here, *Jeanne* is conflated with the prostitutional; inescapably we slide back to the companion painting Manet's portrait of her had condensed: *Olympia. Jeanne* is imaginatively reconfirmed as the exotic but venal sign of sexuality, a sex worker like the one in the casual photograph of a Paris brothel (Fig. 9.12).

A portrait?

Jeanne Duval is said to appear in two works by Manet, both dated to 1862 (Figs 9.5, 9.13), the period in which the artist first encountered *Laure* and when he was painting her portrait (Fig. 9.15) and using her as a model for the painting *Olympia* (Fig. 9.17).[72] The stretcher bears – in what is taken by the Manet archivist Tabarant to be Manet's hand, but his widow's by the dissenting Adhémar – the inscription *Maîtresse de Baudelaire Couchée*, although Tabarant consistently titles the painting *Portrait of Jeanne Duval*, based on an identification given by the artist's widow.[73] Tabarant describes it: 'Jeanne is dressed all in white, seated, legs extended, on the right of a sort of sopha. Her head extends beyond its back rest. A creole face [*visage de créole*], dry, hard, where the eyes become dark caverns of blackness, she is bareheaded, the straight locks of her hair hang on each side on her shoulders.'[74] Tabarant insists on the 1862 dating, and so the painting must have been in the studio at the same time as *Olympia* was being developed. Yet there could not be a greater distance between *Laure* as she appears in the fictive space of a downmarket courtesan's bedroom and *Jeanne* as she is represented in Manet's 'portraits'. One is part of the the Orientalist *mythos* even as she is used to negate it; the other belongs in a series of Manet paintings that I can label only his 'women in white'.[75] These are mostly scenes of intimate spaces, domestic spaces, featuring women of Manet's own class and social circle. Everything in the painting places it simply as the initiating work of this succession showing Manet's fascination with the *modernité* of 'women in white' in which wives and friends are the models. The woman in this painting has a muslin day dress in the crinoline fashion of the time. At her neck she wears a crucifix and a bracelet, and she holds a fan. In this work we have a portrait of a contemporary French Catholic woman.

On the biographical axis, however, the existence of the painting *Baudelaire's Mistress* and its watercolour study are frankly puzzling. Jeanne Duval and Baudelaire had separated in February 1861, and they never met again apart from one brief visit by Jeanne to Baudelaire in March that year, when, according to Enid Starkie, 'she dragged herself, feebly to him, to obtain help, for she only just left hospital, the workhouse hospital, since there had been no money after he had left'.[76] Starkie completes her story of Jeanne Duval at this point with the following résumé:

> She was back once more in Baudelaire's life; but there was nothing more to hope from her; drugs, drink, illness, paralysis, had wrought destruction on her mind and body; she cared little to what depths of baseness she sank to obtain money to gratify her cravings. She felt a certain warmth towards Baudelaire and a pricking of conscience when he was near, but drugs and drink played such havoc even with the best of feelings that she forgot all decency when she needed money.[77]

The constant refrain in texts of this period on Jeanne Duval, therefore, is that she was a prematurely aged, infirm and disabled woman who more or less dropped out of Baudelaire's life at this point.

Is the painting evidence to the contrary? Is it possible or even probable that she would have been in Manet's studio in 1862 or even 1864? Why did Manet plan and execute this painting at this date? Is the dating wrong? Did Jeanne Duval model for Manet independently of Baudelaire's contact with Manet? Was she another 'black woman' to study in addition to *Laure*? Or does the painting of a modern French woman with crucifx at her neck suggest that she did not figure for Manet as 'the dark lady'? Is there a difference between 'the dark lady' and the *black* woman, the 'negress'? None of these questions is attended to in the art historical literature. Instead we have this kind of commentary – by Françoise Cachin, who so admired *Repose* – on a painting that is known from its studio labelling in 1884 as *Baudelaire's Mistress*.

> The portrait is a strange one; here, the accusation of ugliness flung at Manet's models by contemporaries, so surprising to us today when it describes such women as Victorine Meurend or Berthe Morisot, is for once justified. The image is terribly revealing, and one can imagine Baudelaire's reaction to this devastating record of a face once passionately loved, now sickly, hardened and embittered.[78]

Mythicised biographical information is read into the painting as a way to account for how the painting looks. Is Françoise Cachin justified in seeing this painting as a record of a face, as a revealing image? Let me quote a few more responses to a painting that Manet possibly saw fit to exhibit in 1865 at the Galérie Martinet but never to display in his studio. Cachin cites Jacques-Emile Blanche in 1924: 'the masterpiece dropped out of sight . . . a mask, strange and exotic, and "fateful", a body emaciated, lost in the folds of a vast billowing skirt of *cafe au lait*'.[79] Félix Fénéon saw the painting exhibited at the gallery of *La Revue Indépendante* in 1888 and wrote:

> Ennobled with strangeness and with memories, another canvas shows the fabled mistress of Baudelaire, the wayward and dolorous *créole* Jeanne Duval. Before a window curtained in floating white, she lounges like an idol, like a doll. Baudelaire's verses offer us a good likeness:
>> Good fun, and love, and all good cheer
>> Bubble in thee, old cauldron; yes,
>> Thou'rt no more young, my very dear,
>> Thou'rt no more young, and none the less,
>> Thy caravans by madness borne
>> Have given thee that lustrousness
>> Of things that have been too much worn
>> And are beguiling none the less.
> The flat, swarthy visage abjures all emotion, and to either side swirls the implausible immensity of a summer dress with broad violet and white stripes.[80]

In the knowledge of the identity of the sitter, the figure in the painting is 'blackened' by writers who call upon the trope of the dark lady. She is the idol and the doll, without emotion, her face a mask, exotic and fateful. This all adds up, in Cachin's utter confidence in calling the portrait 'ugly'.

The painting

It is true that the pose is casual and intimate and that such a relaxed position could be associated with erotic imagery. As we have seen in the case of *Repose*, reclining on a sofa immediately evoked Orientalist overtones. But what we have is a Goyaesque reworking of the odalisque through the format of the portrait to transform both and shift their potentiality in the direction of a specific *modernité*. Colliding opposing tropes on one canvas invites each to kill the other – the strategy that Manet was consistently exploring in the early 1860s, taking on the conventions of Western painting, one by one, to create a critical space for the modern as a tactic of formal desolation: 'differencing'. But what sets this painting apart from Manet's essays in the nude, the Orientalist scene, the portrait and so forth is what appears to be an uncharacteristic failure in the painting of the face and especially the eyes; the eyes that Nadar said were huge like soup bowls.

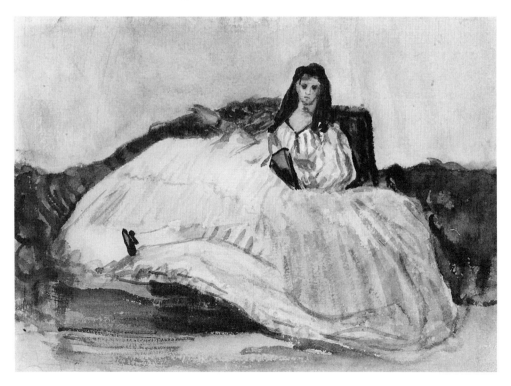

Fig. 9.13 Edouard Manet, *Baudelaire's Mistress Reclining*, 1862, watercolour, 16.7 × 23.8 cm. Bremen, Kunsthalle

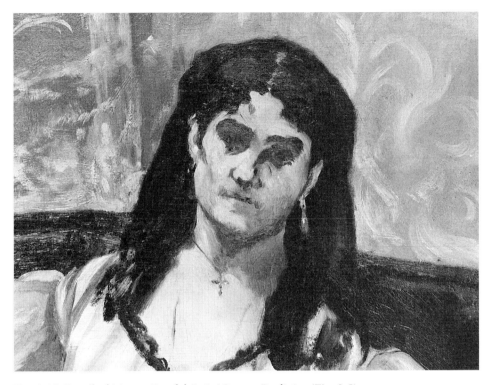

Fig. 9.14 Detail of Manet, *Baudelaire's Mistress Reclining* (Fig. 9.5)

The painting (Fig. 9.5) and even more so the watercolour (Fig. 9.13) are odd. Firstly the woman's head is remarkably small in proportion to her whole body. This disproportion, more marked in the watercolour, may be the effect of the mass of the crinoline, and seems all the more disturbing compared to the size of the hand resting on the couch's backrest. The mouth is a tiny thin line. The face is dominated by the two black holes (Fig. 9.14) where the eyes should be. In a sense, what we encounter here is the painterly equivalent of 'blank darkness'. Careful examination of the painting reveals that the painter has indicated the eyes themselves within these black patches. These eyes – the seat of the personality, what Baudelaire, writing on the portrait in true romantic spirit, would call the window to the soul, the place where human expression is indexically represented – these are indeterminate. Manet the painter is the master of the touch. He was good at eyes. Here is an aberration.

Contrast the face of the sitter in *Young Woman Reclining in a Spanish Costume* of *c.* 1862 (Fig. 9.6). Abbreviated and sure, the painted touch creates a striking expression and characterful portrait with economy and sureness. The eyes are dashes of black paint, but painted so that the trail of the brushstroke will evoke the lashes and the lid. This kind of Halsian touch is, however, unusual for Manet at this date, because the eyes are so important for Manet. It is their size and effect that provides Manet's work with some of its most arresting power. Think of the stare of the European woman in

Olympia and *Le Déjeuner sur l'Herbe*, and the importance of the gaze and its signifiers, the eyes, are clearly a feature of 'Manet' the author. Manet could paint eyes exceptionally well and did paint them as a key element in what we take to be the 'Manet' of the early 1860s. In this painting he funked it. Why indeterminacy now, why such inattention, why could this face not find a painterly equivalent to the person who modelled for it, or to the fantasy the artist's friend had projected on to it?

I suspect that Jeanne Duval was never in the studio and that this is not a portrait. The whole set-up is oddly inconsistent and tentative. Manet is so bold in his setting of figures in space, in using the Velázquezian grey to show up the solidity of his figures. The thing she sits on is indeterminate: what shape is it? What are her feet on? Why does she cling to the backrest? Contrast the generality here with the detailing of upholstery and structure down to the casters of the chaise longue on which the woman reclines in *Young Woman Reclining* (Fig. 9.6). Why does the curtain with its awful lacy decorations billow thus and where it is? Why the wind? Is the fancifulness of the details a result of the untoward experiment of Manet inventing a painting based perhaps on a glimpse of Madame Duval in Neuilly in 1861? Or did the only evidence he had to hand come from a tiny smudged *carte-de-visite* photograph left him by the failing syphilitic poet with a request for a portrait? Could that explain the deep shadowing around the eyes – evoked in the early photograph of Berthe Morisot (Fig. 9.3) – that he could then never paint? We cannot be sure. But the facts as we have them and art history has accepted them do not stand up.

The irony is that all that was being attempted in this painting of a woman in white, signifying aspects of modernity in costume, pose and attitude, found a complete resolution only when Manet came to paint his friend and fellow artist the *European* bourgeoise Berthe Morisot, in *Repose* (Fig. 9.2). When we confront the painting *Baudelaire's Mistress* (Fig. 9.5) after a series of images of *Berthe*, it is impossible not to ask why the supposed painting of *Jeanne* is so bereft of all these complex evocations of subjectivity and affective modernity? Why not picture thus she who lived with Baudelaire for nineteen years and was, like him, marked by those definitively modern afflictions – their shared syphilis which eventually disabled her and killed him? the common experiences on hashish and opium? their drinking? Why are these the signs of Baudelaire's suffering genius and agonistic basis of a distinctly modern creativity when they are only the symptoms of her endemic baseness and hereditary degradation?

The texts of twentieth-century art history and literary biography I have had to read are as crude as any of the eighteenth- and nineteenth-century discourses which assumed that skin colour naturally makes one susceptible to sexual and alcoholic excess. Jeanne Duval suffered, as Fanon did, from what he named at the height of French colonial conflict in the 1950s 'the racial epidermal schema'. This made her skin with its slight residue of melanin more than the boundary between inside and outside, a surface only. Instead it became the dense locus of the only personality she would be allowed to have: witch, vampire, doll, idol, beast. That is to say none at all that is considered human.

This portrait, seen in both conjunction and total contrast with that of *Repose* – *Berthe* – Manet's final take on the subject, makes the point that, in that guise, *Jeanne* is not other at all, and yet, in that telling moment of artistic inability which are her pitted eyes, she is thrown from her historical hybridity – her creative combination of the terrible collision of African and Europe – back into the worst excesses of Africanist discourse: blank darkness. At that point colour as pigment – black and white, which was Manet's tool and part of his artistic project – compounded the mythic binary where blackness becomes the place of nullity, void, uninscribed and uninscribable.

LAURE

If *Jeanne* was never actually in Manet's studio on the Rue Guyot in 1862, a woman named *Laure* came to sit for a portrait study (Fig. 9.15). She was sketched in an early essay for another scene of modernity (Fig. 9.16) and modelled for a major Salon canvas (Fig. 9.17). If representations of *Jeanne* and *Berthe* evoke the problematic of race through a subliminal Orientalism, those of *Laure* are radically different because 'she' becomes a site and sign for a de-Orientalising and anti-Africanist project that was momentarily possible around 1862. The tactic was sustained neither in Manet's subsequent work, as I have already argued, nor in the *Salonnier* and modernist Orientalism that took renewed inspiration from a misreading of Manet's major painting of 1863–5.

Achille Tabarant, the Manet archivist, cites Edouard Manet's 1862 *carnet* (note-book) where the French artist had noted: 'Laure, très belle négresse, Rue Vintimille 11, au 3e'.[81] Tabarant adds: 'This address, could one not think that it was Baudelaire who pointed her out?/who gave it?' In Tabarant's mind *Jeanne* inevitably leads to *Laure*, 'belle négresse'. 'Négresse' refers to a social category in European history which appears merely to be a physical observation. *Nègre*, *négresse* in the feminine, is not actually *noir* in French, that is, black, but derives from the Portuguese word for black, *negro*. A distinction based on the political metaphysics of colour is veiled in the obscurity of a foreign language but it, none the less, preserves, linguistically, a historical genealogy of European colonisation and race relations. Research into the use of the word *nègre* in French dictionaries and encyclopedias of the eighteenth and nineteenth centuries reveals that the word fundamentally functioned as a synonym for slave, and, while arguments raged over the environmental or racial causes of differ-ences between Europeans and Africans, the term kept in place a profound disjuncture between those thus designated and their humanity.[82] To call *Laure* a *négresse*, as does Zola as well in his famous commentary, is to locate her in the place of the slave – a coincidence made explicit in Zacharie Astruc's sub-Baudelairean and therefore Africanist, or ironic Orientalist, poetry with which *Olympia* was framed when exhibited at the Salon in 1865.

The adjective 'beautiful' – *belle négresse* – calls to mind the presence of another beautiful black woman within the biblical canon. In the *Song of Songs* which is part of

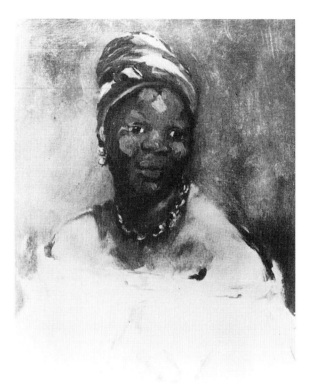

Fig. 9.15 Edouard Manet, *Portrait of Laure*, *c.* 1863, oil on canvas, 59 × 49 cm. Private Collection

Fig. 9.16 Edouard Manet, *Children in the Tuileries Gardens*, 1862, oil on canvas, 38 × 46 cm. Providence, Rhode Island School of Design Museum (museum appropriation)

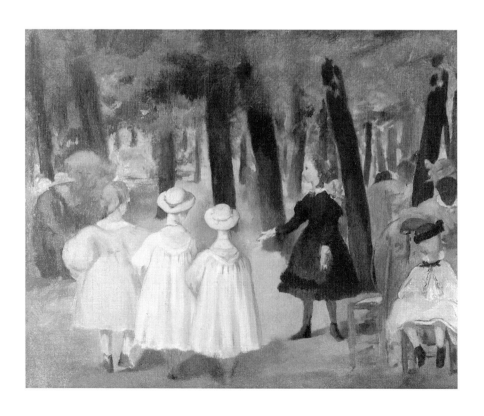

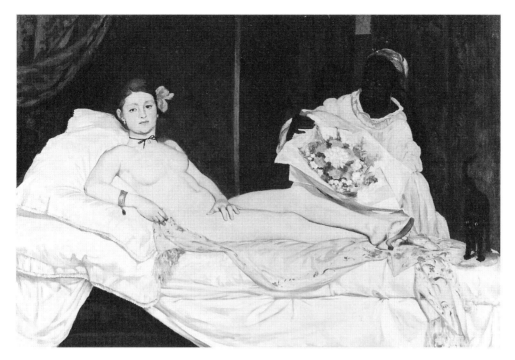

Fig. 9.17 Edouard Manet, *Olympia*, 1863–5, oil on canvas, 130.5 × 190 cm. Paris, Musée d'Orsay

both Hebrew and Christian bibles, occurs this much-disputed line: 'I am beautiful [. . .] black.' In that gap different translations place either *and* or *but*. The Vulgate Latin Bible of the Catholic Church and the King James English Bible of the Anglican Protestant Church favour '*but* black', both of them being embedded in a theology of colour based on the blackness of sin and illuminating whiteness of Christian salvation which will make the sinner 'white as snow'. Even in the combinatory literal translation of the Hebrew as 'black *and* beautiful' there lies a potential split, for the conjunction implies that its two sides are not, of themselves, synonymous.[83] The two qualities are listed side by side, added to each other not necessarily as a natural association.[84]

Sliding down the threads linking the deeply embedded mythic coherence that traverses both formal and popular culture, early bourgeois colonialism and our contemporary world, I dare to make a startling visual juxtaposition with a still from Douglas Sirk's film: *Imitation of Life* (1959), which formally reverses the terms of *Olympia* that it echoes, while also critically disturbing the erasure of black feminine subjectivity (Fig. 9.18). In *Imitation of Life* two women, each widowed with a child, a black woman, Annie Johnson (Juanita Moore), and a white woman, Lora Meredith (Lana Turner), meet when they are both without jobs and resources.[85] Lora offers Annie a home while she tries to get her break into acting. She does, becoming a major Broadway star. Annie remains her maid and housekeeper. In this scene Annie is

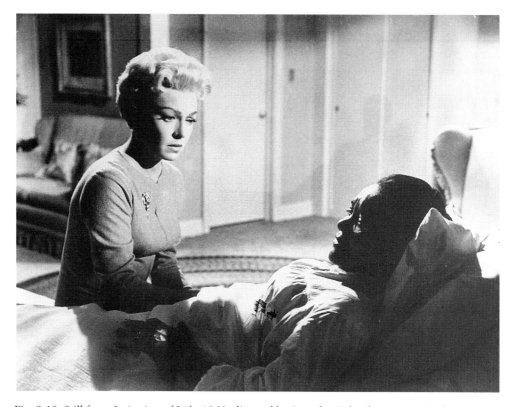

Fig. 9.18 Still from *Imitation of Life*, 1959, directed by Douglas Sirk. Photo: British Film Institute

dying. Asking Lora to read her instructions for the funeral she has planned for herself, she mentions various people Lora must contact. Lora is shocked that Annie has friends – a life beyond Lora's space at whose edges the black servant takes her necessary but almost invisible place – and the critical moment of the film is when it presents Annie's funeral in a black community, where the world of Annie's faith, social life and cultural identity was sustained, while it remained unimagined by the white woman who reshaped their common experience as women into the hierarchy where race was class. The film's closing scene retrospectively comments with biting irony on the way the white world incorporates and erases a black woman's unique subjectivity. In the same move Annie Johnson becomes the representative of all that black femininity is allowed to be in white culture: a servant. As the generic type, the loving black maid, she is denied the complexity of character and the signs of individuality which are articulated so dramatically in the film through the ambition of Lora to make her own mark in the world as a creative performer. At her death Annie upstages Lora for a moment to reveal the network of communal relations and spiritually enriched cultural forms that secured her humanity and social identity in constant opposition to a blind and indifferent white society's ignorant perception of her only in its service.[86]

All that supports the biographical subject in our culture is absent in the archive in which *Laure* is momentarily recorded in a painting and a notebook, and some rent registers. I must then ask: Does the painting collude with what Frantz Fanon called a 'spattering of black blood', the colouring of a subject which erases the person, or are there any signs in the painting that might allow the figure for which a young woman named 'Laure' modelled to signify other than blank darkness, servitude or the sexual stereotyping of exotic sexualities?[87] Is the painting critical in relation to the ideological resources which came to it burdened with the long history and complex semiotics of Western racism?

The painting

Negra sum sed beata.[*]

Issues of blackness and beauty are central to reading this painting. Painting manipulates coloured pigments. Colour will both relate to the rhetoric of colour and deconstruct it in a kind of banal literalism of painting's necessary materials. How the two match and mismatch is the subject of this section.

Current analyses of the painting *Olympia* (Fig. 9.17) by Manet have turned against one of the almost contemporary texts published in January 1867 in its defence by the novelist Emile Zola.[88] Zola dismissed the outcry against the painting's notorious subject, the apparent shameless display of modern commercial sexuality in a parody of the ideals of high art, by stressing the painting's primarily formal concerns.[89] Zola was in fact inventing for painting a version of his own naturalist aesthetic: 'The artist has worked in the same manner as Nature' he writes in the midst of the following passage on Manet:

> I say 'masterpiece' and I don't retract the word. I maintain that this painting is the veritable flesh and blood of the painter . . . Here we have one of those 'penny-plain, twopence-coloured' pictures as the professional humorists say. Olympia, lying on white linen sheets, appears as a large pale mass against a black background. In this black background is seen the head of a negress carrying a bouquet of flowers, and that famous cat which so diverted the public. At first sight one is aware of only two tones in the picture – *two violently contrasting tones*. Moreover, all the details have disappeared . . . Accuracy of vision and simplicity of handling have achieved this miracle. The artist has worked in the same manner as Nature, in large, lightly coloured masses, in large areas of light, and his work has the slightly crude and austere look of Nature itself . . . Some people tried to find a philosophic meaning in the picture, others, more light-hearted, were not displeased to attach an obscene significance to it. Ho there! proclaim out loud to them, *cher Maître* [sic] that you are not at all what they imagine, and a picture for you is simply an excuse for an exercise in analysis. You needed a *nude* woman and you

chose Olympia, the first-comer. You needed some clear and luminous patches of colour, so you added a bouquet of flowers; you found it necessary to have some dark patches so you placed in a corner *a Negress and a cat*. What does all this amount to – you scarcely know, no more do I. But I know that you have succeeded admirably in doing a painter's job, the job of a great painter; I mean to say that you have forcefully reproduced in your own particular idiom the *truths of light and shade* and the *reality of objects and creatures*.[90] (my emphases)

Despite having only indirectly furnished the basis for an over-reductive formalist reading of the painting during the twentieth century, even Zola's *naturalist* insistence on seeing the painting in terms of its pictorial construction by contrasts is not without interest here. Zola noted that the painting worked by a very clear distribution of lights and darks so that (in another translation) 'at first glance you distinguish only two tones, two strong ones played off against each other'. It would be my contention that, whether or not intended, this commentary registers tropic oppositions at the level of a formal discussion of tonal contrast. Rhetorical meanings opposing black and white, European and 'Negress', are absorbed through this pathway so that the unspoken difference between cultures and identities is normalised, factually, as a matter of pictorially structuring contrasts of colour. The opposition between two strong tones, dark and light, one black (i.e. coloured) and the other pale and nude (i.e. not spoken of as coloured, as white) will inflect and also be embodied asymmetrically by the two figurations of woman – *a nude* and *a negress* – in the painting. Their femininities – classed and culturally particularised, for *négresse* is synonymous with slave – will disappear into what that tonal opposition does, and does not, allow us to think about them as we read the painting through Zola's verbal description of it as a tonal system.

Yet, on the other hand, the apparent opposition is structurally produced. The meaning of each element, therefore, depends on its relation to the other. Instead of there being difference, that is, given opposites or diversity, there is merely *différance*. Meaning is induced by the necessary deferral of each term to another in the chain of signifiers. Dark and light are mere values in a single system, each dependent on the other. Just so might we have to think that *nude* and *negress* function in constant oscillation to produce each other's deferred meaning. It cannot, therefore, be merely a matter of saying that so far art history has attended to the 'white' woman and ignored her 'black' companion, and that now we will redress that imbalance and focus attention on the 'black' woman. The meanings generated for this painting are based on the *relations* between all its elements, and thus the nude becomes a 'white' figure as opposed to a racially unmarked one because we now note that there is also a 'black' woman (I use this term to interrupt the circuit which places 'negress' as twin to 'nude') represented in this painting in a critical semantic relation to the 'white nude'. That relation is signified in the only way painting can signify: through colour relations and tonal oppositions which collectively rely on each other and relay to each other to hold the whole picture together as a single visual, and thus semiotic, field.

The woman is, however, 'black' only because the painting marks ethnic difference coloristically and, I suggest, locates it not in the ideological realm of fantasy but in a concrete historical present. How can it do this? Does the painting make that move through one of its major semantic resources, colour, or does it construct a tonal system, as Zola suggests, which then appears semiotically to produce an opposition black and white, which would be read ideologically in terms of a racialising system? My provisional answer is that the tactical move in the painting is to make tonal opposition function as colour, temporarily liberating its meanings from the racist straitjacket.

There is plenty of black and white pigment in the painting. Firstly there is the bed linen which covers the bed on which the naked woman lies and stretches from one side of the canvas to the other forming an almost uninterrupted expanse along the lower edge of the painting. The effect of so much white is to make the upper reaches of the canvas, painted to depict green drapery, brown and gold floral wallpaper and a doorway, merge into a general darkness in which one has to work hard to make out the range of tones that are broken only by the band of gold that marks the edge of the wallpaper. In no way, however, could one call this a 'black' background, except by eliding the colour with darkness. Peer as one might, the geography of the room loses its importance because of the luminous, intense brightness in the foreground which is so close that we feel we could touch it. Against these two major areas of light/dark opposition there are two figures and a cat. The cat is black, that is, it is painted in a series of graduated black pigments. Against the green of the drapery, its arched back and erect, curling tail are just discernible and its yellow eyes and shiny nose break into the blackness to define its face. Its paws stand on a fold of the silk shawl on which the naked woman lies and its feet cast dark, smudgy shadows.[91]

Given the tonal scale of the bed, the background and the cat, the women in the painting are neither black nor white. Deep chestnut brown and a kind of dusky pink with yellowish tints for exposed skin must suffice as a crude definition of the colours in which the European and the Afro-Caribbean woman are manufactured in paint on the canvas. Clothed in her nakedness – or perhaps disrobed from nudity into a classed nakedness as some would argue – the European woman modelled by Victorine Meurend wears some clothes after all: a pair of elegant gold and blue slippers, only one of which is still on her left foot, a golden bangle on her right arm, a black ribbon tied in a bow round her neck and holding there a tear-shaped jewel which seems to match her earrings, though they are probably sizeable gold studs. Finally there is an orangey-pink orchid in her hair, tucked above her left ear. This touch of colour in the form of a hothouse flower figures the sexual morphology her hand so adamantly protects and yet proclaims, long before Georgia O'Keefe made us think about about flowers so sexily or Judy Chicago explored the visual poetics of female sexuality through a formal, floral analogy. Maybe *they* remembered Victorine's orchid. And, of course, she holds her large silk shawl in her right hand. It implies a possible narrative. It could have clothed her, and possibly, we are to presume that it recently did, before being slipped off to reveal her to whomever stood, might stand, or stands now in the place

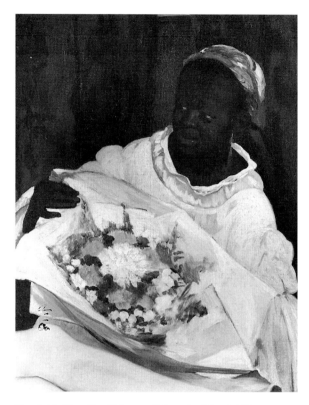

Fig. 9.19 Detail of Manet, *Olympia* (Fig. 9.17)

the painting constructs beyond its immediate frame as a necessary part of its semantic proposition.[92]

The African-Caribbean-French woman is more consistently dressed (Fig. 9.19). She wears, however, a European-style dress which seems too large for her. Some have called it a nightdress, suggesting a sexual narrative linking the two women.[93] I suggest that it is a dress of outdated fashion from the earlier years of the century which has moved through the second hand clothes markets of Paris.[94] The dress is an intense pink with a white undershirt or infill so that the woman necessarily appears dark against this large expanse of light colour. Had the artist painted her dress in sombre colours, the contrast with her skin would not be so marked, but then again, the richness of the tonality of her skin – a moment's attention by the painter to the specificity of hue and tone – would not have been so intense without the sharp contrast of the pink. On the other hand, the freshness of that pink endows the skin of the European woman nearby with a certain sallowness, which only the blueish tints in the shadows redeems from deadness – an association hard to resist if one reads the outcry of contemporary critics.[95]

The African-Caribbean-French woman wears a headwrap around her hair.[96] This is a very complex and important sign. I want to suspend temporarily its social referent by

making a Zolaesque move to keep attention focused on its pictorial status. The headwrap is richly coloured, but not excessively. Too large or too intense an area of colour here would have disastrous effects on the structure of a painting that works on the tension between a horizontal and an off-centre vertical axis. There is already a great deal going on visually in the right-hand side of the painting – the slippers, the hang of the shawl, the cat, the bouquet, the standing figure in her luminous pink dress. Too much activity in the upper right – a brightly colored headwrap to compete with the blooms for instance – would distract from this dual focal structure which drives the painting forward to the canvas surface and generates the immediacy of the space, itself breaching thereby the conventions T. J. Clark has discussed for holding the representation of sexuality at an imaginary distance for polite voyeurism.[97] Its modernist idiom depends on the muting of that headwrap.

Yet no colour at all in the bandanna would be a breach of naturalist precision – not accuracy in a banal realistic sense, but rather what I conjecture or project as Manet's political acuteness in putting this figure thus dressed in his painting. The bandanna is a highly specific signifier precisely in the combination of its being there atop the head of a black woman clothed in European cast-offs and its understated facticity. More insistently painted, it would have become too powerful a sign of the exotic. It could have *Orientalised* the painting. My argument – based on the hysterical reading for the transformative detail – is that this painting is an *anti*-Orientalist or *de-Orientalising* work. The painting of the headwrap is the sign which indexes this painting of the nude exhibited at the Salon to another aesthetic scene, *Orientalism*, but then positions it *critically*, *differencing* the Orientalist politics of race, colonialism and sexuality.[98]

Without wanting to displace existing arguments about how this painting might be read in relation to the conventions it disrupted in order to articulate a form for aspects of modern sexuality, I suggest that one important axis has been neglected. That axis is established by the figure of 'the other woman', the woman for whom 'Laure' modelled as a crucial element in the painting's renegotiation of its own context of production. Ignoring the painting's relation to Orientalism means ignoring the modernity of this representation of a black woman as a working-class woman in the metropolis, a *black* Parisienne, a *black* faubourienne. It produces an implicit and uncritical prostitutionalisation of *Laure* by the conflation of servitude and its sexualised setting. It means maintaining the artificial divide between the works canonically celebrated as the founding texts of modernism, i.e. paintings by 'Manet and his followers', and those dismissed by that canon as *Salonnier* academic realism in the service of corrupt colonial fantasy, i.e. works by Gérôme and others who fashioned the Orientalist theme in the Salons of the Second Empire and Third Republic (Fig. 9.25). By acknowledging the reference in this painting to Orientalist texts, another dimension of its strategic difference, differencing its current canons – whether you call that move modernism or not – can be discerned. But the main point is that it gives us a way to locate this figure modelled by Laure within metropolitan modernity and not as either blank darkness (Zola) or exotic attribute of venal sexuality (Gilman, Clark, Reff), which is where she stands in typical art histories.

Manet first encountered the woman named *Laure* working as a nursemaid in the Gardens of the Tuileries. There is a painting of *Children in the Tuileries*, dated to *c*. 1861–2 (Fig. 9.16). On the right-hand side of the painting is a woman in a pink dress with a white infill at the neck. On her head is an orangey-red headwrap. Her face is not painted. But it is 'coloured'. She is clearly a woman of African descent in contemporary European garments with a headwrap. It is large, the colour of the orchid in the painting *Olympia*, and has the characteristic accents of the tied ends protruding from the head, which ensure that we do not misrecognise it as a turban. Working as a nanny in a household made rich through property in the West Indies or other African colonies, born free or a free woman since 1848, the date of the final abolition of slavery in French lands, this figure indexes us to a social reality beyond the sexual script of black servants in Orientalist pictures or courtesans' households.[99] The dress, colour and headwrap are too much of a coincidence not to suggest that Manet saw this woman, painted her as part of a scene of modern sociability and bourgeois life and then saw in her prosaic presence in a Paris park a way to make a move on another artistic trope with which he was having a lot of difficulty at the time – the nude.[100] But if Manet incorporated this model into his projected works on the topic, she would, by virtue of the fact of being African or African-Caribbean, bring a whole range of references imposed upon that identity by four centuries of Western culture, with which he would then have artistically to contend. Despite her place in French society as a nursemaid temporarily turned artist's model, her 'colour' would reference his painting to Orientalist stagings of the mixed-race scenes of Western sexual fantasy widespread in popular erotic prints.

Taking a working-class African-Caribbean-French woman from her place in class relations amidst Paris's fashionable families at play in the Imperial gardens and juxtaposing her to a naked Parisian working-class woman on a bed could not but resonate in predetermined ways. What did Manet do to this possibility, given that he decided to make that shift and leave *Laure* out of one scene of modernity in which he was working in 1861–2 (*Music at the Tuileries*, London, National Gallery) and ask her to model for another (*Olympia*) that deals at different levels with the archive of Western representations of heterosexuality. These encompass the Venetians (Titian), the Spanish (Goya) through to the contemporary popular French imagery that was both licit and illicit, painted, lithographed and recently photographed. Manet had to take on one current form of its articulation – the Orientalist siting of sexuality, where ethnicity and racial, cultural and geographical othering provided the necessary conditions for the representation of European male heterosexual fantasies about female sexuality because female sexuality was being imagined through what social and economic colonisation and exploitation had made it possible to imagine white people could do to other, non-Western people. The legacy of colonialism is that, while race and sex have independent determinations, they are perpetually part of a mixed economy in which one is often the scene or sign of the other. Instead of collapsing the racist myths of black female sexuality on to the prostitutionalised white woman and 'spattering' both bodies with their abject sexualisation, I want to read 'the other

woman' in the painting as the point that resists such colouring – the point that can be made to disrupt the desire with which most of the existing art historical readings of the painting are complicit. I want to inscribe within the canon of interpretation the possibility of a feminist desire for that otherness of another way to read the canon by assisting the difference that Manet's painting tried to intrude into the field of representation and sexuality in 1863–5.

The nude

This painting is predominantly discussed by art historians in relation to the discourse of the nude (Kenneth Clark), the crisis of the nude in the 1860s in French painting (Farwell) and the point of intersection between the nude (how sexuality gets some representation in art) and a historically precise and classed discourse of Woman in the 1860s (T. J. Clark).[101] These frames for the painting are perfectly reasonable but they are possible only because of the erasure of the other woman, *Laure*.

For T. J. Clark the 'black maid' is a stock character.[102] As Homi Bhabha has since argued, however, the stereotype is a major sign in colonial discourse, precisely because it seems to create a fixity for otherness that, none the less, constantly breaks down. Its 'failure' derives from what Homi Bhabha argues is the fetishistic character of the stereotype, oscillating between disavowing and commemorating difference, and hence desire.[103] The 'stockness' that Clark misrecognises, therefore, derives from and helps maintain relations that are just as material as are those of class. The servitude of slavery was absolutely a part of European capitalist formation and its class relations in Britain and France – the two countries in whose artistic repertoires we find the recurring presence of a black servant.[104] By 1666 slave traders were leaving Nantes for Guinea and on to the West Indies.[105] Africans were brought back to Europe to work in their owners' households and to appear in paintings as a part of a complex ritual of display of these emergent bourgeois selves and the ostentatious wealth they accumulated through the dehumanisation of the Africans and their slave labour on Caribbean plantations. As a genre of visual representation, Orientalism, based on an incipient and later violently colonial relation to Islamic North Africa, specifically combined the ideological revision of two distinct orders of economic relations. In what we call Orientalist scenes, such as Jean-Marc Nattier (1685–1766), *Madame Clermont: A Painting Representing a Portrait of the Late Mlle Clermont, Princess of the Royal Blood and Superintendent of the Queen's Household Represented as a Sultana Leaving her Bath assisted by Slaves* 1733 (Fig. 9.20), there are Orientalist elements derived from fantasies about the Islamic segregation of women, introduced through the representation of the European woman costumed as a sultana, set as if in a harem scene of Oriental intimacy – fabricated, since European men would not be allowed into the women's quarters. The fake Sultana is then combined with African attendants, who function as an indexical sign for slavery and slave-based colonisation in the triangular trade between Europe, Africa and the West Indies/America, although it is apparently projected on to Islamic culture itself. The presence of the slaves and

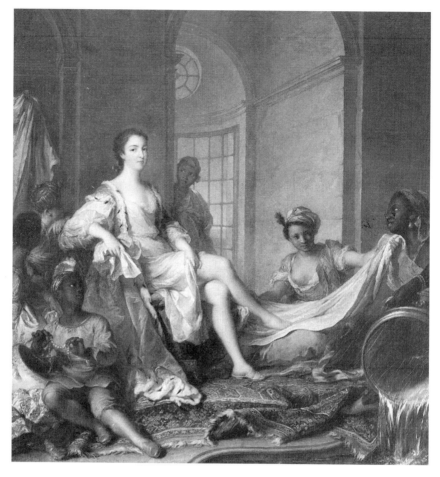

Fig. 9.20 Jean-Marc Nattier (1685–1766), *Mademoiselle Clermont Leaving her Bath*, 1733, oil on canvas, 110 × 106 cm. London, The Wallace Collection

servants is almost always oblique. Their gestures and position in the painting's composition and colour scheme correspond to the social invisibility and marginal status as real people which their ideological – but not their economic – status within slave-owning societies produced.[106] Mlle Clermont has six attendants. One, holding the towel, wears a turban, and seems coded as Turkish or Arab, relating to her fancy dress as a sultana. On the extreme edges of the painting, and peering round a door in the background, are figures that appear to be African. The pressure of the painting's central brightness, the naked legs of the princess of the royal blood, pushes these figures to the margins and makes their faces hard to read given the harsh tonal contrasts thus created. One face survives this compositional centrifuge. It is the head of a young African woman. Wearing a headwrap, one heavy pear-drop earring dangling, she gazes earnestly at the 'enthroned' princess as she empties the brass basin, creating a pictorial tension by the direction of that look, which further conspires to

focus our vision on the exposed white body at/as the painting's centre. This painting passed through Paris salerooms in 1858 and was commented upon with enthusiasm in the art press.[107] Perhaps it was known to Manet.

In the scholarly studies on the painting *Olympia*, many precedents are traced for images of reclining white nudes – the most obvious of which are *The Venus of Urbino* (*c.* 1538, Florence, Uffizi) by Titian, copied by Manet *c.* 1853, and the *Nude Maja* (1796, Madrid, Museo del Prado) by Goya. This kind of pictorial genealogy continues to enforce the focus on the nude white woman in the painting with the rest as accessories to that display of/for European sexuality. There is, however, a major difference between the two possible precedents, Titian and Goya: the presence of other women. The Titian *Venus of Urbino* includes what some art historians call an 'Ethiopian' (maybe a Cushite? who is *negra sum sed/sic beata*) maidservant, kneeling at the *cassone* (marriage chest) in the background. But she does not look at the white woman. Such a combination of European sex goddess and African servant thus has a long but explicitly historical genealogy from Venice through to the rest of Europe as each country in turn began to trade with Africa's both Islamic and African cultures. The pairing forms the major trope of nineteenth-century Orientalist erotica as well as appearing even in subject paintings that evoke another, surprising genealogy to Judith and her maidservant Abra (Fig. 9.21).

In choosing this combination, Manet's picture must be then deemed to be participating or intervening in the *longue durée* of Orientalist discourse and representation. This is why so many of the other precedents for his painting are subjects called *Odalisque*, that was the central vehicle for Orientalist visual fantasy, even though the imagery remains consistently ambiguous about the ethnicity of the figure. The main point is that the Odalisque is never black: just as in Zola's reading, there is the nude and there is the negress, synonym for slave.

In his comprehensive study of the possible sources for the painting *Olympia*, Theodore Reff further cites Ingres's *Odalisque à l'esclave* (1858, Paris, Musée du Louvre) and *Odalisque* by Delacroix, dated 1847, and in 1983 Françoise Cachin illustrated *Odalisque* by Jalabert of 1842 (Fig. 9.22) and one scene called *Odalisque* by Léon Benouville of 1844 featuring also an African attendant (Fig. 9.23).[108] The fact that the pictorial source-hunters come up with Orientalist material has not led to questions about the Orientalist siting of *Olympia*. Thus, yet another, and to my mind crucial, reference point remains obscured: Delacroix's *Women of Algiers* of 1834 (Fig. 9.24).

In this painting three women sit or recline, in a largish room, hung about with heavy drapery. On the right-hand side, the only active, upright figure is that of an African woman, who appears to be leaving the room. As an artistic device, she seems related to Nattier's figure, on the edge, her look acting to focus the spectator's, yet drawing attention back to her own specificity. In Delacroix's painting the African servant twists to look back, holding her hand up to draw up the curtain as she leaves the room. The hand is surely important in the chain of connections I am tracing. The African woman is clothed, wearing light slippers on her feet, jewellery including earrings, armbands

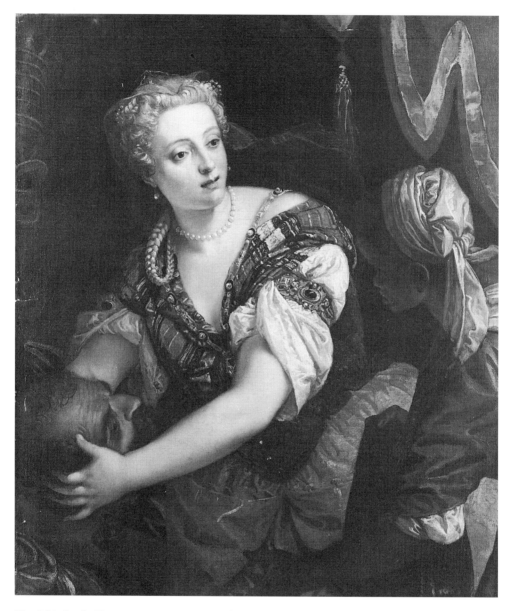

Fig. 9.21 Paolo Veronese (*c.* 1528–88), *Judith with the Head of Holofernes*, oil on canvas, 111 × 100.5, Vienna: Kunsthistorisches Museum

and finger rings. Her kerchief is tied in a distinctive way. It is not a turban which it begins to resemble.[109] Typically, this figure is still pushed to the edge of the painting. Up against the drapery there is no space within which her figure will gain the kind of resonance that envelops the other three women, whose features are equally ethnic – other – in their representation. In contrast to their languor or passivity, the African woman's animated movement, her Baroque *contraposto* and expressive hand gesture

290

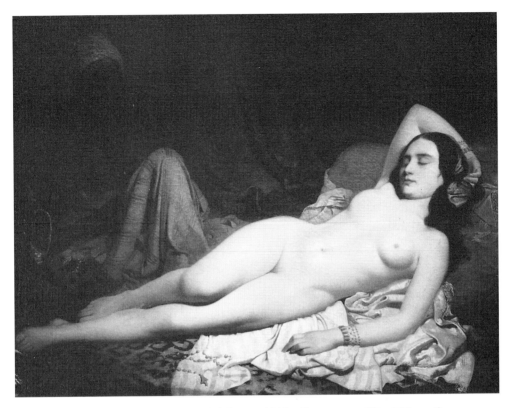

Fig. 9.22 Jean Jalabert (1815–1900), *Odalisque*, 1842, oil on canvas, 85 × 120 cm. Carcassonne, Musée de la Ville de Carcassonne

make her a critical focal point on the right-hand side of the painting. Neither subservient nor accessory, she is represented there, embodied and the topic of the painter's considerable attention. Her verticality opposes but structurally balances the reclining woman who looks out at the spectator, curving her body to fit the opposite corner of the painting. Imagine this painting without the intervening pair, borrow the flower, think about half-slippered feet, worry about that black hand and . . . the ghost of Manet's painting takes preliminary form.

One little clue allows me to begin to make this link between Manet's and Delacroix's work. Amongst the many drawings that we assume are part of the preparatory thinking-through of Manet's project in the early 1860s, there is a watercolour and india ink drawing, dated 1862–8 (?) titled *Odalisque*. The dating of the drawing is still the subject of speculation. Its origin in the early 1860s makes sense in terms of a number of solutions being explored by Manet's trying out references to Ingres, to erotic lithography and to Orientalist themes – all elements of the existing pictorial archive for work on sexuality and representation. *Odalisque* can be linked to Delacroix's *Women of Algiers* because of the explicit ethnicity of the Orientalised Jewish or Arab face. The faces would be important in Manet's final work; they will

291

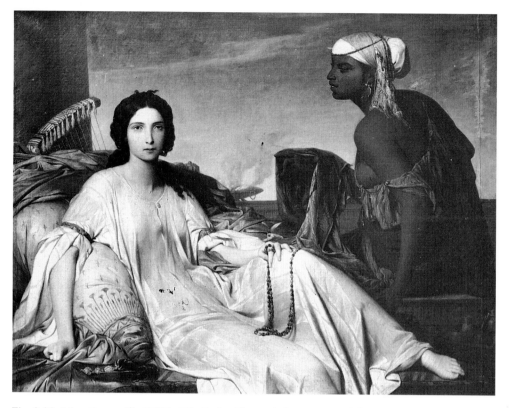

Fig. 9.23 Léon Benouville (1821–59), *Esther* (formerly known as *Odalisque*), 1844, oil on canvas, 144 × 162 cm. Pau, Musée des Beaux Arts

socially and historically define the modernity – the historical specificity – of his protagonists.[110] Different body types and facial types had to be explored for their rhetorical possibilities, and the presence of this wash drawing in the archive suggests that the field of Orientalism was part of Manet's research in specifically referenced ways.[111] The important question is what moved *Olympia* from being an essay in any one of these types of painting to being one which staged the basis of their representation of sexuality as an issue which the painting would present but not itself sort out.

If for a moment we speculate on a relation between the painting *Olympia* (Fig. 9.17) and the *Women of Algiers* by Delacroix (Fig. 9.24), we would have to start with the scenario and all its occupants. Might the naked European woman, so obviously a local Parisian (according to most of the critics in 1865 and subsequently), be a transgression of two elements of the Orientalist *mise-en-scène* for bourgeois sexual fantasy? Namely, it happens to *others* and it happens *elsewhere*. This figure's significance, on at least one level, lies in the fact that she is definitively *not* 'an Odalisque', not an Arab or Jewish woman, but a local Parisian. But we know that Orientalist scenarios were on offer in the brothels in Paris in the 1860s and as part of more select commercial sexual services.

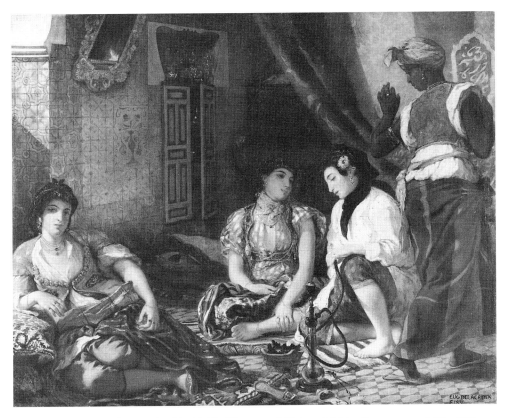

Fig. 9.24 Eugène Delacroix (1798–1863), *Women of Algiers*, 1834, oil on canvas, 180 × 229 cm. Paris, Musée du Louvre

Does Manet's painting – by its factual reconstruction of the deceit – show up the theatrical masquerade of Orientalist painting which used the mimetic facility of painting to render the fantasy in imaginary time and space with compelling exactitude? Does his prosaic 'realism' – that 'crude and austere look of nature itself' in Zola's phrase[112] – disarm the delusional realism of the *Salonnier* Orientalist?[113] The always shocking daytime lighting Manet had begun to use is never so alarming as in its function here as a dispeller of mystique in favour of the put-on show, mocked-up in the studio, insisting that, even were it in the courtesan's bedroom, the whole thing would always be but a shoddy sham.

The woman hired to help out in the house isn't any more exotic than the Parisian working woman that she, in fact, also was. She is made prominent in the painting. Moved from the margins to a position on the right-hand side of the painting, her figure exactly matches that of the European woman on the left. She moves forward into the foreground space – as Lubaina Himid's reworking of this image – as opposed to leaving it, as in the Delacroix. Mieke Bal even suggests that she is sitting down.[114] The Orientalist fantasy usually depended upon the clothes. So, in this negotiation of the trope, the European woman is underdressed – her faded oriental silk shawl lies

293

discarded – and her sexuality is crudely put on display. The sexual charge promised by Orientalism depended on the narrative excuse of the harem or the bath house as a justification for the sight of exotic sensuality. Manet strips away that deceit. The African woman is dressed, but as a European, in cast-offs from from the working-class districts' second-hand clothes markets, thus refuting her usual role as a figure of exoticism and luxury, except for that quietly understated headwrap whose warm reds link with the strong red note of her coral earrings to help frame, shape and make visible her characterful face, and it holds in place a trace of a historical, cultural and geographic identity.[115]

What I am suggesting is this. In European painting the combination of an African woman as slave or servant and an Oriental harem or domestic interior with reclining women, clothed or nude, represents a historical conjunction of two, distinct aspects of Europe's relations with the world it dominated through colonisation and exploited through slavery. The relations with Islamic culture – colonisation – and with African peoples – trade in slaves and goods – collapse in Orientalist paintings into a trope for masculine heterosexuality that is held in place by the displayed sexual body of a European or pale-skinned Arab woman. That there were Africans in Islamic North Africa there can be no doubt, but this rhetorical combination of sex and servitude is 'logical' only in an economy that has slavery as its political unconscious, and sedimented in its social rituals and erotic fantasies. This legacy – materially and ideologically – is, was part of Western modernity. Painters ambitious to negotiate modernity's representation would have to pass through the defile of Orientalism, which repeatedly occurs as the site of this specific configuration of power as sexuality and desire, whether imagined on visits to harems abroad (were they indeed permitted?) or mimicked in brothel mock-ups and courtesans' workrooms in metropolitan capitals. The painting *Olympia*, I suggest, also works with and works over such Orientalist material, and that is why there are two women of different ethnicities in this painting. This is why Africa – and its histories, complexly woven like the sign of the headwrap itself – is at the centre of modernity.[116] But if slavery and colonialism are the historical conditions for Orientalist representation, they were ideologically displaced by the mythic structures of representational Orientalism. I am arguing that my reading of *Olympia*'s doubled femininity, reading for the other woman, places the painting in a critical relation to Orientalist myth by making its modernity explicit both through what the painting does to locate the white woman in time, space and class relations and through its calculated and strategic revisions to the trope of the African woman – now also signalled as a figure located in time, space and class relations, that is in the history of the then present, as another Parisian proletarian. In a way this involves shifting from a stress on race, to finding ways to incorporate difference as specificity while also revealing the women as having some things in common: class becomes the means to provide a gender and a history for them both. De-Orientalising the set-up involves allowing gender and class to frame issues of 'race' which were so critical to the *mise-en-scène* of sexual fantasy in Orientalist works.

The failed legacy

If part of the meaning of *Olympia* is its negative relation to its pictorial and ideological resources, so another aspect can be discerned by works that were influenced by it – works which precisely renege on this painting's attempted negation of Orientalism. The paradoxical legacy of Manet's work was to put a white woman at the centre of a reconsolidation of Orientalist representation in later nineteenth-century French culture. By looking at paintings that *postdate Olympia*, we may also be able to see the painting as a hinge between a historically created archive and a specifically nineteenth-century ideological reinvestment in Orientalism, which the painting *Olympia* had attempted, unsuccessfully, to dissipate.

The standardised trope that recurs in the years *after Olympia* is a return to a structural opposition: that of a fully naked European or noticeably pale-skinned Arab or Turkish woman being bathed, massaged, or prepared by a half-clad African servant whose naked torso may or may not be painted to attract the gaze. She will usually be more muscled and physically active than the whiter woman in the painting. But all of her body seems less significant to the painters than her headwear. In a painting by Gérôme of 1870, *The Moorish Bath* (Fig. 9.25), an African woman bears a huge brass basin, dull in tone. This leads the eye to a gold pendant on her naked chest and then to the brilliantly golden cloth that is wrapped around her head like a huge diadem. Her face is obscured. This head-dress is her sign. In Debat Ponson's *The Massage* (1883, Carcassone, Musée des Beaux Arts) a reclining Caucasian female lies on the marble slab, her boneless flesh being worked by the hands of a muscled, half-clad African woman with a dull orange head covering. Its warm tones relate to those of her golden-brown skin and in turn to the red of her sash/gash just below her waist.

It is thus that colour is 'spoken' in *Salonnier* painting. The woman of Africa is not a protagonist in the painting but simply the site of colour, not as blackness but as that substance which can be signified through golden jewellery – the gold for which the Spanish and their later European followers killed and murdered, committed genocides – and through colourful fabrics which are signs of slavery and the economics of early capitalism.[117] In the early work of Frédéric Bazille, an artist associated with the Independents before his early death in 1870, there are two works facing as it were in opposite directions: one towards Gérôme and the other towards Manet. They recognise certain possibilities in Manet's project while succumbing to the pressure of the continuing power of Orientalist representation. In *The Toilet* (1870, Paris, Musée d'Orsay) an African woman, half wrapped in a striped towel, kneels to help a naked white woman with her slipper. Standing on the right of the painting, is a European woman, fully dressed in contemporary fashion, in effect appropriating the costume of *Laure* and further underlining the return to the myth of the African slave. In the same year Bazille painted *Negress* [*sic*] *with Peonies* (Fig. 9.26). Dressed, however, in European clothes, she is juxtaposed to flowers, and painted with the care for features and expression associated with a portrait. Her striped headwrap, tied at the back, becomes a prominent device to frame her face and set up a colour opposition with the

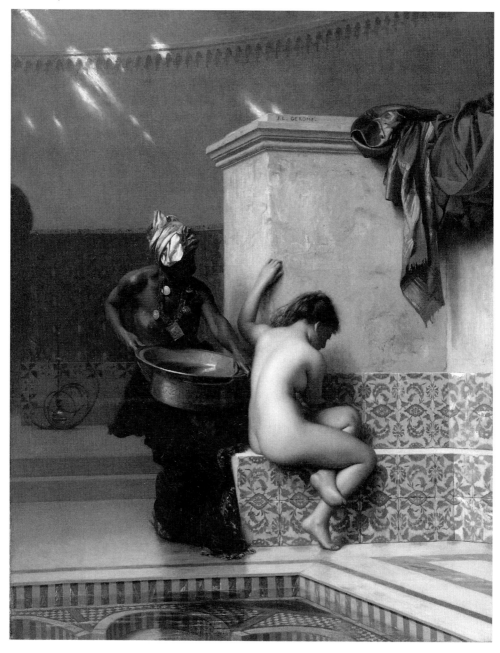

Fig. 9.25 Jean-Léon Gérôme (1824–1904), *The Moorish Bath*, 1870, oil on canvas, 50.8 × 40.8 cm. Boston, Museum of Fine Arts (gift of Robert Jordan from the collection of Eben D. Jordan)

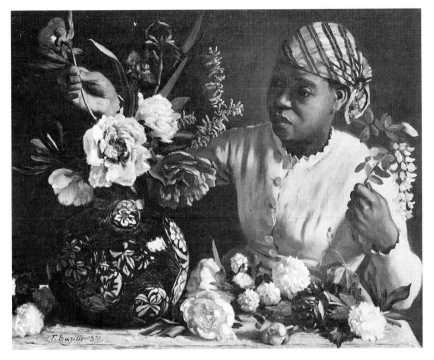

Fig. 9.26 Frédéric Bazille (1841–70), *African Woman with Peonies*, 1870, oil on canvas, 60 × 75 cm. Montepellier, Musée Fabre

flowers she is arranging – linking the painting notionally with the de-Orientalising move of Manet's representation of *Laure*. Commentators affirm that the study clearly refers to the right-hand section of Manet's painting, underlining, by focusing exclusively on the relation of the African woman to flowers, the displacement of sexual exoticism for a metonymic relation of 'colour'.[118]

Possibly as preparation for *Olympia*, Manet painted a portrait head of the model 'Laure' around 1863 (Fig. 9.15). The presence of the portrait of 'Laure' in the oeuvre of Manet indexes the painting for which she later modelled in the guise of a servant to a major portrait of an African woman in French art which also attempted to locate an African woman in *political* modernity. In 1800 Marie-Guillemine Benoist (1768– 1826) painted a seated portrait of the African or African-Caribbean servant her sailor brother-in-law had brought to France from the Antilles, *Portrait of a Negress* (Fig. 9.27). The sitter has no name, despite the fact that the portrait was, particularly at this time, an intended visual record of a specific person. The woman is presented seated, dressed in political colours: a white gown with a red sash and a blue shawl draped over the chair. It would be hard to miss the references to the tricolor despite the fact that the painting was acquired for the crown in 1818, when it entered the Luxembourg (going into the Louvre on the artist's death in 1826, while a print after it was produced in 1829).

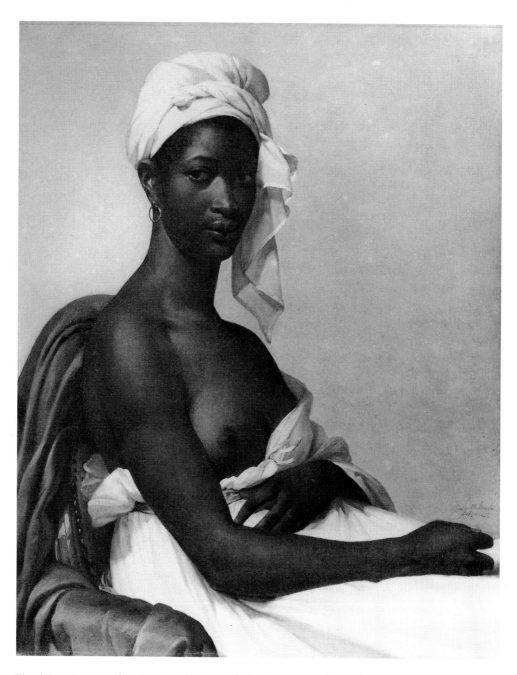

Fig. 9.27 Marie-Guillemine Benoist (1768–1826), *Portrait of an African Woman*, 1800, oil on canvas, 81 × 65.1 cm. Paris, Musée du Louvre

The woman is in high Paris fashion – a loose-fitting, white gown tied below the breasts with a sash, before it was taken off her shoulders to expose one naked breast. Such exposure hardly reads as such to women art history students used to classes in art history in the West. We see women exposed before us in a variety of guises in most of the lectures and classes we attend. They are called 'the nude'. Their vulnerability and 'publication' is never mentioned. We learn to take it for granted that women's breasts must be seen. Like picnickers at a perpetual *Déjeuner sur l'Herbe*, we sit in art history class wondering whether, because we are dressed, we belong with the gentlemen who disport themselves amongst the naked ladies, or whether we too should undress and strike the pose so as to show solidarity with the naked woman so cavalierly put there for all to see.[119]

Another scene comes to mind: the slave market where naked men and women were exposed to the calculating gazes of their would-be owners, who checked their teeth, felt their muscles and fondled their genitals to make sure of a good buy.[120] These two scopic regimes stand in important relation to each other. The nude is the commodity which allows its owner – or now, collective surrogate owners – rights to look and appraise a fictive woman's sexual allure and purposes. The looking is normally done dressed; the looked-at wears only art's nudity – that means no woman's sex or sexuality in sight, though a hand will trail to remind the viewer of its hidden spaces or clutch a cloth to protect it from visual violation.[121] How shall we now rethink that link between the normality of the exposed woman in the art class and lecture room with clothed people looking at naked women and the power play encoded in the contrast between people of colour deprived of what they take to be their identities, be that through clothes or simple aprons, or other markings on the body, and the slave owners' probable finery as they did their work of reducing human beings to labouring animals over whom they would exercise the right of life and death?

Did the young woman – the one posing in Benoist's portrait (Fig. 9.27) – suddenly brought to France, see any difference between the slaver at the market, who showed her or her mother or her grandmother naked to a buyer, and the studio of her owner's/ master's sister-in-law where she was partially disrobed to be painted in that condition which we call art – but which is just another site of power where your human identity can be diminished by the exposure of your vulnerable body to a costumed and protected gaze? Did she want her breast to be the object of appraisal and connoisseurial discussion in public exhibition? Did she realise that its exposure signified liberty? Does her hand lie on her waist or does it clutch the dress to her, resisting further exposure? Then what of the terrible irony of her head-dress – a considerable length of muslin tied to remind us of the Phrygian cap of liberty?[122] Slavery was temporarily abolished in the French colonies in 1794 only to be re-established by Napoleon in 1802. The trade in slaves was not abolished in French territories until 29 March 1815, and slaves were emancipated finally only in 1848 after the Republic was again established. During the eighteenth century planters were allowed to bring slaves to France, although technically there could be no slavery on French soil, on condition that they registered them and took them back to the colonies.[123] This portrait was painted in that window

of incomplete liberty when nothing but the terms of service and submission had changed. Perhaps the young woman need not have worried – as a work by a woman artist, her portrait would soon fall into oblivion and not be the object of much discussion until feminists came along to excavate a history of women artists and once more made her go through the ordeal of display – this time her body serving the cause of European women's creativity.

One other woman exposed to the European gaze must be named in this genealogy of shame: Saartje Baartman, whose predicament was so brutally brought into the field of *Olympia* scholarship by Sander Gilman (Fig. 9.28).[124] Saartje Baartman (her original name is unknown) was a young woman from the Khoi San people of Southern Africa who was brought to Europe and put on display because Europeans were intrigued by the protuberant shape of her buttocks. On her premature death in 1815 at the age of twenty-five her body was dissected, with casts made of her genitalia, which to this day form part of the collections of the inaptly named Musée de l'Homme in Paris.[125] The gazes of science, medicine, sexuality, art and ethnography converged on a body in which, through her ghastly epithet, the Hottentot Venus, the sex goddess and the African other were conflated and became a part of French historical culture as a dissected corpse signified by her female sex that the white hand in *Olympia* so pointedly protects and reclaims.[126]

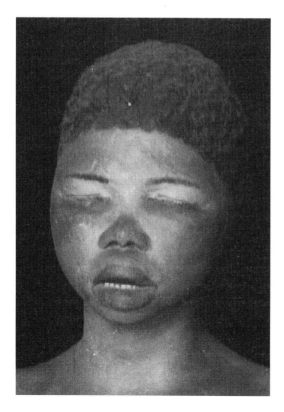

Fig. 9.28 *Death Mask of Saartje Baartman*. Paris, Musée de l'Homme, Laboratoire Anthropologique

Sliding down the metonyms of history, there are links between the slave market block and our schooled acceptance of the normality of the hierarchy of clothed viewers or masters and unclothed objectified female objects in art history. Manet's portrait of *Laure* and his painting *Olympia* do not, at least, inflict that wound of exposure on *Laure*. When we look at this painting we do not have to ignore the sitter's feelings in order to be able to bear to look at her at all. If we did not wonder about those feelings in the once real relations of the picture's production, we would be showing exactly what Gayatri Spivak, in the epigraph to this chapter, warns us against – total complicity with the institution – the institution of art which has its real and ideological roots in the same modernity that gave us enslavement and destruction of over twenty million Africans.

Framed

The painting *Olympia* came before the public at the Salon of 1865, framed in specific ways which offer further evidence for the connections embedded in this painting between modernity and 'race' figured through images of slavery and blackness.

In the Salon *livret* the title *Olympia* derived from a poem. Five stanzas of the fifty that Manet's friend Zacharie Astruc composed were inscribed on the frame. The first reads:

> Quand, lasse de rêver, Olympia s'éveille,
> Le Printemps entre au bras du doux messager noir,
> C'est l'esclave à la nuit amoureuse pareille,
> Qui vient fleurir le jour délicieux à voir:
> L'auguste jeune fille en qui la flamme veille.

There are several translations provided in the literature. Mine goes like this:

> When, weary of dreaming, Olympia awakes
> Spring enters in the arms of a gentle *black* messenger
> The *slave*, who is like the amorous night
> comes to adorn with flowers the day delicious to behold:
> the majestic young girl [*fille* can also mean prostitute]
> in whom the flame of passion is on its guard [or burns forth].
> [*veiller* means to watch, awaken, but some translate this verb as *burn*]

Most art historians dismiss this pathetic parody of Baudelaire's 1857 *Fleurs du Mal*. Olympia would appear to be someone who was asleep, and thus the name may be attached to the reclining figure, who is, however, now awake, and on her guard.[127] The danger of connecting one figure in the image to the name *Olympia* outside the poem is that the writer personalises one woman; she has a name, she is a subject; she is the

prostitute and so forth, while the other is unremarked. The title of the painting, with this verse inscribed on its frame, refers to the whole scenario. Olympia as a figure in the poem awakes because she is tired of dreaming, tired of the old fantasy, perhaps. Something clearly beautiful and refreshing enters the room in the arms of a gentle messenger. Messengers are common in poetry – they are often like the wind, soft and gentle and associated with nature. But this messenger is coloured. It/she is black. There is then a strong contrast between the colourfulness associated with spring – in contrast to winter's gloom and perhaps also night's darkness – and its bearer's nominated 'blackness'. (This may bring to mind Frantz Fanon's chilling inversion when a chilling whiteness afflicted him with a mournful blackness) But this blackness is contiguous with the subject of the next sentence – the slave. A free messenger bringing spring becomes a slave, linking that blackness to slavery and placing slavery right there on the frame and around the picture. The slave is compared to the night of love and yet the slave will also make the day blossom. On this basis some have read the poem as a statement of the women's mutual sexual pleasure, their lesbian love, an idea forcefully excluded in the heterosexist interpretations which must make a place in the picture for the phallus via the imagined client either waiting outside (he who has sent the bouquet) or there where the viewer stands, beholding the revealed body while the maidservant offers his flowers from the other side of the bed. Both readings are historically possible and probably co-exist since the display of lesbian sex was another part of the heterosexist commercial sex economy, as we have seen in Chapter 4.[128] But the point to catch is that the poem allows the dynamics of an exchange between Olympia, the majestic *jeune fille*, and the black messenger-slave while not dealing at all with an exchange between Olympia and a client with an accessory maidservant. The word that really throws the whole, and is yet the centre of the verse, is the word *slave*. Yes, there is the metaphor 'slave of love' and it could be such a lover's offering that celebrates a night of love with yet more delicious sensations. But historically that axis is curtailed by the word's following on from the phrase *gentle black messenger*.

The next few verses serve to confirm that what Astruc saw in Manet's studio and composed his verses to complement was an Orientalist image. The whole poem is called *La Fille des Iles* (*Daughter of the Islands*) and the next verse goes:

Où puisses-tu ces airs d'esclave ou de sultane,
Cette indolence reine et ce vague sommeil,
Cette langueur d'infante et ta pose profane?
Mais ton corps virginal, rien d'obscur ne le fane
Jeune lys d'Orient au calice vermeil.

Where could you [singular and informal] put on these airs of slave or sultana,
Enjoy this royal indolence and this vacant sleep,
Indulge in the languidness of a Spanish princess in a profane pose?
But your virginal body, nothing dark or low will fade or tarnish,
Young lily of the Orient with a vermillion calyx.

[*Obscur* can also mean humble in the sense of social status – modest, mean and low; it evokes notions of mystery as well as gloom.]

I want only to underline the poem's juxtaposition of slave and sultana,[129] and note that the verse plays upon notions of the put-on, airs, play-acting, which run the gamut from Venetian sleeping nymphs to Goyaesque royalty and the profane *desnudas* that would be the referent points for any intelligent criticism of the painting. Such pictorial associations are framed within an ironical Oriental trope which, it seems, was not spoken in the critics' responses in 1865. Or was it? We will probably find only its offended traces in the language of pervasive blackness signalled by the evocation of apes, monkeys and gorillas.[130]

This issue comes to the fore through consideration of the second frame for the painting: the response by caricaturists. Just as we could use the caricatures in the press to imagine the historical unconscious of the viewers of Manet's painting *Repose*, so too the caricatures that responded to *Olympia* reveal the impossibility of one painting's final displacement of its own ideological materials and investments.

Since Mina Curtiss first published an article on caricatures of Manet's paintings in 1966, these images have served to indicate what the painting's first viewers saw when they looked at *Olympia* in 1865. This 'seeing' is not literal, of course, for it is mediated by the extreme liberties that the rhetorics of caricature permit. But rather like the analysand's discourse, these images can be read symptomatically; they betray the areas where interest or discomfort was its most intense. The caricatures blank out the background and focus on the figurative group: two women, a black cat and flowers. Because the caricatures were conceived and printed in black and white, what is lost is, precisely, colour. This enables the caricaturists to establish overtly the connections they saw implied by the painting, even if, as I would argue, in the painting itself, colour was used to escape the opposition between black and white, and thus to erode the metaphorics of Africanist discourse.

The cat and the African attendant are the same colour: black. In Cham's *La Naissance du petit ébeniste* (Fig. 9.29) the reclining figure is 'blackened' to signify the dirtiness of her hands and feet. Dirt is also imputed in Bertall's image. The commentary tells us that the woman is ready for a much-needed bath. Dirt is a metaphor for sex, and for the filth of disease associated with commercial sexuality.[131] The jokes and visual puns prostitutionalised the image. That involved uglifying the imaginary prostitute, blackened with dirt, degraded and classed with the stain of venal sex. But, although this specific sexualisation of the reclining figure is achieved by 'spattering' her with blackness, arguably, more violence was revealingly unleashed on the figure of *Laure*. In two images she is remade as a 'black mammy'. Made old and fat, and utterly defeminised, she is certainly no longer 'black but/and beautiful'. In effect she is displaced on to the figure of the crone, who so often accompanied or procured the young girl for prostitution in, for instance, seventeenth-century Dutch representations of sexual activity, and who functions as the antithesis of desirability while also marking the transitory nature of youth and beauty, whose other face she is: death.[132]

Fig. 9.29 Caricatures of *Olympia* at the Salon of 1865: Bertall, *Journal Amusant*, 27 May 1865; Cham, *Charivari*, 1865; Bertall, *L'Illustration*, 3 June 1865

In the same two caricatures, both by Bertall for different papers, she is made to grin, her white teeth flashing in a black face, creating an image of obscene connivance in total contrast to the restrained regard of *Laure* in the original painting. Finally the headwrap is prominently featured in these conversions of the painting, changed from the understated but significant sign to become an exaggerated detail of a costume that is clearly not European. *Laure* is expelled from her modernity, her presence in Paris, put back into grotesque fancy dress. In a sense she is stereotypically othered in ways which reveal the relays between blackness, dirt, sexuality, slavery, animality and a hierarchy of difference. Crude and brutal, these extremely unfunny reflections of the painting do not mirror its strategic moves on the social and pictorial archive that was its referent. They reinstate everything that those strategies aimed to dislocate. In place of Manet's historically constrained revision of the Orientalist mytheme of the African as slave which allows feminists in the 1990s to read for 'the other woman', a virulent racism re-inscribes the violence and convergence of Orientalist and Africanist representation condensed in this aged caricature. In a world where *nègre* is synonym for black but means slave, to make her once again, unquestionably, a *negress* is to suspend the momentary historical subjectivity and humanity that, I have argued, the composition and colour orchestration of Manet's painting attempted.

But let me be clear, as my final case study appears to endorse the canonical Manet, if for different readings. What I have argued is a possible reading, secured by the use of evidence I share with all the other art historians and feminist critics who might puzzle over this painting. It does not, however, curve back to heroise Manet as a man of progressive political sympathies. Art works are complex and, at times, profound, moments of what Marx called 'a totality of many relations and determinations', all of which embed the work within both networks of historical and social production of meaning and deeper, mythic structures that surface in the repetition of rhetorical tropes. Manet was a strategic player in his practice, but what any of his paintings as the product of that practice made possible depends ultimately on the ways they are read, how their signs are processed, on the reader's or viewer's desire, which, too, is embedded in time and place, in social process and psychic life. The frame which I have tried to create around this painting exceeds the narrow limits of art history's heroic tales of great artists and their art. I have been reading for and with the other, seeing from the view elsewhere, to imagine by identification with the erased or marginal another visuality in which to conjugate aesthetics, politics and ethics: is that perhaps what I mean by 'feminist desire' that can difference the canon, by weeping as well as dancing in the Louvre?

CONCLUSION

This chapter has been about 'what's in a name?' *Laure, Jeanne, Berthe* index this project to women. *Laure* has a name but no surname and was a model. *Jeanne* Duval appears in this archive only as *Baudelaire's Mistress*, but *Berthe* Morisot has a name,

a surname, a career, a family. Yet in a terrible irony it was her face and body, accessed through class and race, that allowed her in Manet's portraits to become the expressive epitome of a 'dark lady of European modernism'. Her name signifies not blankness or darkness but a place where whiteness and blackness could be appropriated by Manet outside the Africanist discourse and where blackness was indexed to sadness, mourning and melancholia: to loss. The real dark ladies were simply a subjective absence: a hole as black as the eyes of Manet's *Jeanne*.

Berthe Morisot has a civil status in bourgeois modernity and creative status in an art which constructs and affirms the European bourgeois self. Whether it is *Repose* or *The Balcony* it is always *Berthe* – her name relaying us to this historical and creative 'person' and to the accumulating meanings offered both by her own paintings and those by Manet and others of her. She lived and died remembered. The photograph with which I began (Fig. 9.1) is compelling for its rarity: the image of a professional woman in middle age. Her white hair stops her being used photographically to signify the dark lady. Her posture suggests a comfortable sitting position, not one constrained, forced and illegible as in Manet's 1870 painting *Repose*. I do not want to end up blaming the white woman in order to see the black women of modernity. But it is deeply sad that there are no images like this one for either *Laure* or *Jeanne* Duval that would allow us to contemplate a life after Manet – a life beyond the complex, puzzling, ambivalent and interesting workings of those paintings in that complex moment of early modernism. For *Jeanne* Duval, who was probably a similar age when Manet 'painted' her to that of Berthe Morisot in this photograph, we have only misogynist or racist legends or Angela Carter's fanciful but still problematic fantasy. For *Laure*, we have nothing. Thus in the end, for all the tenuous threads I have woven to trace the links that connected *Laure*, *Jeanne* and *Berthe*, we meet the final blank darkness of absence and silence in the archive of modern Western history where there is no memorial. Instead we can revisit the painting for which a woman named *Laure* modelled and make sure that 'the other woman' as painted into this visual space is recognised for the critical and significant part her image played in a decanonising move recouped by misrecognition for canonical Western modernism. From that acknowledgement stems another: the complex imbrication of race, sexuality, gender and class in all historical moments of modernity and in all its cultural products. In order to change the ways in which what has been a selective tradition pre-shapes our present, we must desire that knowledge of the other and the other knowledge of ourselves, and let difference reconfigure the canon that is both inside each self as well as outside in the institution we call art's histories.

NOTES

1 Gayatri Chakravorty Spivak, 'Imperialism and Sexual Difference', *Oxford Literary Review* (*Sexual Difference*), 8, 1–2 (1986), p. 225.
2 M. L. Bataille and G. Wildenstein, *Berthe Morisot: Catalogue des peintures, pastelles et aquarelles* (Paris: Editions des Etudes et des Documents, 1961); Denis Rouart, ed., *The*

Correspondence of Berthe Morisot (London: Betty W. Hubbard, 1950); new edition ed. Kathleen Adler and Tamar Garb (London: Camden Press, 1986); Charles Stuckey and William P. Scott, *Berthe Morisot: Impressionist* (New York: Hudson Hills Press, 1987); Teri Edelstein, *Perspectives on Morisot* (New York: Hudson Hills Press, 1990); Anne Higgonet, *Berthe Morisot* (Berkeley: University of California Press, 1990): Anne Higgonet, *Berthe Morisot and Images of Women* (Cambridge, Mass.: Harvard University Press, 1992); Margaret Shennan, *Berthe Morisot: The First Lady of Impressionism* (Stroud: Sutton Publishing, 1996).

3 I am drawing on Cleo McNelly, 'Nature, Women and Claude Lévi-Strauss', *Massachusetts Review*, 26 (1975), pp. 7–29.

4 *Correspondence* (1986), p. 36. The reference to the painting as a possible street scene occurs in the Salon review by Jules Castagnary in *Siècle*, 11 June 1869, cited in G. H. Hamilton, *Manet and His Critics* (New York: Norton & Co., 1969), p. 138.

5 The phrase is from the critic Francion in 1873, cited by Françoise Cachin, *Manet 1832–1883* (Paris: Réunion des Musées Nationaux, 1983), p. 317.

6 Ernest Duvergier de Hauranne, *Revue des Deux Mondes*, 1 June 1873, cited in Hamilton, p. 165.

7 Beatrice Farwell, 'Manet, Morisot and Propriety', in *Perspectives on Morisot*, ed. Teri Edelstein (New York: Hudson Hills Press, 1990), pp. 45–56.

8 Hamilton, p. 166.

9 Farwell, p. 55.

10 Tabarant suggests that the decor is that of Berthe Morisot's studio and the stuffed, upholstered red couch resembles one in the artist's studio described by Puvis de Chavannes in a letter to Berthe Morisot (Achille Tabarant, *Manet et ses oeuvres* (Paris: Gallimard, 1947). See Bernice Davidson, 'Repose: A Portrait of Berthe Morisot by Manet', *Rhode Island School of Design Bulletin*, 46, (1959), p. 7. Françoise Cachin argues that the painting was completed in Manet's Rue Guyot studio (*Manet 1832–1883)*, p. 317.

11 The usual formulation is this: Edouard Manet is the historical person, but 'Manet' is the author whose artistic identity is derived from a study of the texts and practices which constitute an artistic project. On this revision to the 'death of the author' debate see Geoffrey Nowell-Smith, 'Six Authors in Pursuit of *The Searchers*', in *Theories of Authorship*, John Caughie (London: Routledge & Kegan Paul, 1981), pp. 221–5 and Griselda Pollock, 'Agency and the Avant-garde: Studies in Authorship and History by Way of Van Gogh', in *Avant-gardes and Partisans Reviewed*, Fred Orton and Griselda Pollock (Manchester: Manchester University Press, 1996), pp. 315–42.

12 The term *overdetermination* derives from psychoanalysis: 'The formation is related to a multiplicity of unconscious elements which may be organised in different meaningful sequences, each having its own specific coherence at a particular level of interpretation.' J. Laplanche and J. B. Pontalis, *The Language of Psychoanalysis* (London: Karnac Books, 1973), p. 292.

13 Mieke Bal, 'Visual Rhetoric: The Semiotics of Rape', in *Reading Rembrandt: Beyond the Word–Image Opposition* (Cambridge: Cambridge University Press, 1991), p. 62.

14 *Ibid.*

15 Linda Nochlin, 'The Imaginary Orient', in *The Politics of Vision* (New York and London: Harper & Row and Thames & Hudson, 1991); Reina Lewis, *Gendering Orientalism: Race, Femininity and Representation* (London: Routledge, 1996); Inge Boer, *Rereading the Harem and the Despot*, Ph.D. thesis, University of Rochester, 1992 and 'This Is Not the Orient: Theory and Postcolonial Practice', in *The Point of Theory: Practices of Cultural Analysis*, ed. Mieke Bal and Inge Boer (Amsterdam: University of Amsterdam Press, 1994), pp. 211–19.

16 Homi Bhabha, 'The Other Question: The Stereotype and Colonial Discourse', *Screen*, 24, 6 (1983), pp. 18–36.

17 William B. Cohen, *The French Encounter with Africans: White Responses to Blacks 1530–1880* (Bloomington: Indiana University Press, 1980).

18 Eunice Lipton, *Alias Olympia* (London: Thames & Hudson, 1992).

19 Préfecture du Département de la Seine, 19 août 1839 no. 3969/124, Laure (no surname): 'In the year 1839, the 19 April, born in Paris, rue de Hanôvre, 6, Laure, female sex, daughter of father and mother not named.' Eglise Paroissiale de Saint-Roche baptisms, 1839 (3611) M. Olivier, p. 95, no. 277: 'Laure, in the year 1839, 20 April was baptised Laure born previous evening at Dr Leonard Henri Gery domiciled at rue d'Hanôvre no. 6. The godfather was René Charles Denis Gigord rentier domiciled rue Neuve des Petits Champs, no. 82. The godmother was Marie Claudine Ayres wife Gourd living at Rue Neuve des Petits Champs, no. 82, both signed with us.'

20 Farwell, p. 48.

21 Theodore Reff, *Manet: Olympia* (New York: Viking Press and Harmondsworth: Allen Lane, 1976), pp. 91–5, devotes four pages to the role of this figure in the painting and identifies pictorial precedents for the combination of women of different cultures. He notes the racist typography in which women of African descent were represented in relation to sensuality and sexuality, and suggests an important link with Baudelaire and his life-companion Jeanne Duval. I shall return to these issues later. Sander Gilman, 'Black Bodies, White Bodies: Toward an Iconography of Female Sexuality in Late Nineteenth Century Art, Medicine, and Literature', in *'Race', Writing and Difference*, ed. Henry Louis Gates Jnr., (Chicago: University of Chicago Press, 1989), pp. 223–61; see also Heather Dawkins, *Sexuality, Degas and Women's History*, unpublished Ph.D. thesis, University of Leeds, 1991; Griselda Pollock, *Avant-garde Gambits: Gender and the Colour of Art History* (London: Thames & Hudson, 1992); and Mieke Bal, *Double Exposures* (New York and London: Routledge, 1996). Albert Boime opens his important book *The Art of Exclusion: Representing Blacks in the Nineteenth Century* (London: Thames & Hudson, 1990) with a discussion of the painting and the social symbolism of colour in the construction of the painting itself. I read this short section after I had written this paper and was pleased to find in it a coincidence of perceptions.

22 In writing this I owe a debt to the late Shirley Moreno, whose doctoral research on this theme was sadly curtailed by her untimely death. Her M.A. thesis for the University of Leeds was a pilot study based on the erotic nude in the *Poesie* by Titian: see *The Absolute Mistress: The Historical Construction of the Erotic in Titian's 'Poesie'*, University of Leeds, 1980.

23 Frantz Fanon, *Black Skins/White Masks* [1952] (London: Pluto Press, 1986), pp. 109–15.

24 Christopher Miller, *Blank Darkness: Africanist Discourse in French* (Chicago: University of Chicago Press, 1985), p. 31.

25 Since I first wrote this chapter in 1995, Therese Dolan has published an important article on this painting, 'Skirting the Issue: Manet's Portrait of *Baudelaire's Mistress Reclining*', *Art Bulletin*, 79, 4 (December 1997), pp. 611–29, also proposing through the analysis of the crinoline the relation of the painting to Baudelairean concepts of modernity.

26 These terms are derived from Emile Zola's commentary on *Olympia*, which are discussed later.

27 Shennan, *Berthe Morisot*, provides a review of all the evidence and confirms this hypothesis, pp. 289–91.

28 Amy M. Fine, 'Portraits of Berthe Morisot: Manet's Modern Images of Melancholy', *Gazette des Beaux Arts* (1987), 110, pp. 17–20; and Beth Genné, 'Two Self Portraits by Berthe Morisot', in *Psychoanalytical Perspectives on Art*, ed. M. Mathews-Edo (Hillsdale, N.J., 1987), 2, pp. 133–70.

29 *Correspondence* (1986), p. 131. Margaret Shennan suggests in her biography that we should assume that a powerful relation between the two artists was made impossible by the fact of Manet's marriage and her class.

30 One significant exception is Marc de Montifaud, the pseudonym for the most important woman art critic of the time, Marie-Amélie Chartroule de Montifaud. See Hamilton, pp. 169–70 for her review of the Salon of 1863 in *L'Artiste*, 1 June 1873; and Dawkins, for a major feminist reading of this critic.

31 Farwell, p. 45

32 Cachin, pp. 316–17

33 Cachin, p. 367.
34 *Berthe Morisot with a Bunch of Violets* (1872, Private Collection) and *Berthe Morisot with a Fan* (1874, Chicago Art Institute).
35 Charles Baudelaire, 'Salon de 1846', in *Curiosités esthétiques*, ed. Henri Lemaître (Paris: Garnier Frères, 1962), p. 96.
36 Cited in Tabarant, p. 207.
37 Perhaps Manet was exploring here a little competition with Degas who was at this time making paintings of modern moods in works such as *Interior* (1869, Philadelphia Museum of Art) and *Sulking* (1869–71, New York, Metropolitan Museum of Art). Fine elaborates this reading of the painting.
38 Théodore Duret, *Histoire d'Edouard Manet et son oeuvre* (Paris: Flammarion, 1927) p. 138; cited also in Fine, p. 20.
39 Camille Mauclair, *La Vie amoureuse de Charles Baudelaire* (Paris: Flammarion, 1927), p. 63. The legend is based on information that the photographer Nadar gave to Baudelaire's biographer Jacques Crépet. Nadar, *Charles Baudelaire intime: le poête vierge* (Paris: Blaizot, 1911). Claude Pichois has subjected Nadar's account to historical verification and found a number of discrepancies.
40 The myth is that she was from the Caribbean, Martinique or San Domingo. Crépet's research suggests that she was French-born, since her mother was apparently from Nantes. On the other hand the Jeanne Duval whose name appears in the records of a hospital on the rue du Faubourg Saint-Denis lists her as born in San Domingo. Jacques Crépet, 'Charles Baudelaire et Jeanne Duval', *La Plume* (15 April 1898), 10, p. 242. A mixed cultural heritage of French and African descent is represented in early twentieth-century literary histories in terms of the politics of colour I discussed above. For instance Claude Pichois insists on calling Jeanne Duval a 'quadroon'. Claude Pichois, *Baudelaire: Etudes et témoignages* (Neuchâtel: La Baconnière, 1967).
41 Lemer or Lemaire is the surname in which the death certificate of her mother is addressed: see Jacques Crépet, 'Une femme à enterrer', in *Propos sur Baudelaire* (Paris: Mercure de France, 1957), pp. 149–55; 1989; pp. 203–4. She died at Belleville on 15 November 1853, birthplace given as Nantes, aged sixty-three, 'widow of private means'. Louis Ménard had seen Madame Lemer between 1842 and 1846, and wrote, 'old, respectable-looking Negress, with thick, greasy hair, which tried in vain to twirl over her cheeks and ears'. Cited in Claude Pichois, *Baudelaire*, trans. Graham Robb (London: Hamish Hamilton, 1989), pp. 203–4. In the first mention of Jeanne in Baudelaire's letters, October 1843, she is living with her mother on the Ile-Saint-Louis on the rue Femme-Sans-Tête, now known as rue Le Regrattier.
42 Pichois, *Baudelaire: Etudes et témoignages*. His conclusion is based on careful tracking of records of plays performed and performers listed. He suggests that Jeanne was really called Berthe and that Nadar met her in 1838. Berthe, a mulatress, was listed in Lyonnet, *Dictionnaire des comédiens français*, playing the roles Nadar claims for 'Jeanne' (p. 72). Berthe is also listed performing between 1844 and 1846, the years during which Baudelaire probably met her. There is a poem by Baudelaire dating from this period titled 'Les yeux de Berthe'.
43 Crépet, 'Charles Baudelaire et Jeanne Duval'.
44 See Pichois.
45 This is the phrase used by Zacharie Astruc to describe the maid carrying the flowers in *Olympia*. See later discussion of the figure and the poem.
46 Shelby T. McCloy, *The Negro in France* (Louisville: University of Kentucky Press, 1961), also documents many other prominent authors of mixed ancestry living in France, forming indeed an important literary circle.
47 Enid Starkie, *Baudelaire* (New York: G. P. Putnam & Sons, 1933), p. 243.
48 Cited by Starkie, p. 344.
49 Edward Ahearn, 'Black Woman, White Poet: Exile and Exploitation in Baudelaire's Jeanne Duval Poems', *French Review*, 51 (1977), pp. 212–20.
50 Miller, p. 69.

51 Cachin, p. 97.
52 Jean Adhémar, 'A Propos *La Maîtresse de Baudelaire par Manet* (1862), un Problème', *Gazette des Beaux Arts*, November 1983, p. 178.
53 Letter to Baudelaire cited in Pichois, p. 230.
54 Henri Loyrette, *The Origins of Impressionism* (Paris: Réunion des Musées Nationaux, 1994), pp. 400–1.
55 Nadar, *Charles Baudelaire intime*, pp. 7–8 (author's translation).
56 Théodore de Banville, *Lettres chimériques* (Paris: Georges Charpentier, 1885), pp. 281–2.
57 McNelly, p. 10.
58 Joseph Conrad, *Heart of Darkness* [1902] (Harmondsworth: Penguin Books, 1983), pp. 100–1.
59 Chinua Achebe, 'The Image of Africa', *Research in African Literatures*, 9 (1978), p. 6.
60 Quoted in Mauclair, pp. 63–4.
61 This quotation and those cited in the preceding paragraph are all from Mauclair, pp. 64–5.
62 Gonzague de Reynold, *Charles Baudelaire* (Paris and Geneva: Crès, 1920), p. 41.
63 It is another of those odd but meaningful coincidences. How often does Western Christian culture uses the blood libel against those it others and degrades?
64 Reff, pp. 91–2.
65 Angela Carter, 'Black Venus', in *Black Venus and Other Stories* (London: Picador, 1985), p. 9.
66 *Ibid.*, pp. 19–20.
67 There are several named and many unnamed women, black and white, who 'disappear' into legend in Western discourse. Edmonia Lewis (1843–?), the African-Ojibwe-American sculptor, was one. No one appears to know what happened to her after Frederick Douglass saw her last, though recent research has extended the trail to a visitors' book at the American Embassy in Rome in the early 1900s. Juanita Marie Holland, 'Mary Edmonia Lewis: The Hierarchy of Gender and Race', paper given at the CAA Annual Conference, Seattle, 1993.
68 Starkie, p. 346.
69 Carter, p. 22. Here is perhaps the return of the repressed – the mammy rag that will collapse *Jeanne* back into *Laure*, and thus return her to her role as 'negress', as slave, as black.
70 *Ibid.*
71 *Ibid.*
72 There is the oil painting (90 x 113cm): *Repose* is 148 x 113cm and the *Young Woman Reclining* is 94 x 113cm (a possible companion piece) and a tiny study in watercolour (16. 7 x 23. 8cm). Some speculate that the painting was in fact given to Baudelaire, who had two works by Manet in his rooms in 1866–7, but that it was returned to Manet after the poet's death. Never hung in the studio, the painting was found after Manet's death in 1883 and collected with a series of 'painted studies'.
73 Tabarant, p. 56.
74 *Ibid.*
75 The series in Manet's oeuvre of the theme of the reclining woman and the woman in white includes: *Reading: Mme Maîtret and Leon Leenhof* (1866–75); *The Balcony* (1868); *Repose* (1870); *Portrait of Eva Gonzales* (1870); *In the Garden (Edme Pontillon)* (1870).
76 Starkie, p. 345.
77 *Ibid.*
78 Françoise Cachin, entry on *Baudelaire's Mistress, Reclining*, item 27 in Cachin, p. 97.
79 J. E. Blanche, *Manet* (Paris: Rider, 1924), p. 36.
80 F. Fénéon, *Oeuvres plus que complets*, ed. J. U. Halperin (Geneva, 1970), 1, p. 102.
81 Tabarant, p. 79.
82 Simone Delesalle and Lucette Valensi, 'Le Mot "Nègre" dans les dictionnaires françaises de l'Ancien Régime', *Langue Française*, 15 (1972) pp. 79–104; Paul Brasseur, 'Le Mot "nègre" dans les dictionnaires encyclopédiques françaises du XIXe siècle', *Cultures et Développements*, 8, 4 (1976), pp. 579–94; Cohen, pp. 130–3.

83 The Song of Songs, 1:5, discussed in Miller, p. 30. As a passing irony, I was preparing this chapter during the Jewish festival of Pesach/Passover during which festival it is tradition to read the Song of Songs, so the voice of the black woman was heard and misheard yet again in the context of her powerful creative presence in the Jewish liturgy. The Beloved speaks to those who are not black: 'Stare not at me that I am swarthy/That the sun has darkened me'. This passage reiterates the assumption of a fundamental state of whiteness, a norm for human beings, some of whom have been *blackened* by the sun. This ancient explanation for difference of skin colour has acquired heavier meanings. For instance in the patristic idea of Christian redemption as a lightening and whitening, an environmental argument is made the justification for a necessary conversion, which will happen metaphorically, leaving the physical signs unchanged – a double bind. There are a number of other instances of colour politics in the Jewish canon which also reveal the symbolism of black and white. For instance Moses marries a Cushite (thought to mean Ethiopian) woman, for which he is rebuked by Miriam and Aaron. Miriam is punished for questioning the actions of her brother by being afflicted with a kind of short-term leprosy, which turns her white as snow (Numbers 12). There, whiteness is a negatively connoted state, unnatural, diseased. (Cf. Leviticus 13 on leprosy as a disease indicated by whiteness.)

84 Edwin Long's painting *The Babylonian Marriage Market* (1882, Egham, Royal Holloway College) dramatically underlined this disjunction by representing, in a frieze along the foreground, women in descending order of beauty starting with a Caucasian and concluding with an African woman, whom he placed outside the market as a servant to the potential brides.

85 I am indebted to Louise Parsons in her work on the relations in representation between black women and white women for this juxtaposition: *Revolutionary Poetics: A Kristevan Reading of Sally Potter's Gold Diggers*, Ph.D. thesis, University of Leeds, 1993.

86 Lucy Fisher, ed., *Imitation of Life: Douglas Sirk, Director* (New Brunswick: Rutgers University Press, 1991). The film is based on a novel of this title by Fannie Hurst, which was made into a film by John Stahl in 1934. Fannie Hurst lived with the novelist and writer Zora Neale Hurston, whom she originally hired as a live-in secretary.

87 Sander Gilman's work on this painting traces associations between sexuality, degeneration and race and suggests that the coincidence of the black woman with the white woman functions to inflect the latter with notions of degenerate and excessive sexuality ('Black Bodies, White Bodies'). This reading is now taken on board in ways in which T. J. Clark's analysis of the class issues of the painting is not; see S. Eisenman, *Nineteenth Century Art: A Critical History* (London: Thames & Hudson, 1994). Yet Mieke Bal reveals how much projection is required to see the figure of Laure as diseased or sexualised in Manet's painting, p. 206.

88 Emile Zola, 'Une nouvelle manière en peinture: Edouard Manet', *L'Artiste: Revue du XIXe siècle*, 1 (January 1867), reissued Paris: Dentu, 1867, as a pamphlet to accompany Manet's private exhibition coinciding with the Exposition Universelle in Paris. Reprinted in translation in Theresa Ann Gronberg, *Manet: A Retrospective* (New York: Hugh Lauter Levin Associates, Inc., 1988), pp. 62–96.

89 Of course, this is an anachronistic statement since a critical discourse called formalism did not exist in the mid-nineteenth century and was not possible to imagine at this point. The transformation we name modernism was a cultural politics which, reconfiguring the relations of signifier and referent under specific historical conditions, made the ideology of formalism possible. Formalist critics like Roger Fry and Georges Bataille drew support for their claim to Manet's indifference to subject matter from a misreading of Zola's case in 1867.

90 Zola, in Gronberg, pp. 75–6.

91 There are two breaks in this white expanse. The bed linen is caught up on the left to reveal the rich brown/red of the mattress which echoes the patterned colour of the wall-paper above it, beyond the face of the reclining woman. On the right end of the bed, the pearly shawl with its colourful tracery of delicately embroidered floral designs and golden fringe hangs over the edge of the bed almost to the bottom of the canvas – abruptly

meeting a thin line of brown paint probably representing the mattress and thus balancing the exposed portion on the left.

92 Such a reading is made explicit in Cézanne's parodic *A Modern Olympia* (1873–5, Paris, Musée d'Orsay), in which the black maid is pulling away the shawl to reveal the nude white woman to the male client who is now included in the painting.

93 Dawkins, p. 68.

94 See the previous chapter for another comment on this dress. I am grateful to Crystal Hart for conversation about servants' costumes and second-hand clothes markets.

95 The body was compared to a cadaver by contemporary critics: T. J. Clark cites a critic called Ego, writing in *Le Monde Illustré* – 'her body has the livid tint of a cadaver displayed in the morgue' – and a comment by Victor Fornel: '[she was exposed] like a corpse on the counters at the morgue, this Olympia from the Rue Mouffetard, dead of yellow fever and already arrived at an advanced state of decomposition'. T. J. Clark, *The Painting of Modern Life: Paris in the Art of Manet and His Followers* (London: Thames & Hudson; New York: Knopf, 1984), pp. 96–7.

96 It is difficult to know what to call the head-dress. Tabarant, writing of the portrait of Laure I shall mention shortly, describes her wearing a 'madras', which Littré's *Dictionnaire de la langue française* (Paris: Hachette, 1882) defines as 'A kind of handkerchief made out of satin and cotton which are made in India and whose colours are bright and intense. Imitations in France are made out of cotton.' The origin of the word is the city of Madras. Others have referred to a *toque*, which is a French word for a special kind of hat worn by judges and jockeys somewhere between a helmet and a ceremonial hat. The most developed analyses of the head wrap I have found so far have concerned the history of its use and meanings in the African American communities. I am grateful to Helen Bradley Griebel for sharing her work with me: *New Raiments of the Self: African American Clothing in the AnteBellum South*, Ph.D. thesis, University of Pennsylvania, 1994 (Minneapolis: Berg, 1998).

97 T. J. Clark, 'Preliminaries to a Possible Treatment of Manet's *Olympia* in 1865', *Screen*, 21, 1 (1980), p. 33.

98 This argument was first mentioned in my *Avant-garde Gambits: Gender and the Colour of Art History* (London: Thames & Hudson, 1992), pp. 21–5. The term 'orientalism' derives from the work of Edward Said, *Orientalism* (London: Routledge, 1978). Orientalism in painting has been the topic of several major, though uncritical, exhibitions, for instance Donald Rosenthal, *Orientalism: The Near East in French Painting 1800–1880* (University of Rochester Memorial Art Gallery, 1982), and Mary Ann Stevens, *The Orientalists: Delacroix to Matisse* (London, Royal Academy, 1984); Philippe Jullian, *The Orientalists* (Oxford: Oxford University Press, 1977). For a critical review of the thematic in the visual arts see Linda Nochlin, 'The Imaginary Orient', in *The Politics of Vision* (London: Thames & Hudson, 1991), pp. 33–59.

99 Antonin Proust wrote in his memoir of Manet: '[he] went almost everyday to the Tuileries between two and four o'clock, creating studies in the open air, under the tress, representing the children that played and the groups of nursemaids that lounged in the chairs. Baudelaire was his customary companion. Strollers regarded with curiosity the elegantly attired painter who set up his canvas.' Antonin Proust, 'Edouard Manet: Souvenirs', *La Revue Blanche*, Feburary–May 1897, pp. 170–1.

100 It seems that Manet was exploring a major painting in the early 1860s involving the nude – and a clothed attendant. Starting with the Apocryphal story of Susanna and the Elders, transforming it into the biblical tale of The Finding of Moses, he prepared a painting in which a seated female nude is attended by a darker-skinned, dressed servant, *Study for The Surprised Nymph* (1860/1, Oslo Nasjonalgalleriet). This darker woman has been rediscovered through X-ray study in a reworked version, retitled *Nymph and Satyr* when exhibited in St Petersburg in 1861, known since 1867 as *The Surprised Nymph* (1859–61, Buenos Aires, Museo Nacional de Bellas Artes). Note also the drawing *After the Bath* (1860/1 Chicago, the Art Institute of Chicago), where the attendant is both drawn and effaced by crude but heavy hatching strokes which render her a dark area, a frame for the

detailed and luminous white nude body in the first plane of the drawing. In the etching *The Toilette* (1861) associated with this project, the dark-skinned attendant turns her back to the female nude, now clutching a cloth to cover her exposed body. All we can discern behind the head of the foreground figure is the tie of the attendant's headwrap.

101 Kenneth Clark, *The Nude: A Study in Ideal Art* (London: John Murray, 1956); Beatrice Farwell, *Manet and the Nude: A Study in the Iconography of the Second Empire* (New York and London: Garland Publishers, 1981); T. J. Clark, 'Preliminaries', pp. 38–9. The later version of this argument published in his 1984 book concludes that the radical character of the painting lies in the fact that her nakedness does articulate a class identity. The problem raised here is the exclusiveness of the categories and the implied hierarchy between class as the major struggle and other relations of social power such as gender, race and sexuality as minor. I would argue that we can diminish the material and ideological force of none of these forms of social exploitation and oppression and can get at effective critique only by trying to articulate their always complex relationships and mutual inflections. Slavery, as C. L. R. James and many others have argued, was one of the major economic foundations for Western capitalism, and its abolition was not simply the victory of humanity and conscience but rather resulted from shifts in capitalism itself, in which proletarianised wage labour promised to be more profitable than slaves who required no wages but equally without them could not consume and thus further expand capitalist markets. See C. L. R. James, *The Black Jacobins* (London: Allison & Busby, 1980), pp. 51–4.

102 *Ibid.*

103 Homi Bhabha, 'The Other Question: The Stereotype and Discourse', *Screen*, 24, 6 (1983) pp. 18–36.

104 James, p. 47.

105 Robert L. Stein, *The French Slave Trade in the Eighteenth Century* (Madison: University of Wisconsin Press, 1970); Philip O. Curtin, *The Atlantic Slave Trade* (Madison: University of Wisconsin Press, 1970).

106 David Dabydeen, *Hogarth's Blacks* (Manchester: Manchester University Press, 1987); Fred Wilson, *Mining the Museum* (Baltimore: Maryland Historical Society, 1993).

107 *L'Artiste*, 3 (1858), p. 456. It was in the Verons Sale in 1858 and was sold for the considerable sum of 14,000 francs. In her intervention through reworking Hogarth's painting *The Countess's Levée* from the series *Marriage à La Mode* as representative of a national moment in British art and history into the present configuration of ideological and political conflict, Lubaina Himid re-made the figure of the black servant serving coffee to the eager listener in her distractingly brilliant white satin dress into the figure of the black woman artist in the present, and still racist, feminist art world. As a larger than life cut-out, dressed in black, this figure's semiotic identity is a matter not of her 'colour' but of her place and her scale. The real relations of power are those of ownership or servitude and the ways their ideological legacy as racism still structures contemporary relations between artists from the black and white communities. Lubaina Himid uses formal means, scale and position, to make her claim to creative status within the art world and beyond that, in the world of *realpolitik* and real danger. Scale and position also challenge that 'stock character' of black women as the servants of white economies and their cultures by making her the figurative and questioning centre of the allegorical scene.

108 Reff; Cachin, p. 178. The first reference to the Jalabert occurs in François Mathey, *Olympia* (Paris and London: Editions du Chêne and M. Parrish, 1948).

109 There is a sheet of studies for the painting (Paris, Musée du Louvre) which includes a drawing of the African woman, detailing her hand gesture and her headwrap. It is generally thought that this figure was drawn from a model in Paris, as she does not appear in the detailed studies made apparently on the spot when Delacroix was allowed to visit the women's quarters of a private house in Algiers. These studies include the names of the women, transcribed by Delacroix as Mouney Ben Sultane, Beliah, Zera Tuboudje. Some have suggested that the only interiors to which he had access were Jewish and thus these women represent Jewish women. But the names on the drawings and the costumes suggest

that the anecdote of his visit to private women's quarters of a Muslim household in Algiers is acceptable. Jewish women in Delacroix's drawings wore dresses and a special four-cornered head-dress. See Lee Johnson, *The Paintings of Eugène Delacroix 1832–63* (Oxford: Oxford University Press, 1986), plates 196–7. Charles Cournault, who provided the information of Delacroix's visit, recalled being told that there were women *and* children in these apartments. The familial character of women's quarters is always erased to recreate the harem as the space of enclosed sexuality rather than the locus of maternity.

110 This detail of identity in *Odalisque* shows up by contrast to those drawings which examine what a European artist, Ingres, had to offer Manet, where the face of the nude is left disturbingly blank. (See for instance *Study for Olympia*, 1862/3, Paris, Musée du Louvre, Cabinet des Dessins.)

111 Françoise Cachin prefers to date the drawing to the dated etching. She writes, however: 'The romantic, Oriental theme inspired by Ingres and above all by Delacroix, is exceptional in Manet's work, and it was in a quite different spirit that he later painted *The Sultana* (RW I, 175)', p. 191. I endorse the first part of the sentence but question the exceptional character. I suspect it stems from wanting to keep a wedge between Orientalism and modernism proper when it is shown so often that the two are endemically entwined. One of the functions of the modernist canon is to maintain this historically false separation.

112 Zola, in Gronberg, p. 75.

113 On this 'reality effect' (Barthes) see Nochlin, pp. 36–41.

114 Bal, p. 284.

115 Helen Bradley Griebel concludes her analysis with a suggestion that the headwrap has its roots in African adornment of the head and hair in a variety of cultures, and finds its material in the beginnings of trade where human beings were exchanged for woven cloth, often itself from India (Madras). An imposed usage as a sign of bondage in the Americas, and a functional way of preventing hair lice, accrued ideological significance within African American/Caribbean negotiation and resistance to their situation so that a badge of slavery could also be a sign of continuity with a preserved ancestry. See Bradley Griebel.

116 I have a slight problem with chronology here as it seems that many of the obvious paintings in which this conflation of Orientalism and slavery occurs postdate *Olympia* (1863). Of course this trope appears earlier and widely in lithographs and prints that circulate on the edges of public, exhibited and official culture, providing intermediate spaces beween gross pornographies, underground erotica and public discourses on and thus managements of the materials of sexuality and its representation. Heather Dawkins's research into the context of this painting throws this area of sexual representation into the foreground. She has found that the largest body of work which attracted censorship in the 1860s were representations of mixed-race sex scenes or scenes of intimacy between women of mixed race. This she suggests must make us question the overwhelming prostitutionalisation of the painting in most of the readings made of it in recent years. Certainly it is a painting about sexuality – but this other archive to which this painting must refer indicates another set of boundaries or potential transgressions that Manet's project skirted. Not the border between high and low, public and private circulation of sexy scenes, but between licit and illicit, acceptable and obscene, between male and female sexualities which are figured through the trope of colour.

117 I am grateful to Professor Joanne Eichler for conversations about traded textiles in African dress.

118 J. Patrice Marandel, *Frédéric Bazille and Early Impressionism* (Chicago: The Art Institute, 1978), p. 112.

119 This question was made into a series of feminist cartoon drawings by Jackie Fleming in 1978. The young woman in the series first sees a make-up ad and redoes her face; then she sees a fashion ad and reclothes herself *à la mode*; she then visits an art gallery and follows the painting's lead. She undresses and lays herself out in the aesthetic pose, only to be arrested and removed by two burly booted police*men*. The painted series was done

in lieu of an essay for the first feminist lecture course I gave at the University of Leeds.

120 The slave market was a popular subject with Gérôme, who painted just such scenes: see Gerald M. Ackerman, *The Life and Work of Jean-Léon Gérôme* (London: Sotheby's Publications, 1986), nos 79, 162, 217, 222, 328.

121 On this gesture see Nanette Salomon, 'The *Venus Pudica*: Uncovering Art History's "Hidden Agendas" and Pernicious Pedigrees', in *Generations and Geographies in the Visual Arts: Feminist Readings*, ed. Griselda Pollock (London: Routledge, 1996), pp. 69–87.

122 It has been argued that the bare breast symbolises Liberty and that the extended length of the material shows that the subject cannot be a slave. Gislind Nabakowski *et al.*, *Frauen in der Kunst* (Frankfurt am Main: Suhrkamp, 1980), 1, p. 283.

123 McCloy.

124 Gilman.

125 Georges Cuvier, 'Extraits d'observations faites sur le cadavre d'une femme connue à Paris et à Londres sous le nom de Vénus Hottentote', *Mémoires du Musée d'Histoire Naturelle*, 3 (1817), pp. 259–74, reprinted with plates in 1824. Sander lists six publications of autopsies of African women which detailed and often illustrated their genitalia. Two of these were published in 1867 and 1869.

126 I have chosen not to illustrate this famous image, as some attempt not to replicate her exposure. For illustrations and other documents see Paul Edwards and James Walvin, *Black Personalities in the Era of the Slave Trade* (London: Macmillan, 1983).

127 Farwell, *Manet and the Nude*, makes the important point that the reclining nude is traditionally a sleeper and that part of Manet's innovation was precisely to wake her up and make her so alert – confusing the traditional freight of this imagery: the fantasy of voyeuristic viewing of an unconscious nudity. Hence Kenneth Clark's evident alarm about the attachment of so assertive a consciousness to the nude body which can effectively fulfil its visual task only if consciousness is temporarily vacated.

128 Not only has Heather Dawkins affirmed this through her research in the files of censored imagery in the 1860s which showed mixed race scenes of two women, but, in competitive response to this painting, it is thought that Courbet painted *The Sleepers* (1866, Paris, Musée du Petit Palais), a lesbian scene which puts them back to sleep. The work was commissioned by Khalil Bey.

129 According to Littré, *sultane* was already a synonym for prostitute. Manet painted a work with the title *La Sultane* (1871, Zürich, E. G. Bührle Collection), which Charles Moffett suggests should be read as a costumed prostitute. Her diaphanous gown exposes her nudity, yet the artist seems to have tried to invent the signs of ethnic difference in her features to correspond with the divan and the pipe in the foreground. *The Passionate Eye: Impressionist and Other Master Paintings from the E. G. Bührle Collection* (Zürich: Artemis Verlag, 1990), no. 23.

130 Amédée Cantaloube in *Le Journal Amusant*, wrote of 'a sort of female gorilla, a grotesque in india rubber surrounded by black, apes on a bed' and probably the same writer, now named Pierrot, wrote of the woman on a bed 'a sort of monkey making fun of the pose of . . . Titian's Venus'. Cited in Clark, 'Preliminaries' p. 26.

131 See Alain Corbin, 'Commercial Sexuality in Nineteenth Century France: A System of Images and Regulations', *Representations*, 14 (spring 1986), pp. 209–19.

132 Artemisia Gentileschi's representation of Judith with her servant Abra as a young woman marks an earlier resistance to this other trope of young beauty and aged horror as the two faces of womanhood.

Julie Manet, 1894 (daughter to Berthe Morisot), photograph. Paris, Private Collection

EPILOGUE

I want to end with another photograph dating from 1894. Same dress, same face, another woman. Julie Manet, Berthe's daughter . . . but that's another story: or is it? Mothers and daughters and mourning. That's where I began and where I shall end, for now.

Julie Manet after her Marriage, photograph. Paris, Private Collection

317

BIBLIOGRAPHY

Abel, Elizabeth, *Virginia Woolf and the Fictions of Psychoanalysis*. Chicago: University of Chicago Press, 1989.

Achebe, Chinua, 'The Image of Africa', *Research in African Literatures*, 9 (1978), pp. 1–15.

Ackerman, Gerald M., *The Life and Work of Jean-Léon Gérôme*. London: Sotheby's Publications, 1986.

Adams, Hazard, 'Canons: Literary Criteria/Power Criteria', *Critical Inquiry*, 14 (1988), pp. 749–64.

Adhémar, Jean, 'A propos *La Maîtresse de Baudelaire* par Manet (1862), un problème', *Gazette des Beaux Arts* (November 1983), p. 178.

Ahearn, Edward, 'Black Woman, White Poet: Exile and Exploration in Baudelaire's Jeanne Duval Poems', *French Review*, 51 (1977), pp. 212–20.

Aiken, Susan Hardy, 'Women and the Question of Canonicity', *College English*, 48, 3 (March 1986), pp. 288–99.

Alexander, Christine and Sellars, Jane, *The Art of the Brontës*. Cambridge: Cambridge University Press, 1995.

Altieri, Charles, 'An Idea and Ideal of a Literary Canon', *Critical Inquiry*, 10, 1 (1983), pp. 37–59.

Bal, Mieke, *Reading Rembrandt: Beyond the Word–Image Opposition*. Cambridge and New York: Cambridge University Press, 1991.

—— 'Reading Art?' in Griselda Pollock, ed., *Generations and Geographies in the Visual Arts: Feminist Readings*. London: Routledge, 1996, pp. 25–41.

—— *Double Exposures: The Subject of Cultural Analysis*. New York and London: Routlege, 1996.

Bal Mieke and Boer, Inge, eds, *The Point of Theory: Practices of Cultural Analysis*. Amsterdam: University of Amsterdam Press, 1994.

Barthes, Roland, *Mythologies* [1957], trans. Annette Lavers. London: Paladin Books, 1973.

—— 'Deux Femmes/Two Women', in *Mot pour Mot/Word for Word No. 2 Artemisia*. Paris: Yvon Lambert, 1979, pp. 8–13.

Bataille, Marie-Louise and Wildenstein, Georges, *Berthe Morisot: Catgalogue des peintures, pastelles et aquarelles*. Paris: Editions des Etudes et des Documents, 1961.

Baudelaire, Charles, *Curiosités esthétiques*, ed. Henri Lemaître. Paris: Garnier Frères, 1962.

Beckett, Jane and Cherry, Deborah, 'Clues to Events', in Mieke Bal and Inge Boer, ed., *The Point of Theory: Practices of Cultural Analysis*. Amsterdam: University of Amsterdam Press, 1994, pp. 48–55.

Benjamin, Walter, *Charles Baudelaire: A Lyric Poet in the Era of High Capitalism*, trans. Harry Zohn. London: New Left Books, 1973.

Benstock, Sheri, *Women of the Left Bank 1900–40*. London: Virago Press, 1987.

Betterton, Rosemary, 'Mother Figures: The Maternal Nude in the Work of Käthe Kollwitz and Paula Modersohn Becker', in Griselda Pollock, ed., *Generations and Geographies in the Visual Arts: Feminist Readings*. London: Routledge, 1996, pp. 159–79.

Bhabha, Homi, 'The Other Question: The Stereotype and Colonial Discourse', Screen, 24, 6 (1983), pp. 18–36.

Bloom, Harold, *The Anxiety of Influence*. Oxford: Oxford University Press, 1973.

—— *The Western Canon: The Books and Schools of the Ages*. New York: Harcourt Brace, 1994.

Boime, Albert, *The Art of Exclusion: Representing Blacks in the Nineteenth Century*. London: Thames & Hudson, 1990.

Bradley Griebel, Helen, *New Raiments of the Self: African American Clothing in the AnteBellum South*. Minnesota: Berg, 1998.

Brasseur, Paul, 'Le Mot "Nègre" dans les dictionnaires encyclopédiques françaises du XIXe siècle', *Cultures et Développements* 8, 4 (1976), pp. 579–94.

Breeskin, Adelyn, *Mary Cassatt: A Catalogue Raisonné of the Graphic Work* [1948]. Washington, D.C.: Smithsonian Institution Press, 1979.

—— *Mary Cassatt: A Catalogue Raisonné of Oils, Pastels, Watercolours and Drawings*. Washington, D.C. Smithsonian Institution Press, 1970.

Bronfen, Elisabeth, *Over Her Dead Body: Death, Femininity and the Aesthetic*. Manchester: Manchester University Press, 1992.

Broude, Norma and Garrard, Mary D., *Feminism and Art History: Questioning the Litany*. New York: Harper & Row, 1982.

Broun, Elizabeth and Gabhart, Ann, *Old Mistresses*. Baltimore: Walters Art Gallery, 1972.

Brownmiller, Susan, *Against Our Will: Men, Women and Rape*. London: Secker & Warburg, 1975.

Bruns, Gerald, 'Canon and Power in the Hebrew Scriptures', *Critical Inquiry*, 10, 3 (1984), pp. 462–80.

Buci-Glucksman, Christine, 'Catastrophic Utopia: The Feminine as Allegory of the Modern', *Representations*, 14 (1986), pp. 221–9.

Cachin, Françoise, *Manet 1832–1883*. Paris: Réunion des Musées Nationaux, 1983.

Carter, Angela, *Black Venus and Other Stories*. London: Picador, 1985.

Caruth, Cathy, ed., *Trauma: Explorations in Memory*. Baltimore and London: Johns Hopkins University Press, 1995.

—— *Unclaimed Experience: Trauma, Narrative and History*. Baltimore and London: Johns Hopkins University Press, 1996.

Citron, Marcia, *Gender and the Musical Canon*. Cambridge: Cambridge University Press, 1993.

Cixous, Hélène, 'The Laugh of the Medusa' [1975], trans. Keith and Paula Cohen, *Signs*, 1–4 (1976), 875–93. Reprinted in Elaine Marks and Isabel de Courtivron, ed., *New French Feminisms*. Brighton: Harvester Press, 1981, pp. 245–64.

—— 'Castration or Decapitation?', trans. Annette Kuhn, *Signs*, 7, 1, (1981), pp. 41–55.

Clark, Kenneth, 'What is a Masterpiece?', *Portfolio* (February/March 1980), pp. 42–53.

Clark, T. J., 'Preliminaries to a Possible Treatment of Manet's *Olympia* in 1865', *Screen*, 21, 1 (1980), pp. 18–41.

—— *The Painting of Modern Life: Paris in the Art of Manet and his Followers*. New York and London: Knopf and Thames & Hudson, 1984.

Clayson, Hollis, *Painted Love: Prostitution in the French Art of Impressionism*. New Haven and London: Yale University Press, 1991.

Cohen, William B., *The French Encounter with Africans: White Responses to Blacks 1530–1880*. Bloomington: Indiana University Press, 1980.

Conrad, Joseph, *Heart of Darkness* [1902]. Harmondsworth: Penguin Books, 1983.

Corbin, Alain, 'Commercial Sexuality in Nineteenth Century France: A System of Images and Regulations', *Representations*, 14 (Spring 1986), pp. 209–19.

Crépet, Jacques, 'Charles Baudelaire et Jeanne Duval', *La Plume*, 10 (15 April 1898), pp. 242–4.

—— 'Une femme à enterrer', in *Propos sur Baudelaire*. Paris: Mercure de France, 1927, pp. 149–55.

Curtin, Philip O., *The Atlantic Slave Trade*. Madison: University of Wisconsin Press, 1970.

Dabydeen, David, *Hogarth's Blacks*. Manchester: Manchester University Press, 1987.

Davidoff, Leonore, 'Class and Gender in Victorian England', in Judith L. Newton *et al.*, ed., *Sex and Class in Women's History*. London: Routledge, 1983, pp. 17–71.

Davidson, Bernice, 'Repose: A Portrait of Berthe Morisot by Manet', *Rhode Island School of Design Bulletin*, 46 (1959), pp. 5–10.

Dawkins, Heather, *Sexuality, Degas and Women's History*. Unpublished Ph.D. thesis, University of Leeds, 1991.

—— 'Frogs, Monkeys and Women: A History of Identifications across a Phantastic Body', in Richard Kendall and Griselda Pollock, eds, *Dealing with Degas: Representations of Women and the Politics of Vision*. London: Pandora Books, 1992. Now London: Rivers Oram Press, pp. 202–17.

Delesalle, Simone and Valensi, Lucette, 'Le Mot "Nègre" dans les dictionnaires françaises de l'Ancien Régime', *Langue Française*, 15 (1972), pp. 79–104.

Derrida, Jacques, 'Différance', in *Speech and Phenomena and Other Essays on Husserl's Theory of Signs*, trans. David B. Allison. Evanston: Northwestern Press, 1973.

Dolan, Therese, 'Skirting the Issue: Manet's Portrait of *Baudelaire's Mistress Reclining*', *Art Bulletin*, 79, 4 (December 1997), pp. 611–29.

Duncan, Carol, ' Virility and Male Domination in Early Twentieth Century Vanguard Art', *Art Forum* (December 1973), pp. 30–9. Reprinted in Norma Broude and Mary D.Garrard, ed., *Feminism and Art History: Questioning the Litany*. New York: Harper & Row, 1982, pp. 292–313.

Duncan, Carol and Wallach, Alan, 'The Museum of Modern Art as Late Capitalist Ritual: An Iconographic Analysis', *Marxist Perspectives*, 1 (1978), pp. 28–51.

Duret, Théodore, *Histoire d'Edouard Manet et son oeuvre*. Paris: Flammarion, 1927.

Edelman, Hope, *Motherless Daughters: The Legacy of Loss*. New York: Delta, 1994.

Edelstein, Teri J., *Perspectives on Morisot*. New York; Hudson Hills Press, 1990.

Edwards, Paul and Walvin, James, *Black Personalities in the Era of the Slave Trade*. London, Macmillan, 1983.

Ellis, John, 'On Pornography', *Screen*, 21, 1 (1980), pp. 81–108.

Ewbank, Inge-Stina, 'Transmigrations of Cleopatra', *University of Leeds Review*, 29 (1986/7), pp. 61–78.

Ezell, Margaret J.M., 'The Myth of Judith Shakespeare: Creating the Canon of Women's Literature', *New Literary History*, 21, 11 (1990), pp. 579–92.

Fanon, Frantz, *Black Skins/White Masks* [1952]. London: Pluto Press, 1986.

Farwell, Beatrice, *Manet and the Nude: A Study in the Iconography of the Second Empire*. New York and London: Garland Publishers, 1981.

—— 'Manet, Morisot and Propriety', in Teri J. Edelstein, ed., *Perspectives on Morisot*. New York: Hudson Hills Press, 1990, pp. 45–56.

Felman, Shoshana, *What Does a Woman Want? Reading and Sexual Difference*. Baltimore and London: Johns Hopkins University Press, 1993.

Felman, Shoshana and Laub, Dori, *Testimony: Crises of Witnessing in Literature, Psychoanalysis, and History*. New York and London: Routledge, 1992.

Fetterly, Judith, *The Resistant Reader: A Feminist Approach to American Literature*. Bloomington: Indiana University Press, 1977.

Fine, Amy M., 'Portraits of Berthe Morisot: Manet's Modern Images of Melancholy', *Gazette des Beaux Arts*, 110 (1987), pp. 17–20.

Fisher, Jean, 'Editorial: Some Thoughts on Contamination', *Third Text*, 32 (1995), pp. 3–8.

Foucault, Michel, *The History of Sexuality Volume 1: An Introduction*, [1976] trans. Robert Hurley. Harmondsworth: Penguin Books, 1979.

Fox-Genovese, Elizabeth, 'The Claims of a Common Culture: Gender, Race, Class and the Canon', *Salmagundi*, 72, (1986), pp. 131–43.

Frelinghuysen, Alice C. *et al.*, *Splendid Legacy: The Havemeyer Collection*. New York: Metropolitan Museum of Art, 1993.

Freud, Sigmund, 'Creative Writers and Daydreaming' [1908], in *Art & Literature*, *Penguin Freud Library* 14. Harmondsworth: Penguin Books, 1985, pp. 129–42.

—— 'Leonardo da Vinci and a Memory of His Childhood' [1910], in *Penguin Freud Library*, 14. Harmondsworth: Penguin Books, 1985, pp. 143–232.

—— 'On the Universal Tendency to Debasement in the Sphere of Love' [1912], in *On Sexuality*, *Penguin Freud Library*, 7. Harmondsworth: Penguin Books, 1977, pp. 243–60.

—— 'Mourning and Melancholia' [1917], in *On Metapsychology*, *Penguin Freud Library*, 11. Harmondsworth: Penguin Books, 1984, pp. 245–68.

—— *New Introductory Lectures* [1933]. *Penguin Freud Library*, 2. Harmondsworth: Penguin Books, 1973.

Freud, Sigmund and Breuer, Josef, *Studies in Hysteria* [1895]. *Penguin Freud Library*, 3. Harmondsworth: Penguin Books, 1991.

Fuss, Diana, 'Reading like a Feminist', *Differences* 1, 2 (1989), pp. 77–92.

Gallop, Jane, *Feminism and Psychoanalysis: The Daughter's Seduction*. London: Macmillan, 1982.

—— 'Annie Leclerc Writing a Letter, with Vermeer', *October* 33 (1985), pp. 103–18.

Garb, Tamar, 'Renoir and the Natural Woman', *Oxford Art Journal*, 8, 2, (1985), pp. 3–15.

—— *Sisters of the Brush: Women's Artistic Culture in Late Nineteenth Century Paris*. New Haven and London: Yale University Press, 1994.

Garber, Marjorie, 'Bisexuality and Vegetable Love', in Lee Edelman and Joseph Roach, eds, *Public Fantasies*. London and New York: Routledge, 1998.

Garrard, Mary D., *Artemisia Gentileschi: The Image of the Female Hero in Baroque Art*. Princeton: Princeton University Press, 1989.

Gates, Henry Louis Jnr., ed., *'Race,' Writing and Difference*. Chicago: University of Chicago Press, 1989.

—— *Loose Canons: Notes on the Culture Wars*. New York and Oxford: Oxford University Press, 1992.

Genné, Beth, 'Two Self Portraits by Berthe Morisot', in M. Mathews Edo, ed., *Psychoanalytical Perspectives* (Hillside, N.J., 1987), 2 (1987), pp. 133–70.

Gilman, Sander, 'Black Bodies, White Bodies: Toward an Iconography of Female Sexuality in Late Nineteenth Century Art, Medicine and Literature', in Henry Louis Gates, Jnr., ed., *'Race,' Writing and Difference*. Chicago: University of Chicago Press, 1989, pp. 233–61.

Gorak, Jan, *The Making of the Modern Canon: Genesis and Crisis of a Literary Idea*. London: Athlone Press,1991.

Gould, Stephen Jay, 'The Hottentot Venus', *Natural History*, 91. (1982), pp. 20–7.

Graham-Brown, Sarah, *Images of Women: The Portrayal of Women in Photography in the Middle East 1860–1950*. London: Quartet Books, 1988.

Gronberg, Theresa Ann, *Manet: A Retrospective*. New York: Hugh Lauter Levin Associates Inc., 1988.

Grosz, Elizabeth, *Sexual Subversions: Three French Feminists*. Sydney: Allen & Unwin, 1989.

—— *Volatile Bodies: Towards a Corporeal Feminism*. Bloomington: Indiana University Press, 1994.

Guilbert, Yvette. *The Song of My Life: My Memories*, trans. Béatrice de Holthoir. London: George Harrap & Co., 1929.

Guillory, John, 'Canonical and Non-Canonical: A Critique of the Current Debate', *English Literary History*, 54, 3. (1987), pp. 483–527.

Hamer, Mary, *Signs of Cleopatra*. London: Routledge, 1993.

Hallberg, Robert Von, *Canons*. Chicago: Chicago University Press, 1984.

Hamilton, George H., *Manet and His Critics*. New York: Norton & Co., 1969.

Hartigan, Lynda Roscoe, *Sharing Traditions: Five Black Women Artists in Nineteenth Century America*. Washington, D.C.: Smithsonian Institution Press, 1985.

Havemeyer, Louisine, *From Sixteen to Sixty: Memoirs of a Collector* [1930]. New York: Metropolitan Museum of Art, 1993.

Higgonet, Anne, *Berthe Morisot*. Berkeley: University of California Press, 1990.

—— *Berthe Morisot and Images of Women*. Cambridge, Mass.: Harvard University Press, 1992.

Himid, Lubaina, 'In the Woodpile: Black Women Artists and the Modern Woman', *Feminist Art News*, 3, 4 (1990), pp. 4–5.

—— *Revenge: A Masque in Five Tableaux*. Rochdale: Rochdale Art Gallery, 1992.

Hirsch, Marianne, *The Mother–Daughter Plot: Narrative, Psychoanalysis and Feminism*. Bloomington: Indiana University Press, 1989.

Hirst, Paul and Woolley, Penny, *Social Relations and Human Attributes*. London: Tavistock, 1982.

Holland, Juanita Marie, 'Mary Edmonia Lewis: The Hierarchy of Gender and Race', paper given at College Art Association Conference, Seattle, 1993.

Hughes-Hallett, Lucy, *Cleopatra: Histories, Dreams, Distortions*. London: Bloomsbury, 1989.

Irigaray, Luce, 'This Sex Which Is Not One', 'Commodities Among Themselves', in *This Sex which Is Not One*, trans. Catherine Porter. Ithaca: Cornell University Press, 1985, pp. 23–33; 192–7.

—— 'The Bodily Encounter with the Mother' Margaret Whitford, ed., *The Irigaray Reader*. Oxford: Basil Blackwell, 1991, pp. 34–47.

Jameson, Fredric, 'Postmodernism or the Cultural Logic of Late Capitalism', *New Left Review*, 146 (July–August 1984), pp. 53–93.

—— *Postmodernism or, The Cultural Logic of Late Capitalism*. London and New York: Verso Books, 1991.

Jardine, Lisa, *Still Harping on Daughters: Women and Drama in the Age of Shakespeare*. Brighton: Harvester Press, 1983.

Jones, Amelia, *Sexual Politics: Judy Chicago's Dinner Part in Feminist Art History*. Los Angeles: University of California Press, 1996.

Jullian, Philippe, *The Orientalists*. Oxford: Oxford University Press, 1977.

—— *Montmartre*, trans. Anne Carter. Oxford: Phaidon, 1977.

Kamuf, Peggy, 'Writing Like a Woman', in Sally McConnell-Ginet, Ruth Borker and Nelly Furman, ed., *Women and Language in Literature and Society*. New York: Praeger, 1980, pp. 284–99.

Kaplan, Cora, *Sea Changes: Essays on Culture and Feminism*. London: Verso, 1986.

Kelly, Mary, 'Reviewing Modernist Criticism', *Screen*, 22, 3 (1981), pp. 41–62 . Reprinted in *Imaging Desire*. Boston: MIT Press, 1996, pp. 80–106.

Kendall, Richard and Pollock, Griselda, eds, *Dealing with Degas: Representations of Women and the Politics of Vision*. London: Pandora Books, 1992. Now London: Rivers Oram Press.

Kofman, Sarah, *The Enigma of Woman: Woman in Freud's Writings*, trans. Catherine Porter. Ithaca: Cornell University Press, 1985.

—— *The Childhood of Art: An Interpretation of Freud's Aesthetics*, trans. Winifred Woodhull. New York: Columbia University Press, 1988.

Kristeva, Julia, 'The System and the Speaking Subject' [1973], in Toril Moi, ed., *The Kristeva Reader*. Oxford: Basil Blackwell, 1986, pp. 24–33.

—— 'La Femme ce n'est jamais ça' [1974], in Elaine Marks and Isabel de Courtivron, eds, *New French Feminisms*. Brighton: Harvester Press, 1981, pp. 137–41.

—— 'Women's Time' [1979], in Toril Moi, ed., *The Kristeva Reader*. Oxford: Basil Blackwell, 1986, pp. 187–213.

—— *Desire in Language*, trans. Leon Roudiez. New York: Columbia University Press, 1980.

—— *Strangers to Ourselves* [1988], trans. Leon Roudiez. New York: Columbia University Press, 1991.

Lacan, Jacques, *Ecrits: A Selection*, trans. Alan Sheridan. London: Tavistock, 1977.

—— *The Ethics of Psychoanalysis 1959–1960*, ed. Jacques-Alain Miller, trans. Dennis Porter. London and New York: Routledge, 1992.

LaCapra, Dominick, 'Rethinking Intellectual History and Reading Texts', *History and Theory*, 19 (1980), pp. 245–76.

—— 'Canons, Texts and Contexts', in *Representing the Holocaust: History, Theory and Trauma*. Ithaca: Cornell University Press, 1994.

Laplanche, J. and Pontalis, J.B., *The Language of Psychoanalysis*. London: Karnac Books, 1973.

Lauretis, Teresa de, *Technologies of Gender: Essays on Theory, Film and Fiction*. London: Macmillan, 1987.

Lauter, Paul, *Canons and Contexts*. Oxford and New York: Oxford University Press, 1991.

Levi, Primo, *The Drowned and the Saved*. London and New York: Simon & Schuster, 1988.

Lewis, Reina, *Gendering Orientalism: Race, Femininity and Representation*. London and New York: Routledge, 1996.

Lichtenberg Ettinger, Bracha, 'Matrix and Metramorphosis', *Differences*, 4, 3, (1992), pp. 176–207.

—— *Matrix Borderlines*. Oxford: Museum of Art, 1993.

—— *The Matrixial Gaze*. Leeds: Feminist Arts and Histories Network Press at the University of Leeds, 1994.

—— 'Matrixial Borderspace in Subjectivity as Encounter', in John Welchman, ed., *Rethinking Borders*. London: Macmillan Academic, 1996.

—— 'The With-In-Visible Screen', in Catherine de Zegher, ed., *Inside the Visible: An Elliptical Traverse of Twentieth Century Art in, if and from the feminine*. Boston: MIT Press, 1996.

Lipton, Eunice, *Alias Olympia*. London: Thames & Hudson, 1992.

Loyrette, Henri, *The Origins of Impressionism*. Paris: Réunion des Musées Nationaux, 1994.

McCloy, Shelby T., *The Negro in France*. Louisville: University of Kentucky Press, 1961.

McNelly, Cleo, 'Nature, Women and Claude Lévi-Strauss', *Massachusetts Review*, 26 (1975), pp. 7–29.

Marandel, J. Patrice, *Frédéric Bazille and Early Impressionism*. Chicago: Art Institute of Chicago, 1978.

Marks, Elaine and de Courtivron, Isabel, eds, *New French Feminisms*. Brighton: Harvester Press, 1981.

Marx, Karl, *The Eighteenth Brumaire of Louis Napoleon* [1852], in Karl Marx and Friederich Engels, *Selected Works in One Volume*. London: Lawrence & Wishart, 1970, pp. 96–226.

Mathews, Nancy Mowll, *Mary Cassatt and the 'Modern Madonna' of the Nineteenth Century*. Unpublished Ph.D. dissertation, New York University, 1980.

—— *Mary Cassatt*. New York: Harry N. Abrams, Inc., 1987.

—— *Mary Cassatt: A Life*. New York: Villard Books, 1994.

Mathews, Nancy Mowll, ed. *Mary Cassatt: A Retrospective*. New York: Hugh Lauter Levin Associates Inc., 1996.

—— *Cassatt and Her Circle: Selected Letters*. New York: Abbeville Press, 1984.

Menzio, Eve, 'Self Portrait in the Guise of "Painting" ' in *Mot pour Mot/ Word for Word. No. 2 Artemisia*. Paris: Yvon Lambert, 1979, pp. 16–43.

Metz, Christian, *Psychoanalysis and Cinema: The Imaginary Signifier*. London: Macmillan, 1982.

Miller, Christopher, *Blank Darkness: Africanist Discourse in French*. Chicago: University of Chicago Press, 1985.

Miller, Nancy K., 'Re-reading as a Woman: The Body in Practice', in Susan R. Suleiman, ed., *The Female Body in Western Culture: Contemporary Perspectives*. Cambridge, Mass. and London: Harvard University Press, 1988, pp. 354–62.

Montrelay, Michèle, 'Inquiry into Femininity', trans. Parveen Adams, *M/F*, 1 (1978), pp. 83–102.

Moreno, Shirley, *The Absolute Mistress: The Historical Construction of the Erotic in Titian's 'Poesie'*. Unpublished M.A. thesis, University of Leeds, 1980.

Morgan, Jill, 'Women Artists and Modernism', in Lubaina Himid, *Revenge*. Rochdale: Rochdale Art Gallery, 1992, pp. 17–25.

Morrison, Toni, *Playing in the Dark: Whiteness and the Literary Imagination*. Cambridge, Mass. and London: Harvard University Press, 1992.

Mulvey, Laura, *Visual and Other Pleasures*. London: Macmillan, 1989.

Nadar [Félix Tournachon], *Charles Baudelaire intime; le poête vierge*. Paris: Blaizot, 1911.

Nochlin, Linda, 'Why Have There Been No Great Women Artists?', in Thomas B. Hess and Elizabeth C. Baker, ed., *Art & Sexual Politics*. New York and London: Collier Macmillan, 1973.

—— 'The Imaginary Orient', in *The Politics of Vision: Essays on Nineteenth Century Art and Society*. London: Thames & Hudson, 1991.

—— 'A House Is Not a Home: Degas and the Subversion of the Family', in Richard Kendall and Griselda Pollock, eds, *Dealing with Degas: Representations of Women and the Politics of Vision*. London: Pandora Books, 1992. Now London: Rivers Oram Press, pp. 43–65.

Oliver, Kelly, *Reading Kristeva: Unravelling the Double Bind*. Bloomington: Indiana University Press, 1993.

Orton, Fred and Pollock, Griselda, eds, *Avant-gardes and Partisans Reviewed*. Manchester: Manchester University Press, 1996.

Parker, Rozsika, *The Subversive Stitch: Embroidery and the Making of the Feminine*. London: Women's Press, 1984.

Parker, Rozsika and Pollock, Griselda, *Old Mistresses: Women, Art & Ideology* [1981]. London: Pandora Books, 1981, new ed. 1996. Now London: Rivers Oram Press.

Parsons, Louise, *Revolutionary Poetics: A Kristevan Reading of Sally Potter's Gold Diggers*. Unpublished Ph.D. thesis, University of Leeds, 1993.

Perlingieri, Illya Sandra, *Sofonisba Anguissola*. New York: Rizzoli, 1992.

Pichois, Claude, *Baudelaire: Etudes et témoignages*. Neuchâtel: La Baconnière, 1967.

—— *Baudelaire*, trans. Graham Robb. London: Hamish Hamilton, 1989.

Pointon, Marcia, 'Artemisia Gentileschi's, *The Murder of Holofernes*', *American Imago*, 38 (1981), pp. 343–67.

Pollock, Griselda, *Vision and Difference: Feminism, Femininity and the Histories of Art*. London: Routledge, 1988.

—— 'Painting, Feminism, History', in Michelle Barrett and Anne Phillips, eds, *Destabilising Theory: Contemporary Feminist Debates*. Cambridge: Polity Press, 1992, pp. 138–76.

—— *Avant-garde Gambits: Gender and the Colour of Art History*. London: Thames & Hudson, 1992.

—— 'Critical Critics and Historical Critiques or the Case of the Missing Women (On Mary Cassatt's *Reading Le Figaro*)', *University of Leeds Review*, 36 (1993/4), pp. 211–45. Reprinted in Griselda Pollock, *Looking Back to the Future: Essays from the 1990s*. New York: G&B Arts International, 1999.

—— 'Territories of Desire: Reconsiderations of an African Childhood', in George Robertson *et al.*, eds, *Travellers' Tales: Narratives of Home and Displacement*. London: Routledge, 1994, pp. 63–92.

—— 'The Ambivalence of the Maternal Body: Psychoanalytical Readings of the Legend of Van Gogh', *International Journal of Psychoanalysis*, 75, 4, (1994), pp. 802–13.

—— 'Killing Men and Dying Women: A Woman's Touch in the Cold Zone of American Painting in the 1950s: A Short Book in Ten Chapters', in Fred Orton and Griselda Pollock, eds, *Avant-gardes and Partisans Reviewed*. Manchester: Manchester University Press, 1996, pp. 219–94.

—— *Vincent van Gogh and Dutch Art: A Study of Van Gogh's Notion of the Modern*. Unpublished Ph.D. thesis, University of London, 1980. To appear as *The Case Against Van Gogh: The Cities and Countries of Modernism*. London: Thames & Hudson, 1999.

Pollock, Griselda, ed., *Generations and Geographies in the Visual Arts: Feminist Readings*. London: Routledge, 1996.

Rabinow, Rebecca A., 'The Suffrage Exhibition of 1915', in Alice C. Frelinghuysen *et al.*, eds, *Splendid Legacy: The Havemeyer Collection*. New York: Metropolitan Museum of Art, 1993, pp. 89–98.

'Rethinking the Canon' (special issue), *Art Bulletin*, 78, 2 (June 1996).

Rich, Adrienne, *Of Woman Born: Motherhood as Experience and Institution*. New York: Norton Press, 1976.

—— *On Lies, Secrets and Silence*. London: Virago Press, 1980.

Rifkin, Adrian, 'Art's Histories', in Al Rees and Frances Borzello, ed., *The New Art History*. London: Camden Press, 1986, pp. 157–63.

—— *Street Noises: Parisian Pleasures*. Manchester: Manchester University Press, 1993.

Riley, Denise, *Am I That Name? Feminism and the Category of 'Woman'" in History*. London: Macmillan, 1988.

Rivkin, Ellis, *The Shaping of Jewish History: A Radical New Interpretation*. New York: Scribner, 1971.

Robinson, Lillian, 'Treason Our Test: Feminist Challenges to the Literary Canon', *Tulsa Studies in Women's Literature*, 2 (1983), pp. 83–98.

Rosenthal, Donald, *Orientalism: The Near East in French Painting 1800–1880*. Rochester: University of Rochester Memorial Art Gallery, 1982.

Rouart, Denis, *The Correspondence of Berthe Morisot* [1950], trans. Betty W. Hubbard. Introduction Kathleen Adler and Tamar Garb. London: Camden Press, 1986.

Rubin, Gayle, 'The Traffic in Women: Notes on the "Political Economy" of Sex', in Rayna Reiter, ed., *Towards an Anthropology of Women*. New York: Monthly Review Press, 1975, pp. 157–210.

Said, Edward, *Orientalism*. London: Routledge, 1978.

Salomon, Nanette, 'The Art Historical Canon: Sins of Omission', in Joan Hartmann and Ellen Messer-Davidow, eds, *(En)gendering Knowledge: Feminism in Academe*. Knoxville: University of Tennessee Press, 1991, pp. 222–36.

—— 'The *Venus Pudica*: Uncovering Art History's "Hidden Agendas" and Pernicious Degrees', in Griselda Pollock, eds, *Generations and Geographies in the Visual Arts: Feminist Readings*. London: Routledge, 1996, pp. 69–87.

Sartre, Jean-Paul, 'Class Consciousness in Flaubert', *Modern Occasions*, 1, 2 (1971), pp. 379–89, 587–601.

Scarry, Elaine, *The Body in Pain: The Making and Unmaking of the World*. New York and Oxford: Oxford University Press, 1985.

Sebestyan, Amanda, 'Artemisia Gentileschi', *Shrew* 5, 2 (1973), pp. 1–2.

Segal, Hanna, 'A Psychoanalytical Approach to Aesthetics', in Melanie Klein, ed., *New Directions in Psychoanalysis*. London: Tavistock Publishing, 1955, pp. 384–406.

Shennan, Margaret, *Berthe Morisot: First Lady of Impressionism*. Stroud: Sutton Publishing, 1996.

Silverman, Kaja, *The Acoustic Mirror: The Female Voice in Psychoanalysis and Cinema*. Bloomington: Indiana University Press, 1988.

Silverman van Buren, Jane, *The Modernist Madonna: Semiotics of the Maternal Metaphor*. Bloomington: Indiana University Press, 1989.

Smith, Susan L., *The Power of Women Topics and the Development of Secular Medieval Art*. Unpublished Ph.D. thesis, University of Pennsylvania, 1978.

Smith Rosenberg, Carroll, 'The Female World of Love and Ritual', in *Disorderly Conduct: Visions of Gender in Victorian America*. New York and Oxford: Oxford University Press, 1985.

Spivak, Gayatri Chakravorty, 'French Feminism in an International Frame', *Yale French Studies*, 62 (1981), pp. 154–84. Reprinted in *Other Worlds: Essays in Cultural Politics*. New York and London: Methuen, 1987, pp. 134–53.

—— 'Three Women's Texts and a Critique of Imperialism', *Critical Inquiry*, 12 (1985), pp. 243–61.

—— 'The Rani of Sirmur', *History and Theory*, 24, 3 (1985), pp. 247–72.

—— 'Imperialism and Sexual Difference', *Oxford Literary Review* (*Sexual Difference*), 8, 1–2 (1986), pp. 225–40.

Stallybrass, Peter and White, Allon, *The Politics and Poetics of Transgression*. London: Methuen, 1985.

Starkie, Enid, *Baudelaire*. New York: G.P. Putnam & Sons, 1933.

Steedman, Carolyn, *Landscape for a Good Woman*. London: Virago Press, 1986.

Stein, Robert L., *The French Slave Trade in the Eighteenth Century*. Madison: University of Wisconsin Press, 1970.

Stendhal, Renate, ed., *Gertrude Stein in Words and Pictures*. London: Thames & Hudson, 1995.

Stevens, Mary Anne, *The Orientalists: Delacroix to Matisse*. London: Royal Academy, 1984.

Stuckey, Charles and Scott, William P. with Lindsay, Suzanne, *Berthe Morisot: Impressionist*. New York: Hudson Hills Press, 1987.

Suleiman, Susan R., *The Female Body in Western Culture*. Cambridge, Mass. and London: Harvard University Press, 1988.

Sulter, Maud, *Passion: Discourses on Black Women's Creativity*. Hebden Bridge: Urban Fox Press, 1989.

—— 'Without Tides, No Maps', in Lubaina Himid, *Revenge: A Masque in Five Tableaux*. Rochdale: Rochdale Art Gallery, 1992, pp. 27–35.

Swan, Jim, '*Mater* and Nannie: Freud's Two Mothers and the Discovery of the Oedipus Complex', *American Imago*, 31, 1 (1974), pp. 1–64.

Tabarant, Achille, *Manet et ses oeuvres*. Paris: Gallimard, 1947.

Tawadros, Gilane, 'Beyond the Boundary: Three Black Women Artists in Britain', *Third Text*, 8/9 (1989), pp. 121–50.

Tickner, Lisa, *The Spectacle of Women: Imagery of the Suffrage Campaign 1907–14*. London: Chatto & Windus, 1987.

Walker, Cheryl, 'Feminist Literary Criticism and the Author', *Critical Inquiry*, 16, 3 (1990), pp. 551–71.

Ward Bissell, Richard, 'Artemisia Gentileschi – A New Documented Chronology', *Art Bulletin*, 50, 1 (1968), pp. 153–68.

Wardi, Dina, *Memorial Candles: Children of the Holocaust*, trans. Naomi Goldblum. London and New York: Routledge, 1992.

Weigel, Sigrid, 'From Gender Images to Dialectical Images in Benjamin's Writings', *New Formations – The Actuality of Walter Benjamin*, 20 (1993), pp. 21–32.

Weiss, Andrea, *Paris Was a Woman*. London: Pandora Books, 1996.

Weitzenhoffer, Frances, *The Havemeyers: Impressionism Comes to America*. New York: Harry N. Abrams, 1986.

West, Cornel, 'Minority Discourse and the Pitfalls of Canon Formation', *Yale Journal of Criticism*, 1, 1 (1987), pp. 193–201.

Whitford, Margaret, *The Irigaray Reader*. Oxford: Basil Blackwell, 1991.

Williams, Raymond, *Marxism and Literature*. Oxford: Oxford University Press, 1977.

Wilson, Fred, *Mining the Museum*. Baltimore: Maryland Historical Society, 1993.

Wittig, Monique, 'One Is Not Born a Woman', in Henry Abelove *et al.*, eds, *The Lesbian and Gay Reader*. London and New York: Routledge, 1993.

Woolf, Virginia, *A Room of One's Own* [1928]. Harmondsworth: Penguin Books, 1974.

Zemel, Carol, *Van Gogh's Progress: Utopia, Modernity in Late Nineteenth-century Art*. Berkeley and London: University of California Press, 1997.

Zemon Davis, Natalie, *Society and Culture in Early Modern France*. Stanford: Stanford University Press, 1965.

Zola, Emile. 'Une nouvelle manière en peinture: Edouard Manet', *L'Artiste: Revue du XIXe siècle 1* (January 1867). Reprinted Paris: Dentu, 1867.

—— *Germinal* [1884], trans. Leonard Tancock. Harmondsworth: Penguin Books, 1954.

—— *La Terre* [1888] *Earth*, trans. Ann Lindsay. London: Elek, 1954.

INDEX

Abel, Elizabeth 213
academic institutions: role in creating
 canons 3, 4; special studies and the canon
 6–7, 11, 193; women's presence xiii
Académie Julian 182
Achebe, Chinua 268
Adheémar, Jean 263, 272
Adorno, Theodor 172
aesthetics: Freud on 13–14, 18, 98;
 hierarchies of race, class and gender 25,
 91; Kristeva on 33, 98; of resistance 173;
 and the unconscious 29
Africa: colonial exploitation and slavery
 170–1, 172, 187, 188, 190–1, 255, 277,
 286, 287, 294, 300, 301; Diaspora 170;
 eruptions of violence 193; mapping and
 framing of 176, 186; Middle Passage of
 slavery 190–1; sexualisation as feminine
 179, 187; Western association with
 blackness/darkness 182, 257, 277;
 Western myths 172, 182, 286
African Americans: exclusion from canon
 5, 187; experience of Josephine Baker
 182
African culture: appropriation/mis-
 appropriation of 171, 176, 186, 289;
 influence on Post-Impressionism 179; and
 modernism/modernity xvi, 177, 179, 185,
 286, 294, 297; transformations and
 Himid's paintings 169, 177, 179, 186;
 women artists 187; see also black culture;
 North African culture
African women: artists 187; colonial
 exploitation of 300; representation of
 286–7, 289–92, 294, 295
Africanism: in Baudelaire's poetry 263, 277;
 discourse 256–7, 266–7, 277,
 305; Manet's displacement of 257, 264,
 277; presence within canons of white
 art and literature 5, 183, 268; racism

304; and representations of femininities
 254
agricultural economy: in late nineteenth
 century 45, 46, 47
Aiken, Susan Hardy 5–6
alliance: strategies xv, 11, 194, 195–6
ambivalence: feminism and visual
 representations xiv; of the maternal body
 35, 39, 60, 91
American art: collecting 236
American literature: canon 5
animality/bestiality: fantasies of rural
 working-class sexuality 43, 48, 50, 51,
 52–3, 56–8, 222; in representations of
 African women 268–9
Annales school of thought: concept of
 history 27
Annunciation: images of 215
Anquetin, Louis: *Moulin Rouge* 71
anthropology: misappropriation of non-
 Western cultures 171, 267–8; and
 psychological history of the individual 13
art: and creation of images and symbols
 231, 233–4; and culture wars xiv, 4, 9; as
 discourse of the other 61, 109–10, 158;
 hierarchies of media and materials 24–5;
 institution of 301, 306; Kristeva's theory
 of aesthetic practices 31, 33; as object
 created by discourse 27; and
 psychoanalysis xiv, 15–16, 150, 230, 303;
 as therapeutic practice and release 189,
 190; women set in opposition to xiii, 229
l'art féminin 218, 229
art galleries: and the canon 4, 10–11
art historians: feminist 11–12, 13, 24–5,
 35–6, 71–2, 101–3, 124, 135, 254–5,
 305; racist vocabulary 85
art history: canons 1, 3–4, 61, 172, 187,
 254, 306; as discourse 12, 27, 95, 98,
 172; failure to account for rural genre 50;

failure to address maternal loss 157–8;
feminism and the canon xiii–xiv, 8, 18,
26, 61, 98, 247, 306; feminist
interventions 12, 26–9, 36, 61, 65, 95,
101–3, 106, 124, 130, 172, 187, 254,
300, 305; as hegemonic discourse 11–12,
91; heterosexist imperative 41;
importance of authored works 65;
misunderstanding of Gentileschi's work
109; modernist 186, 269; and *Olympia*
256, 282, 287, 289; perceptions of
Cassatt 235, 236; perceptions of Degas
235; phallocentric discourse 5; and
psychoanalysis 27–8, 34, 61; selective
tradition 10, 187; as social history 12,
61; and special studies 193; as the story
of Man 23–4
artists: of African descent 172; and
biography 14, 61, 97, 98, 106–7, 111,
188, 262; and the canon xiii, xiv, 3–4,
13, 16; as created by discourse 27, 110;
gaze of 231–3, 300; as 'great men' or
heroes 13–14, 18–19, 61, 87; and models
41–3, 46–7, 58, 225; and mythic
structures 9, 39, 61; as producers rather
than authors 145–6; and projections onto
myth 117; and psychoanalysis 15–16,
34–5; as suffering geniuses 39, 41, 61,
90; transcending binary gender difference
34, 185; virile and autogenetic identity
34–5, 87; *see also* women artists
Asian culture: traditions 5
Astruc, Zacharie: poetry framing *Olympia*
277, 301–3, 309n
authorship: of Gentileschi 139, 146, 147;
importance to art history 65; notions of
xiv–xv, 145–6, 156
autobiography: and painting 106, 108;
women's xvi, 131, 156–7, 164
Avril, Jane 71, 72, 75, 79, 83

Baartman, Saartje 300
Bacon, Henry 218
Baker, Josephine 182, 183
Bal, Mieke: xviii, 189, 293; on biblical
stories and myths 115–16, 119; on rape
in Rembrandt's *Lucretia* paintings 117,
158–60, 162, 163; and new poetics:
hysterics xv, 254
Banville, Théodore de 260, 267, 268
Barbauld, Anna Laetitia: in Samuel's *Nine
Muses* 17
Barnes, Djuna 179
Barney, Nathalie 179
Baroque: history painting xv, 98, 110–11,
111–12, 116, 133, 135, 138, 157, 196

Barthes, Roland 9, 116, 122, 175, 217
Bastien-Lepage, Julien 53
Baudelaire, Charles: xvi, 275, 276, 277; in
Courbet's *The Artist's Studio* 264;
drawings of Jeanne Duval 264–5, 266,
268–9; *Les Fleurs du Mal* 260, 269, 301;
involvement with Jeanne Duval 255, 261,
262–3, 269, 272, 276; and Manet 255,
258, 260–1, 261, 262, 264; poetry
262–3; theories of modernity 255, 258,
260
Bazille, Frédéric: *African Woman with
Peonies* 295–7, 297; *The Toilet* 295
Beach, Sylvia 179
Beaton, Cecil: photograph of Stein and
Toklas 183, *184*
Beaux, Cecilia 240n
Beckett, Jane 169
Bell, Vanessa 177
Bellini, Giovanni 228
Benjamin, Walter: on gender difference and
modernity 87
Benoist, Marie-Guillemine: *Portrait of as
African Woman* 297–300, *298*
Benouville, Léon: *Esther (Odalisque)* 289,
292
Benstock, Sheri 177
Benvéniste, Emile 217
bereavement xv, 109, 151, 164, 259
Bertall: caricatures of Manet's paintings
259, *259*, *304*, 303–5
Bey, Khalil 88, 314n
Bhabha, Homi 83–4, 287
Bible: canonical texts 13, 277–9
biblical stories 110–11, 115–17, *117*
Bièfvre, Edouard de: *L'Almée* 133, 133–5,
134
binary oppositions: blackness and whiteness
256–7, 277; deconstruction of 8; and
establishment of counter-society 192;
Man versus Woman xv, 30, 34, 177,
183–5; and negation of women's cultural
practices 25, 34; and the Other 5
biography: and artists 14, 61, 97, 98,
106–7, 111, 188, 262; Freud on 14–15;
of Gentileschi xiv, 97; and Jeanne Duval
272, 276; and Laure 281; of Virginia
Woolf 130–1; of women artists 106–7,
151
bisexuality: Garber's study 183
Bissell, R. Ward 115, 123
Biswas, Sutapa 173
black culture: and modernity 172–3, 188;
and postmodernism 173; salvaging a
future 186–7; *see also* African culture;
North African culture

120–1, *121*, 122; style of painting 103, 105, 157, 163

Carriera, Rosalba: *The Man in Grey* 37n

Carter, Angela: *Black Venus* and Jeanne Duval 270–1, 306

Carter, Elizabeth: in Samuel's *Nine Muses* 17

Cassatt, Katherine Kelso 230–3, 234; paintings by daughter Mary 231–3

Cassatt, Mary: xvi, 9, 24, 27, 179, 188, 199, 236, 254; comparison with Degas 237–9; exhibition at Durand Ruel's gallery (1891) 201, 213; femininity in her work 199, 217, 221, 222–5, 229–30, 234, 239; as feminist 202, 237, 239–40; importance to modern art 236, 237; Knoedler's Gallery exhibition xv, 202, 204, 231, 234–40, *235*; and the maternal 35, 207, 229–30, 231–3, 239; modernity 176–7, 199, 221, 230, 237; as painter of mothers and children 202, 204, 206–10, 218, 221, 230, 231, 234–5, 239; photograph *200*; relationship with mother 230–1, 234; representations of bourgeois world 202, 210, 218, 221–2, 225–6, 226, 239; representations of working woman 222, 239; technical aspects of her work 201, 204, 206–7, 210, 212–13, 218, 221, 230, 237; works: *The Coiffure* 222; *Family Group* 231; *The Fitting* 220, 221–2; *In the Box* 178; *In the Omnibus* 217–21, *219*; *Lady at Tea Table* 239; *The Letter* 213, *214*, 217; *Louisine Havemeyer and her Daughter Electra* 204, 207–9, *208*, 234; *The Maternal Caress* 226, *227*, 230; *Modern Woman* (mural) 229; *The Mother's Kiss* 226, *227*; *Portrait of Katherine Kelso Cassatt* 231, *232*; *Reading Le Figaro* 231–3, *232*; *Woman at a Coffee Table* 65; *Woman Bathing* 222–5, *224*; *Woman and Child* 239; *Young Mother Sewing* 204–7, *205*, 239, *239*

castration: complex 33, 58, 73, 74, 79; and deficiency in the body 77, 86; representation as symbolic 109; and sacrifice 193; threat of the mother/woman 100, 124, 148, 217; of woman 83, 148

ceramics: arts 24

Ceres: symbolic image of 53, 55

Cham: caricatures of Manet's paintings 259, *259*, 303–5, *304*

chastity 53–5, 112, 113, 133, 163

Chéret, Jules 71

Cherry, Deborah 169

Chicago, Judy: *The Dinner Party* 37n, 283

child: effect of culture 59, 68, 101, 217; experience of loss 190, 228–9; experience of sexuality and difference 31–2, 52, 59, 67–8, 70; and the family 59, 67–8, 69–70; and the maternal/mother 29, 32, 50, 57–8, 59, 69–70, 73, 87, 101, 149, 207, 211, 218, 230

Chocolat 83, 85–6

Choubac, Alfred: cover image for *Fin de Siècle* 83

Christianity: images of mother and child 228; splitting of femininity 249; theology of darkness/blackness and light/whiteness 257, 279

cinema: representations of maternal loss 150

Cixous, Hélène 97, 123–4, 165n

Clark, Kenneth 4, 145, 287

Clark, T.J. 196–7n, 201, 225, 285, 287

class relations: in Cassatt's work xv–xvi, 221, 222–5, 239; conflict and sexuality in *Germinal* 56, 57; difference and the feminine 217, 239, 294; divisions within women's collectivity 35, 91, 99, 217; and exchange between artist and model 47, 58, 225; feminist analysis 199; and formation of masculinity 59, 60, 88–9; hierarchies 91; in Manet's paintings 35, 225, 254; and Orientalism 294; and power in the canon 24; prejudices of Degas 222; and sexuality 56, 89, 91, 221, 259, 262; Toulouse-Lautrec 86, 89; and women's bodies in the nineteenth century 47, 50–1, 57, 59, 67, 70

Claudel, Camille 97

Cleopatra: history of 135, 150; images and myths 111–12, 133–8, 143, 146–7, 148–51, 157, 158, 163, 170, 187; painting of in *Villette* 133–5, 135–6; in Shakespeare 123

Cleopatra (Gentileschi paintings) xv, 138–45, *140*, *144*, 146–7, 149, 151–3, *152*, 154–5, 157, 158, 163, 164, 244n

Cold War: art history 171

Colette 179

collectivity: and femininity 31; and feminism xv, xvi, 26, 35, 91, 195–6

colonialism: and artistic representations 179; erasure of black feminine subjectivity 279, 280; exploitation of Africa 171–2, 172, 187, 188, 255, 277, 286, 287, 294, 300, 301; and Orientalism 254, 286, 294; racism 256, 286–7; role of black women 182, 185; and selectivity of canons 171; Spanish 295

colonisation 6, 277, 286, 294

247, *250*, 276, 305; relationship with
Manet 247, 258; threads linking with
Jeanne and Laure xvi, 254, 258, 264,
305–6; as 'white lady' 259, 260–1
Morrison, Toni 5
Mosquera, Gerardo 196n
mother/Mother: bourgeois/upper class 57–8,
69, 210; and daughter 204, 207–10, 229,
230, 317; debasement of 69, 217, 229;
desire for 18, 67; and fantasies of
wholeness and intimacy 29, 50, 60, 74,
148, 149–50, 193, 207, 226, 228; and
father/Father 59, 100; feminine relation
to 18, 35, 158, 229–30; figure of xiv, 18,
34, 91, 149, 199, 230; importance to
feminist reading of art 35, 157–8; and
lack 59, 72; loss of xvi, 150, 151–3, 153,
156, 157, 164, 228–9, 230; male
fantasies 47–8, 50, 58, 67, 229;
masculine relation to 34, 35, 52, 59, 73,
228–9; 'murder' of 34, 35; as Other 217,
230; and patriarchal notions of art 25,
34–5, 87; psychoanalytical theories 217;
relationship with child 29, 50, 69–70, 87,
101, 149, 207, 211, 230; and splitting
of the subject 60, 69–70, 100;
transfiguration in modernist culture 75,
90, 229
Moulin Rouge 85
mourning 305, 317; feminist analysis 192,
194, 195; Freud on 169, 189; and
modernity 260; and personal narrative
xvi, 170, 187, 188, 189
Mulvey, Laura 77, 240n
Mure, Pierre La: *Moulin Rouge* (book
cover) *42*
muse: trope of 263
museums: culture of 237; and
misappropriation of non-Western cultures
171; of modern art 170; role in creating
canons 4, 10–11, 133, 136, 171, 186
music: canons 3, 4
mythologies: feminist xiv 8, 130, 131–2,
164; suffering hero of modern art xiv, 39;
of women artists xiv, 8
myths: of afterlife 155; concepts of the
artist 61; created by women 18–19;
definitions and ideas of 9, 117, 149; of
femininity 9, 28; Judith Shakespeare
123–4, 131–2, 158, 164; Lucretia 158,
164; and Western culture 133, 135

Nadar (Félix Tournachon) 249, 261, 262,
264, 265–7, 268, 270–1, 274
Nantes: connections with Duval 262, 270
Naomi *see* Ruth and Naomi

Napoléon Bonaparte 299
narcissism: and the artist 14, 18; feminist
desire and women artists 18; Freudian
ideas 13, 14, 15, 16; Greek ideals 267; of
masculinity xiv, 13, 73
narrative: in art xv, 98, 112–13, 114, 156,
173; in Himid's paintings 176, 186; of
history writing xvi; personal xvi, 173,
195–6
National Gallery (London) 36–7n, 133
National Women's Party 202
Nattier, Jean-Marc: *Madame Clermont
Leaving her Bath* 287–9, *288*
needlework: arts 24
Nefertiti, Queen 173
négresse: idea of 258, 267, 269, 273,
277–9, 282, 289, 305
neotribalism: and self-analysis 192
Neveu, Pierre Dumoustier Le: *The Hand of
Artemisia Gentileschi Holding a
Paintbrush* 96
New York: *Firing the Canon* platform 5;
Havemeyer exhibition at Metropolitan
Museum 202, 234; Suffrage Benefit
exhibitions at Knoedler's Gallery xv, 199,
202–4, 213, 231, 234–40
Nin, Anaïs 179
Nochlin, Linda: xiii, 5, 16, 19n, 53, 210, 222
North African culture 249, 254
Nourse, Elizabeth 218
the nude 83; in art history 299; in Kenneth
Clark's writings 145, 287; as figuration of
white woman 282, 283, 289; links
between viewing and slave market 299,
301; in *Olympia* 256, 258, 282, 283,
286, 289; Renaissance images 105, 113,
139–42, 144, 147, 256; represented as in
masculine economy 225
Nuenen (Netherlands): Van Gogh's
depiction of peasants 43, 46, 57
nursemaid: and male bourgeois fantasies 48,
52, 57, 58, 70, 74; *see also* maid; servant

Oceania: misappropriation of culture 171
Octavian, Emperor (later Augustus) 150
Odalisque paintings 252, 289
Oedipal complex: and the child's
development 32, 48, 59, 68; and the
father 70, 77–9, 207; Freudian emphasis
18, 77, 91, 228; masculine betrayal and
aggression 56–7, 58; and the mother 69,
233; narrated by canons 5–6, 16; and
Toulouse-Lautrec 77, 79
O'Keefe, Georgia 9, 97, 186, 283
Old Masters: works at Knoedler's Gallery
exhibition xv 202, 203

'old mistresses' xiii, xiv, 24
Orientalism 135, 257; in Baudelaire's poetry
 263, 277; and colonialism 254, 286, 294;
 image of Cleopatra 133; Manet's dis-
 placement of 257, 264, 272, 274, 277,
 285, 286–7, 289, 291–5, 305; racism
 304; representation of sexuality 291, 292,
 294; traditional representation in art 252,
 254, 285, 287–9, 293–4
Orton, Fred 90
the Other: xiii, xv, 6, 59, 199, 222;
 discourse of 5, 61, 109–10, 158;
 femininity as 24, 193, 230, 234;
 figuration in Toulouse-Lautrec 85, 86, 89,
 91; figure of maid 225, 239; implications
 of inclusion in the canon 5; and
 lesbianism 215; as Mother 217, 230;
 woman as 25, 26, 31, 101, 157, 234

Page, Ethel 240n
Paris: black women artists' experience 182;
 brothels 87, 89, 271, *271*, 292; as capital
 of Western modernism/modernity 182,
 183, 252–4; Cassat exhibition at Durand
 Ruel's gallery 201; circle of Toulouse-
 Lautrec 71, 87; importance of late
 nineteenth-century painting 236; Musée
 de l'Homme 300; Nouveau Cirque 83;
 presence of radical women in the 1920s
 177; *Revue Nègre* 182
Parker, Rozsika: *Old Mistresses* (with
 Pollock) xiii, 5
Parole de Femme 215
Parsons, Louise 310n
pastels: use of by Cassatt 204, 212–13, 218,
 230
pastiche: postmodernist 172, 188
patriarchy: Greco-Roman-Christian 148,
 150, 163; historical legacies of 27; laws
 of 60, 135; legends of 14; notions of
 woman 25, 130, 162, 163, 183, 196,
 233–4, 262, 270; Renaissance period 129,
 130; seventeenth-century Rome 111, 164;
 women's contradictory responses to
 power systems 192–3
peasants: representations by Breton 46, 53,
 57; representations by Millet 43–5, 53;
 representations by Pissarro 46, 201;
 studies by Van Gogh 43, 58; Van Gogh's
 views 55
Pellet, Gustave 88
phallic imagery: in Picasso's work 41
phallocentrism: deconstruction of 28;
 discourse of art history 5; feminists'
 contest with 28, 32, 33, 59, 99, 100–1,
 193–4, 213, 270; historical legacies of 27,

150; idea of the Woman 8, 18, 72, 148,
 185; ideologies of the difference xv, 27,
 28, 59; and sexual difference 74, 102,
 148, 211; and the symbolic 213, 229; of
 Western culture 27, 41
phallus: and fetishism 74, 75, 77, 83
Phidias 265, 267
Philip II, King of Spain 113
The Piano (film) 270
Picasso, Pablo 35, 41, 170, 179, 229
Pichois, Claude 262, 264
pictograms 211, 212
Pissarro, Camille: on Cassatt's works 201;
 Four Studies of Nude Women Bending
 45, 46; *Studies of Female Peasant*
 Bending 45, 46
pleasures: fantasies of the nurturing female
 58; of femininity 8, 28, 102, 109, 130,
 146, 151, 234; of looking at pictures 148;
 of male child 73; *see also jouissance*
political activism: and feminism 193; for
 more women artists 10
political power: and image of Cleopatra
 135; and myth of Lucretia 158
politics: and subjectivity 173
Pollock, Griselda: *Old Mistresses* (with
 Parker) xiii, 5
polylogue: for re-vision of the canon 6
Polynesia: influence on Post-Impressionism
 179
Pontoise: Pissarro's paintings of peasant
 community 201
Pope, Theodore: photograph of Cassatt *200*
pornography 83, 88, 90, 105
postcolonialism: feminist history painting
 xv, 95, 186, 187; repression of black
 femininities by white feminism xv, 188;
 theories of visual representation 254
postmodernism: and black culture 172–3;
 and collapse of history 172; and liberal
 pluralism 193–4; and modernity 173; and
 pastiche 172
power: of gender and class 24, 47, 58;
 masculinity 9, 158; and selectivity of the
 canon 3, 4–5, 24; and sexuality 25–6, 91,
 103, 107, 183; Western hierarchies 91,
 173, 192
Princeteau, René 79
print-making: Cassatt's work 230; Japanese
 71, 225
Proctor, Nancy 255
producer: artist as 145–6
prostitutes: as artists' models 46–7; and
 bourgeois/upper class male fantasies 50,
 51, 58, 67, 69; caricatures 303–5; in
 Degas's work 229, 231, 237; masculine

INDEX

Rivkin, Ellis 3
Rochdale Art Gallery: *Revenge* exhibition 169
Roger-Marx, Claude 88, 89–90
Roman culture: myths 150, 158
Rome: in seventeenth century 107, 111, 147, 151, 158, 164
Royal Festival Hall (London) 186
Royal Society of the Arts: exhibition seen by Charlotte Brontë 133
Rubens, Peter Paul: painting of Susanna and the Elders 113
Rubin, Gayle 29
rural imagery: and bourgeois male fantasies 50–1; genre of painting 43, 50, 52, 57, 60; in *Germinal* 55; and images of chastity 55
Ruth and Naomi: painting by Victors *195*; story 191–2, 194, 195–6

Sabatier, Apollonie 269
sacrifice: and the phallocentric order 58, 60, 193
Said, Edward: on Orientalism 135, 254
Salomon, Nanette: xviii, 5, 41, 106–7, 107–8; *The Art Historical Canon: Sins of Omission* 1
Samuel, Richard: *Nine Living Muses 17*
Sartre, Jean-Paul: biography of Flaubert 107
Savage, Augusta 182
sculptors: inspiration of Cleopatra 187
Segal, Hanna 190
Segard, Achille 202
self-analysis: of feminist writing xiv, xvi, 18, 60–1, 102–3, 119, 192, 199, 252
self-reflexivity: in reading women artists xv, 33–4, 95, 143
semanalysis: Kristeva on process in language 30–1
semiotics: Kristeva's theories 30–1; and psychoanalysis xv; of representation xiv, 28, 71–2, 98, 108, 115, 147; and sexual difference 27, 30, 61
Semitic culture: appropriating for modern theories 149
separations: and the subject 29, 59, 73, 226–8
servant: figure of xvi, 257, 269, 280, 289, 289–91, 294; *see also* maid; nursemaid
Seurat, Georges: *Le Chahut* 71
sex: political economy of 28
sexism 7, 26
sexual abuse: trauma of 109
sexual difference: and beginnings of modernism 43, 71–2; binary of 30, 34,

177, 183–5; and the canon xiv, 8, 9, 10, 18, 26; child's experience of 31–2, 52, 59, 67–9, 70; configurations in artistic works 235; and constitution of the subject 27, 28, 59, 100, 211; as determined by language 73, 185; and gender 26, 32, 34, 60, 100, 185; and homosexual love 213; inscription through psychic formations 27, 32–3, 61, 67; modernisation of by feminism xiv, 27–8, 99; mythologies 9, 16, 39; patriarchal law of 60; and phallocentrism 74, 102, 148, 211; politicisation of issues 193, 194; re-vision of xiv; semiotics 27, 30, 61; and social relations xvi, 26, 202
sexual discrimination: and selectivity of canons 4–5
sexuality: the affectionate and the sensual 67–9; and animality 48, 51, 52–3, 56–7, 57; and Biblical heroines 116; as bourgeois construct 53, 56, 58, 69; and the canon xiv, 24, 39, 306; and class 56, 89, 91, 221, 259, 262; correlation with creativity 33; and the dark lady 249; divisions within women's collectivity 91; and fantasy 43, 52, 68, 148, 286; female–female 88; feminist cultural analysis xiv, 27, 199; images of male artist 41–3; lesbianism 183–5; of nineteenth-century women 47–8; and the nude 287, 289; and Orientalism 291, 292, 294; patriarchal notions of women 25, 162, 163, 196; and political power of Cleopatra 135, 150; as psychically formed 41–3, 52, 57, 61; race and racism 259, 262, 276, 286–7, 300; and representations of women xv, 87–8, 112, 116, 132–6, 150, 256, 271, 285, 287; and subjectivity 27, 28, 32–3, 43, 75, 100, 150–1; and violence 103
Shakespeare, William: figure of Cleopatra 123; sister of, in *A Room of One's Own* 129–32, 138, 156, 158
signifiers 29–30, 32, 117, 211; Kristeva on 30–1, 147–8, 185; process of language 30–1, 59, 185
signs: feminist perspectives 30, 33, 98, 146, 185, 189; women as 26, 28, 33, 193
Silverman, Kaja 20–1n, 60, 77, 93n, 229, 234, 237
Silverman van Buren, Jane 226, 233
Sirk, Douglas: *Imitation of Life* (film) 279–80
sisterhood: concept of 35
slavery: African as slave 287–8, 294, 295, 304; exploitation of Africa 190–1, 287,

342